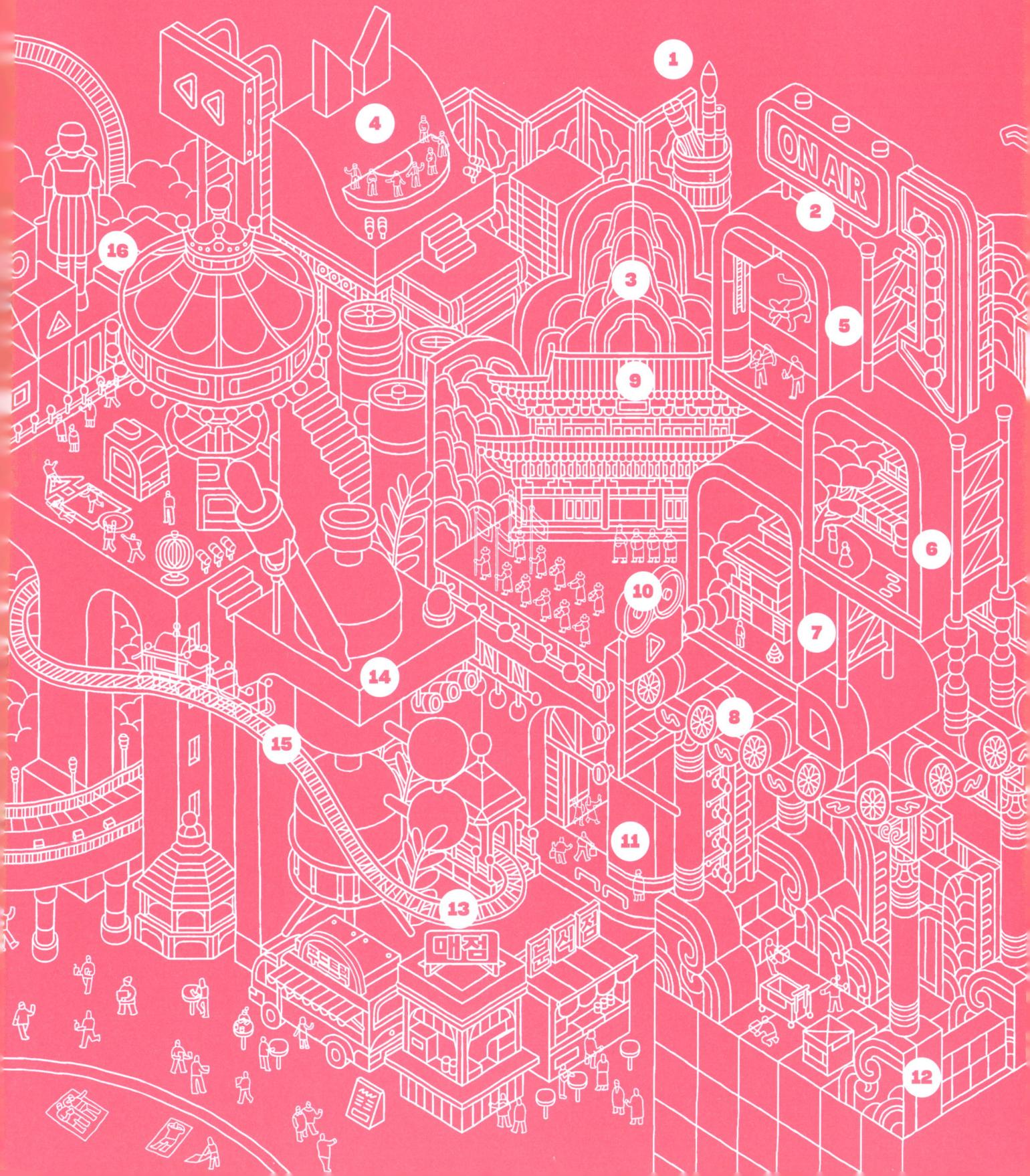

FIND THESE ON THE COVER

1. CRAFT AND PAINTING ACCESSORIES
2. CINEMA
3. LANDSCAPE SCENERY IN THE STYLE OF TRADITIONAL PAINTING
4. BTS IN CONCERT
5. *THE HOST*
6. *THE HANDMAIDEN*
7. *PARASITE*
8. TRADITIONAL ROOF
9. GYEONGBOKGUNG PALACE
10. DAECHWITA PARADE
11. SHOPPING CENTRE
12. BEHIND THE SCENES AND FILM SETS
13. FOOD COURT: STANDS SELLING STREET FOOD AND TRADITIONAL CUISINE
14. COSMETIC PRODUCTS
15. PALANQUIN ROLLER COASTER
16. *SQUID GAME* DOLL
17. A SHAMAN PERFORMING A RITUAL NEXT TO A SACRED TREE
18. JANGSEUNG TOTEM POLES
19. BOTTLE OF SOJU
20. ILLUMINATED NEON SIGNS
21. N SEOUL TOWER
22. EULJIRO BY NIGHT
23. HONGDAE BAR TOUR
24. ITAEWON CLUB
25. PEGGY GOU IN CONCERT
26. COFFEE BREAK ON EMERGENCY STAIRCASE
27. AT A POJANGMACHA
28. GANGNAM CLUB

K Culture 한국

K-Pop, Cuisine, On Screen, and more
Celebrating the Korean Wave

simon clair

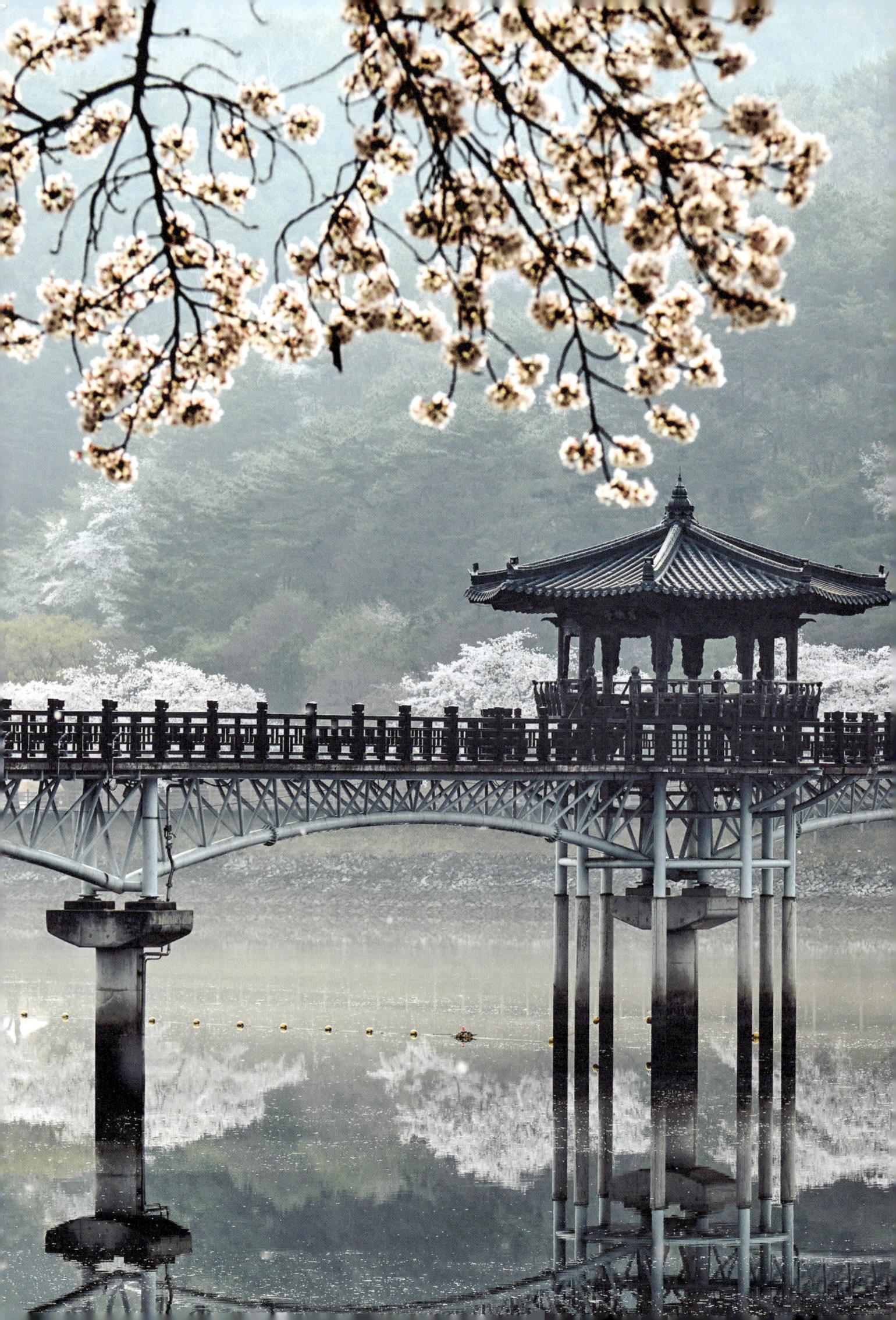

CONTENTS

FOREWORD

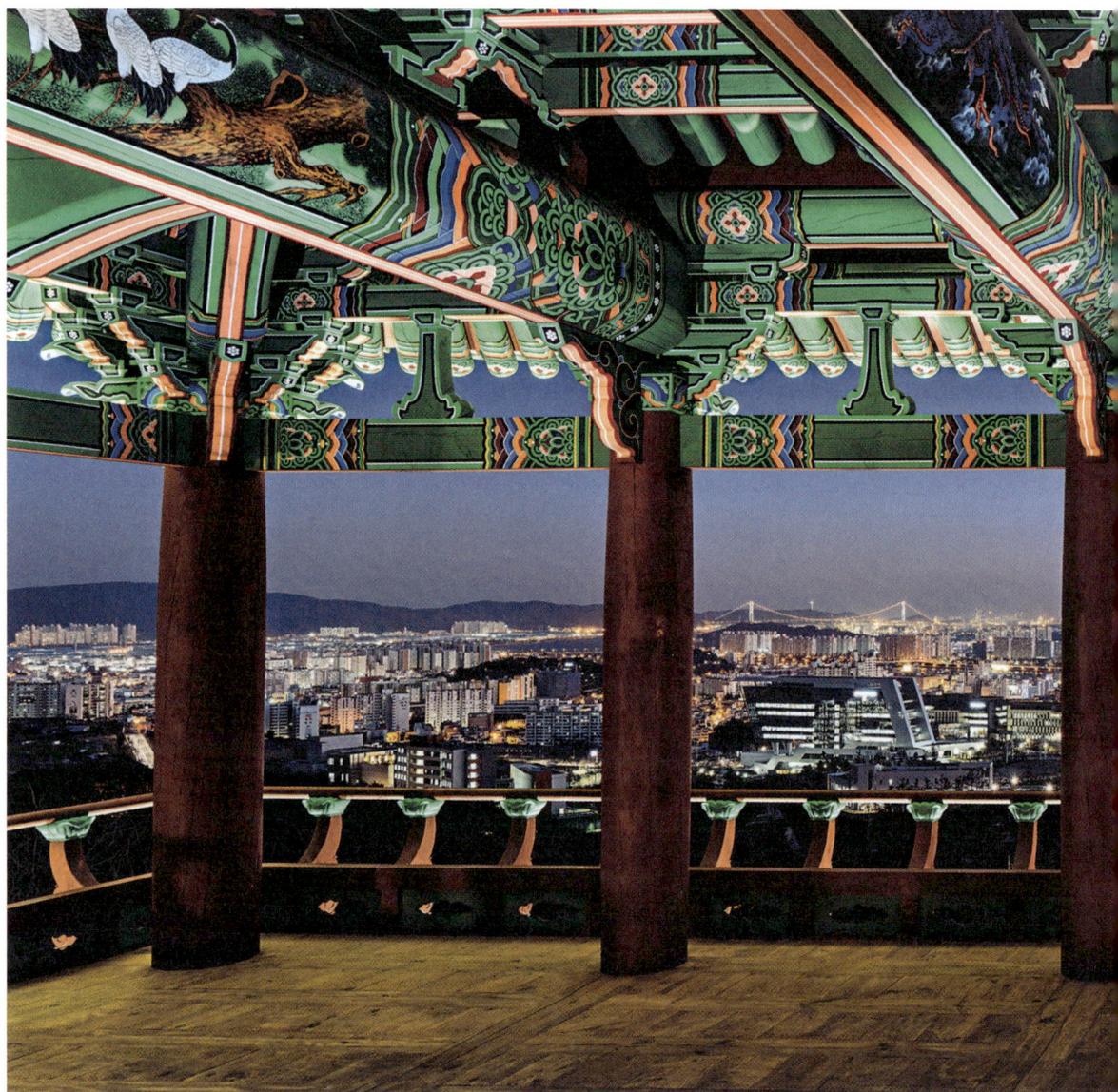

In recent years, Korean popular culture has taken the form of a tidal wave sweeping over the West. Whether it's music, film, drama series, fashion or cuisine, South Korea is establishing itself as a key player on the world stage. You only have to look around to realise this. BTS is nothing less than the biggest-selling band in the world. *Squid Game* is the most watched series in the history of streaming service Netflix. And the film *Parasite* by director Bong Joon-ho won a Palme d'Or and four Oscars, including for best picture and best director. In other words, when it comes to popular culture, South Korea can stand proudly alongside the three great powers that have already distinguished themselves in the genre, namely the United States, Japan and Europe. Better still, it represents a new approach which is modern, young and carefree.

South Korea started to make waves in the early 1990s, with the first signs of the current tidal surge. On the Korean peninsula, they call it *hallyu*, a term which literally means "Korean wave" and refers to the meteoric rise in the spread of Korean culture beyond its borders. At that time, The Land of the Morning Calm initially exported its culture to China. The first K-pop songs and TV dramas

↑
The Hamwolru Pavilion overlooking the port city of Ulsan.

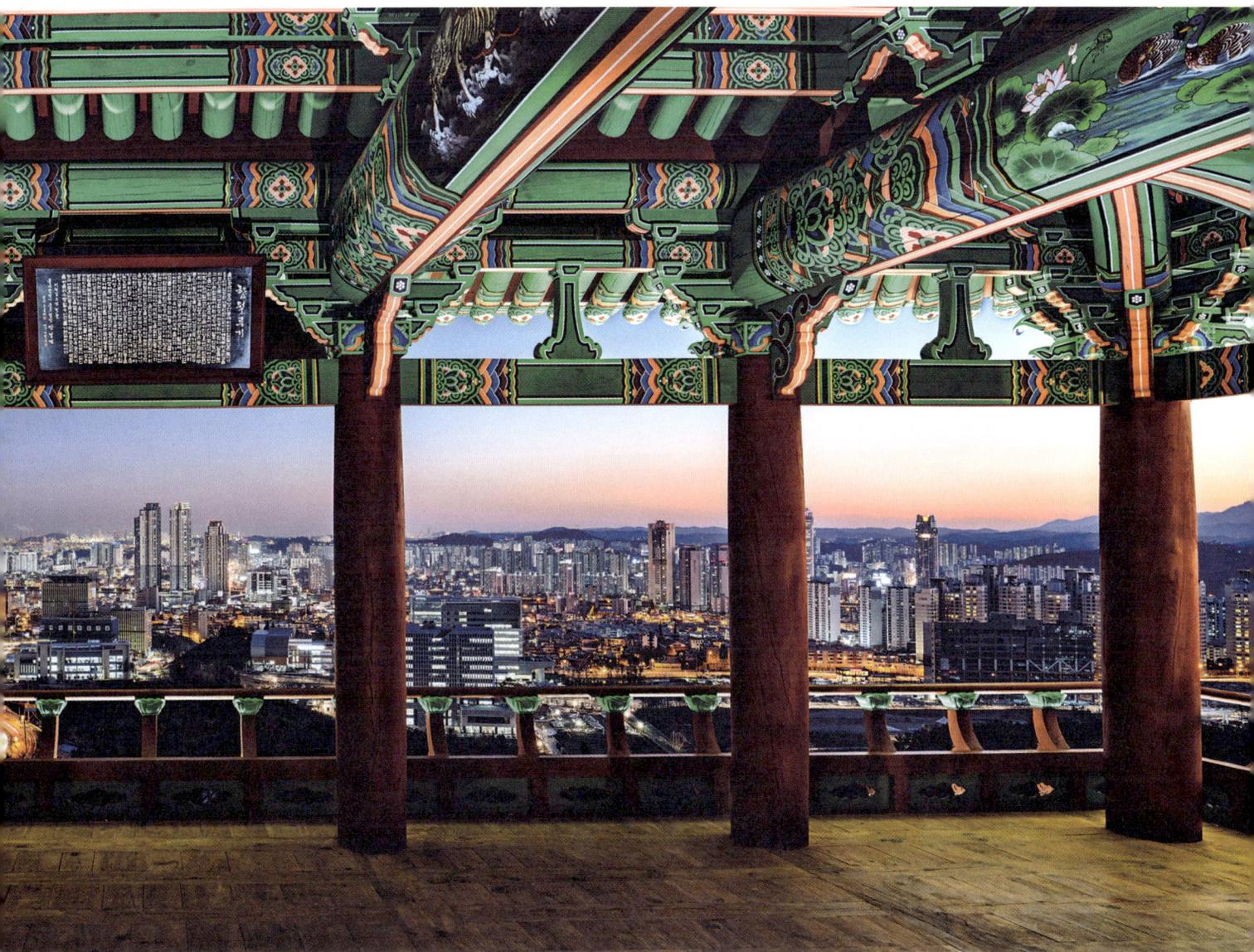

quickly became hugely popular with the country's Chinese neighbours. South Korea understood the importance of soft power in international politics. From that time onwards, the impact of the *hallyu* phenomenon would continue to spread over the coming years, especially among the younger generations. To such a point that in 2023, Korean influence is everywhere: we now talk about K-pop, K-dramas, K-food, K-beauty, etc. The reign of K-culture has begun!

There are several reasons for the spectacular success of Korean culture overseas. First, the power of the Korean cultural industry, structured around huge communication conglomerates such as Hyundai and Samsung, which facilitate the dissemination of content on mobile phone screens and online platforms. Secondly, in a world worn down by environmental collapse and social inequalities, Korean pop stars offer a message which resonates in the hearts of the public because it's positive and unifying, sexy without being shocking, and modern without being subversive. Thirdly, the importance of the connection forged with fans is a key factor. In the West, it's unusual for an artist to pay undue attention to their audience during the creative process, at the risk of being accused of opportunism. But in South Korea - a country renowned for its hospitality - the interactions between an artistic work and the people who appreciate it are fundamental. This explains the active role artists give to their fans by regularly inviting them to express their opinions or participate in their projects. In return, fans feel they must support their favourite artists at all costs.

This exuberant enthusiasm of fans of Korean pop culture can make the uninitiated feel that they are excluded from a movement everyone is talking about. This book offers different gateways into contemporary South Korea and what drives it. It would take thousands of pages to fully explain all the complexities of this multi-faceted country. This book aims to arouse the reader's curiosity and familiarise them with today's K-culture so they too can ride the wave...

1
K-POP

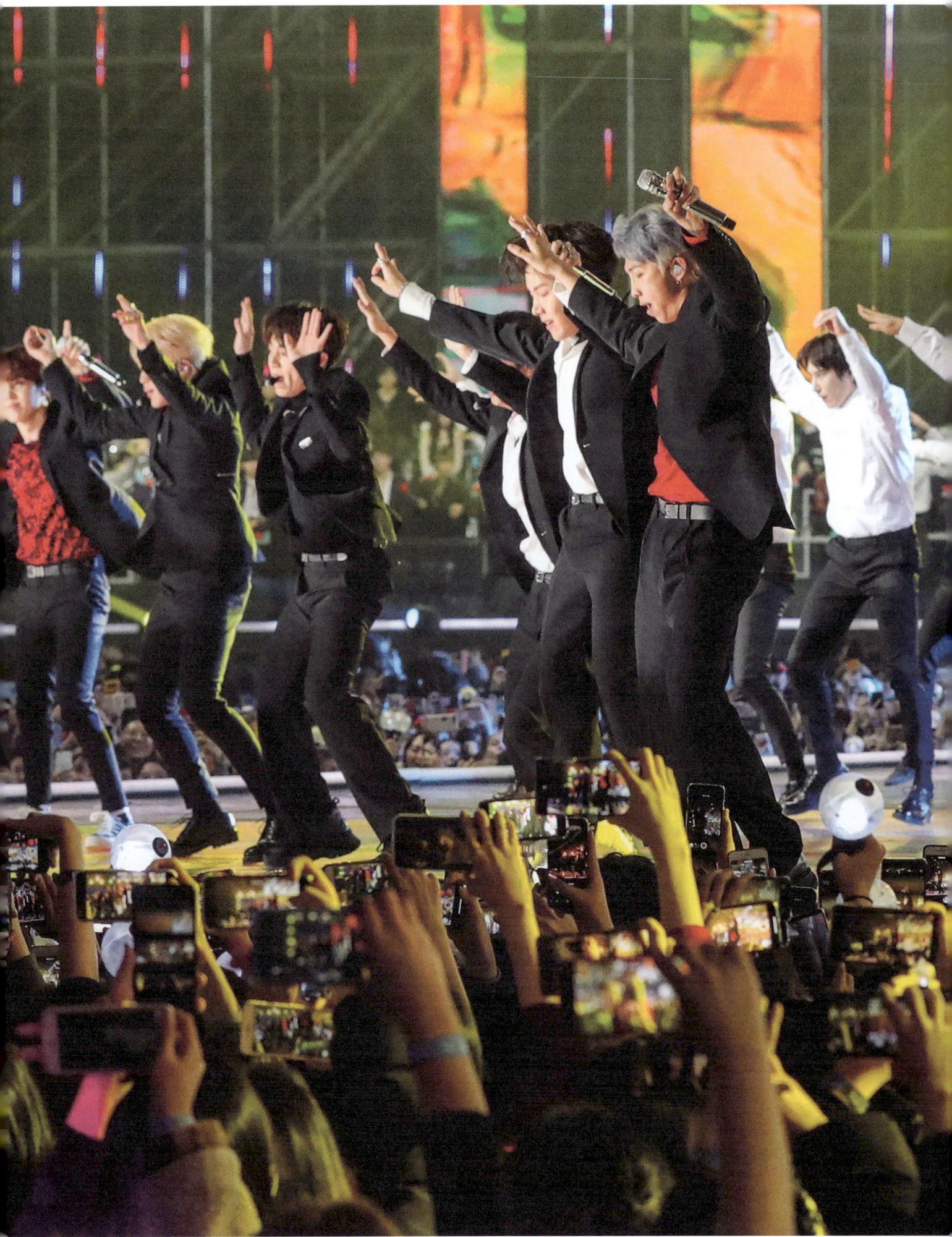

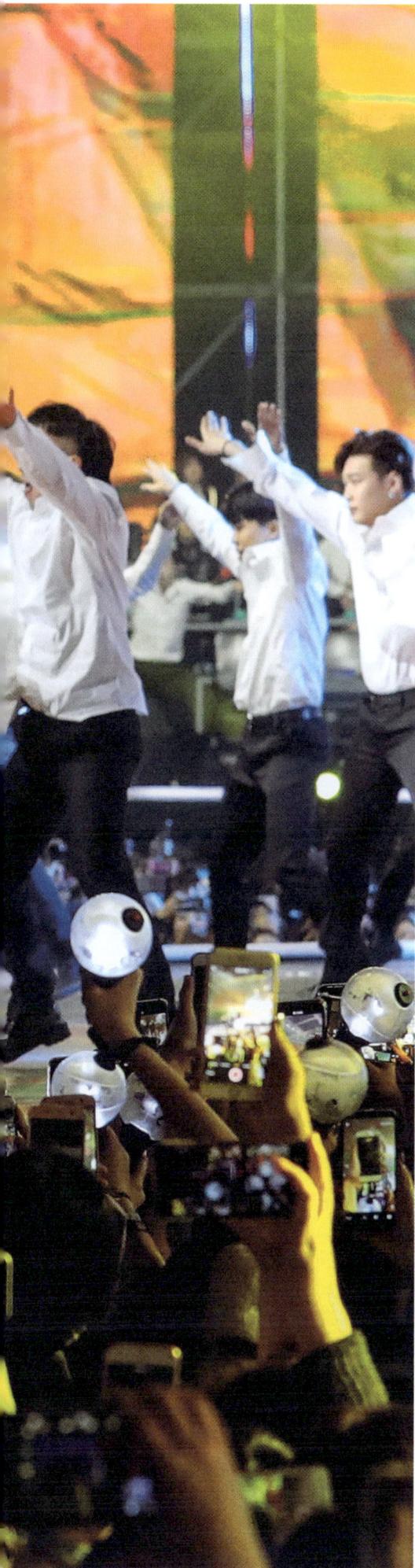

INTRODUCTION

케이팝

P. 06-07
—
Blackpink's Rosé, Jennie, Lisa and Jisoo perform at the 2022 MTV VMAs.

←
BTS at the 33rd Golden Disk Awards in the Gocheok Sky Dome on 6 January 2019 in Seoul.

One of the most popular musical genres in the world, K-pop has unique energy.

It's something no one saw coming. In March 2019, the group BTS announced a one-off concert at the Stade de France. The sceptics smiled, immediately thinking that the venue might possibly lend itself to the arrival of Beyoncé, Drake or Rihanna, but certainly not to a Korean boy band. If only they'd known... Just twenty minutes after the concert was announced, it was all done and dusted. The 80,000 seats of the largest stadium in France had sold out in the blink of an eye. For those that missed out, the following week BTS put tickets on sale for a second Stade de France show, which also sold out in record time. In other words, even if the general public isn't always aware of it, in France as everywhere else in the world, K-pop is a musical genre capable of bringing in the crowds on at least as big a scale as American pop. But how did this musical style rise to the top of global pop culture?

To fully understand K-pop, we have to go back to its origins. In the early 1990s, South Korea experienced a spectacular economic boom and after decades of isolation, the country opened up to the world and its influences. Artists such as Yang Joon-il and the group Seo Taiji and Boys began to sing in Korean to tunes inspired by foreign musical genres such as rap, dance, rock and Japanese pop. The result was a huge blend of styles that appealed to young Koreans wanting to distance themselves from the traditional values of their parents. This modern, urban and incredibly slick pop music quickly became known as simply K-pop, the shortened form of "Korean pop". It was just the start for a genre that was about to conquer the world.

A blend of styles that appealed to young Koreans wanting to distance themselves from their parents.

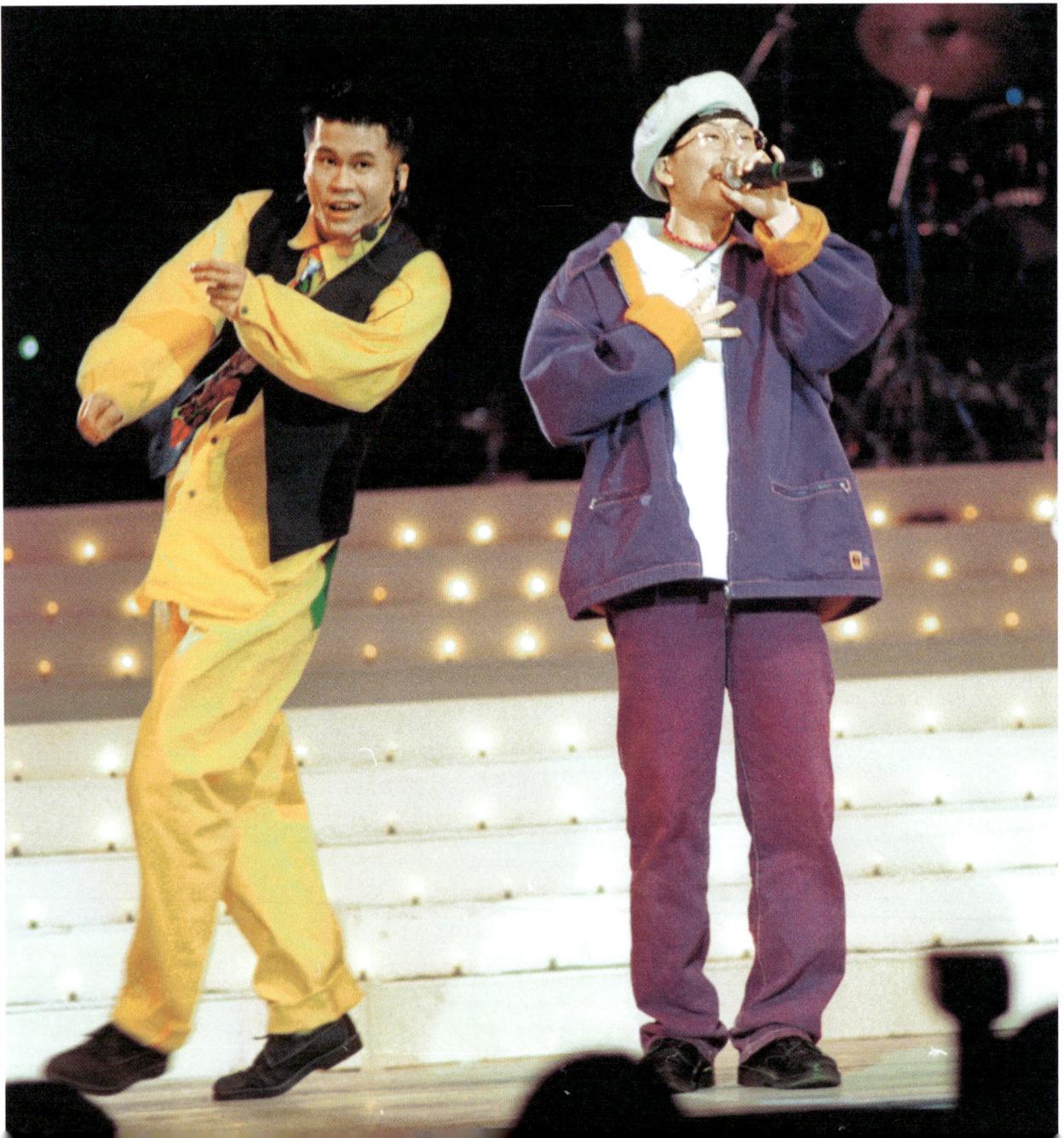

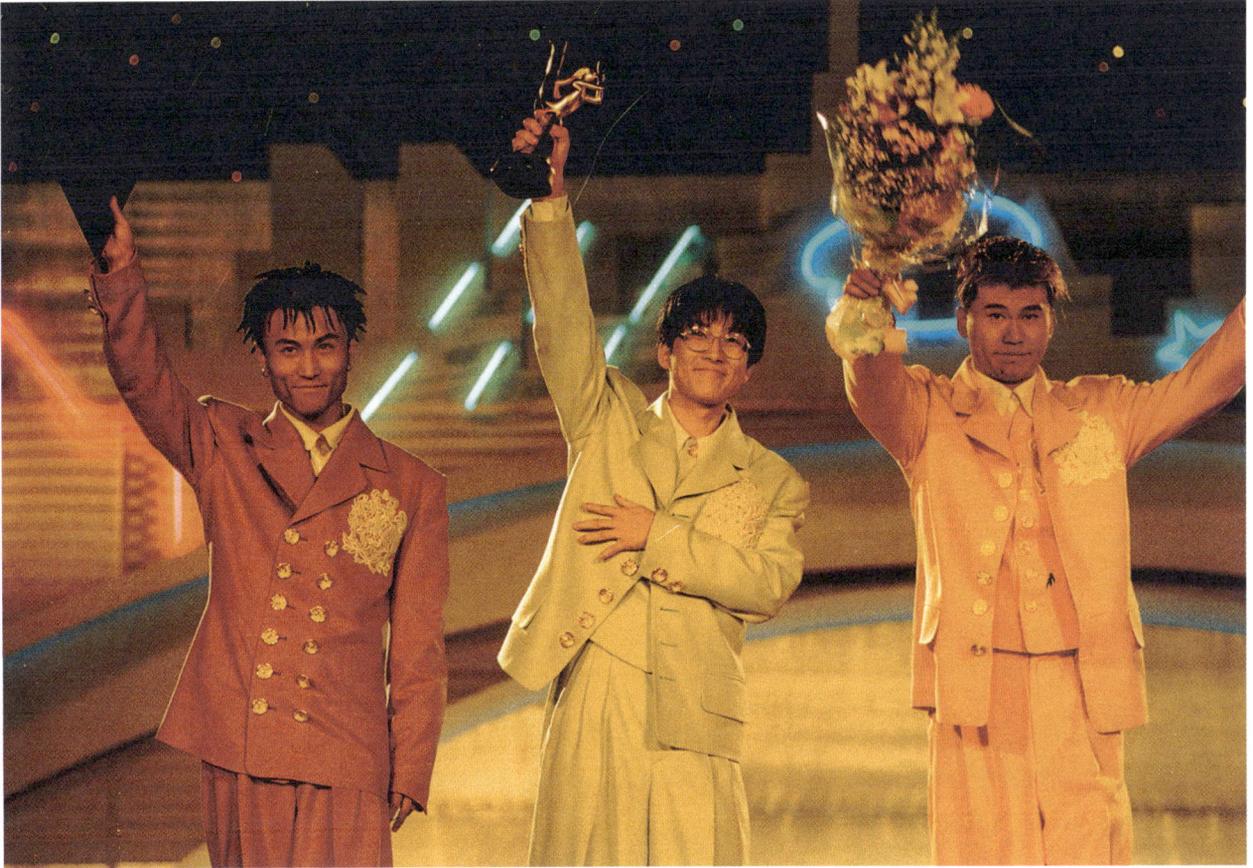

보이 밴드

←↑
Seo Taiji and Boys
performing and
receiving their
trophy at the
8th Golden Disk
Awards in Seoul
in 1993.

In South Korea, everything moves at speed. In the 1990s, huge industrial groups known as chaebol were starting to emerge. The country was keen to develop, and businesses were flourishing. The music industry was no exception. K-pop was quickly taken over by large corporations set up for the purpose, combining the roles of record label and talent agency. This resulted in the creation of SM Entertainment in 1995, YG Entertainment in 1996 and JYP Entertainment in 1997. Nicknamed the "Big Three", these companies revolutionised the genre by imposing a model based on the idol business in Japan. Under this system, artists are scouted by the companies from an early age through an audition process. If successful, apprentice singers then spend several years in the agency as trainees. Here they're trained to sing, dance, act, speak foreign languages and undertake anything else that might help them in their future careers as pop stars. This makes for fierce competition between the artists being developed in this way. The most talented are then launched with great fanfare by the agency, with whom they have to share the income generated by their concerts and record sales. In the very way it operates, the K-pop industry has all the hallmarks of a competition, with its winners and losers, but also its supporters.

11

In the very way it operates, the K-pop industry has all the hallmarks of a competition, with its winners and losers, but also its supporters.

It has to be said: the K-pop public is special. Fans aren't content to simply listen to the latest tracks of their favourite bands, they also want to champion their idols and take them to the top. To do this, they develop full-blown strategies to promote their favourite artists. These can take the form of promotional hashtags on social media, dance competitions on TikTok, or even posts setting specific streaming targets. For example, BTS fans issue daily challenges to their community by asking them to listen to a particular song a certain number of times during the day, or to watch a particular clip on repeat. The goal is simple: to help their favourite K-pop star see their streaming numbers soar and hopefully overtake the competition. This explains the staggering figures achieved by certain groups. On YouTube, it's not uncommon to see Blackpink or BTS clips accumulate more than a billion views in record time.

This ability to coordinate their efforts is what makes K-pop fans so powerful. Former United States president Donald Trump learnt this the hard way in 2020. While campaigning for re-election, he

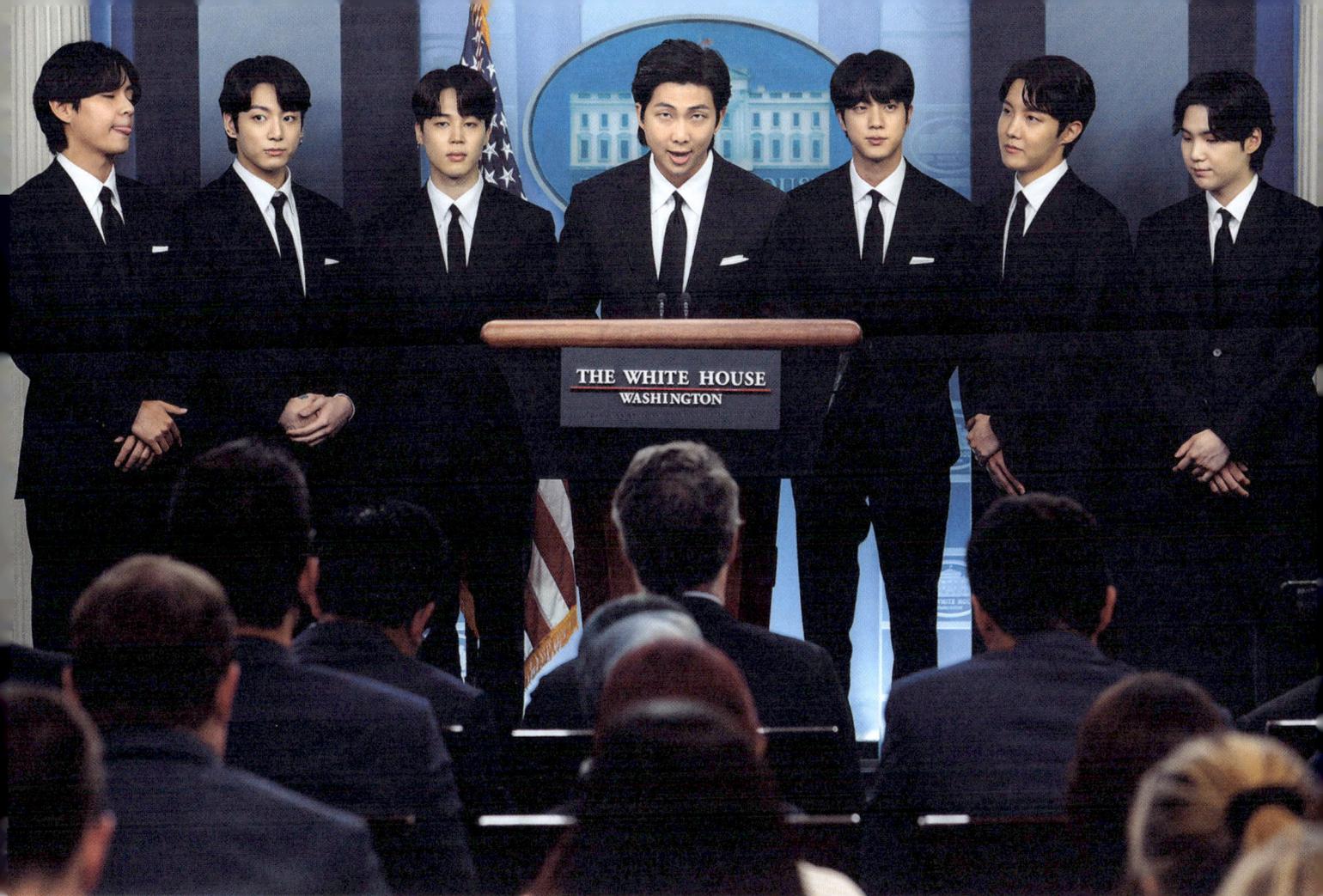

proudly announced that almost a million people had requested tickets for his meeting in the city of Tulsa. But on the day itself, the venue was almost empty. A humiliation for the politician who couldn't really understand what was happening to him. Open to the progressive causes defended by their idols - BTS, for example, have supported the Black Lives Matter movement - K-pop fans took to social media and encouraged their subscribers to register online for the meeting without actually attending, thus ensuring the venue stayed empty. More proof if it were needed that K-pop is much more than just sentimental choruses or seemingly innocuous dance moves. It has quite simply become one of the most popular musical genres in the world and makes a huge contribution to the cultural influence of South Korea on the international stage. Driven by an active and close-knit community that's constantly growing, nothing seems likely to stop its ascent. At this rate, the whole world will soon be listening to G-Dragon, Psy, Blackpink and BTS. And in Europe, it will no longer be a surprise when these stars fill huge stadiums in seconds flat.

IU

THE NATION'S LITTLE SISTER

From debt to the hit parade, she's the living embodiment of the maxim "never give up".

In charts dominated mostly by idol groups, IU is one of South Korea's most successful solo artists. But the path to glory wasn't easy for the woman known as the "Nation's Little Sister". Born into a family ravaged by debt, Lee Ji-eun - her real name - had to go and live with her grandmother many miles from her parents, where she grew up in poverty. As a child, she developed a passion for singing to karaoke in the afternoons and decided to attend auditions. At the age of fourteen, after some twenty unsuccessful attempts, she was scammed by a company that promised her a TV appearance in return for large sums of money. In 2007, fortune finally smiled on her when an agency scouted her. But her first EP was a flop and encouraged her to update her image by embracing a more colourful and upbeat style. From that moment on, the machine was up and running. Her hit "Good Day" proved to be a record breaker, spending five weeks at the top of the Korean charts. She even began a successful career in Japan. With over 1.5 million albums sold and 445 million streams, needless to say, IU has paid off her family's debt.

↓
IU on stage in New Taipei City on 30 November 2019.

09

PARK JIN-YOUNG

THE GODFATHER

One of the big shots on the scene while also responsible for the success of others.

Historically, the K-pop industry has been concentrated around the "Big Three" labels in the sector, namely SM Entertainment, YG Entertainment and JYP Entertainment. CEO of the latter which he named after his initials, Park Jin-young - nicknamed J.Y. Park - wasn't necessarily predestined to manage such a vast company. As a younger man, he dreamt of being an idol. This prompted him to enter singing auditions in 1992. Rejected at every turn, he quickly understood that if he wanted to do his own thing, it was up to him to make it happen. After releasing three solo albums, in 1997 he set up his own business, Tae-Hong Planning Company, which he later renamed JYP Entertainment. With impressive flair, his label launched the careers of groups such as Wonder Girls, Twice, Stray Kids and Itzy, all four of whom have been phenomenally successful. These experiences turned him into a high-flying businessman, but he still continues to pursue his career as a solo artist. Which just goes to show, you can't change your character.

↑
Singer Park Jin-young performs at the Mnet Asian Music Awards on 2 December 2015 in Hong Kong.

JESSI

AMERICAN STYLE

The bad girl of K-pop is never at a loss for words. So much the better.

She's often described as the Nicki Minaj of K-pop. No doubt partly because she was born in New York where she forged a super-tough character from an early age. At fifteen, she returned to live in South Korea with her family, and two years later released a first album that failed to make waves. It was 2005 and her rap-influenced style was ahead of its time on the Korean peninsula. Her image as an American-style bad girl clashed with the prevailing mood and stopped her from winning over the general public. After a few trips back and forth to the United States, her career turned a corner in 2019 when she signed a contract with the brand-new agency of famous singer Psy. Times had changed and her sassy style was now right on target. On hits with powerful rhythms such as "Nunu Nana" and "Zoom", Jessi demonstrates contagious self-confidence that pushes everything out of her path, allowing her to definitively establish herself as the most American of K-pop superstars.

↑
Jessi, also known as Jessica H.O., Korean-American singer, rapper and member of hip-hop trio Lucky J, is the bad girl of Korean pop.

→
Blackpink perform at the 26th Tokyo Girls Collection in the Yokohama Arena on 31 March 2018 in Yokohama.

BLACKPINK

LIFE IN THE PINK

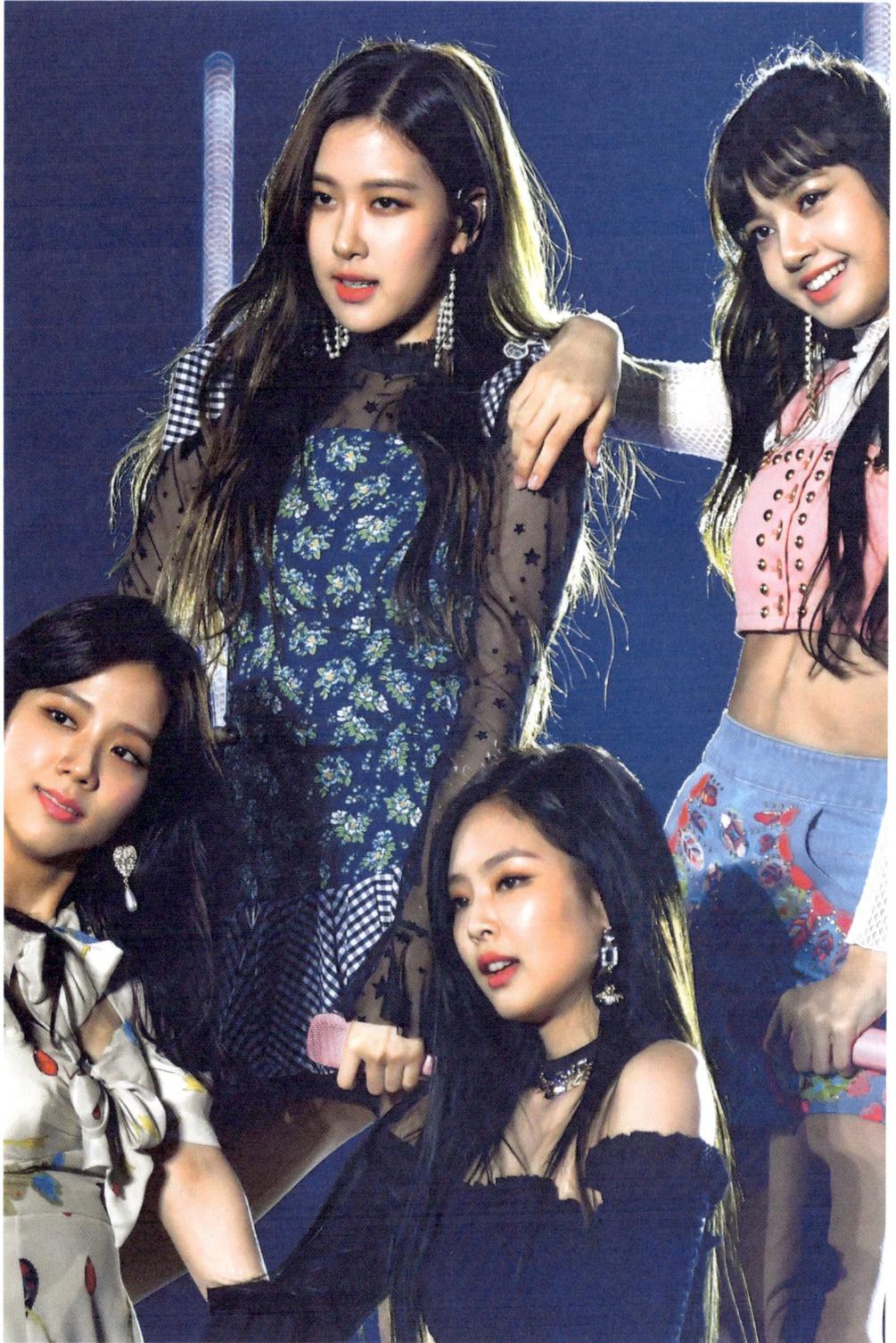

Blackpink is the female equivalent of BTS: an unstoppable force.

The maths is simple: with more than 80 million subscribers, the four Blackpink singers are the world's most followed artists on YouTube. They're also the highest-ranking K-pop girl band in the Billboard 100 and Billboard 200 charts, peaking at number thirteen and number two respectively.

In other words, they're one of the most famous South Korean groups in the world. Formed by the YG Entertainment label, Jennie, Lisa, Jisoo and Rosé started their career as a group in 2016 and immediately enjoyed huge success, releasing songs with ultra-catchy rhythms, explosive dance moves and the ability to switch from singing to rapping and from Korean to English in record time. It's these qualities that make Blackpink an easily exportable group, as evidenced by their appearance at the prestigious Californian Coachella festival in 2019. It seems that nothing can stop Blackpink's rise to the top of global pop.

G-DRAGON
A MULTI-TALENTED PLAYER
G드래곤 KEY

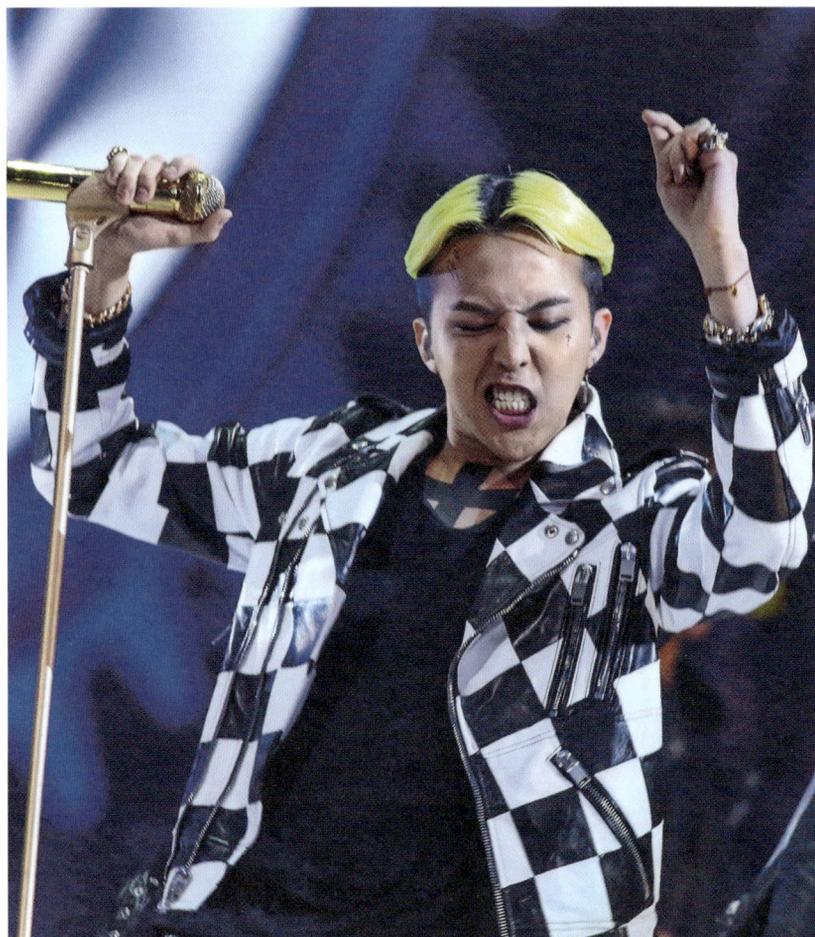

A leading figure in K-pop, he revolutionised the genre, both as a solo artist and with his group Big Bang.

It's no exaggeration to say that G-Dragon is a real icon in South Korea. Born in 1988 in Seoul, he first fell in love with rap after discovering the New York band Wu-Tang Clan. Aged just thirteen, he joined the YG Entertainment teams and began to learn to sing and dance. In 2006, G-Dragon became a member of the group Big Bang where he was seen as one of a kind. K-pop labels are used to imposing their choice of songs on groups but he insisted on writing his own music, injecting his hip-hop influences into the band. The blend was a great global success and Big Bang became the third highest-paid male group in the world, behind One Direction and Backstreet Boys. In 2009, he embarked on a solo career with his first album "Heartbreaker" which sold more than 300,000 copies. Passionate about fashion, today he plays an essential role in the trends lighting up South Korea and continues to be a major inspiration for the world of contemporary K-pop. Jungkook, a member of BTS, often says he would never have started his musical career if he hadn't come across G-Dragon.

↑
G-Dragon performs at the 2013 Mnet Asia Music Awards at AsiaWorld-Expo on 22 November 2013 in Hong Kong.

→
Jimin, J-Hope, Jin, Jungkook, RM, Suga and V from BTS perform at the 2021 Billboard Music Awards in the Microsoft Theatre in Los Angeles.

BTS 방탄소년단
AMBASSADORS OF KOREA

They're the flag bearers of the country and possibly the most followed group in the world.

They're one of the most influential bands on the planet. Created in 2013, BTS are the current driving force of K-pop on the international stage, supported by extremely active fans on social media and an audience that continues to grow at incredible speed. Aware of their potential influence on young people, this boy band of seven singers has no hesitation in engaging with issues beyond the world of music. In 2018, BTS addressed the United Nations General Assembly on the issue of sustainable development. They also regularly speak out in favour of the LGBTQ+ community and minorities in the United States. In 2020, they donated a million dollars to the Black Lives Matter movement, while their hit "Dynamite" reached the top of the American charts. After releasing five albums in Korean and four in Japanese, in 2022 the group announced it would be taking a break to give its members time to develop solo careers. The end of BTS?

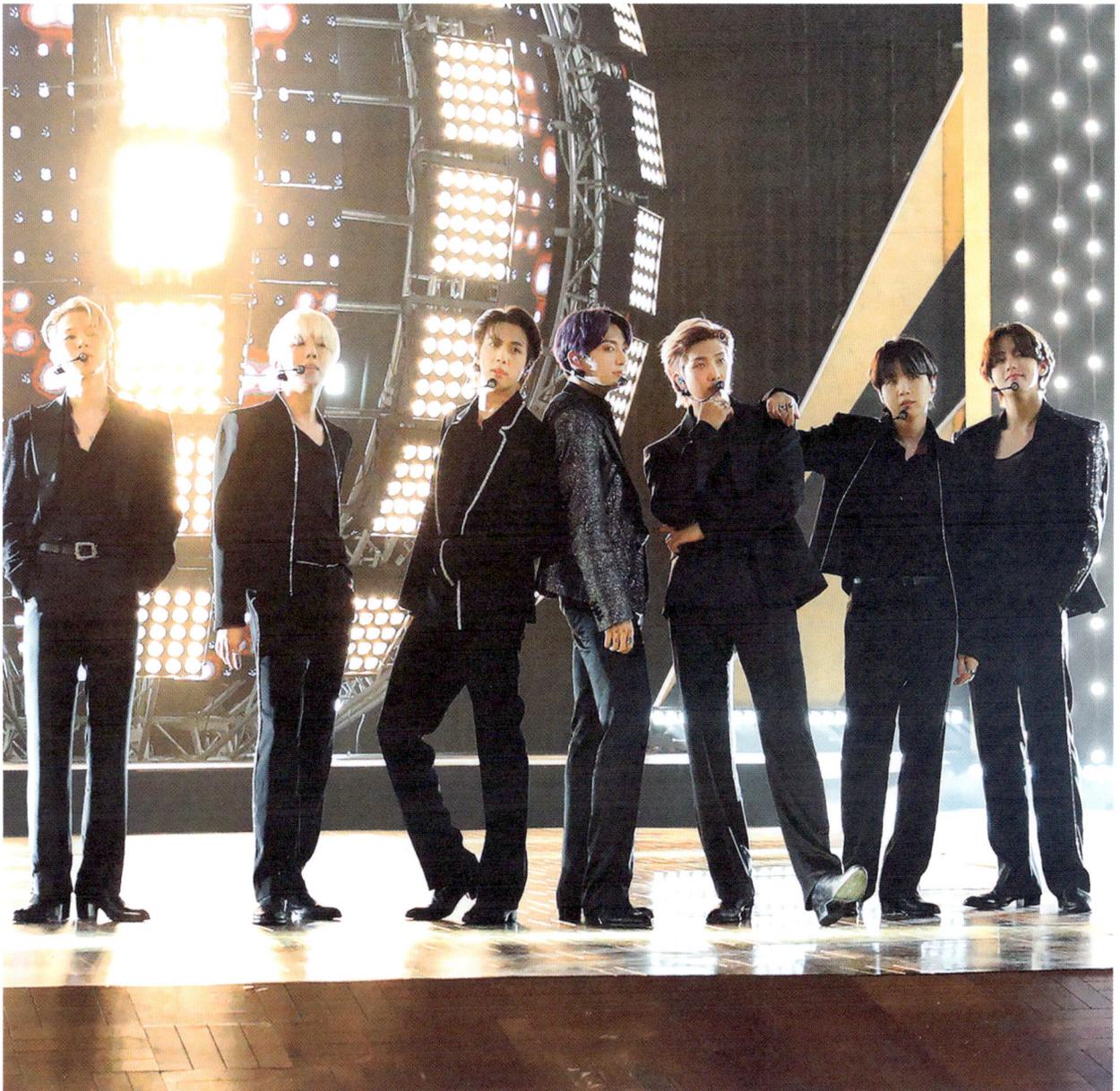

PSY THE BIZARRE SINGER

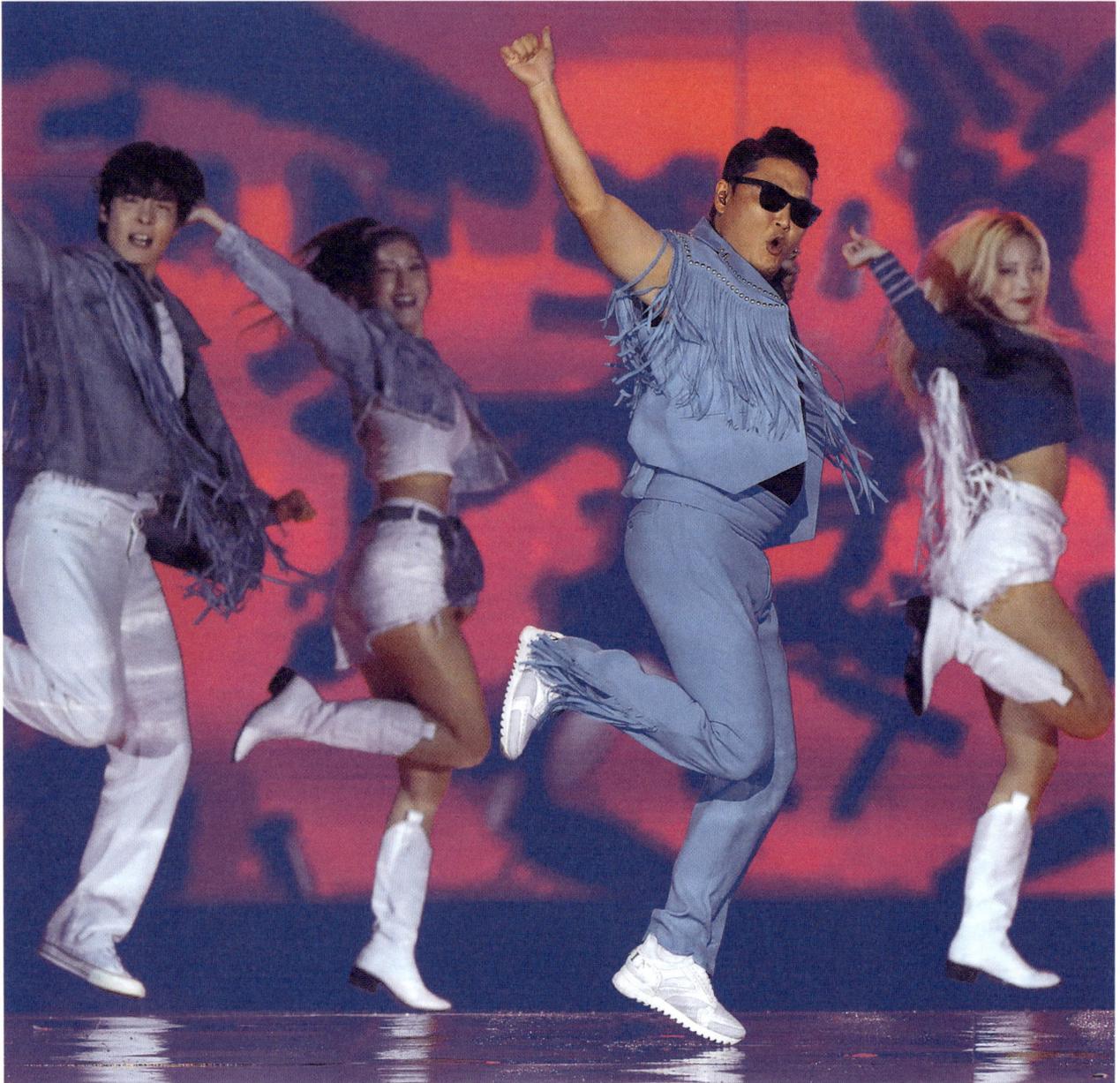

The writer of "Gangnam Style" hasn't always been a prophet in his own land.

Surely there's no need to introduce Psy? Since his hit track "Gangnam Style" with 4.5 billion views on YouTube, the singer has become a planetary star. Born into a wealthy family in 1977, he grew up in Seoul and then left to study in the United States at Berklee College of Music in Boston. Bored by his education, he decided to return to South Korea to try his luck as a singer and rapper. But people found his eccentric persona confusing and the public began to refer to him as "The Bizarre Singer". Government authorities banned sales of his first album released in 2001 because of its explicit and lewd content, and Psy was sentenced to prison several times for smoking cannabis. In 2010, when short of money, he decided to sign a contract with YG Entertainment and released "Gangnam Style" two years later. Paradoxically, this was the start of a difficult period for him. Destabilised by the success of the track, Psy worried about his ability to produce a sequel of the same calibre. He struggled with a drinking problem for several years before resurfacing with the creation of his own agency and releasing a new album in 2022. A hit-tested singer.

SHINHWA

THE ELDERS OF K-POP

With a career spanning almost twenty-five years, Shinhwa is the oldest K-pop group still in existence.

Some people say that K-pop groups never last very long. It's certainly true that between the pressures exerted by record labels, the solo aspirations of band members, artistic differences, and interruptions imposed by military service, it's not uncommon for groups in the genre to break up after a certain number of years. But this isn't the case for Shinhwa, six singers that have stood the test of time. Formed by SM Entertainment, the boy band was launched in 1998 with their debut studio album "Revolver". Over a career of almost twenty-five years, the group has released thirteen albums in Korean, one in Japanese and numerous compilations. A rare phenomenon in the world of K-pop, it even managed to break free from the agency that trained it and keep the name of the band while joining another label. Today, it's the only first-generation K-pop group still together and performing. Legends.

←
Psy performs at the "K-pop Super Live" concert during the 2022 Seoul Festa at the Jamsil Sports Complex.

↓
Members of the group Shinhwa on stage at one of their concerts on 5 February 2017 in Taipei.

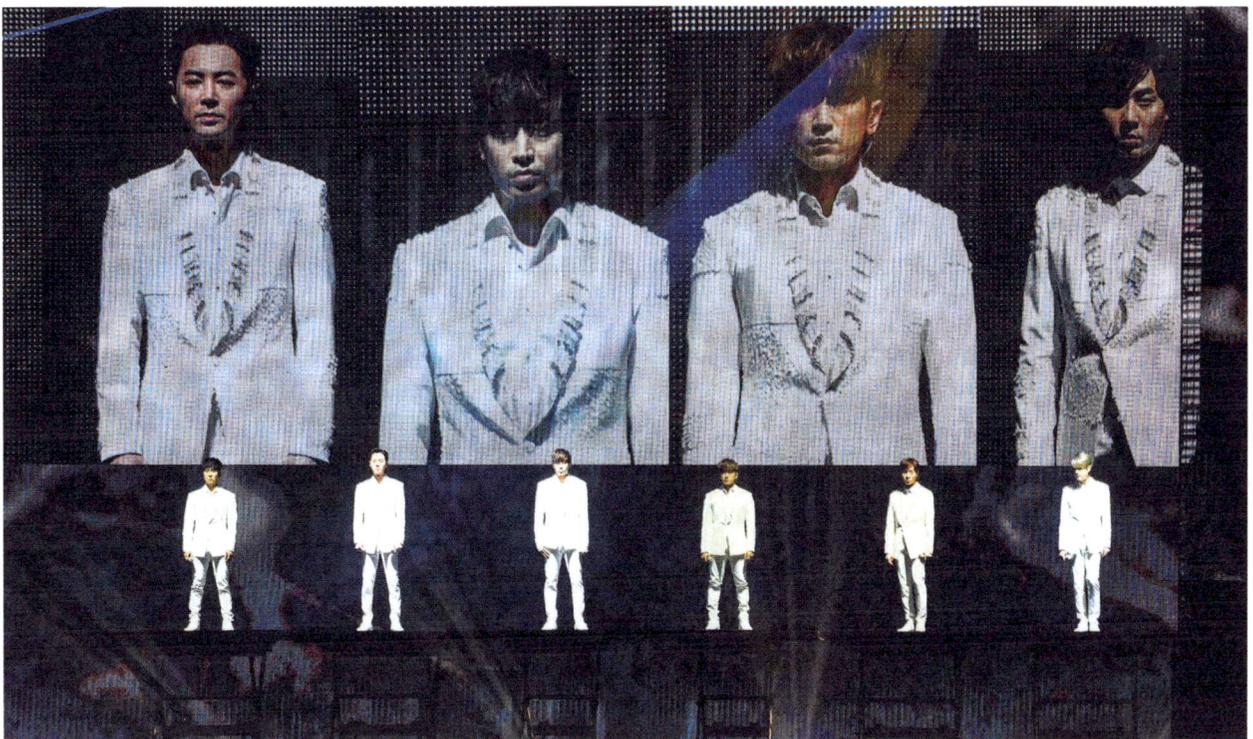

ITZY
FOURTH GENERATION

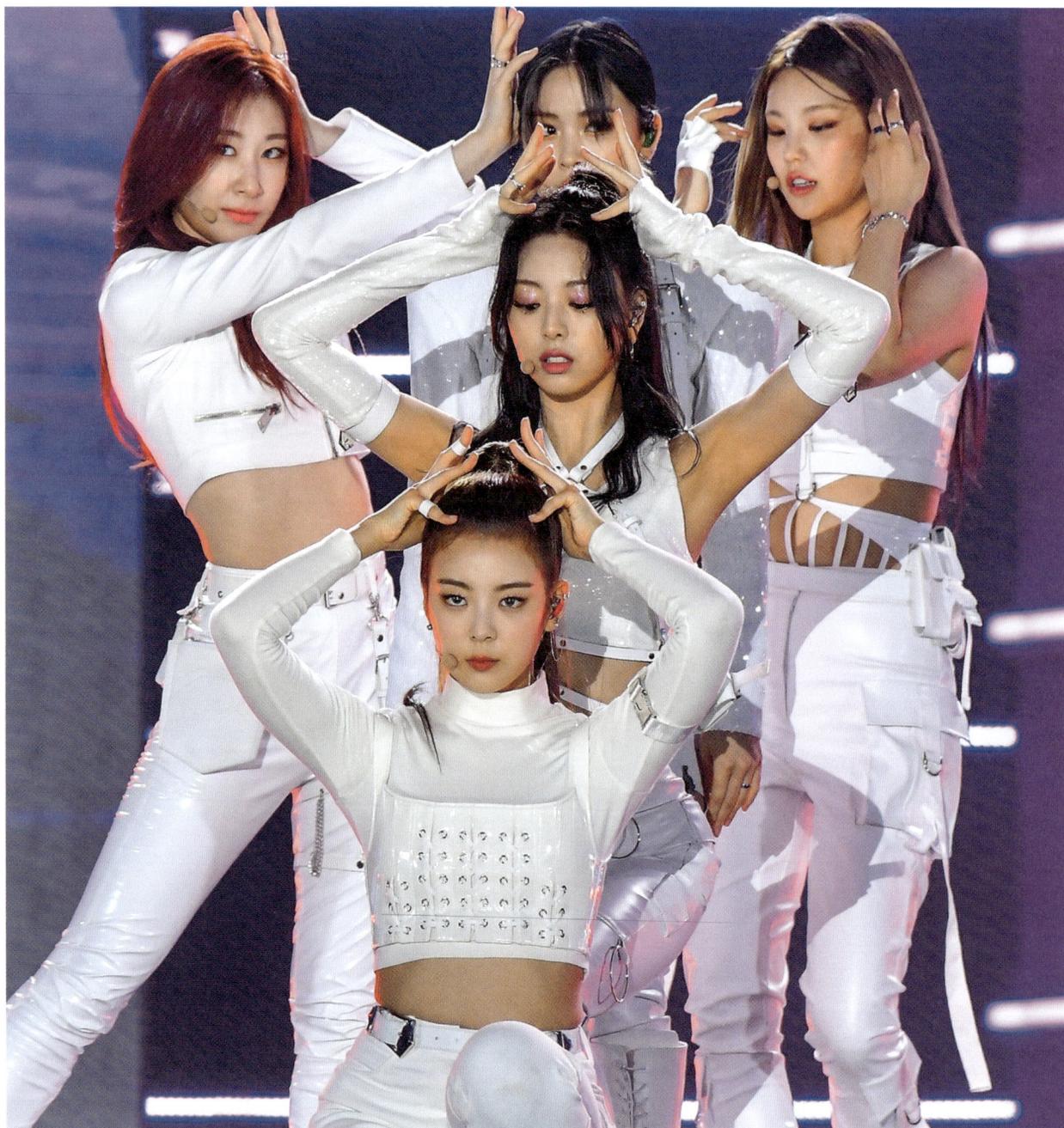

Itzy are newcomers to the K-pop scene and causing a sensation on TikTok.

Each age group has its flagship band. The first generation of K-pop had groups like Shinhwa, the second could count on Big Bang, the third saw the arrival of BTS and Blackpink, while the latest generation has a group like Itzy. Founded in 2019 by JYP Entertainment, the five singers, who are only just twenty, made a flying start with "Dalla" which became a massive hit in South Korea on its release. The track served as a launchpad for the group and is a perfect example of how this generation of K-pop artists has used the emergence of platforms such as TikTok to relay their music to a younger, more connected and more international audience. Clearly targeting the global market, Itzy released an English version of their EP "Not Shy" in 2021. In the same year, cosmetics brand Maybelline appointed them as their new global ambassadors. It remains to be seen whether Itzy will stay the course in the ultra-competitive world of K-pop.

K-STAR ROAD

ROAD OF GLORY

Los Angeles may have Hollywood Boulevard but K-pop has K-Star Road.

It's a must-visit for all fans of K-pop on a tour of Seoul. Created in 2012 following the global success of Psy's hit record "Gangnam Style", this urban project aims to introduce foreign tourists to the culture of K-pop. It's in Gangnam that most of the labels and entertainment companies controlling the industry are located. Here fans can see the agencies of their favourite artists, visit the cafés and restaurants adored by some of their idols, or simply enjoy the atmosphere of this neighbourhood where most of the country's trends originate. K-Star Road is lined with the famous GangnamDol, a kind of giant bear-shaped doll representing seventeen different K-pop groups, including BTS, EXO, AOA and Super Junior among others. And not forgetting a giant GangnamDol in the colours of Psy waiting to greet you at the metro exit. Think of it as a pilgrimage to the land of K-pop.

←
Members of the group Itzy perform at a show in Seoul for the FIFA World Cup.

↓
BTS attend the opening ceremony of K-Star Road in Seoul on 21 December 2015.

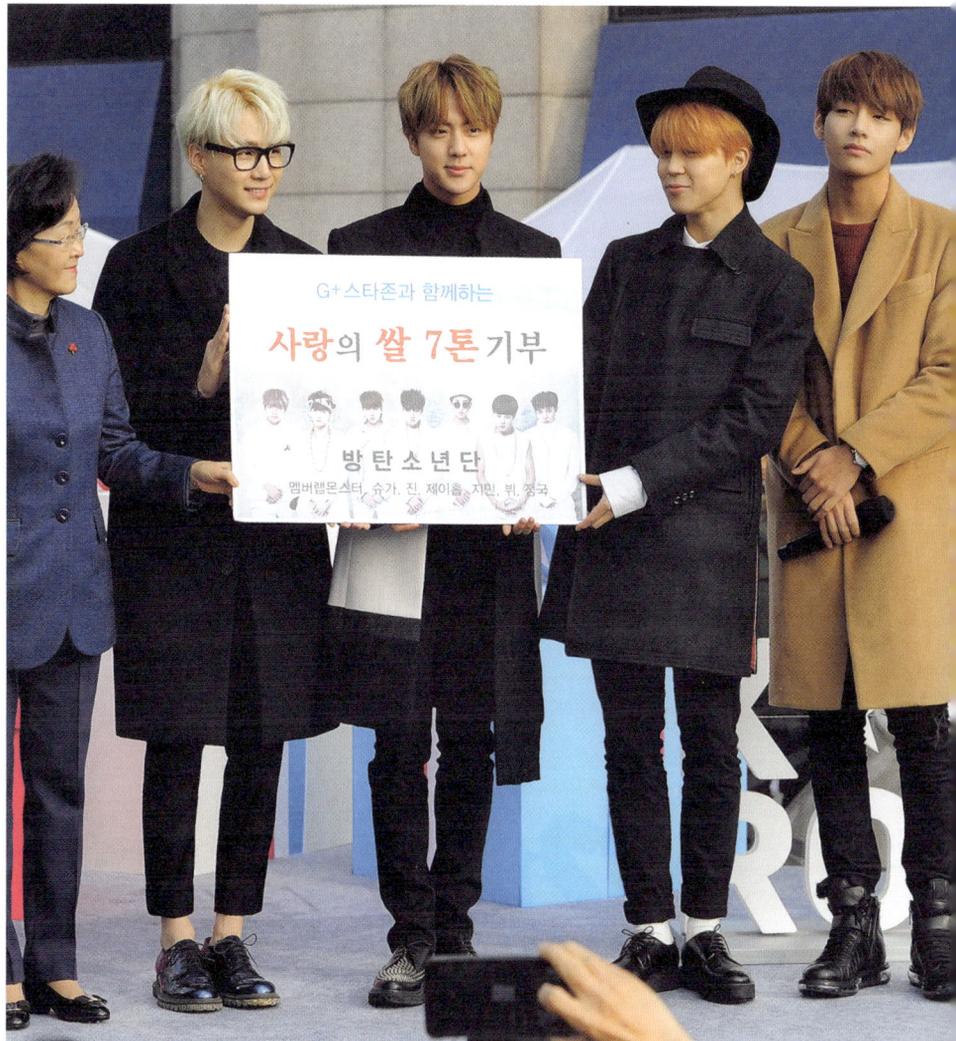

The pioneer of K-pop was shunned by the Koreans for many years

The story of Yang Joon-il is a sad one. Of someone too far ahead of his time in a conservative society suspicious of the slightest new thing. It's not always easy to be first.

In South Korea, K-pop hasn't always had the recognition it gets today. And it was Yang Joon-il who paid the price. Born in Saigon to Korean parents during the Vietnam War, he grew up in Los Angeles before returning to live in South Korea to make his musical debut. In 1991, the release of his song "Rebecca" caused quite a stir. But not for the right reasons. At the time, the country was emerging from several decades of authoritarian rule and attitudes were still very conservative. With his long hair, make-up, earrings and effeminate look, the style of Yang Joon-il clashed with what the public wanted. No one had ever seen anything like it in South Korea. On stage, the audience resorted to literally throwing stones at him while his multiculturalism went against the prevailing nationalism of the time. He was accused of "stealing the work" of Koreans and was even excluded from a TV programme for speaking English on it. "In karaoke bars, people would turn off the machine when Yang's songs were played," recalls an early fan interviewed by AFP. Years later, Yang Joon-il opened up about this difficult period: "I felt that Korea and I were incompatible. The public kept their distance, so during concerts I avoided looking at them." In 1993, without giving any reason for it, an official from the immigration service refused to renew the visa he needed as an American national. Yang Joon-il had to end his career and return to live in the United States.

In the early 2000s, he attempted a return

to the stage which failed and had to resign himself to giving up music. For fifteen years, he alternated between odd jobs, both in the United States where he worked as a cleaner and waiter, and in Seoul where he taught English. But in 2018, South Korean television got out its old videos. Times had changed and the new generation who didn't yet know him fell under the spell of this singer whose style was no longer out of step. He's even starting to be called the "G-Dragon of the Nineties", in reference to the superstar leader of the group Big Bang. The public love him. Almost twenty years after his last appearance as a singer, he was invited to perform on stage in Seoul. "There are no words to describe that moment," he told AFP. "I felt like I couldn't breathe." At over fifty years old, Yang Joon-il has finally fulfilled his lifelong dream of becoming a K-pop star. He's re-recording his old songs and working on the new album demanded by his fans. It's not always easy to be ahead of the times. But as Yang Joon-il told *The Korea Times* in a message to young people in 2022: "Nothing will turn out the way you want it to. But don't worry. In the end, it will all be OK."

A spectator once pushed him off the stage, shouting: "You need a beating!"

↓
Yang Joon-il, a historical figure in the story of K-pop, on stage in the 2010s.

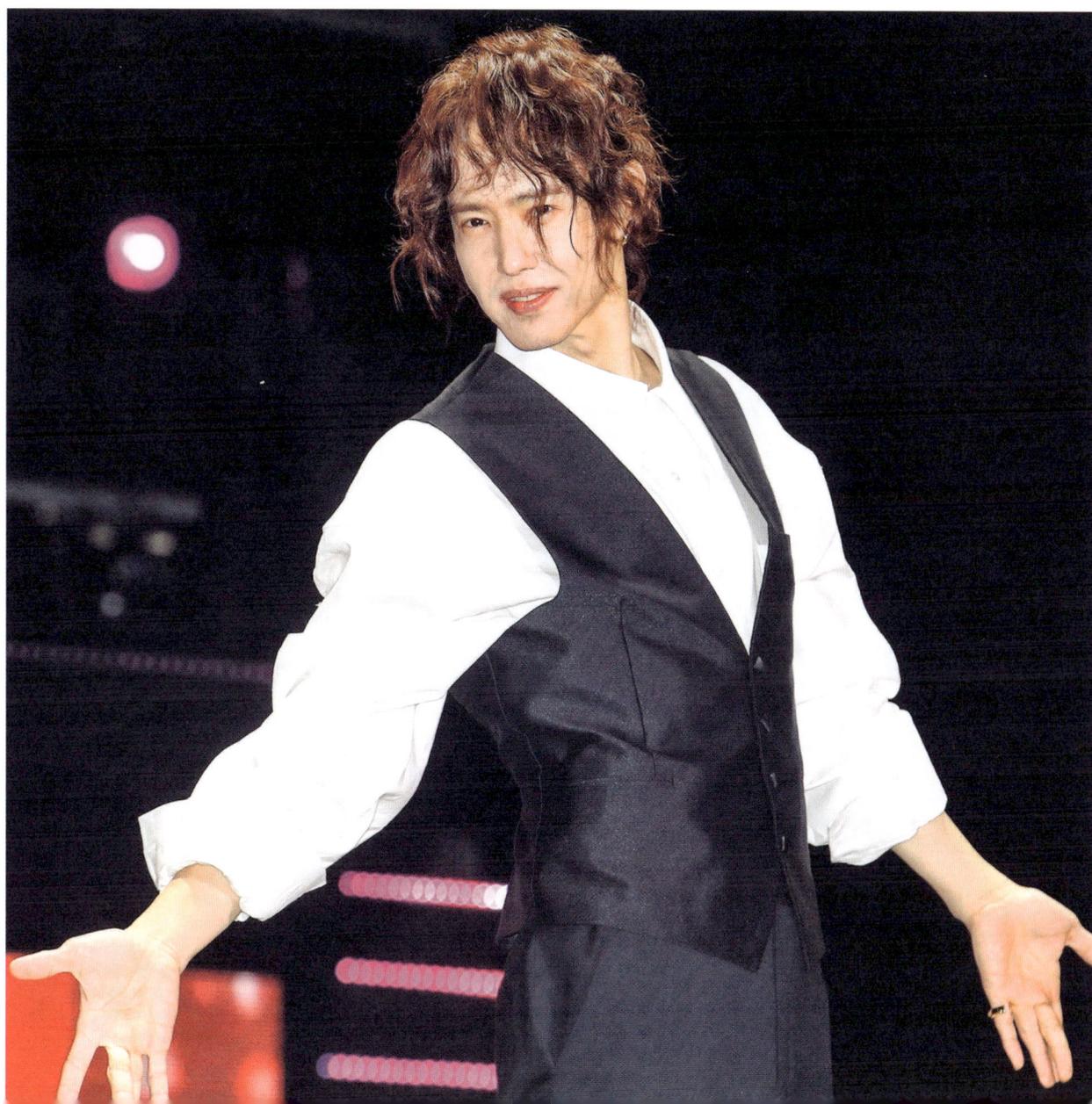

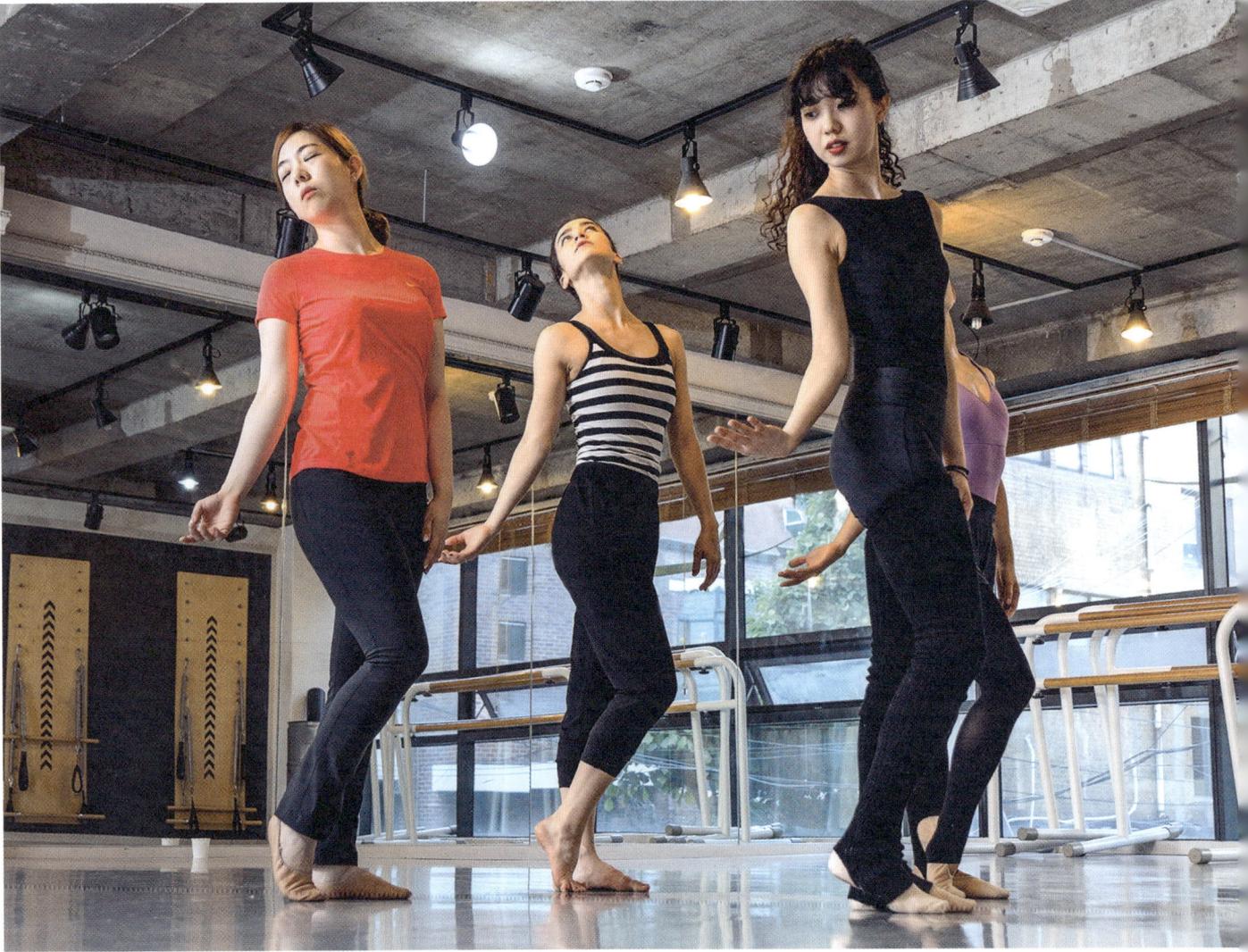

Before becoming K-pop stars, hopefuls have to spend time as trainees

It's a well-oiled system that's almost impossible to avoid. K-pop is like the world of business: before getting a job, training is required.

The K-pop industry has its own ways of doing things with its tried and tested methods. In practice, it's difficult for an artist to be completely independent and avoid the big agencies that control the sector. To get noticed by an agency, aspiring singers have to attend the auditions they regularly organise to scout the stars of tomorrow. The competition is intense and very few people are selected to become artists. For those who manage to get through this stage, it's just the beginning of a long adventure. If successful in auditions, singers then become trainees. They'll be trained for several years to learn the trade with the hope of one day making their debut in the music industry. Separated from their families and assessed once a month, trainees are taught to dance, sing and rap, learn to speak in public, wear makeup and stand in front of a camera. Throughout their training, managers supervise them on a daily basis and check that their protégés don't smoke, drink alcohol or have romantic relationships. Rado, CEO of production company High-Up Entertainment, explains in detail how trainees are evaluated in an interview with the website Koreaboo: "Firstly we have to observe them carefully and assess their image potential. We then carry out selection interviews. Throughout the process, we make sure that their professional goals are clear and their education is good. We also check their Facebook and Instagram accounts as well as any other social media platforms they use. We systematically reject anyone with a criminal past. If ever this kind of past emerged in the group's promotional sessions, the production company would be in trouble and what we've invested would be wasted." Because training to be a star comes at a price. It's estimated that an agency can invest up to a million dollars in a trainee. After a long period of training that sometimes lasts years, apprentice artists can finally jump into the world of K-pop. They often have to finish paying off their training debts before they get paid by the agency. Even after starting their careers, it can take artists several months or even several years before they start to receive their first fees. The right to be a K-pop star is hard-earned.

←
K-pop artists attend schools where they're trained to be stars.

South Korea changed the law so that BTS could postpone their military service

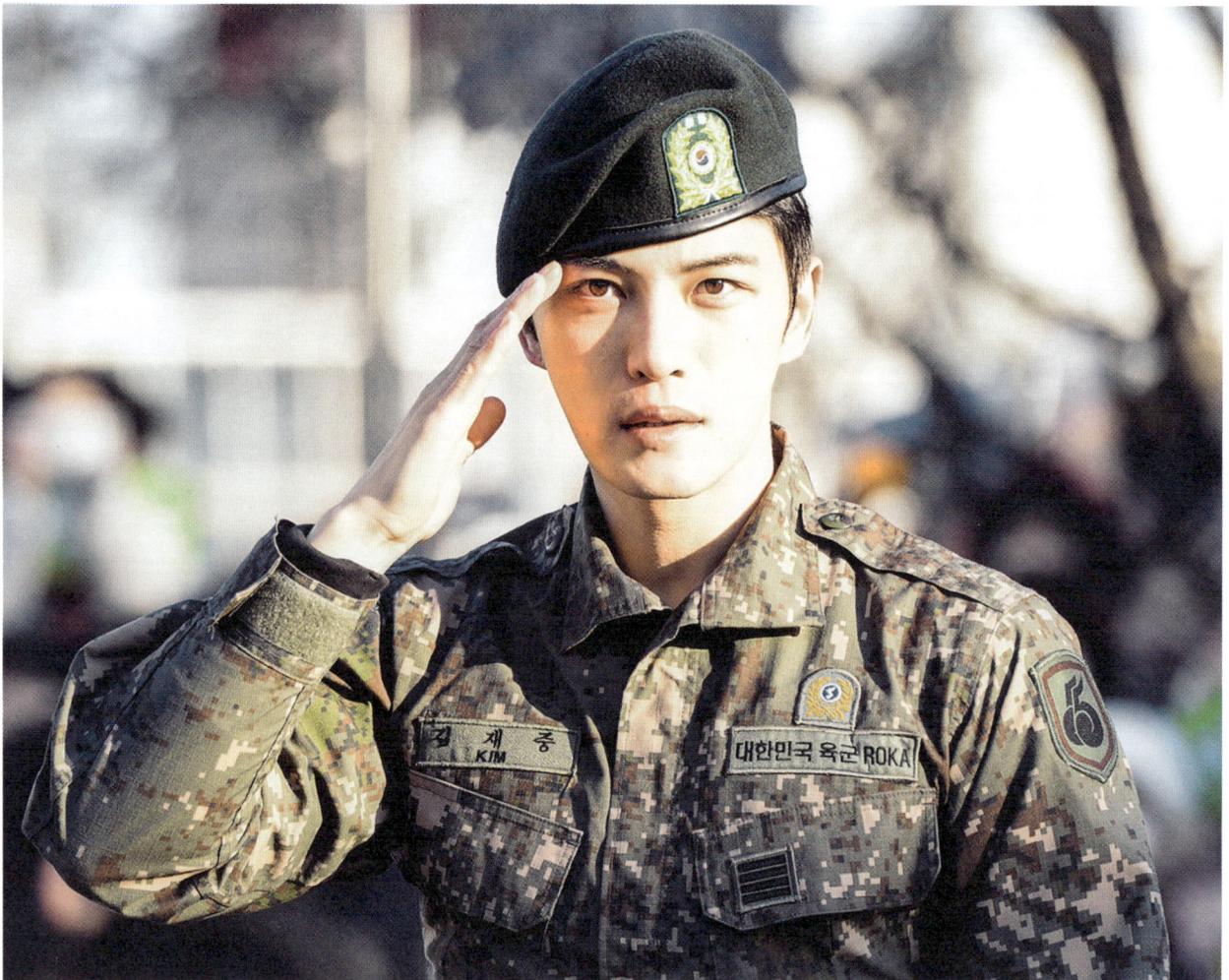

An awkward situation for the Minister of Defence.

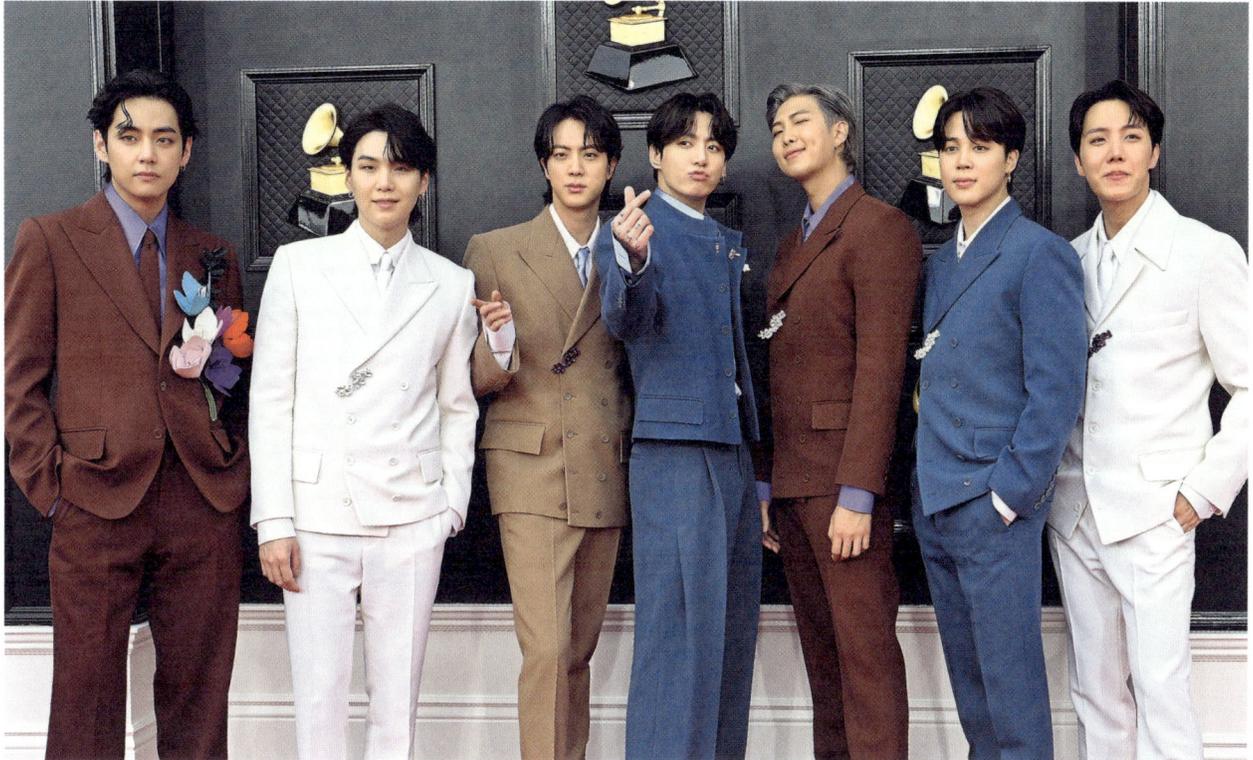

As we all know, laws are supposed to apply to everyone. But if you're a K-pop superstar there's no need to panic and it's always possible to come to some kind of arrangement.

As the situation with its northern neighbours is still tense, in South Korea military service is mandatory. The rule is simple: all men between the ages of 18 and 28 must serve in the national army for a period of at least eighteen months. But it's difficult to apply when the people involved are Jin, Suga, J-Hope, RM, Jimin, V and Jungkook. The seven members of supergroup BTS are some of the most famous stars in the world of K-pop. In 2020, their single "Dynamite" achieved something unprecedented, reaching the top of the charts in the United States. A feat that filled all Koreans with pride and encouraged the Parliament to review the rule on military service so that the singers, who were close to the age of twenty-eight, wouldn't have to put their careers on hold to join the army. An amendment was added to the law, allowing exceptions to be made for K-pop stars whose sales and international influence boost the country's economy. What is now dubbed the "BTS law" is not, however, an exemption. The members of the group were only able to delay their military service up to the age of thirty, which only postponed the problem as the issue arose again in 2022. BTS announced that they were taking a break, but no one was fooled.

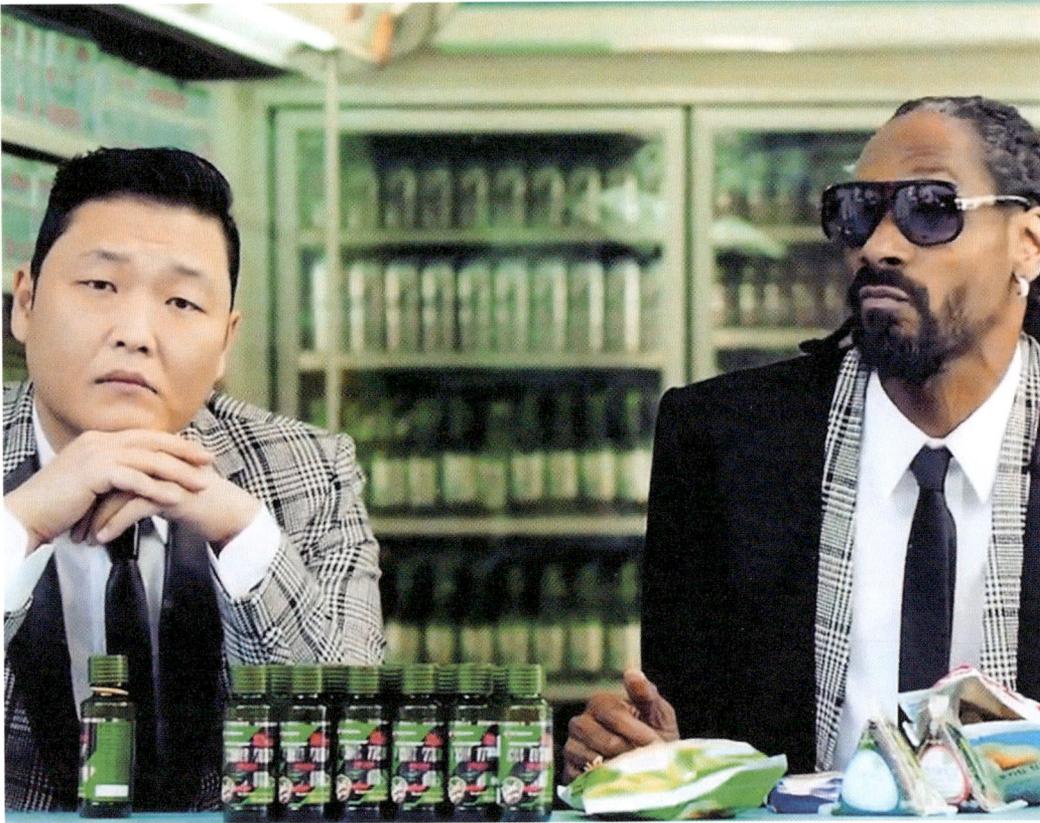

Kanye West, Snoop Dogg and Akon have all already collaborated with K-pop artists

American rappers like to release hit tracks. That's fortunate because K-pop singers make them.

It's common knowledge that rappers have always been obsessed with numbers. In hip-hop, to stand out from the competition, it's important to show others that you're above the fray and are selling records by the truckload. But from a purely statistical point of view, there's no getting away from the facts: few rappers can match the stars of K-pop when it comes to listening figures. Even if the combination may seem surprising, it's logical for American rappers to be attracted to the idea of collaborating with Korean artists. For both sides, this win-win artistic exchange allows them to double their listening and viewing figures and introduces them to a new audience. This explains why the number of songs featuring both K-pop artists and American rappers have increased over the years. Examples include the track "Ayy Girl" by JYJ and Kanye West in 2010, "Like Money" by Wonder Girls and Akon in 2012, and "Hangover" by Psy and Snoop Dogg in 2014. American hip-hop and K-pop: a case of joint combat.

←
Collaboration between Psy and rapper Snoop Dogg on the track "Hangover" in 2014.

↓
Released in July 2012, "Like Money" is a single by Wonder Girls featuring Senegalese-American rapper Akon.

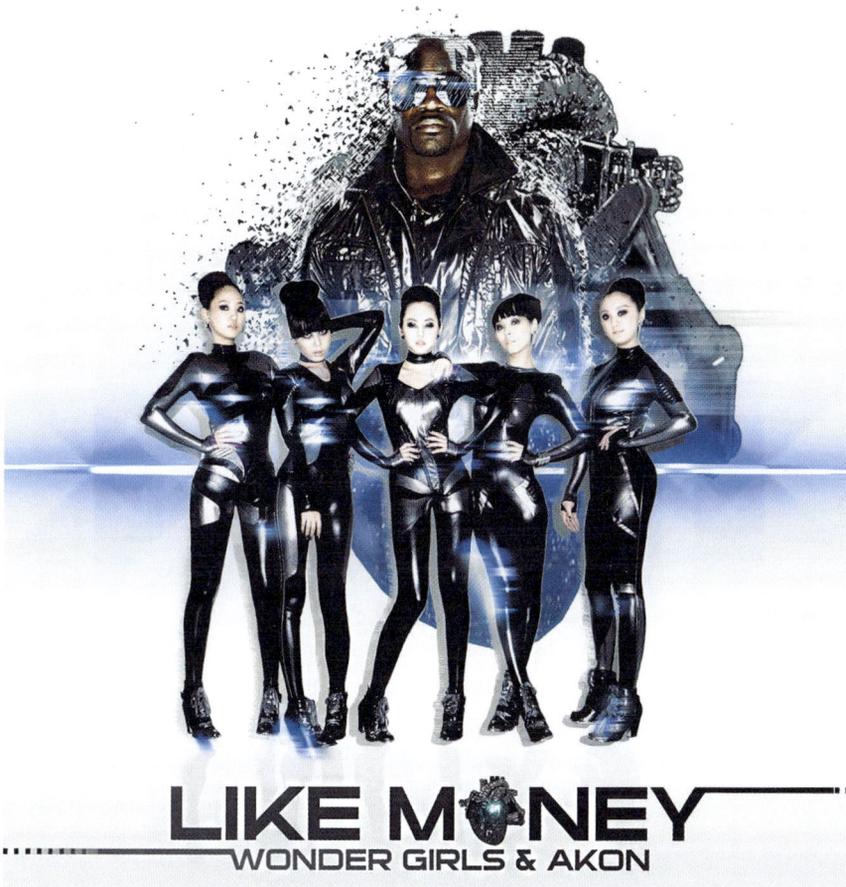

LIKE MONEY
WONDER GIRLS & AKON

Beyond K-pop

FOCUS 1

There's more than just K-pop in South Korea. The country also has dozens of traditional musical styles and at least as many contemporary equivalents.

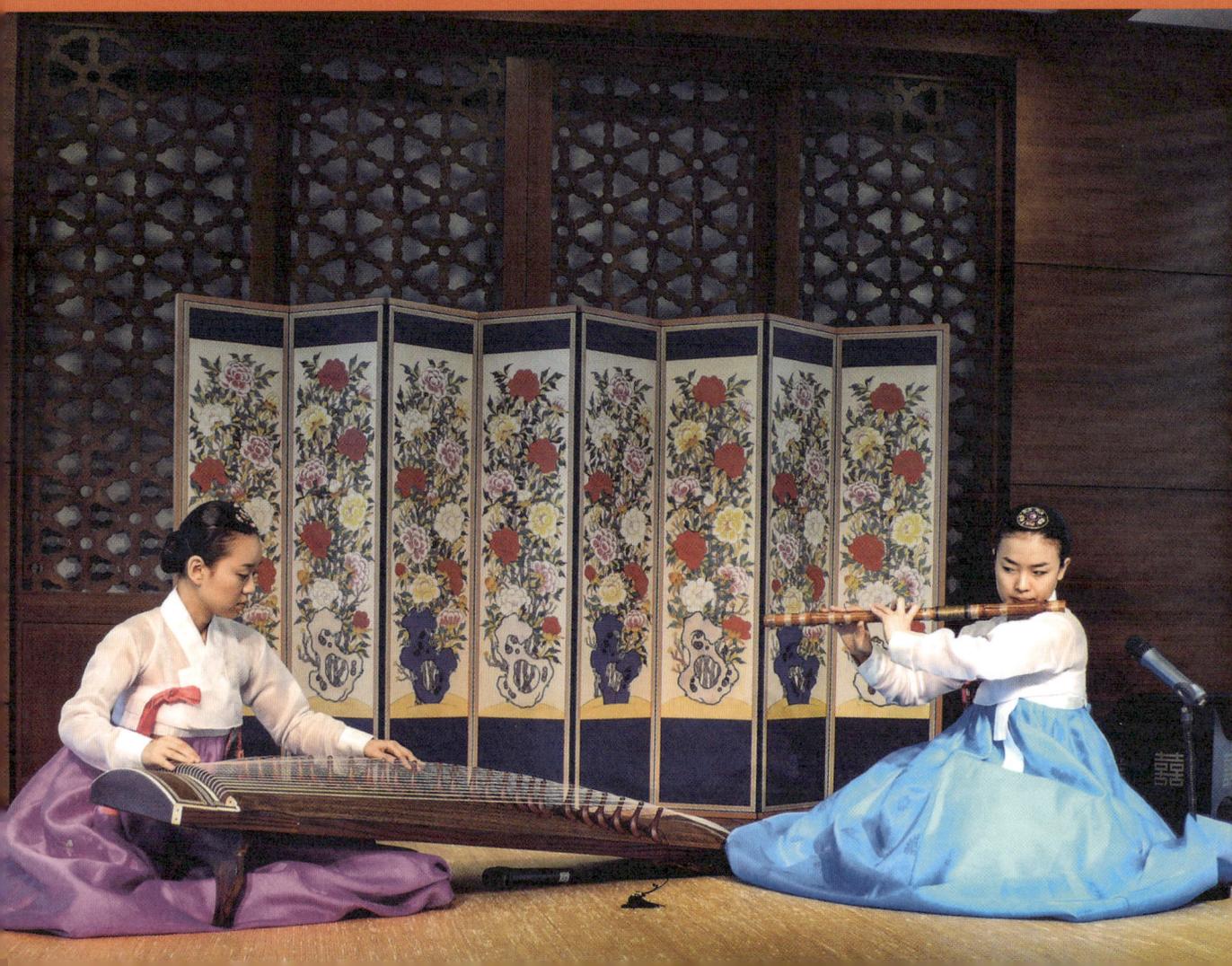

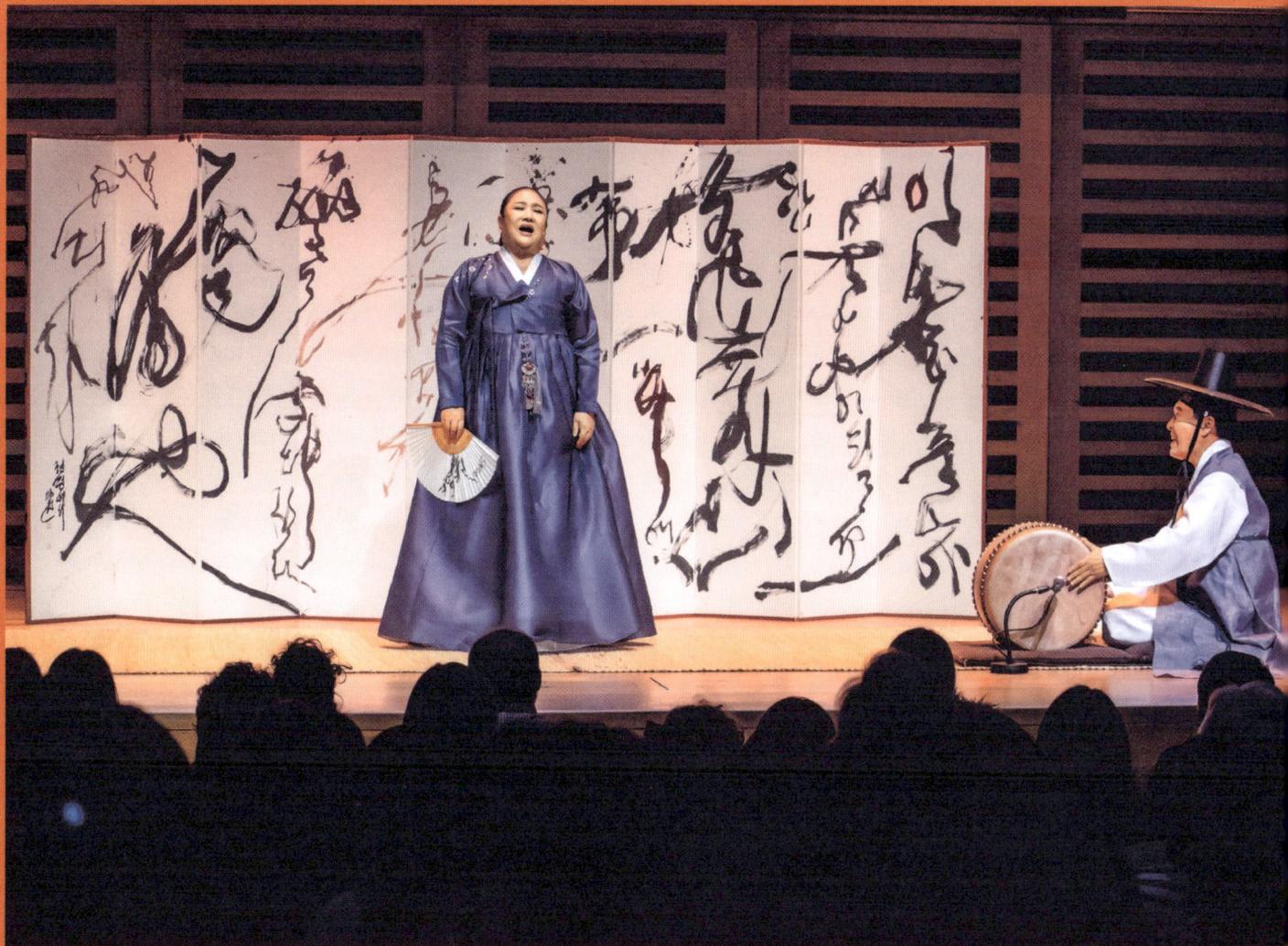

Today, K-pop has reached such a level of popularity all over the world that its success tends to eclipse all other forms of Korean music. It's difficult to make yourself heard when your name isn't Blackpink or BTS. However, when it comes to music, South Korea is a country with a fascinating array of genres. In terms of traditional sounds, the harmonic systems are very different from what you might hear in the West and the rhythmic patterns used can seem unusual to Western ears. The term *gukak*, which literally means "music of the country", is often used to describe this type of folk composition, based on instruments such as the *gayageum* (a kind of twelve-stringed zither), the *haegeum* (a two-stringed violin played vertically), the *piri* (the Korean oboe) and the *daegeum* (a large bamboo transverse flute). During the Goryeo dynasty (918-1392), some of these instruments were used to develop musical styles intended for the royal court, such as *aak* - of Chinese inspiration - or *hyangak* which originated in the Three Kingdoms period. The Joseon dynasty (1392-1910) saw the emergence of *pansori*, a type of Korean opera accompanied by percussion, as well as *minyo*, a popular form of song also widespread in Japan.

←
Traditional music concert in Seoul in 2010.

↑
A *pansori* show, the Korean art of sung storytelling accompanied by the *janggu* (a type of drum), performed in London in 2019.

While these two styles are historically very important, they are just some of the branches of the immense tree represented by Korean folk music with its unrivalled diversity and complexity. Beyond the field of purely traditional music, South Korea also saw the arrival of new genres in the 20th century that paved the way for the K-pop to come. A noticeable example of this is trot music, sometimes also called *ppongjjak*, which became popular in the 1920s under Japanese colonial rule. At that time, the occupying forces imported their own music - known as *enka* - and its Western-inspired sounds met with great success on the Korean peninsula. The Koreans quickly began to assimilate the Japanese genre and produced a local version of it based on a four-beat rhythm inspired by the foxtrot which was very popular in the United States at the time. This is where the name of trot originated from. In the 50s and 60s, influenced by the jazz and rock listened to by American soldiers stationed in South Korea after the war, trot became even more popular, spearheaded by artists like Lee Mi-ja and the Kim Sisters who even had a successful career in the United States. In the 1980s and especially the 1990s, the popularity of the genre started to wane with the rise of early K-pop groups such as Seo Taiji and Boys. Today, exciting musical styles continue to exist and thrive outside the supremacy of K-pop. For example, South Korea is a leading exponent of Asian rap and artists like Jay Park, The Quiett and Nafla are recognised stars here. The K-indie movement combining a mixture of rock and pop has also met with considerable success, reflected in the popularity of bands like Hyukoh and Bolbbalgan4. To sum up, with or without K-pop, South Korea has things to say.

← R&B artist Jay Park performs on the MTV World Stage Live on 14 July 2012 in Kuala Lumpur, Malaysia.

↗ An iconic Korean group from the 1960s, The Kim Sisters went on to enjoy an international career.

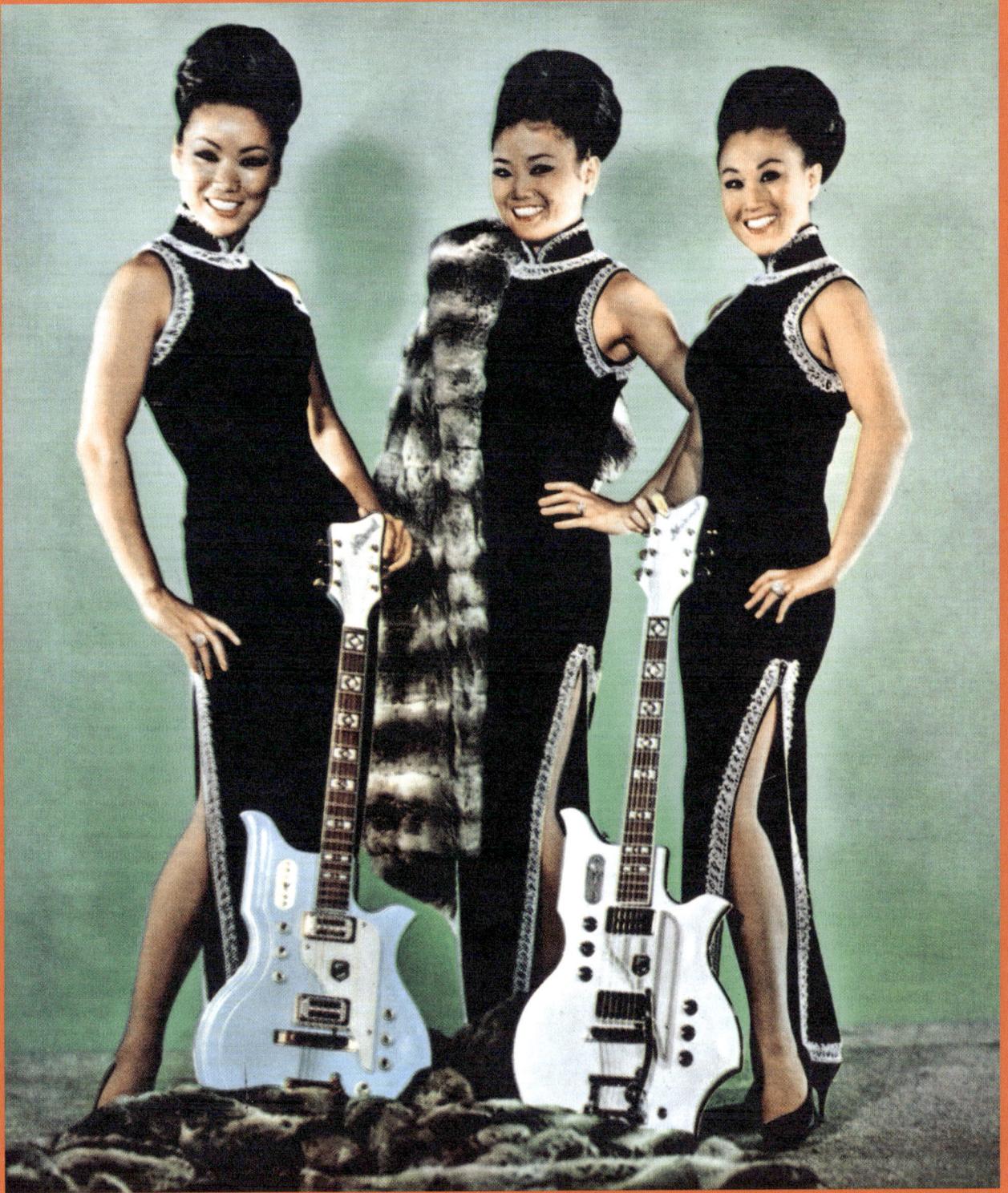

김시스터즈

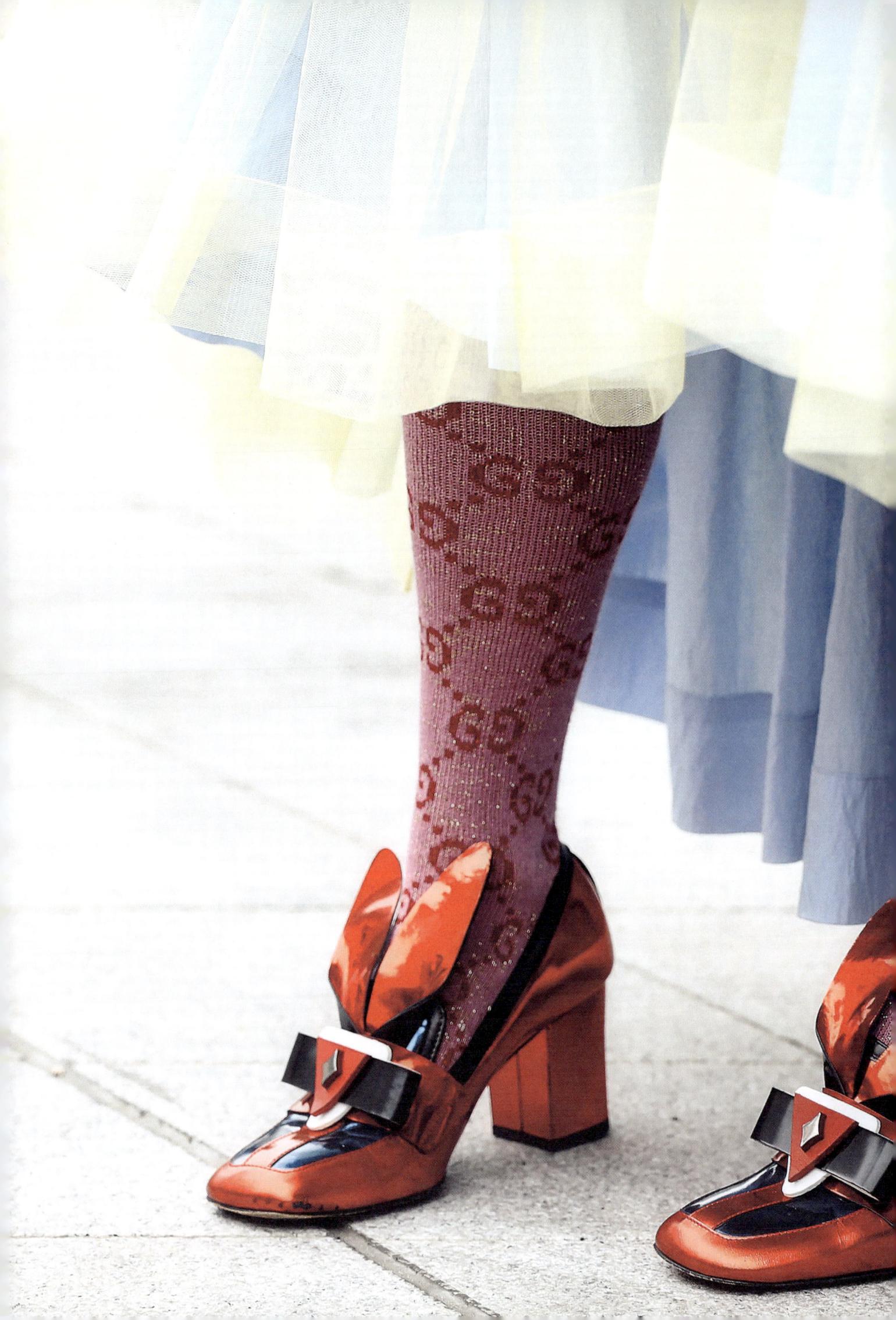

2

K-FASHION

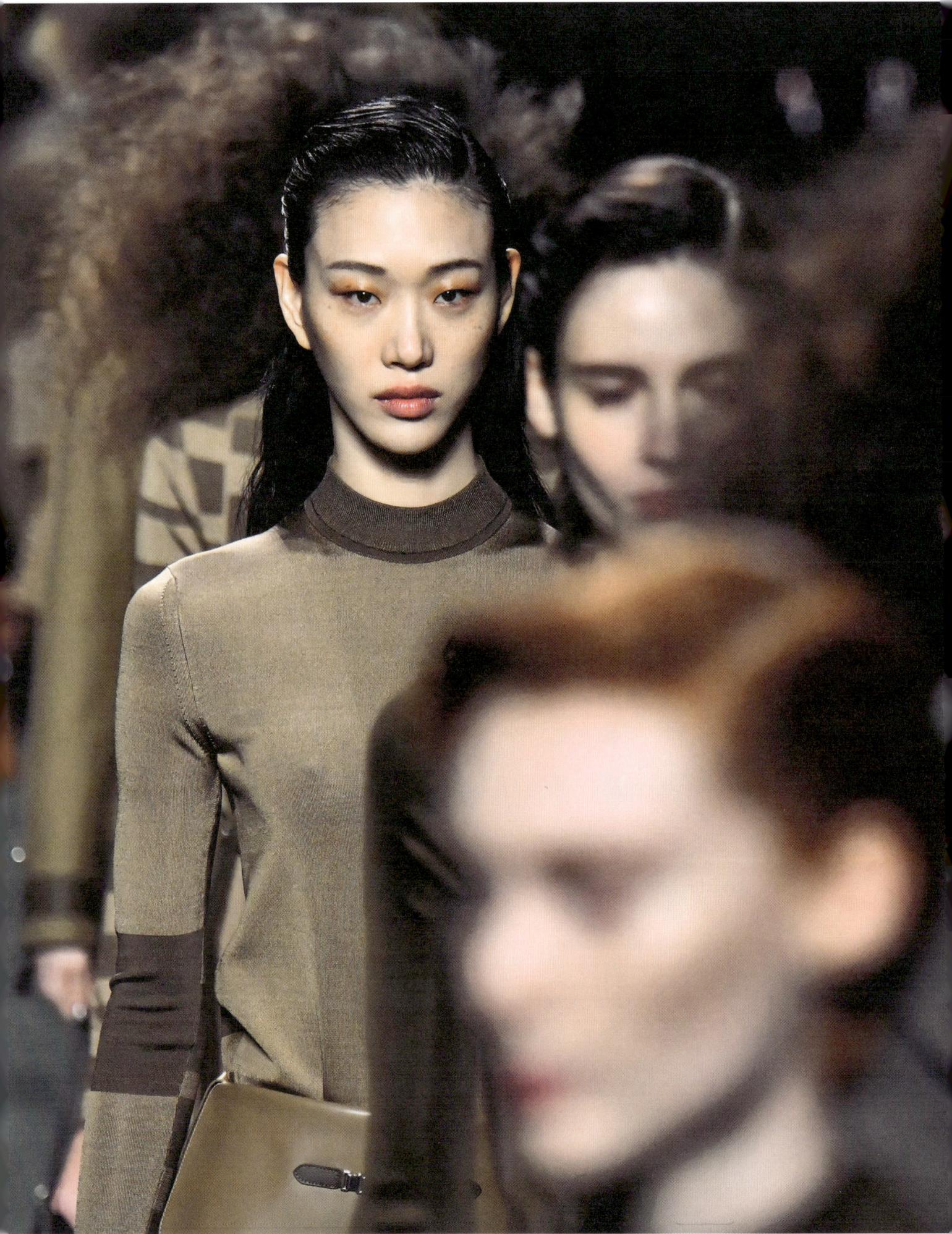

INTRODUCTION

P. 36–37
–
Woman wearing a yellow and blue flounced dress by Minju Kim and Gucci socks at Hera Seoul Fashion Week 2019.

←
Sora Choi on the catwalk in the Hermès ready-to-wear Autumn/Winter 2022–2023 show at Paris Fashion Week.

With its own special brand of beauty standards, South Korea is establishing itself as a pillar of international fashion.

It's no secret that South Korea is known all over the world as a country where fashion and beauty play an essential role. To understand why this should be so, it's important to remember that the structure of Korean society is based on the values of Confucianism. This moral and social doctrine, comparable to the influence of Christianity in the West, champions the idea that the quest for individual virtue promotes the harmony of the group. Given this way of thinking, it's essential to know how to present your best side to others, so as not to lose face and to guarantee a form of social order. In the age of social media and the all-powerful role played by image, this philosophy is encouraging Korean men and women to pay ever more attention to their appearance. In an interview with French newspaper *Le Monde*, a 28-year-old Seoul executive explained this perception of the world: "I could never leave home without makeup. The opinion of others is very important. You have to look your best, so you don't stand out or feel excluded. Here, we don't exist as individuals. We only feel protected within

the group." Because it partly functions on the principles of both standing out and conforming, in a constant dialogue between the individual and the group, the fashion and beauty industry could find no better place to embed itself than South Korea. This probably explains why in recent times the country appears to be making giant strides in the sector. For many years experiencing their Asian identity as a reason for exclusion, Korean men and women are carving out an increasingly important space on the catwalks of the major European haute couture brands. Celebrities such as Soo Joo Park, Sora Choi and Lee Soo-hyuk are seen as icons who are helping to remodel the beauty standards of the Western world by opening its eyes to greater diversity. At the same time, designers such as Hyein Seo and Minju Kim - both of whom studied abroad - are promoting cultural dialogue around clothing by establishing their country of origin as one of the Asian leaders in the field.

In recent years, South Korea appears to be making giant strides in the world of fashion.

↓
Cosmetics are a key part of fashion and the art of looking your best in South Korea.

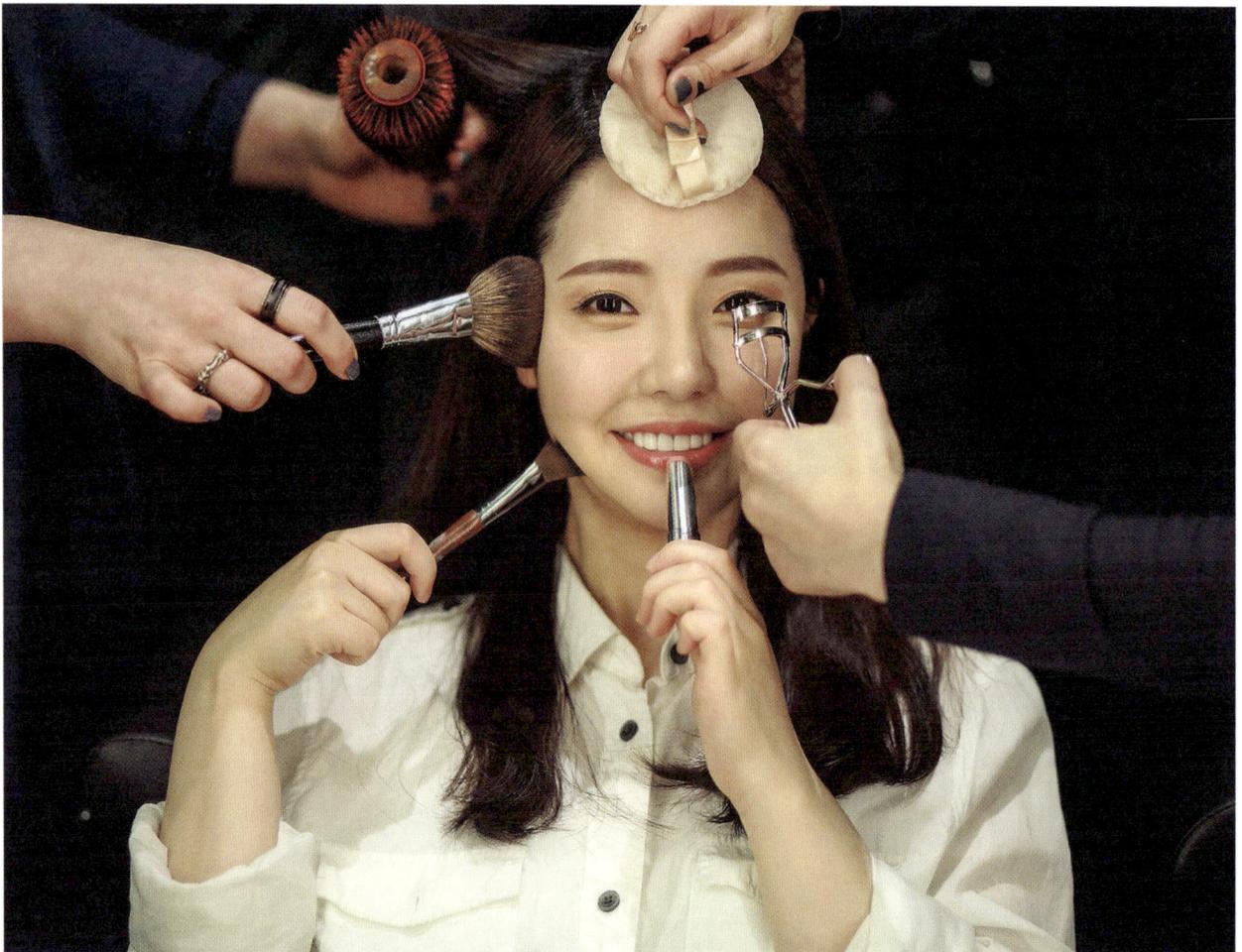

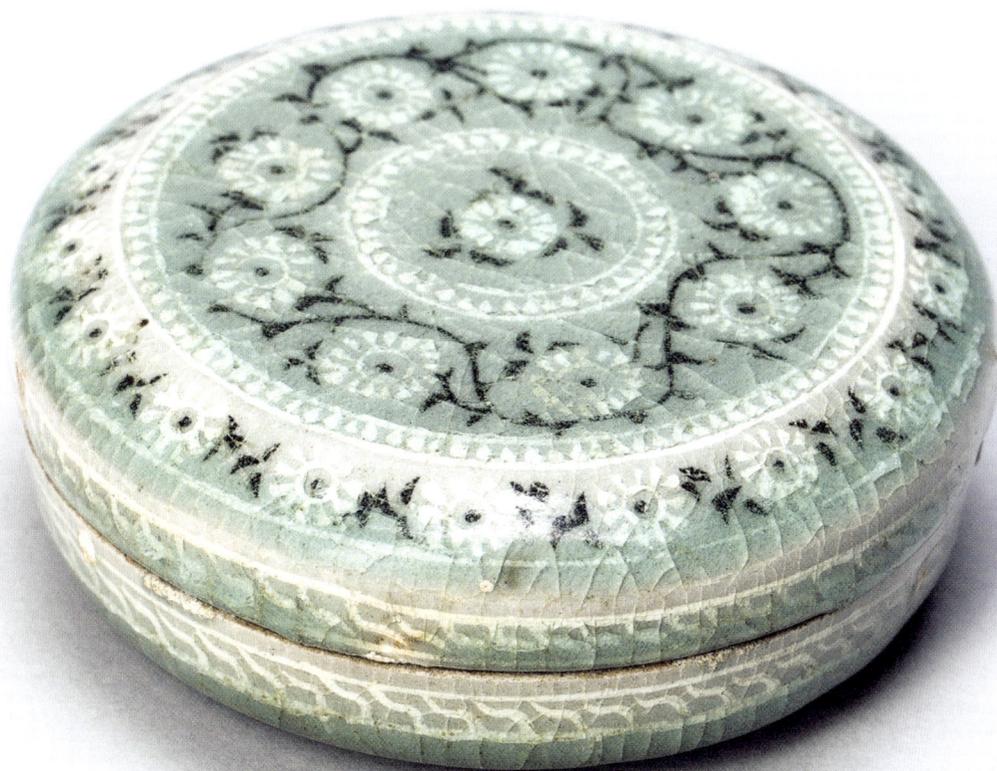

↑
Thirteenth-century cosmetic box decorated with chrysanthemum flowers.

But in South Korea, fashion is obviously not just about haute couture shows and luxury brands. In terms of everyday life, simply walking the streets of Seoul or Busan gives an insight into the issues playing out in this area of Korean society. Trends here are constantly changing, often guided by the latest stylistic innovations presented by the vibrant and ubiquitous world of K-pop.

Despite this, from a more general point of view, certain long-established and highly codified key principles continue to apply in the Korean landscape. The complexion should be pale and evoke the quality of porcelain. Eyes should be wide and adorned with long lashes. Cheekbones should be high, and the chin pointed to create a V-shaped jawline, while hair should be slightly coloured in brown tones to soften the complexion. These beauty standards are a long way from matching the natural physicality of Korean men and women. It therefore takes a certain amount of craft to conform to these conventions, and this explains the essential role played by clothing, cosmetics and surgery in South Korea. "Having cosmetic surgery isn't taboo in Seoul," explains Florence Bernardin, founder of the company Information & Inspiration which deciphers Asian trends for big Western beauty brands, in

an interview with newspaper *Le Monde*. "It's not viewed as a sin of excessive pride, because everyone knows the most beautiful women get the best jobs."

However, this pressure to conform to an ideal of beauty is becoming increasingly burdensome. This explains why in recent years the goalposts appear to be shifting in the world of fashion and beauty. For example, the world of male modelling now includes older men and muscular builds, marking a sharp contrast with the "flower boy" looks of young K-pop singers. And the *geongangmi* trend is gradually redefining perceptions of the female body by imposing the new standard of a strong, athletic and tanned look, a far cry from the traditional beauty standards prevailing in the country. Korean feminists are also contributing to these changes in norms by calling out the immense social pressures women face in terms

of physical beauty. In 2019, they launched an online movement known as "escape the corset", this catchcry referring to the extreme beauty standards imposed on them. Using this hashtag, they post photos and videos of cosmetics thrown in the bin, or of themselves with short haircuts. "Too many women spend one to two hours a day putting on makeup. You don't need to be pretty. Don't be so concerned with how others perceive you," explains YouTuber Bae Lina, a figurehead of the movement, in one of her videos. But there's clearly a long way to go for the feminists of South Korea. Women are still regularly criticised on social networks and in the media for looks that are deemed too extravagant or too provocative. Let's hope that by helping to change mindsets, the most avant-garde fringe of Korean fashion can be a driver of emancipation, creativity and above all, kindness.

한 자 씀

→
Outfit by Minju Kim presented at the annual fashion show of the Antwerp Fashion Academy on 7 June 2012.

It takes a certain amount of craft to conform to these conventions, and this explains the role played by clothing, cosmetics and surgery.

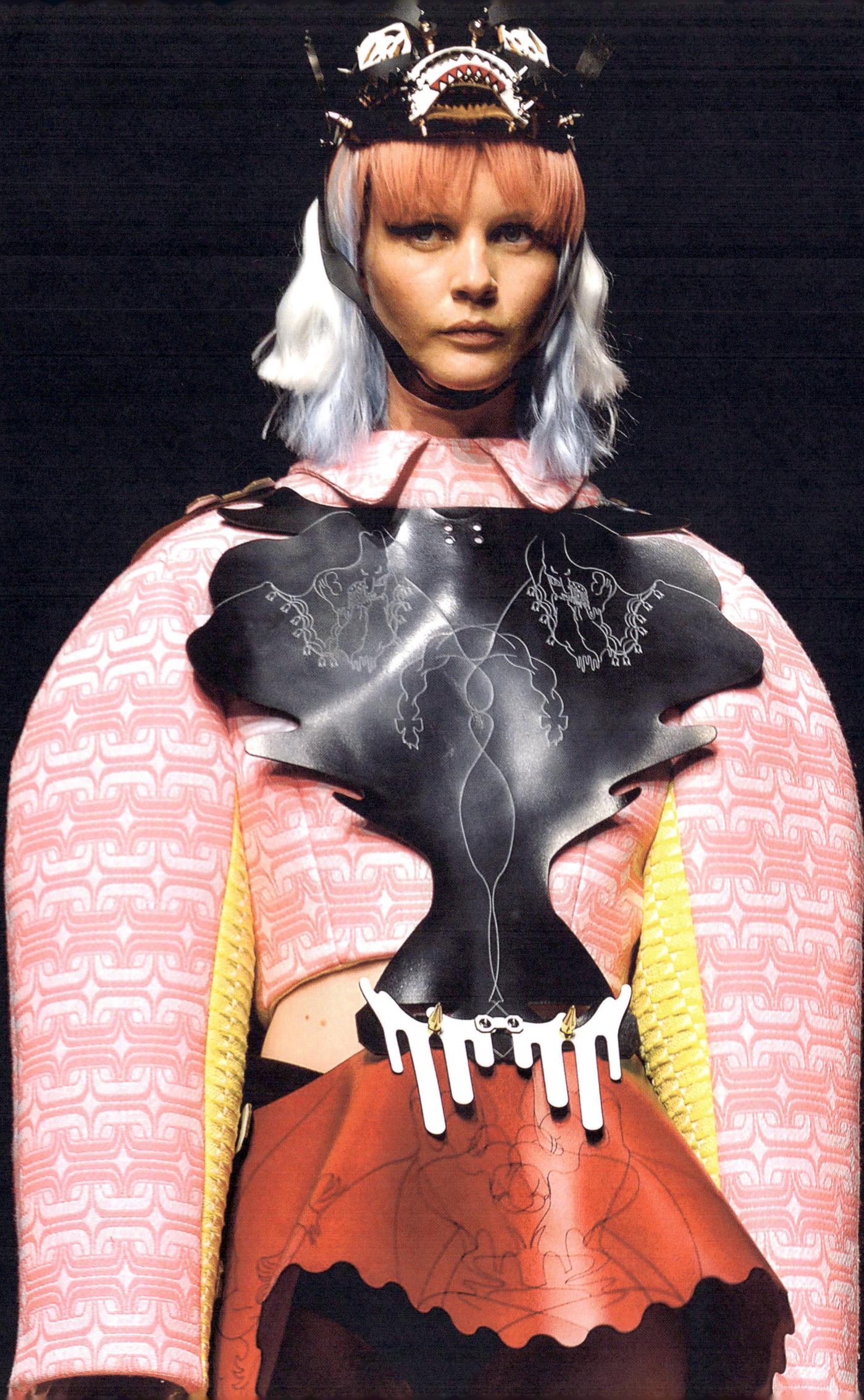

SOO JOO PARK

DYED BLONDE

A model effortlessly shifting the goalposts in the world of haute couture.

She's currently one of Korea's most famous models. Her career is certainly impressive, with more than 200 fashion shows to her name. Born in Seoul, she left South Korea at the age of 10 to live in California and went on to study architecture. It was here, while shopping in a vintage store, that she was spotted by a model scout. She was soon working with Karl Lagerfeld and Tom Ford, bringing physical diversity to the haute couture shows of the time. But Soo Joo Park isn't interested in making this a personal battle. For her, things happen naturally, as she explained to *New York Magazine*: "I don't consider myself to be an Asian model. I think one of the reasons I decided to dye my hair was because I didn't want to be branded as an Asian model. I just wanted to be myself." In 2015, she became the first Asian-American to be the face of L'Oréal. She's also played the role of Sutra in the series *Sense8* broadcast on Netflix and is a DJ.

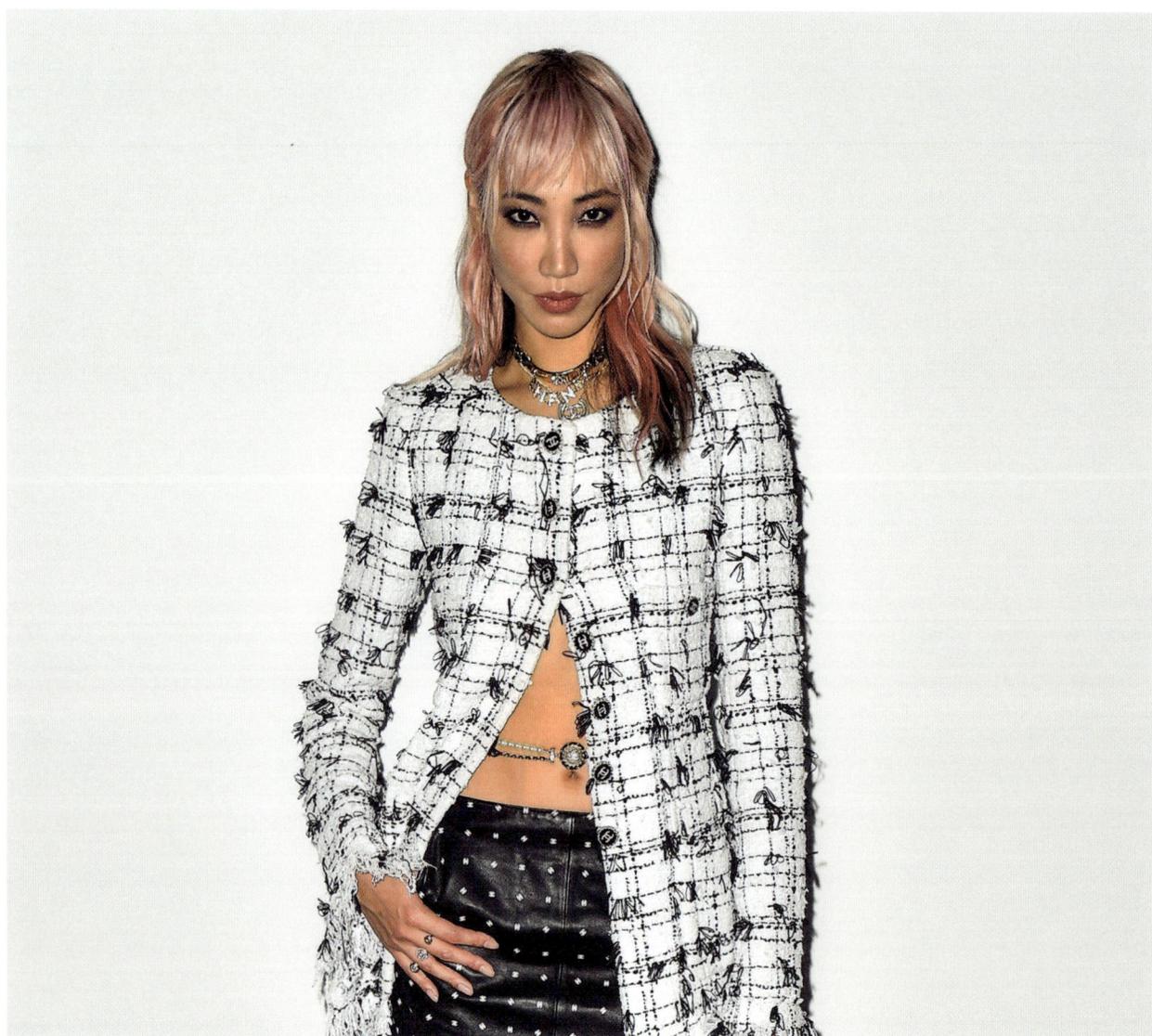

KIM SUNG-HEE

THE OTHER STAR

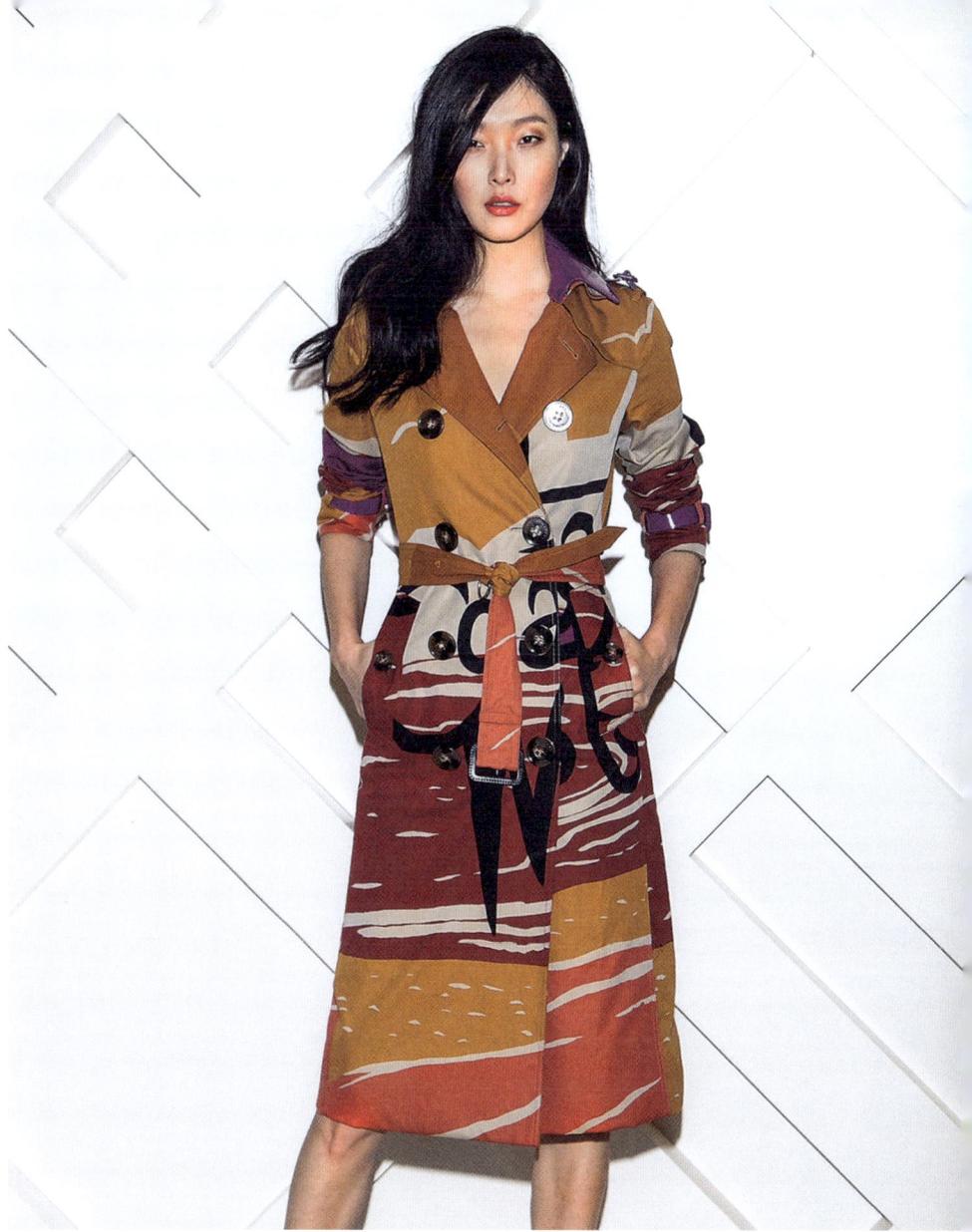

Sometimes it's a hop, skip and a jump from dancing to modelling.

It can be important to know how to change direction. Model Kim Sung-hee learned this by force of circumstance. Originally from Seoul, she grew up with one goal in mind: to become a prima ballerina. So she trained day and night in the hope of attending the dance school of her dreams. "But I was a bit tall for a ballerina: I'm 1.78m and the ideal height is 1.60. You become 10cm taller in pointe shoes and it was impossible to find a male dancer who was taller than me. I was always a soloist or dancing in the background in groups on the stage," she explained to the magazine *Matches Fashion*. In the end, she went to university and became interested in other subjects. She took part in the TV show *I Am a Model* and finished in the top three, signing a contract with the famous agency Esteem Models. In 2013, she quickly rose to international fame when she became the first Asian face of a campaign for the brand Miu Miu, and also started posing for Prada. In other words, Kim Sung-hee is now leading the dance, on her own terms.

← Soo Joo Park on the runway at the Chanel Spring/ Summer 2022 show at Paris Fashion Week on 5 October 2021.

↑ Kim Sung-hee attending a promotional event for Burberry Beauty Box on 18 December 2014 in Seoul.

45

LEE SOO–HYUK

GOLDEN BOY

이수혁

리틀 런웨이

Instead of having one successful career, why not have two?

With more than 3 million followers on Instagram, Lee Soo-hyuk is an undisputed star in South Korea. His modelling career began in 2006 when he walked the runway for the Lone Costume brand of designer Jung Wook-jun. He immediately made a strong impression because his slim figure and pale complexion matched an ideal of male beauty highly fashionable in his native country. As a result, Lee Soo-hyuk was in great demand right from the start. He began to appear on the cover of magazines such as *GQ*, *Bazaar* and *Elle* while also starring in music videos and TV shows. In 2010, he played the main role in the film *The Boy from Ipanema*. The critical success of the movie encouraged him to develop a career as an actor, while he also continued to model at fashion weeks in Paris and London for prestigious houses such as Balenciaga, Balmain and J.W. Anderson. In 2020, after a two-year break imposed by his military service, Lee Soo-hyuk was back in business, starring in the TV series *Born Again* while also being appointed the new face of Nivea Homme. Proof that sometimes you can have it both ways.

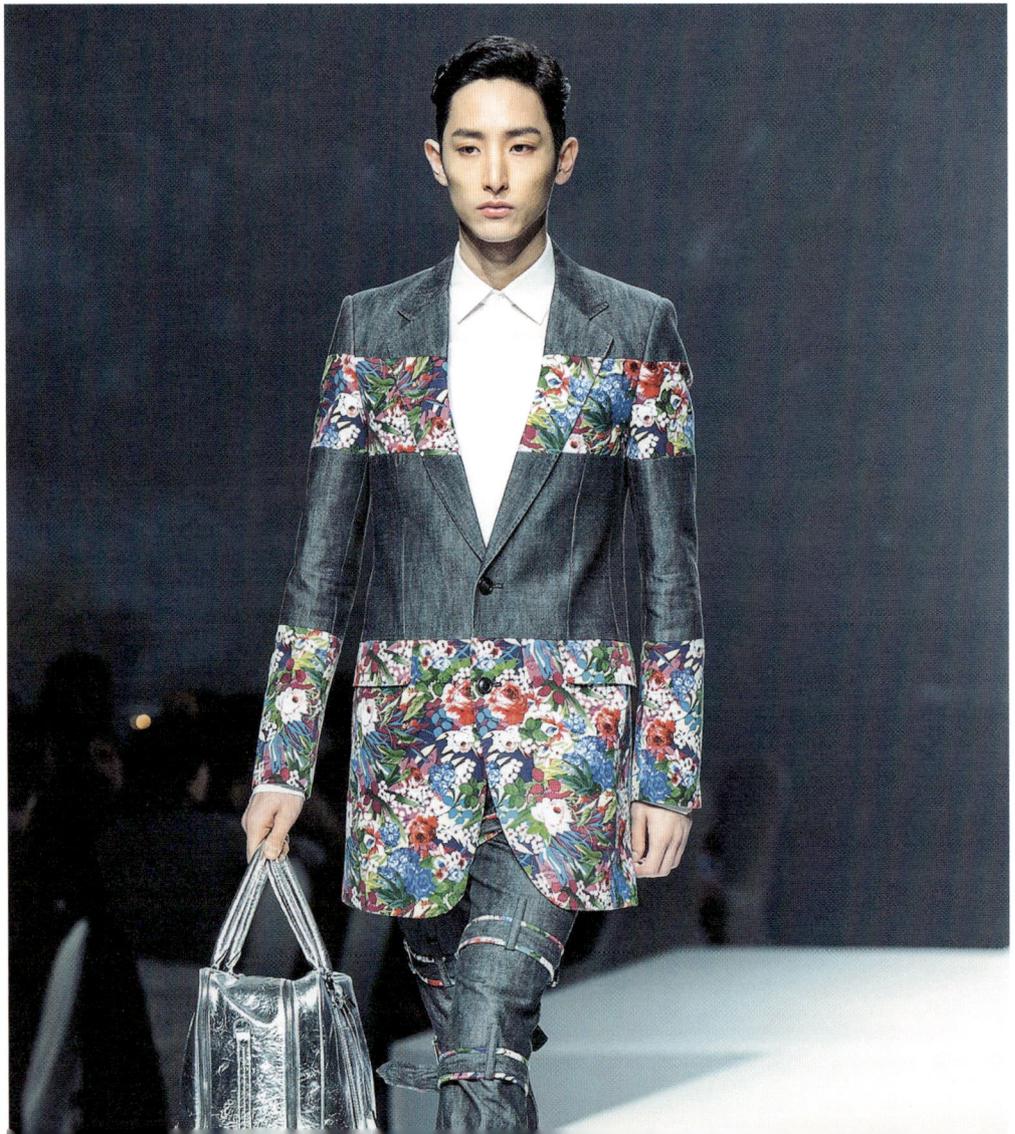

IRENE KIM

A NORMAL GIRL

평범한소녀

Influencer, TV host, model and designer, Irene Kim can do it all.

Although she now appears on the pages of the biggest fashion magazines, influencer Irene Kim is keen to point out that in the beginning she was nothing like a fashion superstar. "I didn't start out as some glamorous supermodel. I'm just a normal girl who loves fashion. People have been very responsive and supportive of what I put out. And I think that has made me more relatable because they've seen my whole life on social media," she explained to the magazine *Harper's Bazaar*. Born in Seattle, the Korean-American came to live in Seoul as a teenager and then began to share her passion for fashion on the internet, mainly through her Instagram account where she now has 2.7 million followers. In 2012, she took the big leap and embarked on a modelling career. One thing quickly led to another. Irene Kim started working with Chanel and Calvin Klein while hosting the TV show *K-Style* on Korean television. In 2018, she even launched her own clothing which she named Ireneisgood. Not bad for a normal girl.

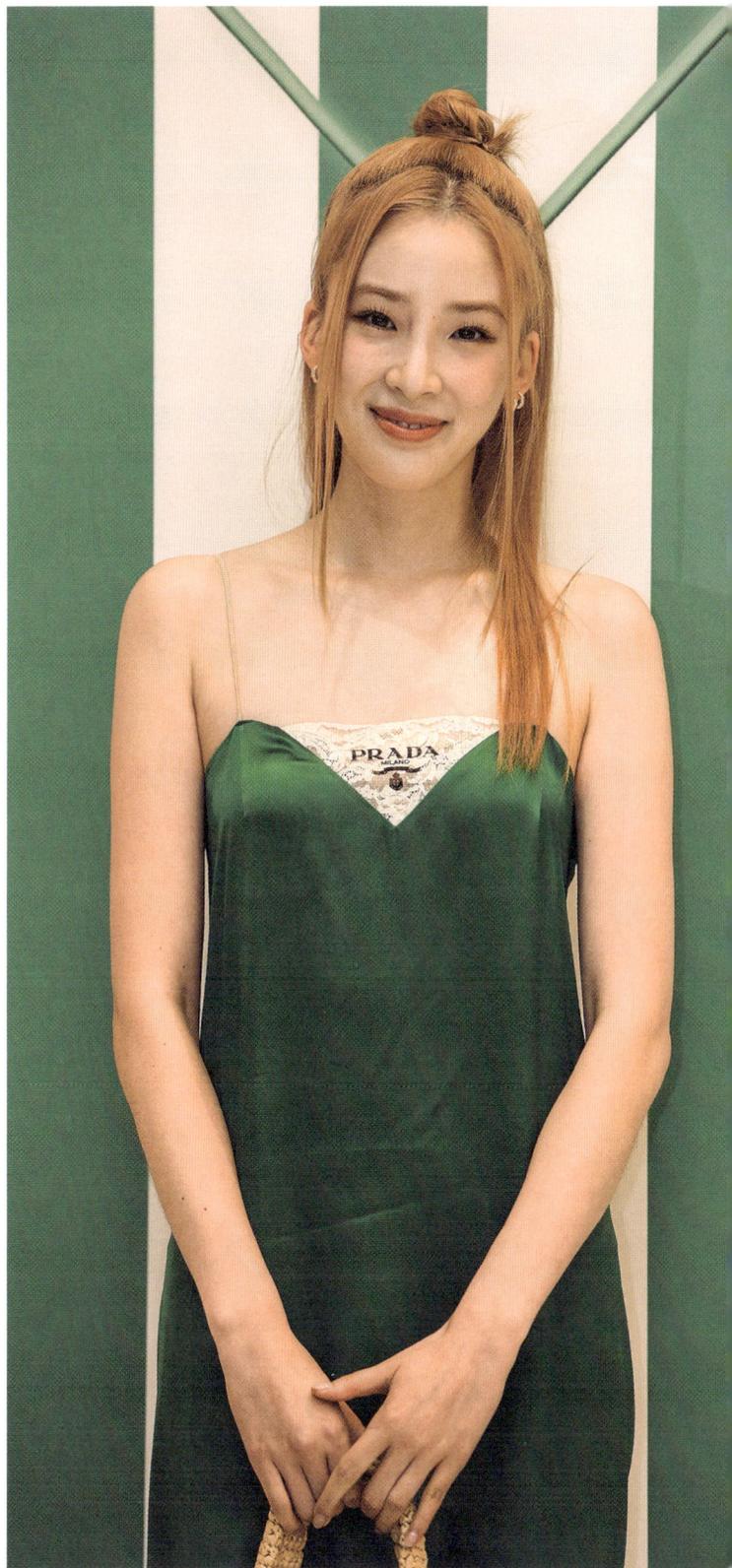

KOREA'S NEXT TOP MODEL

IN THE STARTING BLOCKS

코리아 넥스트 탑 모델

When Korean fashion goes in search of a new star.

In the world of South Korean fashion, over the course of five seasons, this show was a prerequisite to entering the industry. Launched in 2010, the reality TV show was a local adaptation of *America's Next Top Model*. The principle is simple: a dozen participants wanting to start a career in the modelling industry live together in a large shared house for several months. They take part in challenges, photo shoots and meetings with different personalities from the world of fashion and are eliminated one by one as the episodes progress. The last contestant remaining is offered a contract with a modelling agency and the possibility of appearing on the cover of the famous *W Magazine*. As is often the case in this kind of show, the people we remember best aren't always the winners. The most obvious example of this is the young Jung Ho-yeon who was eliminated in 2013 during the fourth season of *Korea's Next Top Model*. She would get her revenge years later by becoming one of the star actresses in the globally successful series *Squid Game*.

ULZZANG

LIKE MANGA

A slender waist, pale complexion and huge pupils – welcome to the world of ulzzang.

In Korean, the word *ulzzang* literally means "best face". And it's a good way of summing up this trend that began to emerge in the early 2000s among the hip young people of Seoul. People who qualify as *ulzzang* can be men or women and aren't necessarily models or celebrities. They're primarily recognised for their typically Asian standards of beauty, inspired mainly by characters from manga or anime. The characteristics of an *ulzzang* usually include a tiny waist, slim face, perfect skin of a pale complexion and huge eyes created using circle lenses, a type of contact lens with a diameter that extends beyond the pupil to make it look bigger. To achieve *ulzzang* status, hopefuls enter online contests where participants are ranked in terms of their beauty. A way of getting noticed that can act as a springboard into the world of film, fashion or music.

KIM CHIL-DOO
A FINE AGE

Yes, you can be over sixty and work as a star model.

In South Korea, social norms relating to generational differences are strongly upheld. After a certain age, it's not acceptable to behave like a young person and this even encourages some people to consider professional retraining to avoid being judged adversely. But this doesn't seem to worry Kim Chil-doo, who started his modelling career in 2016 at the age of 61. In other words, with his full beard, lined face and long hair, he's the antithesis of the beauty standards prevailing in Korean fashion and among stars of K-pop. This hasn't stopped Kim Chil-doo from stepping out onto the runway at Seoul Fashion Week or appearing in a number of Korean magazines. He even recently started an acting career, starring in TV series and films. So, whatever you think of it, there's no age limit when it comes to making your dreams a reality.

↑
Korea's oldest fashion model Kim Chil-doo attends the store launch of Moose Knuckles in 2019 in Seoul.

→
The South Korean sunglasses and clothing store Gentle Monster in Hong Kong.

GENTLE MONSTER

THE SUNGLASSES OF THE STARS

What do Kanye West, Rihanna and Blackpink's Jennie have in common?

Founded in 2011, the South Korean brand Gentle Monster has become a leading purveyor of sunglasses in record time. Reflecting the company's strapline, "innovative experiment", its frames offer a perfect balance between avant-garde extravagance and more retro models, appealing to an audience well beyond the borders of the Korean peninsula. Gentle Monster has acquired a solid reputation with international customers by initiating numerous collaborative projects with respected fashion brands. Examples include Opening Ceremony, Alexander Wang, Fendi and Moncler. A strategy that appears to have paid serious dividends, as the biggest pop celebrities can now be seen wearing Gentle Monster shades, including Kanye West, Justin Bieber, Rihanna, Bad Bunny and Korean singer Jennie, a member of the K-pop group Blackpink. Definitely a brand to watch.

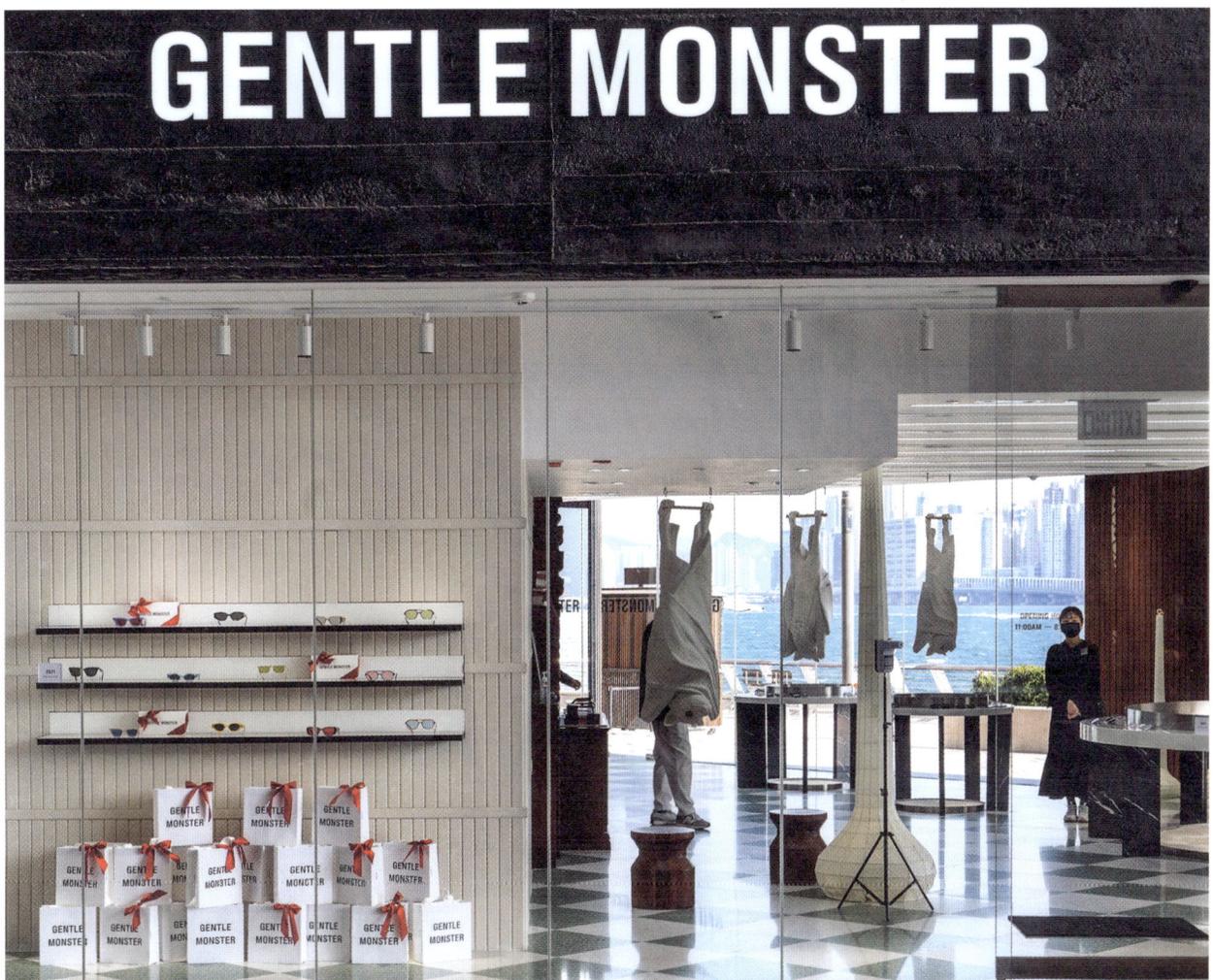

SORA CHOI

TO DIE ON THE RUNWAY

최소라

Her androgynous looks have captivated all the biggest brands.

Prada, Gucci, Chanel, Saint Laurent, Hermès, Givenchy, Dior, Burberry: it's difficult to find a prestigious fashion house that Sora Choi hasn't walked the runway for. At 30, the Korean from the city of Bucheon in the suburbs of Seoul has acquired the status of an icon in the industry. But it was almost by chance that she began to take an interest in fashion. One day she accompanied a nervous friend to a model casting to support her. In the end, it was Sora Choi who was selected, and she found herself thrown into the world of fashion. In 2012, she took part in *Korea's Next Top Model*, winning the show hands down. She started working for Louis Vuitton and her imposing androgynous style was a huge hit on all the biggest runways. She's now taken part in hundreds of shows and is one of the most famous Korean models in the world. She spoke of her passion to magazine *The WOW*: "When you do the same job repetitively, some people might experience ennui or fall into a kind of mannerism. But for me, it gets more fun the more shows I do. I once told my husband that I'd like to die on the runway."

↓
Sora Choi on the catwalk at the Courrèges ready-to-wear Autumn/Winter 2022–2023 show at Paris Fashion Week.

→
Jacket and skirt designed by Minju Kim and worn by a spectator at Harea Seoul Fashion Week in 2019.

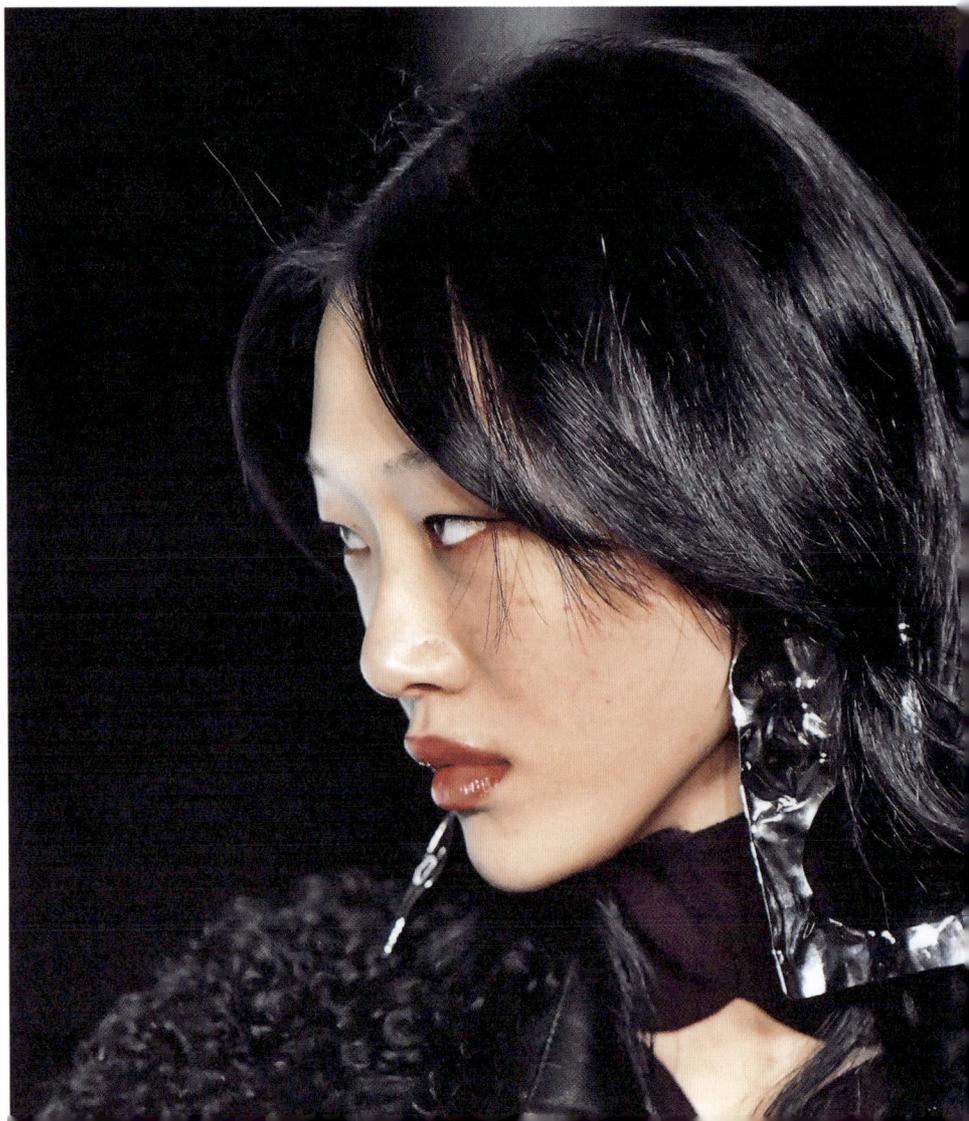

MINJU KIM

FRILLS AND MANGA

With K-pop in her sights, she's the new darling of Korean fashion.

Minju Kim is without doubt one of the greatest successes of Korean fashion in recent years. Born in Gwangju, she graduated from the Samsung Art and Design Institute and became known for her unique style which mixes frilly dresses, pastel prints, exacting standards worthy of haute couture, and inspirations drawn from the manga she read in her youth. In 2020, after creating a collection of ten outfits in just three days, the designer won the first season of *Next in Fashion*, a design competition broadcast on Netflix. Based in Seoul, her brand Minjukim is now worn by K-pop superstars, such as members of BTS and singers in the group Red Velvet. "Working with these artists helped me realise that stage costume is totally different from the clothes I usually make," she explained to the magazine *Hypebae*. It's a way for Minju Kim to establish her work in the pop culture of the country she loves.

One of Rihanna's favourite brands is South Korean

Supported since her debut by the singer Rihanna, designer Hyein Seo has turned Korean fashion on its head, combining it with Flemish avant-garde styling and American streetwear.

In 2014, Hyein Seo was just 23 when she left her native South Korea for the city of Antwerp in Belgium. Here she studied fashion at the prestigious Royal Academy of Fine Arts. Her goal was to become a fashion designer and so she created a first collection which earned her an invitation to New York Fashion Week as an emerging designer. It was at this point that everything started to speed up. Always keen to embrace the latest trends, Rihanna spotted her, and in the same year the American singer appeared in a full outfit by Hyein Seo for her performance at the MTV Movie Awards alongside rapper Eminem. From that moment onwards, the young student's career went into orbit, as she told the magazine *032C*: "After that evening, there was so much demand that I had to make time away from my studies to produce the collection immediately." But the love story between Rihanna and Hyein Seo didn't end there. The following year, the pop star continued to wear the creations of the young Korean whenever she could. For example, she appeared in a T-shirt featuring the words SCHOOL KILLS which would become one of her signature outfits. Hyein Seo continues this sense of irreverence in her creations by mixing influences drawn from her memories as a teenager but also from American streetwear, while at the same time embracing a more avant-garde, unisex and minimalist approach to clothing inherited from her studies in Antwerp. A style in stark contrast with others in her native country of South Korea, where a still highly conservative society can encourage young people to adopt styles that are often relatively restrained and classic in feel. But this hasn't stopped Hyein Seo – who prefers the public to focus on her designs rather than on her as a person – from becoming one of the hippest designer labels of the new generation and from continuing to stand out as one of a kind in the world of Seoul fashion.

↑
Hyolyn aka
Hyorin, a former
member of girl
group Sistar,
attends the
second day of
CJ E&M KCON
2022 Premiere
in Seoul.

→
Lee Si-young,
photographed
here in Seoul in
2013, is a good
example of this
new trend.

Going against the norms of Korean beauty, the geongangmi trend flexes its muscles

In the land of porcelain complexions and slim figures, the fashion of *geongangmi* is using strongarm tactics to redefine current conventions. Next stop, the gym.

Could the beauty ideal in South Korea be changing? While the country has traditionally valued young women with a slim physique and pale skin, the trend of *geongangmi* or "healthy beauty" is shaking up these conventions by advocating a muscular, athletic and tanned body. "I just think having muscles looks cooler. I don't want to be skinny, I want to be bigger. Social standards do exist of course, but for me, there is no better standard than being satisfied with yourself," explained Yoo Wonhee to the newspaper *The Guardian*. This 27-year-old Korean has taken up sport to reshape her body in the image of the new *geongangmi* idols such as pop star Hyolyn, and actress and boxer Lee Si-young. These influencers stage their bodybuilding, Pilates sessions and fitness classes on social media and collect millions of likes, proving that practising sport appeals to young Koreans more than ever. Not to mention the popular reality show *Physical: 100* now streaming on Netflix. According to national census data, the number of people in their twenties attending gyms has more than doubled in recent years. "For many clients, the priorities have shifted from losing weight to enhancing their quality of life," personal trainer Koo Hyun-kyung told *The Guardian* from her women-only gym specialising in strength training and weightlifting. She explained: "You can't have a pale, skinny body and be successful in the world of fitness. So people tend to shift their beauty standards towards aligning with their goals." The *geongangmi* trend is also in part influenced by the changing role of women in Korean society.

For the past ten years, feminist movements have been gaining ground in South Korea and encouraging women to take charge of their lives. Standing firm against tradition and expectations, some women refuse to marry, while others are abandoning the "pure and fragile" beauty ideal imposed by men and replacing it with the quest for a strong and healthy body. But some critics warn against swapping old injunctions for new ones. For example, on the internet, bloggers are already pointing out the limits of *geongangmi*: "I used to have to starve. Now I have to starve and exercise."

South Korea: the world champion of cosmetic surgery

Cosmetic surgery is fully accepted in South Korean society and not in any way taboo. It's often even encouraged.

You only have to walk the streets of any major city in South Korea to realise that the country is obsessed with cosmetic surgery. Large and omnipresent advertising posters extol the virtues of different clinics which, with a bit of clever scalpel work, offer to reshape your chin, enlarge your eyes or beautify your nose. The slogans can be hard-hitting: "They've all done it, except you." It's also not unusual to see people covered in bandages on public transport or out shopping the day after an operation. After the United States and Brazil, South Korea is ranked third in terms of the total number of cosmetic surgeries performed: about 1.2 million per year according to reports from the International Society of Aesthetic Plastic Surgery (ISAPS). But with 74 procedures per 10,000 people, South Korea is also the country with the highest operation rate in the world. The annual revenue generated by this industry is around 5 billion dollars. A figure that's not so surprising given that the practice is accepted in South Korea, and sometimes even encouraged. "In our society, being beautiful is an advantage when looking for a job or a good husband," explained Jung Youngchoon, director of Hershe, one of the capital's best-known clinics, to the newspaper *Le Monde*. "Many parents push their children to have cosmetic surgery for these reasons." Some even offer it as a gift, fearing that their offspring will be subjected to social pressure for not having gone under the knife. The phenomenon also affects men who often seek to conform to the standards set by K-pop singers. In other words, in South Korea, surgery is not taboo but almost a rite of passage. Whether it's wanted or not.

"They've all done it, except you."

←
Advertising for cosmetic surgery clinics in the Seoul subway.

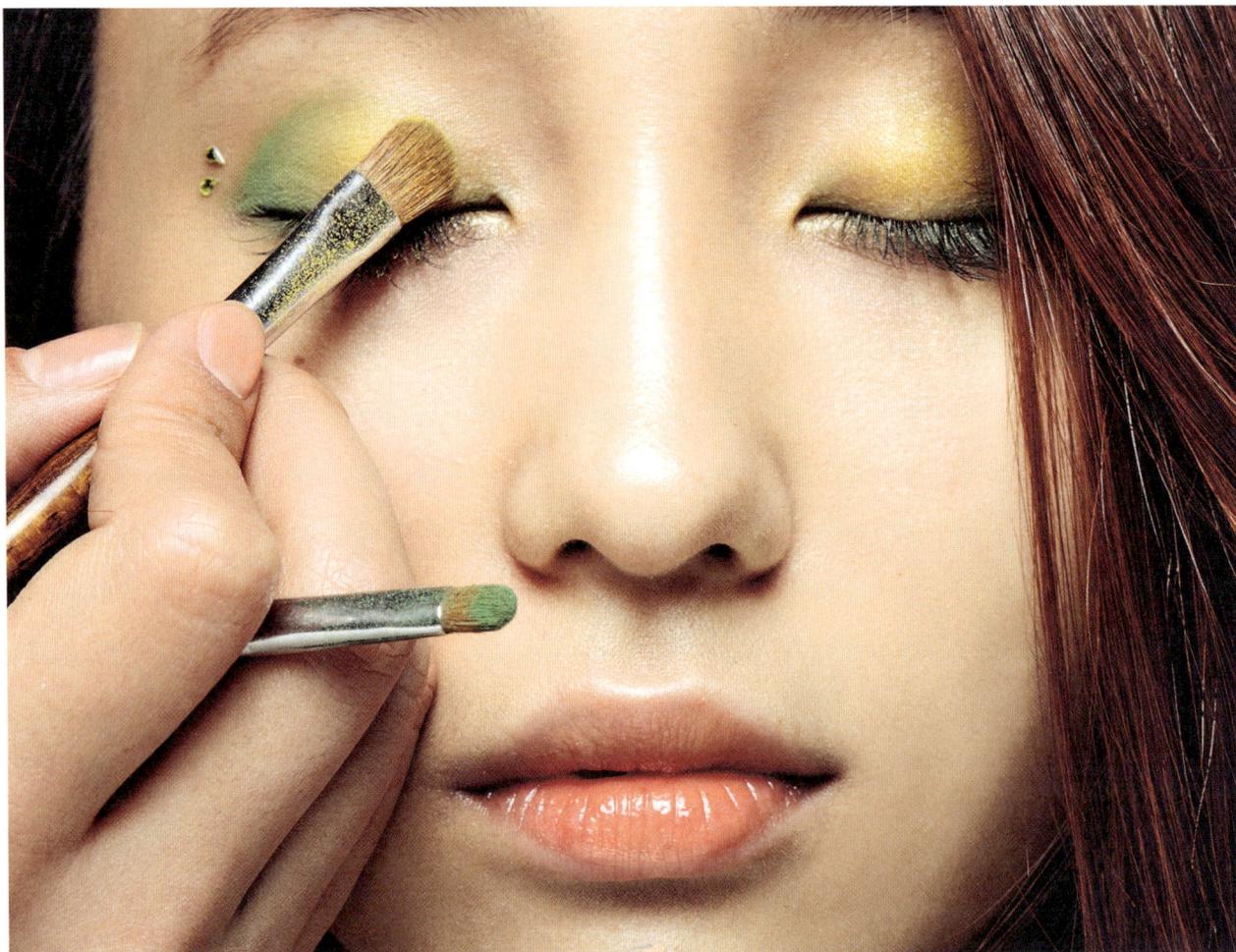

South Korea: a trendsetter for makeup

As the world's largest consumer of cosmetics, the country is a cutting-edge player in the industry, often dictating tomorrow's trends to the rest of the globe.

South Korea has always been a pioneer in the world of cosmetics. To understand why, we have to go back to ancient times. Korean culture has always viewed physical appearance as a reflection of the inner self. Plants, oils and powdered grains were used to create facial scrubs, creams and lotions. But this taste for cosmetics has never been synonymous with extravagance when it comes to makeup. This is because the Confucian philosophy is one of the cornerstones of South Korean society. It emphasises a number of virtues, including the need for women to be

modest and unadorned with a focus on simple elegance. Rather than paying for spectacular beauty treatments that would go against these principles, Korean women have therefore become used to minimalist and discreet makeup routines resulting in a clear and clean complexion. These beauty standards are still very much in vogue on the Korean peninsula.

Today, the country is the world's largest consumer of cosmetic products. It's developed a high-tech skincare industry and for most women it's unthinkable to go out into the world without makeup. Some products that are popular worldwide were first adopted in South Korea before being exported. A good example of this is BB cream, a type of three-in-one cream that moisturises, corrects blemishes, and evens out skin tone. It's popular with Korean women because it can replace foundation and guarantees perfectly smooth skin without redness. Another

trend in The Land of the Morning Calm is gradient lips. A darker colour is applied to the centre of the lips and then faded out to the edges, producing a bitten lip effect which is subtle without being vulgar. Korean women are crazy about the style and it's even gaining traction overseas. "The Korean market is a never-ending source of inspiration for us," Cyril Chapuy, Worldwide Brand President of L'Oréal Paris, explained in 2013 to the newspaper *Le Monde*. But the local cosmetics sector isn't focused solely on its female clientele. In South Korea, increasing numbers of men are also wearing makeup, influenced by K-pop singers with flawless skin. Big Korean beauty brands are therefore adapting to this new audience and now offer moisturising masks, BB creams and eyeliners specially designed for men. A children's makeup market has even emerged in recent years. Proof that cosmetics are an integral part of Korean culture.

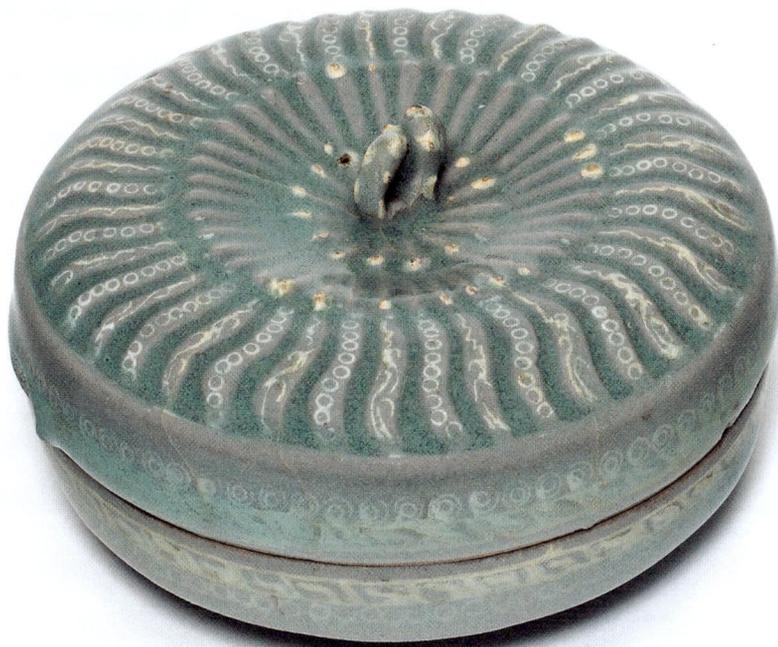

화장품

The skilful art of getting the best out of makeup and cosmetics as practised by the Koreans.

Cosmetic box in the shape of a chrysanthemum flower, Korea, Goryeo dynasty, late 13th century.

Hanbok

FOCUS 2
한복 청자

In a country in perpetual motion, traditional Korean costume continues to be an anchor point in the history and past of the peninsula.

South Korea is a country passionate about fashion where everyone seems to be constantly on the lookout for the latest trends. But this taste for all things new in no way eclipses the centuries-old importance of certain traditional outfits, the most famous of which is undoubtedly hanbok. The word means "Korean clothes" and hanbok can be recognised by its bright colours and simple lines. For women, it generally consists of a *jeogori* (a discreetly decorated jacket often tied with two fabric ribbons) and a *chima* (a type of long and voluminous skirt). The costume for men is a short jacket paired with loose-fitting trousers known as *baji*. Tight at the top and wide at the bottom, hanbok is based on a principle of balance and harmony between opposing forces. Depending on the cut, colours and materials employed, hanbok was used to assert social status and allowed others to immediately identify the individual's role in society. For example, the more noble the wearer was, the more sophisticated the garment became.

Historians date the appearance of the outfit to the period of the Koguryo kingdom (37 BC–AD 668) and believe it was introduced by Scytho-Siberian nomads, a people thought to be of Iranian origin who migrated to Asia and Europe. Over time, hanbok became more complex, especially from the 13th century onwards with the invasion of Korea by the Mongols, which resulted in many different forms of cultural exchange. But it was around the 15th century, during the Joseon period, that the garment became a true fashion phenomenon at the royal court.

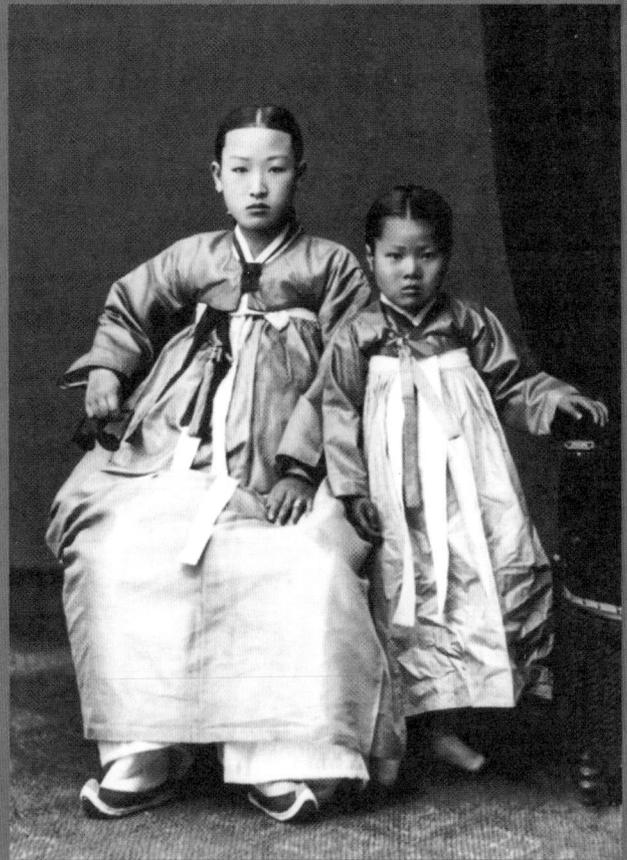

↑
A young woman and her granddaughter pose for a photo in traditional clothing around 1910.

→
As in other Asian countries, the immense importance of fashion has never resulted in historical clothing disappearing from Korean daily life. It's not uncommon to see women dressed in hanbok in the streets and parks.

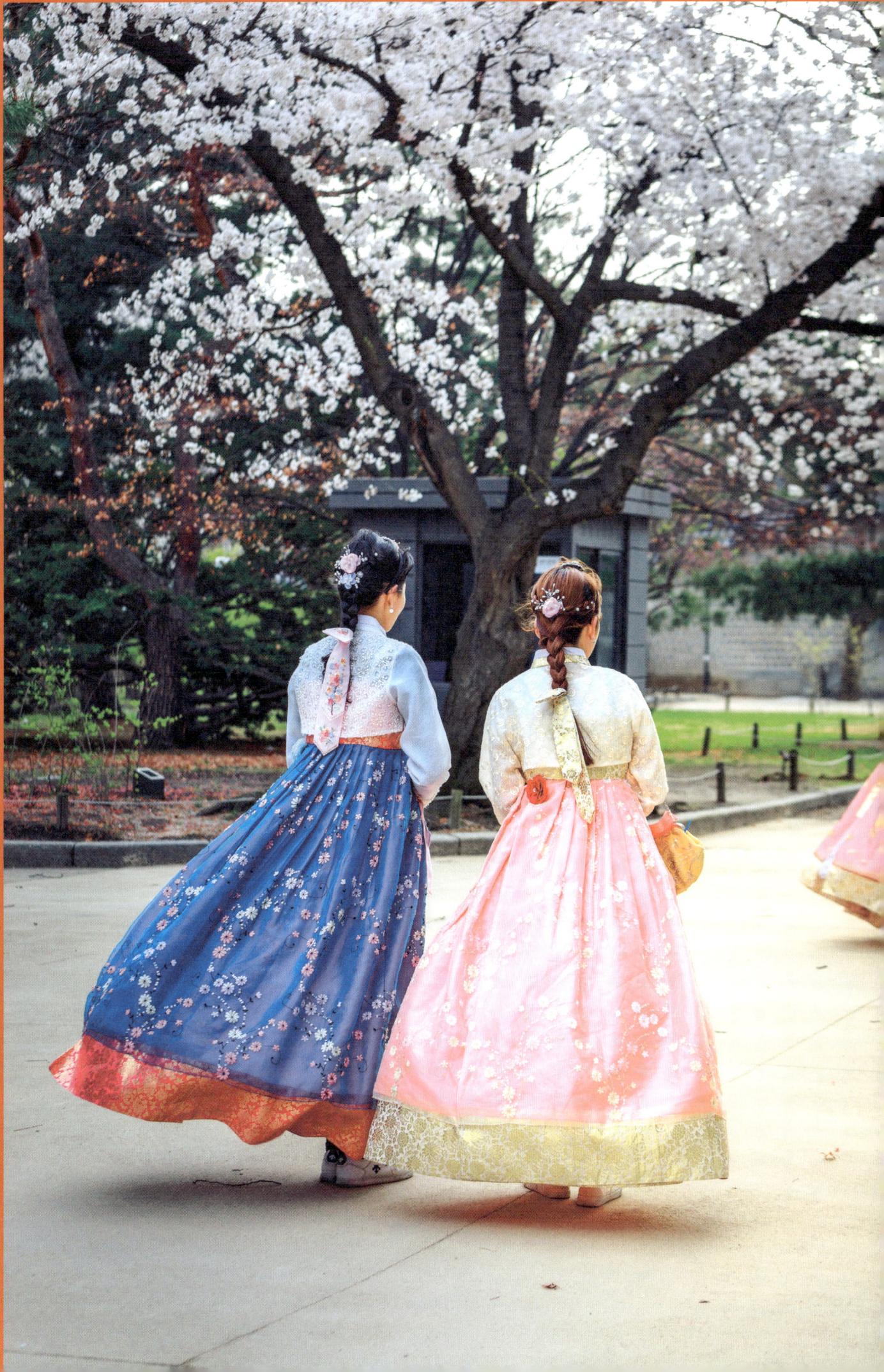

Colours grew increasingly bright, and shapes ever more sophisticated. In the Confucian society of the time, it became a way of discreetly expressing a form of beauty with restraint and modesty, through the addition of accessories and ornaments, such as traditional knots, pendants, embroidery and gemstones. Historian Yi Sông-mi describes the subtle and slight changes in this costume over time: "The design of hanbok has remained much the same over the centuries, although variations have affected the length of the jacket, the width of the sleeves, the length and width of the ribbon on the jacket, the fullness of the skirt, the number of pleats and the height of the waist."

Today, hanbok is still considered to be a national costume. It's very rarely worn on a daily basis but is reserved for special occasions such as New Year's celebrations and wedding ceremonies. Designers like André Kim and Lee Young-hee have also modernised it by showcasing it on haute couture runways and on the pages of the biggest fashion magazines. With the recent popularity of historical K-dramas set in the Joseon period, young people are rediscovering this traditional costume on the small screen, where these successful series sometimes portray it as a star in its own right. Hanbok still has plenty to say by all accounts, and it's a safe bet that future generations will know how to bring out the best of a garment so fundamentally linked to Korean identity.

↓
Scene from daily life in Gyeongbokgung Palace in Seoul with women wearing traditional hanbok in 2018.

↗
Unidentified artist from the Joseon dynasty, *Portrait of a Woman*, circa 1910.

→
"Hanbok" show at Seoul Fashion Week on 23 October 2009.

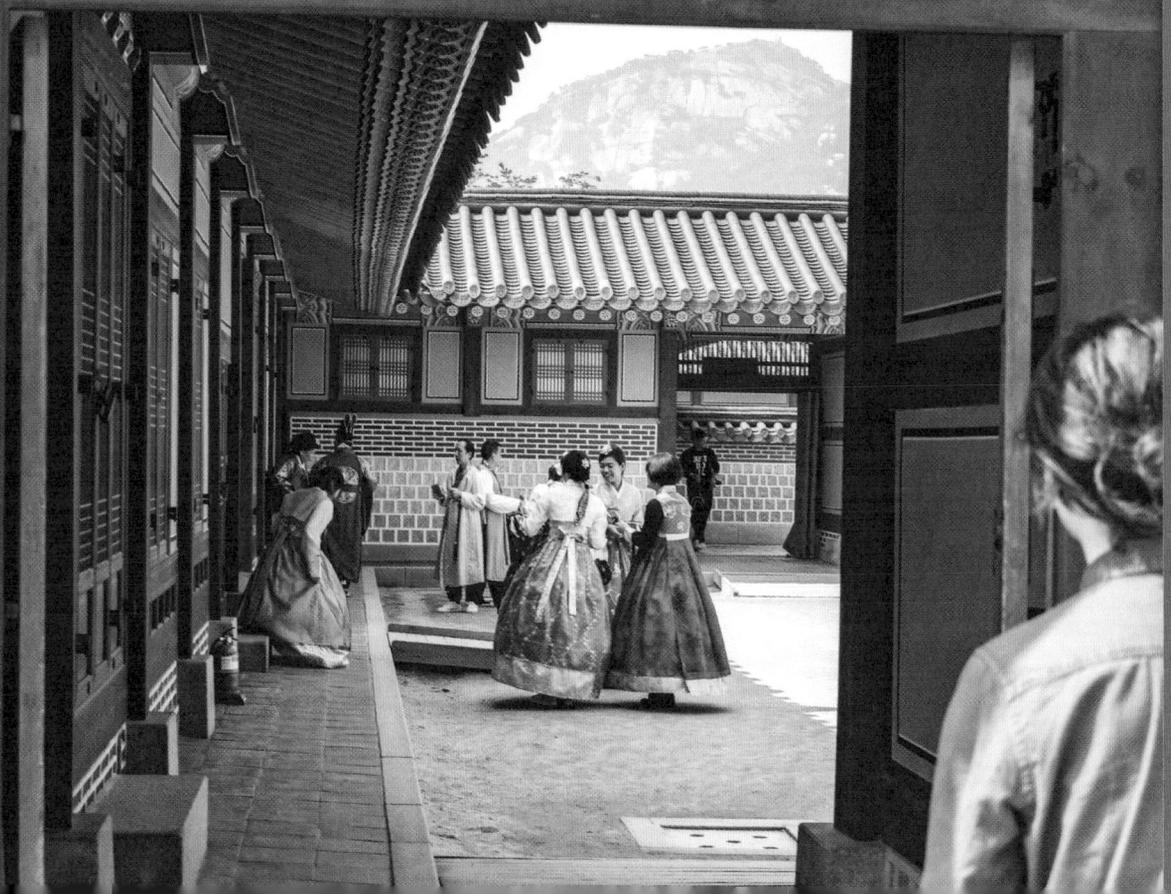

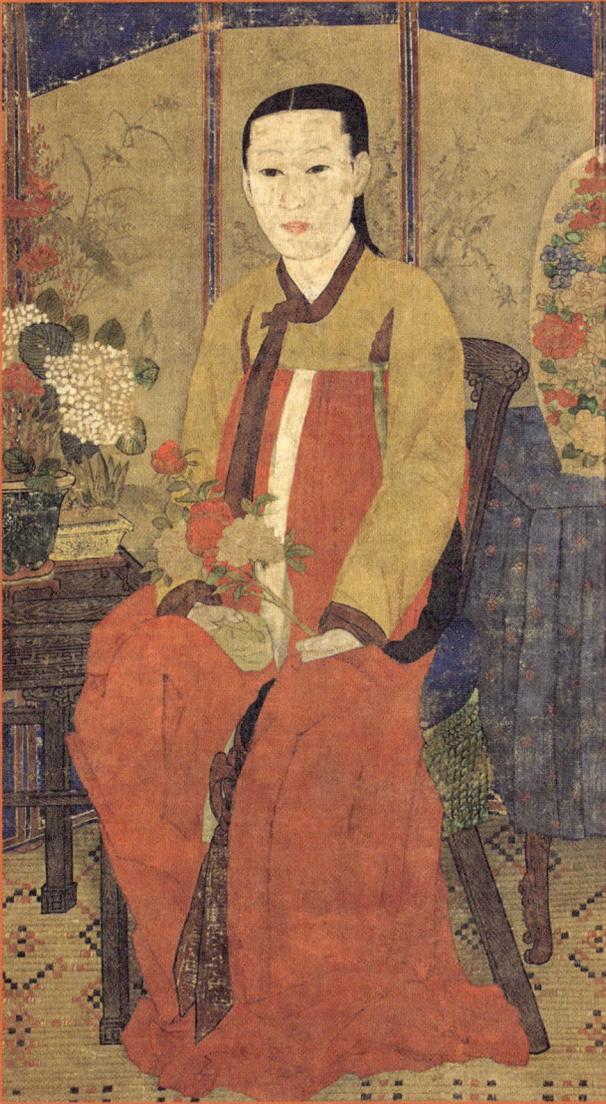
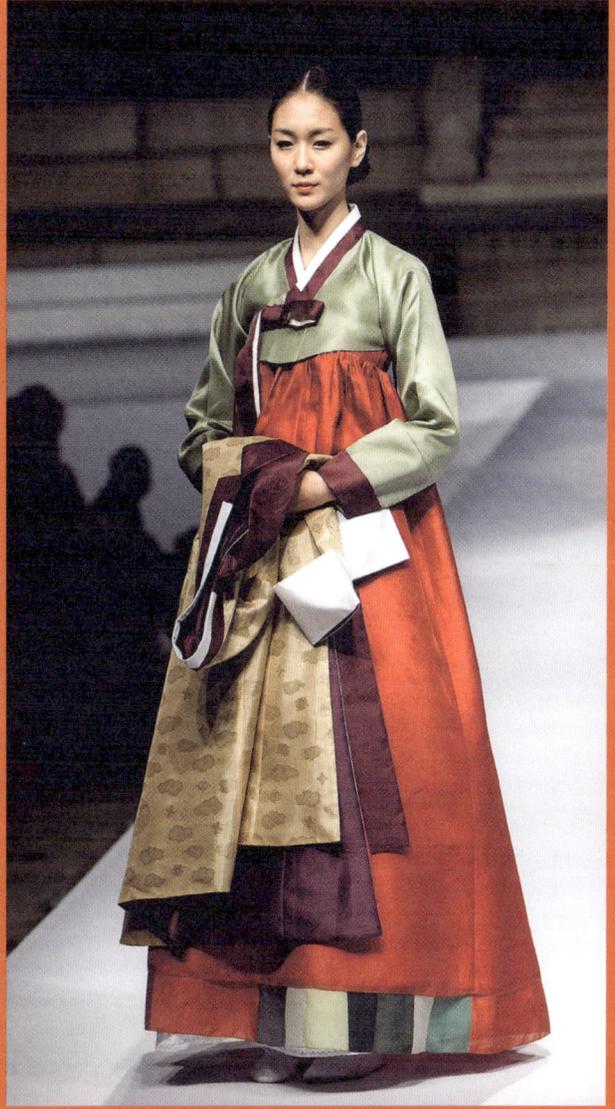

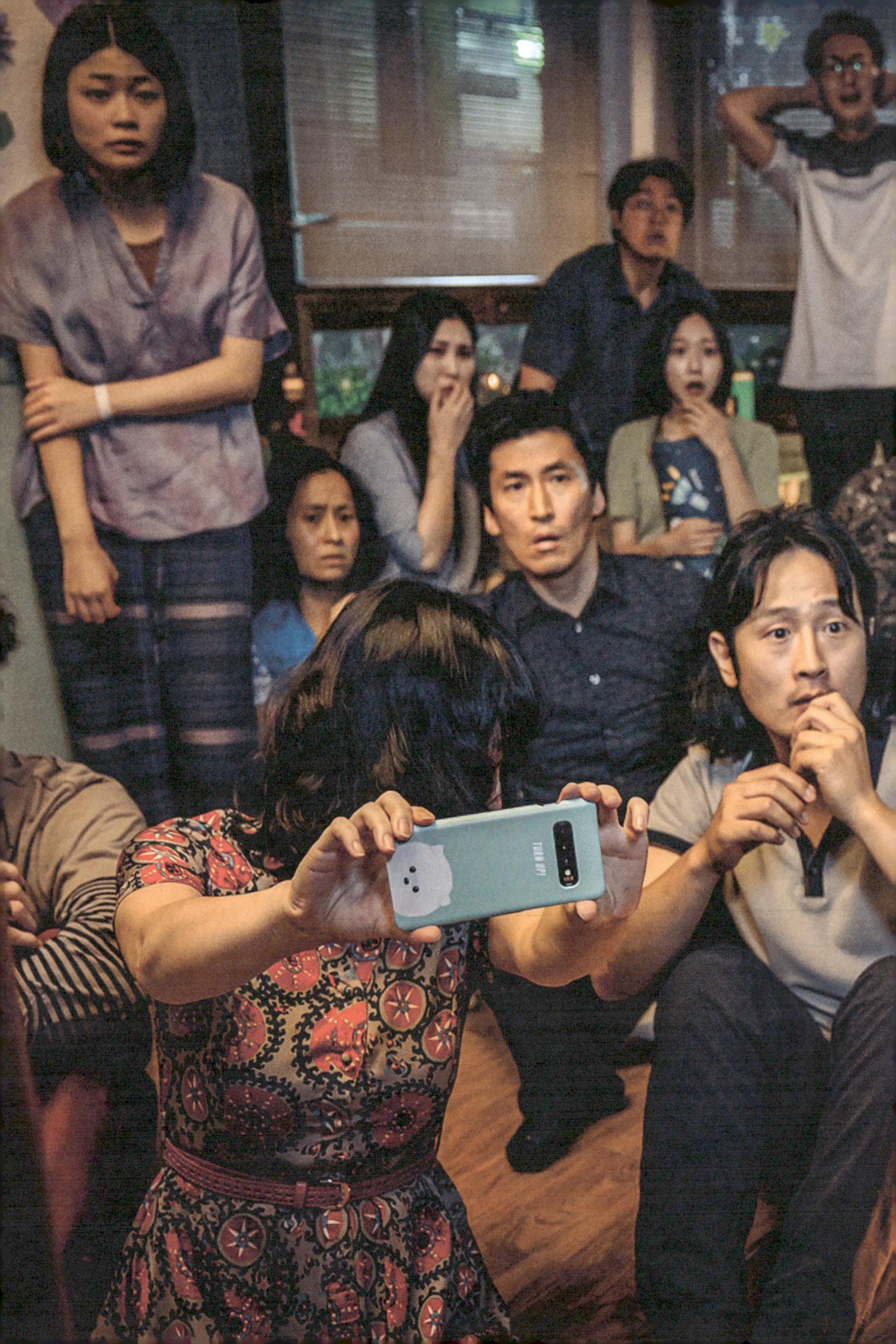

3

K-DRAMAS

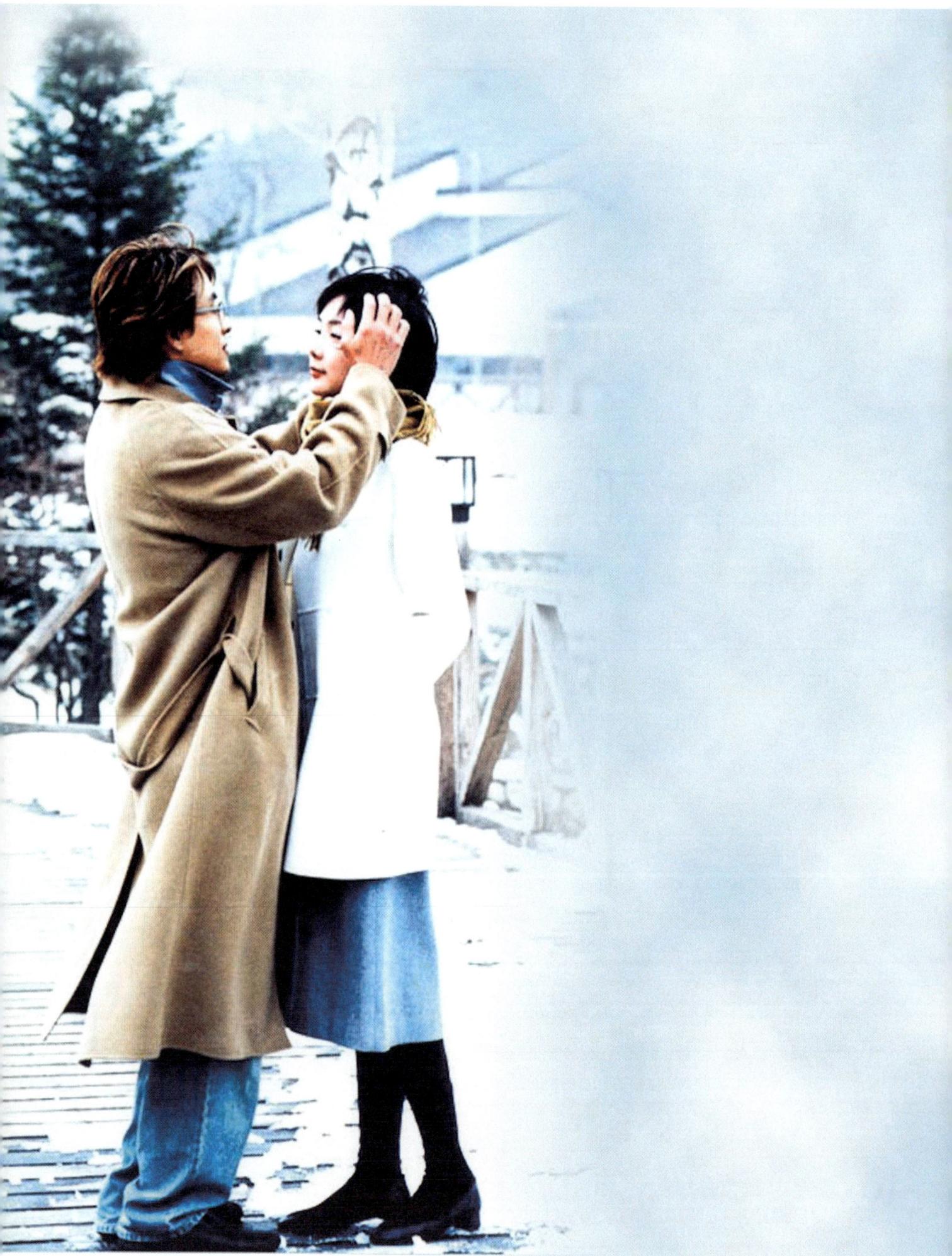

INTRODUCTION

한국 드라마의

P. 66-67
—
Scene from the series *Sweet Home*, broadcast on Netflix since December 2020.

←
Winter Sonata, a series by Yoon Seok-ho, which consists of twenty 50-minute episodes.

When it comes to TV series, South Korea has established a unique style which has proved remarkably popular with audiences across the world.

It might be tempting to think that Korean series – more usually known as K-dramas – are a recent phenomenon, given that their global success has come mostly over the last ten years. But things are obviously more complex than that. In May 1956, as the country was emerging from the Korean War, a new television channel known as HLKZ-TV took to the airwaves. One of its earliest programmes was *Death Row Prisoner*, directed by Choi Chang Bong, and many consider this to be the very first K-drama. But it was particularly in the early 60s, with the arrival of the channel KBS, that these series began to gain popularity in the country - with, for example, *Mr. Ku of Sajikgol* - and ultimately resulted in the birth of an industry entirely dedicated to the production of such programmes. But what are the distinguishing features of a K-drama? The conventions of the genre have of course evolved over the years, but it's still possible to identify certain characteristics. First, unlike the majority of

K-dramas established themselves as an easily exportable format in tune with the times.

Western series, in principle Korean dramas consist of a single season.

On average, episodes last for an hour and are shown twice a week, usually over two consecutive days. The shortest season consists of 20 episodes while the longest can have 100. If the series is extended for a second season, the producers work hard to ensure that it can be watched independently of the first. In terms of themes, certain key ideas are relatively common in the scripts of some programmes, such as the construction of the story around a couple getting romantically involved, differences in social status between the main characters, and obstacles introduced by families to thwart a love story. In others, the context and setting vary from one series to another. *Sageuk*, for example, are long historical dramas based on significant events in Korean history, but there are also series where the plot takes place in more contemporary settings, such as the business world or medical world.

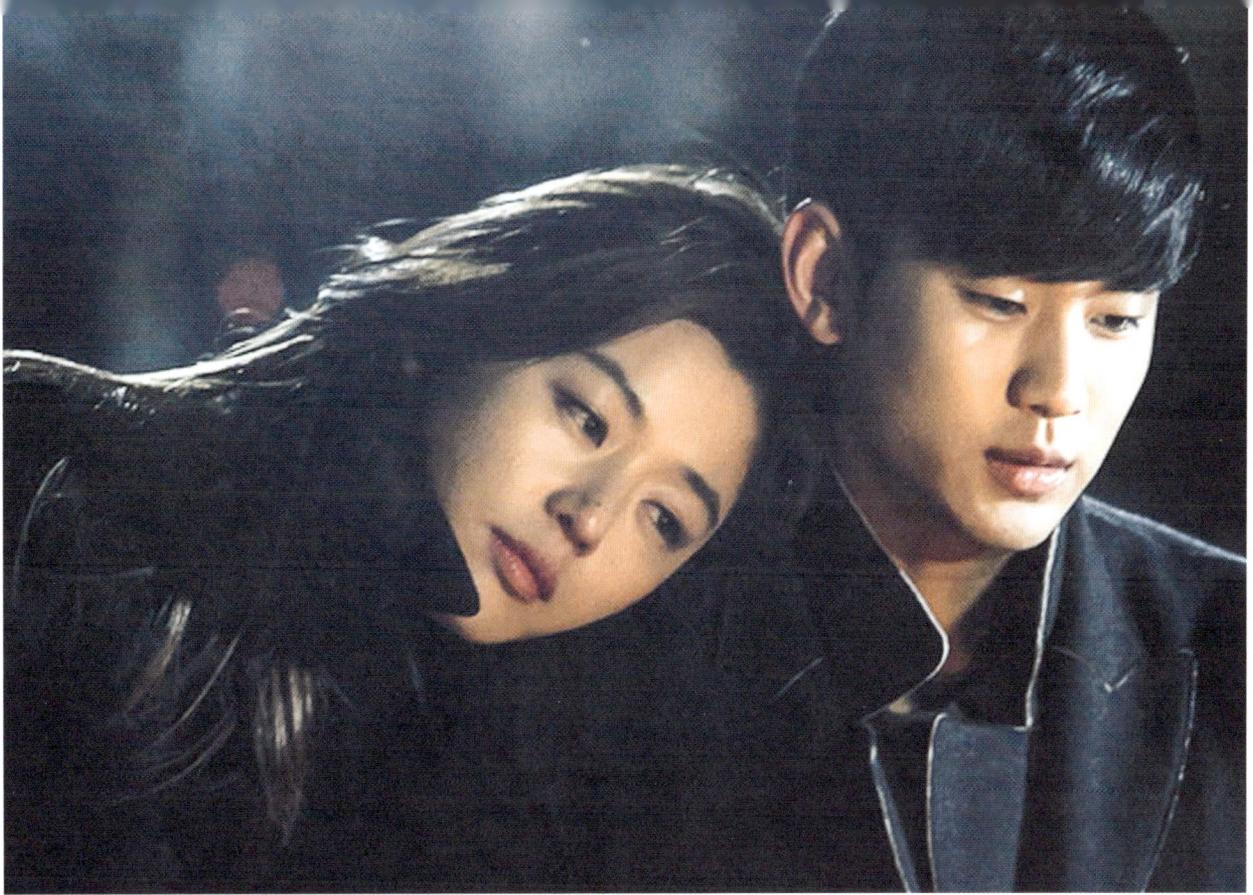

But to understand the world's extraordinary enthusiasm for K-dramas, we have to look back to the early 1990s, when the movement known as *hallyu*, sometimes translated as "Korean wave", started to emerge. At that time, the purchasing power of Koreans increased significantly, thanks to the spectacular economic growth of the country. A new class of consumers was keen to experience different types of cultural output that were more suited to younger audiences. This resulted in the development of a pop music and TV series offering which sometimes replicated certain conventions prevailing in Japan or the United States, but which were adapted for Korean viewers. Driven by a proactive government and powerful industrial conglomerates with creative divisions, the "Korean wave" would quickly become a form of soft power exercised by the country. By tackling universal themes such as love, family, social differences and financial hardship, while at the same time avoiding sex and excessive violence, K-dramas immediately established themselves as an easily exportable format in tune with the times. In the newspaper *Le Monde*, editor-in-chief Michel Guerrin wrote a column on the subject in 2022, describing the appeal of the "local exoticism" of these series in a globalised world: "Korean series proudly promote this aesthetic philosophy in psychologically complex romances, where modesty is such that it often takes 10 episodes to reach a first chaste kiss. [...] The depressed youth of the planet, who are more interested in kindness than freedom of expression, are delighted by this re-enchanted world..." A unifying and comforting positivity that puts the viewer in an ideal frame of mind to consume other associated cultural products, in a country where spinoffs and other promotional goodies are king. An interesting exception is the case of *Squid Game*, a horror series not suitable for under-16s which saw the best-ever launch in Netflix history in 2021, and intrigues and challenges in equal measure. But in practice, despite a script diametrically opposed to the conventions of the genre, this drama generated the same consumerist passion as its more traditional counterparts: after it was broadcast, the Vans brand of white slip-ons worn by the main characters saw sales jump by 7800%.

←
Broadcast between 14 January and 19 March 2002 on the KBS network, *Winter Sonata* continues to stand out as a one-of-a-kind series.

↑
The lead couple in *My Love from the Star*, a series created in the early 2010s.

In other words, wherever they are in the world, fans of K-dramas want more than to simply watch these shows with millions of others. They're also keen to participate in this culture and become part of it. This explains why some filming locations such as Nami Island immortalised in *Winter Sonata*, the village of Petite France featured in *Secret Garden*, and N Seoul Tower in *My Love from the Star*, have become places of pilgrimage for many fans. But these phenomena shouldn't hide the fact that TV series here continue to be overly ethnocentric: they're sometimes guilty of espousing certain problems in Korean society such as racism, the tyranny of beauty standards, sexism and the cult of achievement. Will these issues eventually prevent K-dramas from rising to the very top of global pop culture? A hard one to call, as these issues can be seen as universal, and the Korean wave currently appears to be unstoppable.

Fans of K-dramas are also keen to participate in this culture and become part of it.

→
A Korean poster
for *Squid Game*,
one of the most
popular series
around the globe.

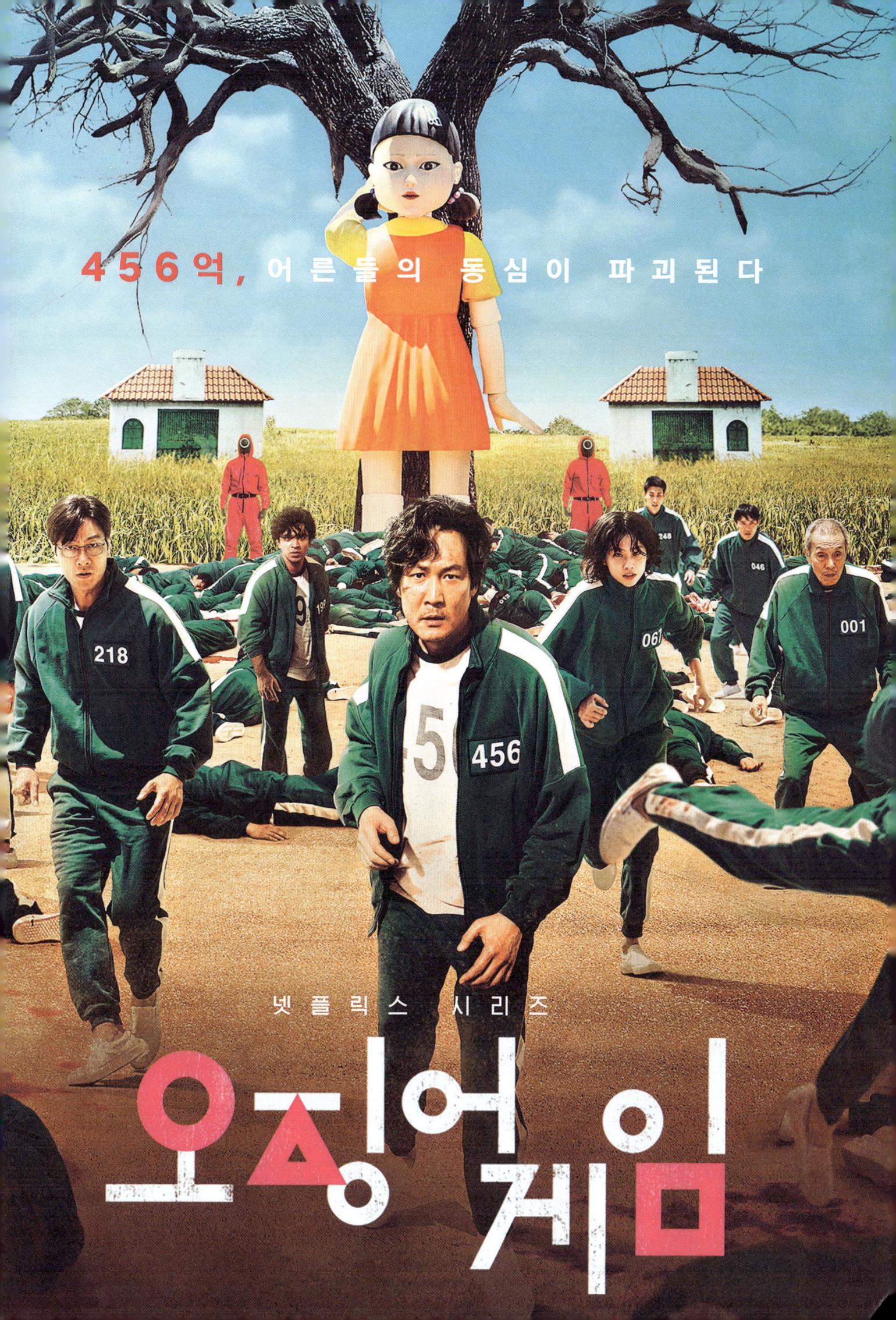

ITAEWON CLASS

A DRINK TOGETHER

The buzz of Itaewon in a cosmopolitan drama which mirrors the neighbourhood.

The Itaewon district in Seoul is known for its nightlife. This is where American servicemen stationed in South Korea used to come and party on their days off. Over the years, the bars have proliferated, and today, all Koreans regularly come here to have a drink and forget the working week. This backdrop is the starting point for *Itaewon Class*, a colourful series featuring beautiful shots of Seoul. In the storyline, a group of friends decide to open a bar and restaurant in the heart of the district, giving viewers the chance to immerse themselves in the daily life of its bustling streets. The appeal of the series lies in its cast and the social and cultural diversity portrayed. *Itaewon Class* champions change by tackling themes such as racism and homophobia head-on, as well as offering all the drama of a must-watch series.

KIM JONG-HAK

THE MAN BEHIND THE CAMERA

한국 드라마 거목

With more than twenty years devoted to the art of TV drama, he's the best-known director of the genre.

Held annually in Seoul since 1974, the Baeksang Arts Awards recognise excellence in theatre, film and TV, including a prize for best series director. Kim Jong-hak was king of this category, winning the prize four times with four different dramas. Graduating with a degree in journalism, he joined the channel MBC in 1977, at a time when Korean television was going through a period of radical transformation. The first programmes in colour were being made and show formats were gradually changing. Meanwhile, Kim Jong-hak continued to climb the ladder. He became assistant director and then director, and in 1992 completed a first series, *Eyes of Dawn*, the biggest Korean production of its time. Thanks to the success of this project, in 1995 he started working on *Sandglass*, often considered to be one of the most important dramas in the history of South Korean television. He went on to direct other hit series, but in 2013 was accused of fraud and embezzlement, which led him to take his own life. Despite this, he's still considered to be one of the masters of Korean TV series.

CRASH LANDING ON YOU

ROMEO AND JULIET

Love across the divide in missile-strewn conflict.

Culture shock. This is the principle behind the series *Crash Landing on You* which was released in 2019 and broadcast on Netflix. It tells the story of a rich South Korean heiress of a large industrial conglomerate who gets blown off course while paragliding and crash-lands in a forest in the North Korean section of the demilitarized zone. Here, she meets a North Korean soldier who offers to help her get back to her country. This is the start of a forbidden love story à la Romeo and Juliet, in which rival families are replaced by warring nations, creating an ideal pretext for exploring these diametrically opposed worlds. On its release, *Crash Landing on You* incurred the wrath of some Christian groups in South Korea who accused it of making the North Koreans too likeable. This didn't stop the series from breaking viewing records in South Korea. Proof that the northern neighbours are just as fascinating as ever.

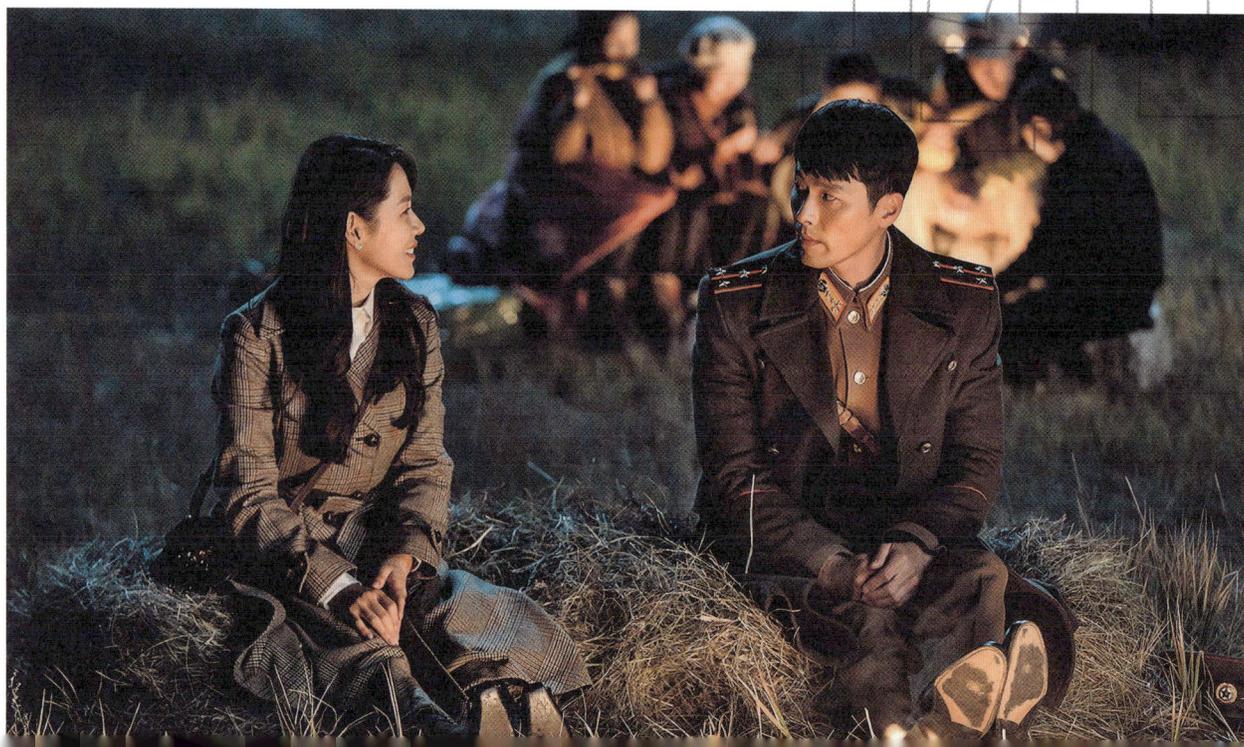

KIM EUN-SOOK

THE GOLDEN PEN

It's simple: a series written by Kim Eun-sook will automatically be a hit.

In South Korea, the K-drama industry is so focused on famous actors and five-star casts that it's easy to forget the unsung heroes and heroines working hard behind the scenes to bring their stories to life. Kim Eun-sook is one of them. The screenwriter first attracted attention with her script for *Lovers in Paris*, a series released in 2004. Hugely popular in South Korea, the Paris setting acted as a romantic and exotic backdrop for its Asian cast. Over subsequent years, Kim Eun-sook became known as one of the greatest romantic comedy screenwriters of her time, with the ability to write romances in a wide variety of contexts and settings. For example, *The City Hall* portrays the world of politics, *Secret Garden* plays with the conventions of fantasy, while *Mr. Sunshine* is set during the Japanese occupation of Korea. Needless to say, like everything written by Kim Eun-sook, these three series were huge hits in South Korea.

←
A touching scene between the two main characters in the series *Crash Landing on You*, first broadcast in 2019.

↑
Kim Eun-sook (blue trousers and beige top) with the team behind her series *The Heirs* at a press conference in Seoul in October 2013.

LEE JONG-SUK

TOP OF THE CLASS

From South Korea to China, everyone loves Lee Jong-suk.

Fans of K-dramas know his face well. With more than 25 million followers on Instagram, Lee Jong-suk is adored by the Korean public. He began his career as a model at the age of just seventeen on the catwalks of Seoul Fashion Week in 2005. He quickly became interested in the world of cinema and comedy and started playing supporting roles in series such as *Prosecutor Princess* and *Secret Garden*. But his breakthrough came in the teen drama *School 2013* where he played a young student, winning him the prize of best new actor at the KBS Drama Awards. In 2015, the phenomenal success of the *Pinocchio* series opened doors to him internationally, particularly in China where he shot several series.

↓
The actor at a press conference for the series *Romance is a Bonus Book* at the Imperial Palace in Seoul on 21 January 2019.

→
The series directed by Kim Jong-hak is one of the most important K-dramas in the country's history.

SANDGLASS

REVOLUTION ON THE SMALL SCREEN

Korean television has a natural milestone: the time before *Sandglass* and the time after.

It's no coincidence that *Sandglass* is often described as one of the most important dramas in the country's history. Apparently in 1995, when each new episode was broadcast, the streets of Seoul would literally empty of people. An anecdote that's not so surprising given that the show was capable of securing an audience share of 65%. *Sandglass* tells the story of three friends during the 70s and 80s, a politically tumultuous time for South Korea. One of the series highlights is an incredible depiction of the Gwangju Uprising, a pro-democracy movement led by students against the dictatorship of Chun Doo-hwan. Through a remarkable reconstruction interspersed with archive material, the series allowed South Korea to exorcise one of the country's most tragic episodes in which hundreds of people were killed by the army. A great moment in the history of Korean television.

NAMI ISLAND

IN THE SHADE OF TREES

On Nami, autumnal leaves are everywhere. As are fans of K-dramas.

Also known as Namiseon (seom meaning "island" in Korean), Nami Island has always been a popular destination for tourists. Located on the Han River, it can be accessed by not only ferry but also one of the longest ziplines in Asia, starting from a tower on the shore opposite the island. It's especially well known for its magnificent forest walkways lined with maples, redwoods and ginkgoes. These impressive trees are what make the island so beautiful, both in autumn as the leaves change colour and line the ground, and in winter when they're covered in snow. This place of natural poetry is the setting for *Winter Sonata*, a series portraying a love story on the island. Since its release in 2001, the drama has been phenomenally successful in Japan, prompting Japanese travel agencies to organise guided tours of the island. On average, it's estimated that more than 500,000 Japanese tourists visited Korea after watching *Winter Sonata*. A statue of the two lovers in the series has even been installed to welcome them to Nami Island.

SQUID GAME

HIGH STAKES

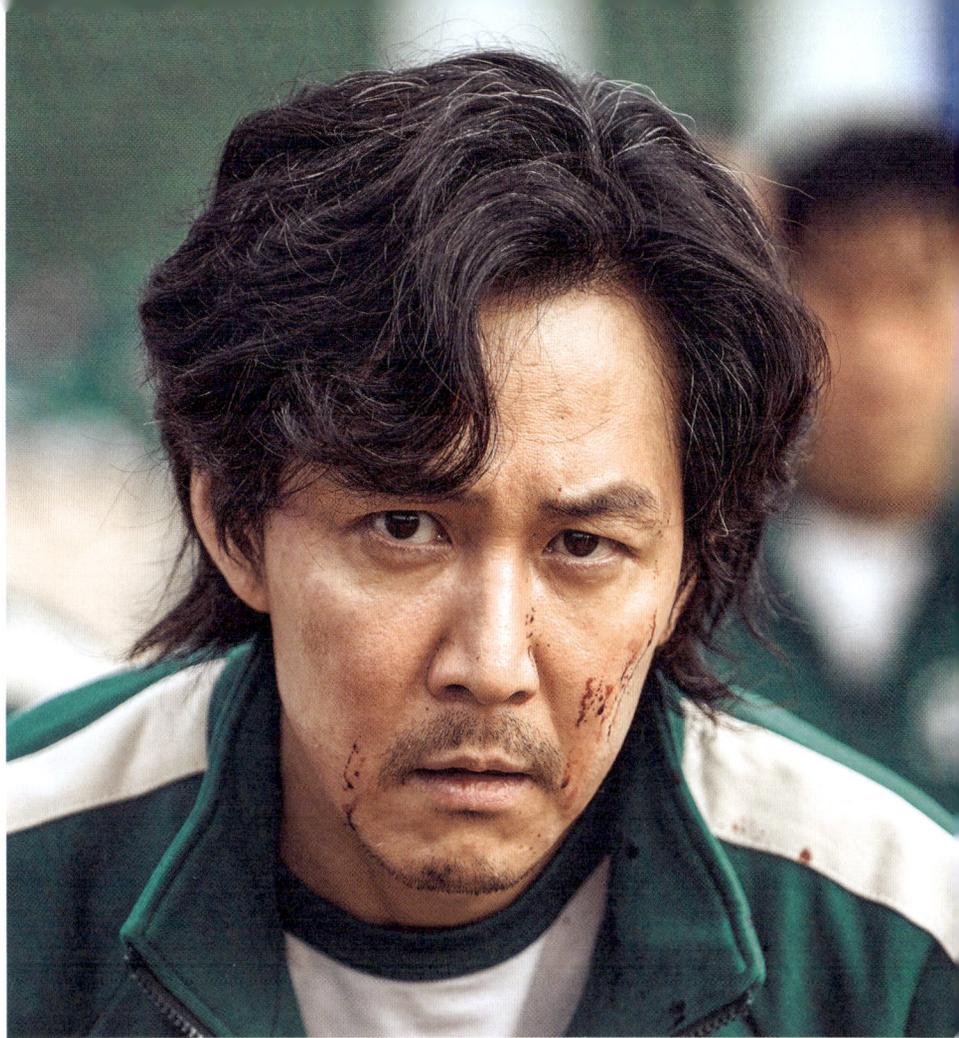

The Netflix flagship series took everyone by surprise, even the Koreans.

It's impossible not to have heard about the global popularity of *Squid Game*, the K-drama broadcast on Netflix. In just seventeen days, the series had 111 million views, making it the most successful launch in the history of the platform. It depicts 456 people in deep financial hardship who become players in a competition based on children's games, with the winner taking a prize of $38 million. One important detail they don't discover until on site: only the winner will survive the deadly challenges. This violent series not suitable for under-16s is a true one-off and owes its success in part to its pop references. The ruthless screenplay is reminiscent of the films *Hunger Games* and *Battle Royale*, as well as the Spanish series *Money Heist* and French reality TV show *Koh-Lanta*. Inspired by the social reality of South Korea, and more particularly the very high rate of debt per inhabitant which pushes some to suicide, *Squid Game* has raised questions in its country of origin, as in this article in weekly magazine *Chugan Kyunghyang*: "Korean viewers are perplexed, not knowing whether to rejoice in the worldwide success of a national product, or lament the fact that the product in question depicts their society as a living hell."

←
Nami Island is known for the beauty of the different tree species that thrive there, offering a dazzling array of colours throughout the seasons.

↑
Lee Jung-jae, a major figure in South Korean dramas and the main character in the hit Netflix series.

KIM HYE-JA

THE MOTHER OF DRAMAS

A rare living legend on Korean television.

She can be considered one of the greatest actresses in the history of Korean television, as evidenced by the staggering number of awards and prizes bestowed on her throughout her career. Kim Hye-ja made her acting debut in 1963, appearing in many series of the period, including *Country Diaries* which was on the airwaves for 22 years. She played a loving mother willing to sacrifice herself for her children, a role that won her the sympathy of all Koreans. While actresses in K-dramas tend to be offered fewer roles as they get older, Kim Hye-ja continues to be an essential figure in the industry. In total, she's acted in more than 90 series and is the only actress to be a four-time winner of the Daesang, considered the most prestigious audio-visual prize in South Korea: in 1979, 1989, 2009 and 2019. With a deep affection for television, Kim Hye-ja has also made a few incursions into the world of cinema, as in the film *Mother* by Bong Joon-ho where she played the lead role.

↑
Kim Hye-ja during a photo shoot at the 62nd Cannes Film Festival in 2009.

→
Led by a teenager, a group of neighbours will fight to survive and try not to turn into monsters!

SWEET

A MONSTER SUCCESS

HOME

There's more than just romance when it comes to K-dramas. Zombies and bloodbaths are also on the menu.

For the uninitiated, it would be easy to think that Korean series only offer romance, particularly as some of the biggest hits of recent years have been love stories. But the world of K-dramas is infinitely varied, and it shouldn't be thought of as limited to this genre. Living proof is the impressive success of *Sweet Home*, released in 2020, with more than 22 million views on the Netflix platform. Adapted from a webtoon - a type of digital comic - this horror series tells the story of a secondary school student who's bullied at school and moves into an apartment building after his family is killed in an accident. The tenants of the building start turning into monsters and the drama morphs into a psychological thriller, with multiple blood-stained massacres. In terms of the themes addressed, *Sweet Home* shares certain similarities with Korean cinema.

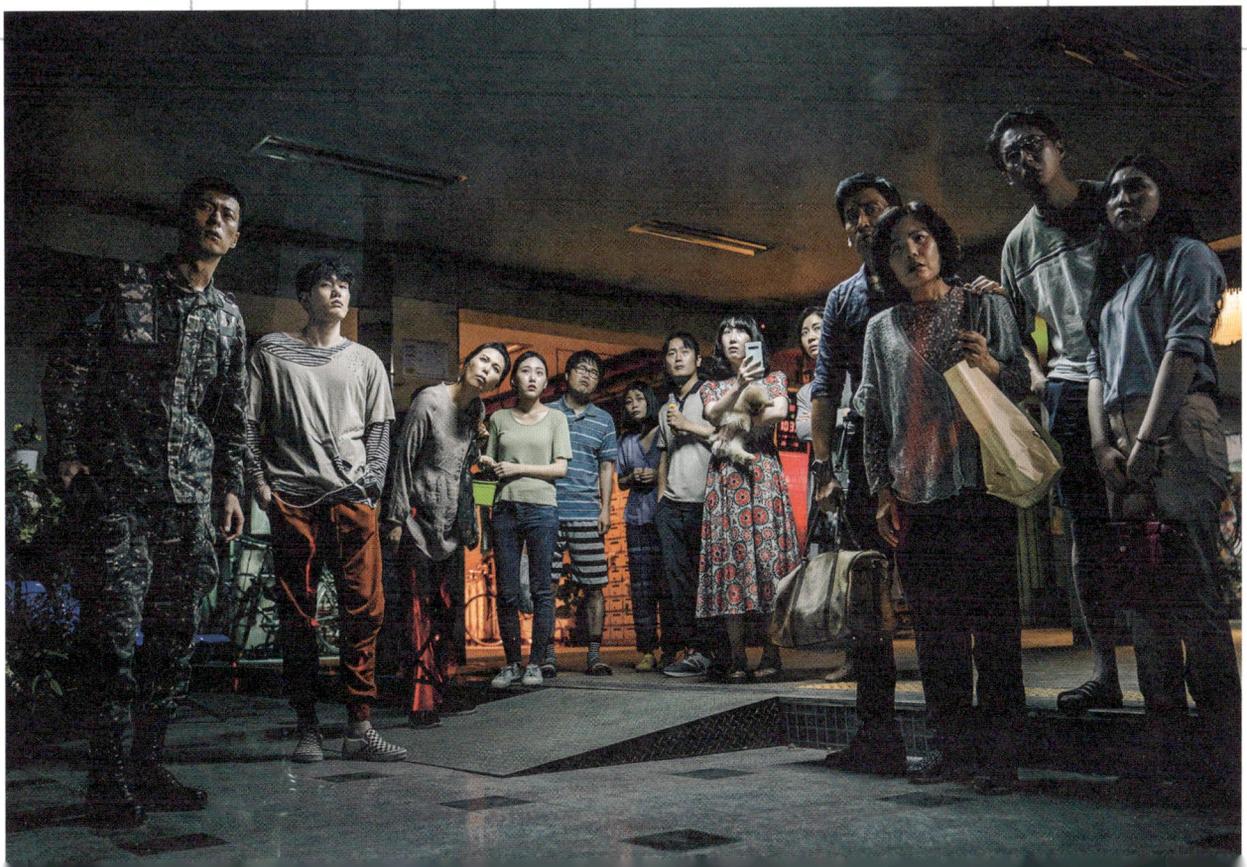

N Seoul Tower is everywhere in K-dramas

서울타워

Because it represents the city better than any other monument, N Seoul Tower has carved out a special place in the scenery of TV dramas.

As well as being one of the most visited places in the capital, N Seoul Tower - also known as Namsan Tower - is a recurring architectural feature in Korean TV series. It appears in almost all dramas set in Seoul, sometimes simply in the background, or up close as the location for shooting a given scene. Built in 1975 on the top of a hill overlooking the city, it was opened to the public in 1980, and soon became a popular destination for romantic dates. From its 236-metre vantage point, it offers a breathtaking panoramic view of the whole city, and also includes an observatory and elegant restaurant, making it an ideal setting for TV romances. As on the Pont de l'Archevêché bridge in Paris, the fencing of the tower is adorned with thousands of padlocks in every colour under the sun, engraved with the names of couples who have declared their love for each other, as depicted in *My Love from the Star* and *The Legend of the Blue Sea*.

Another special thing about N Seoul Tower is its colour. "The weather's going to be good today," says character Choi Yeon-kyung in the series *Live Up to Your Name*, after glancing at the tower. Since 2011, the building has been fitted with

"The weather's going to be good today."

a system to measure air quality. When the tower is blue, it means breathing is easy in Seoul.

The hiking trails winding around the hill on which N Seoul Tower is built also regularly appear in Korean TV series, for example, in episode 15 of *Dr. Champ* and episode 4 of *I Wanna Hear Your Song*. This has made the famous Seoul Tower a rallying point for all fans of K-dramas who are able to immerse themselves in the settings of different series as they make their way around the site. A great way of jumping inside the small screen and putting yourself in the shoes of your favourite characters.

←↑
A symbol of the Korean capital, the top of the tower houses a panoramic restaurant where you can enjoy a meal after visiting the Teddy Bear Museum in which soft toys re-enact the history of South Korea!

서울타워

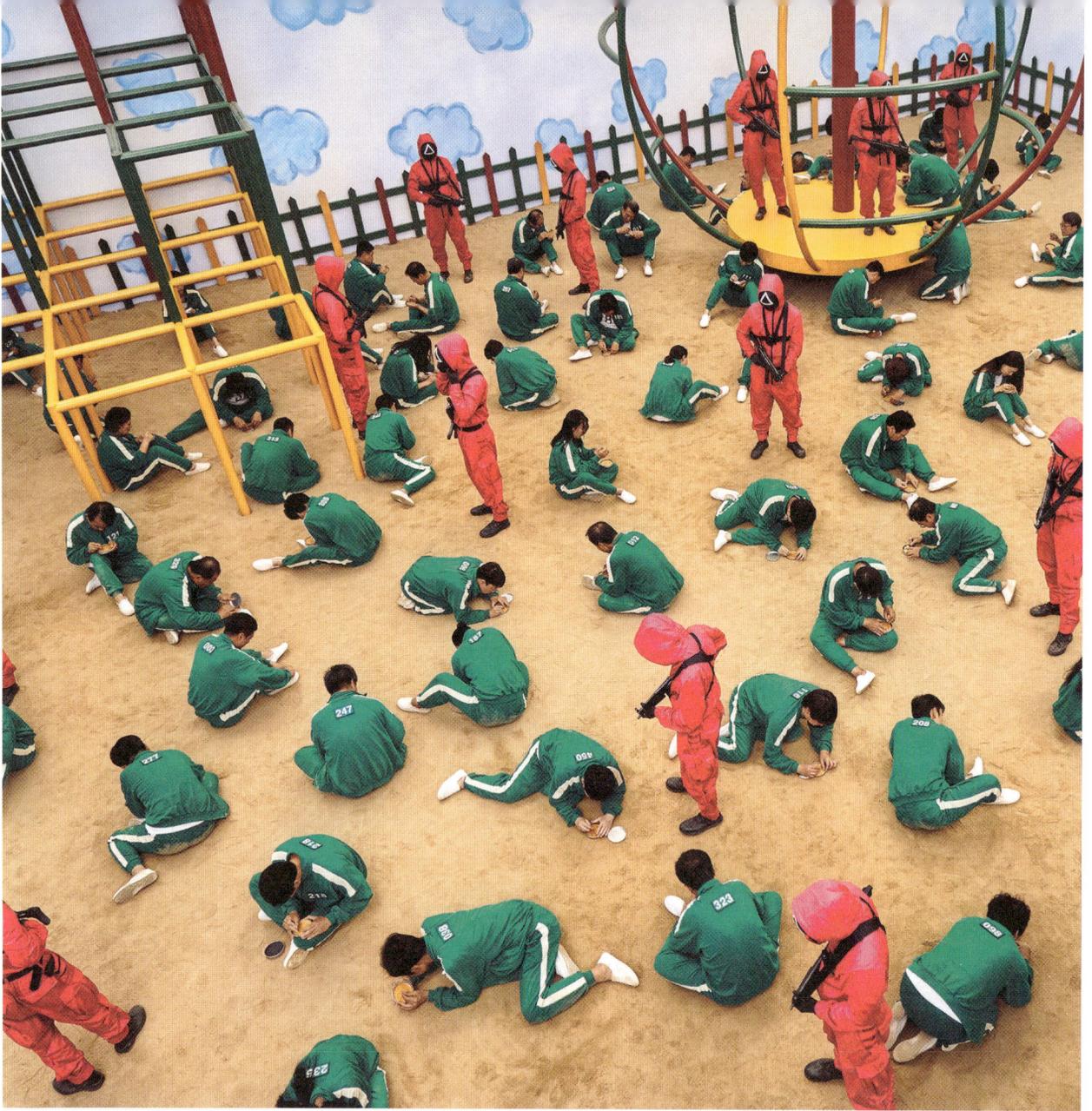

To get back to health, Netflix is feasting on Korean TV series

As the American platform finds it increasingly difficult to retain its subscribers in the face of growing competition, K-dramas could well offer the best of lifelines.

Despite appearances, Netflix isn't in the best of health. The chain has been losing customers for some time now. According to analysis carried out by the firm Antenna and shared by a website specialising in new technologies known as *The Information*, the video streaming platform has already lost 200,000 subscribers and forecasts the loss of at least another two million. A first in the history of the group. Worryingly, nearly 40% of those leaving are historical subscribers, in other words, registered on the platform for more than a year. Worse still, 13% of them have been customers for more than three years. Of course, the American giant still has a record audience of over 220 million subscribers, but these figures are food for thought. Netflix is therefore looking to update its programming with new content that can't be found elsewhere. To do this, the channel is banking on the craze for Korean TV series, a niche that it's already been exploring

for a number of years with growing success. In 2021, Minyoung Kim, Vice President of Content for Korea, Southeast Asia, Australia and New Zealand, shared her thoughts on this enthusiasm for all things Korean: "The K-Wave, or *hallyu* as we call it, is a huge moment of national pride and we're proud to be part of it. Great Korean stories are nothing new; in fact, storytelling is deeply rooted in Korean culture. But today we live in a world where *Parasite* is an Academy Award Best Picture winner, BlackPink plays Coachella, and over 22 million households tune into a horror TV series, *Sweet Home*. Audiences around the world are falling in love with Korean stories, artists, and culture." In the same year, Netflix announced that it had invested $500 million in Korea to develop and diversify its content in the country. Coincidence or not, a few months later, the series *Squid Game* had the most successful launch in the history of the platform.

↖ Scene from the series *Squid Game* with participants wearing their trademark green tracksuits.

← Some of the biggest hits on Netflix are Korean dramas such as *Sweet Home*, where they attract large audiences on the platform.

A village from the south of France in the depths of the Korean countryside

Petite France is like a glitch in the matrix. But this improbable attraction has consistently appealed to directors of K-dramas, making it a popular place of pilgrimage.

A fantasy vision of the French countryside, perfect for filming TV series.

It would be difficult to find anything more surreal. In the countryside around the city of Chuncheon, hidden away in the east of Gyeonggi Province, a tiny village exists that appears to come out of nowhere. Known as Petite France, strolling along its narrow streets is an extraordinarily disorienting experience. There are half-timbered houses, a miniature reproduction of the Eiffel Tower, references to comic book characters Asterix and Titeuf, a museum exhibiting porcelain dolls and a memorial dedicated to Antoine de Saint-Exupéry. As its name suggests, Petite France is a little piece of France hidden away in the middle of South Korea. But how did it get here? Built in 2008 and based on the model of a village in the south of France, this dreamlike attraction aims to quench the thirst of Koreans when it comes to French culture. But in fact it's a typically Asian phenomenon that attracts the tourists here in droves - the K-drama. With its classic French atmosphere and little houses with tiled roofs, Petite France quickly became a favourite location for filming TV series. In 2008, a number of scenes for the series *Beethoven Virus* were shot here. But it was in 2011, with the huge success of *Secret Garden*, that the village started to see the arrival of curious sightseers. Since then, dozens of other dramas have been filmed here, including the famous *My Love from the Star*. Might we one day see a replica of the Gangnam skyscrapers in the middle of the Ardèche?

← ↑
With its colourful houses evoking both the south and east of France, its references to Saint-Exupéry's *Little Prince* and the Eiffel Tower, Petite France is a corner of French *je ne sais quoi* in the Land of the Morning Calm.

Korean TV series are also big in Africa

Despite the clichés they sometimes convey about the continent, K-dramas are increasingly popular among young urban audiences in Africa.

Like everywhere else on the planet, Africa has also experienced the Korean wave sweeping the world. And just as in other places, K-dramas are becoming increasingly popular, proving that the aesthetic and narrative conventions of these TV series resonate all over the world, despite very different cultural contexts. It was in Kenya in 2009 that the television channel GBS, launched by Korean evangelist Ock Soo Park, began programming content of the genre for the first time in Africa. Tanzania followed with the airing of *Jewel in the Palace*, a drama depicting how a young working-class girl gets a job at the royal palace and gradually starts to climb the social ladder. The story struck a chord throughout West Africa, paving the way for the arrival of Netflix on the continent in 2010. It's important to remember, however, that not everyone has access to the famous American platform, and in Africa, K-dramas are still the prerogative of a relatively wealthy urban class. Researcher Suweon Kim, author of the 2017 survey *"Who watches Korean TV dramas in Africa?"* explained to the newspaper *Le Monde* that South Korea is only too happy about this disparity: "It's the economic and intellectual elites who watch K-dramas, in other words, the populations most likely to achieve higher socioeconomic status, or

to become politicians and opinion leaders. Those are the people Korean diplomacy is interested in. K-dramas are an influential tool of soft power." However, despite local enthusiasm for them, South Korean series are still full of stereotypes with regard to Africa. Released in 2022, *Shooting Stars*, for example, uses the soundtrack from the *Lion King* when introducing certain scenes taking place on the continent. There's still a long way to go before Korean series become firmly embedded in the African audio-visual landscape, and they don't yet have the status of the Latin American telenovelas and Bollywood productions that preceded them. But the fact remains that Africa could well be the next gold rush for K-dramas.

←
Jewel in the Palace, a historical series created in the early 2000s, is one of the most popular K-dramas on the African continent.

↓
Korean poster for *Shooting Stars*, a romcom K-drama set in the entertainment world of South Korea.

별똥별

이성경 김영대 윤종훈 극본 이수현 연출 최안규 tvN 제작 MAYS 김윤혜 박소진 이정신

4/22 [금] 밤 10:40 첫 방송 tvN 스트리밍은 TVING

Manhwa

There's more than just Japanese manga out there. A Korean equivalent also exists, which is just as fascinating.

The whole world is familiar with Japanese manga and its reputation already speaks for itself. But it's not the only option. South Korea also has a thriving comic strip culture and is one of the leading producers and exporters in the sector. On the Korean peninsula, the local version of manga is called manhwa. Like its Japanese counterpart, manhwa is strongly influenced by classical Asian art and its Chinese version in particular. Korean manhwa first appeared under the Japanese occupation with the publication of drawings in the newspaper *Daehan Minbo* on 2 June 1909. Signed by cartoonist Lee Do-yeong, these satirical woodcuts depicted Japanese officials as monkeys. The new occupying forces angrily responded by quickly banning publication of the newspaper. But it was too late. Manhwa had arrived and nothing could stop its development. During the Korean War (1950-1953), manhwa played an important role in national propaganda. Cartoonists were set to work and instructed to ignite the patriotism of the people. The artist Kim Yong-hwan, often considered one of the fathers of manhwa, published "The Soldier Todori" which depicted the courage of soldiers on the front line and was hugely popular. In the late 1950s, circulation of the magazine *Manhwa Segye*, dedicated solely to the genre, greatly contributed to its development, and encouraged an open-minded attitude to new themes.

→
Historical woodcut, considered to be the origin of Korean manga, mixed text and drawing, late 19th century.

勞動夜學會顧問
俞吉濬氏

勞動者

고문의 말삼
여보、나라 위ᄒᆞ야、일ᄒᆞ
오、쏘、사람은、
배호
아야、
ᄒᆞᆫ
다

로동자의 대답
데、꿈압소그리ᄒᆞ오리다

As a result, publishers started to produce fantasies, romances and comedies. From the 1970s, and especially the 1980s, manhwa experienced a new lease of life as it joined forces with animation. Comics were produced on an industrial scale, and to satisfy a young readership who couldn't get enough of them, innovations were constantly introduced in terms of drawing styles and modes of narration.

But it was in the early 2000s that the world of manhwa turned a major corner as comics were modified to match new ways of reading. Paper comics became a thing of the past as stories were adapted to screens and designed to be read in one go by scrolling from top to bottom on a smartphone. Known as webtoons, this new format, now freed from the constraints of the printed page, proved immensely popular. For example, the romance series *True Beauty* by Yaongyi has been read more than 200 million times. This turned out to be a godsend for the world of K-drama, which makes a habit of digging into the repertoire of webtoons to bring out adaptations of the most downloaded titles. Today, all Korean mobile phone brands offer the compelling sales argument of including online manhwa in monthly contracts to sell their products. The genre has clearly come a long way since the days when the Japanese censors had it in their sights.

↓
Cartoonist working for a webtoon distribution platform.

→
Cover of the hit manga series *True Beauty*, later adapted into a TV series by Netflix.

YAONGYI

TRUE BEAUTY 4

4
K-NIGHT

INTRODUCTION

P. 96-97
—
"Gangnam Style" night out in the Gangnam district.

←
Neon signs put on a show after dark in the streets of Seoul.

When necessary, Koreans know better than anyone how to ease the pressure. Living proof are the long and frenzied nights of partying, often until the early hours.

It's sometimes called the Land of the Morning Calm. No doubt a roundabout way of saying that its nights definitely are not. Because in South Korea, and especially in the buzzing megalopolis of Seoul, the nightlife is enjoyed just that little bit more than anywhere else. And yet, just like Japan a few years ago, South Korea has an absurd law that prohibits dancing. Initially voted in to combat post-war prostitution, when clubs were mostly strip joints run by the local mafia, the law of course isn't applied these days. Nevertheless, its existence will be very practical if the government ever decides it wants to put pressure on the world of nightlife. But in the meantime, Koreans are free to dance without any problem and will happily party all night long. However, you do need to know about certain rules that are very different from how things are done in Europe. The most important relates to the concept of *cha*. In South Korea, nights out take place in several stages (known as *cha*) and in a very specific order. Unlike the way we party in the West, it's not enough to simply visit one nightclub and emerge from it in the early morning. The Koreans prefer multiple ports of call and it's not uncommon to go to several clubs, restaurants, bars and karaoke rooms over the course of a single evening, giving foreigners the impression of being on a night-time marathon.

Especially as each of these stages usually involves soju. This mild-tasting spirit cements the whole of Korean society together and is synonymous with sociability and good times spent with family and friends. Sold at rock-bottom prices, it's drunk throughout the night and is the go-to beverage for any outing, whether a simple after-work get-together or endless evenings in the clubs of Seoul. "All Koreans know their number: they've identified exactly how many bottles of soju they can drink on a night out. They have 50% blood and 50% soju running through their veins," jokes Julia Mellor, a Korean alcohol specialist for The Sool Company, in an interview with the magazine *Trax*. So forewarned is forearmed: Korean nights are a boozy affair, and it will be hard to make it otherwise.

Foreigners can have the impression of being on a partying and drinking marathon.

↓
Peggy Gou performs at the We Love Green Festival on 1 June 2019 in Paris.

→
Psy performs "Gangnam Style" at the 2012 MTV EMAs in Frankfurt.

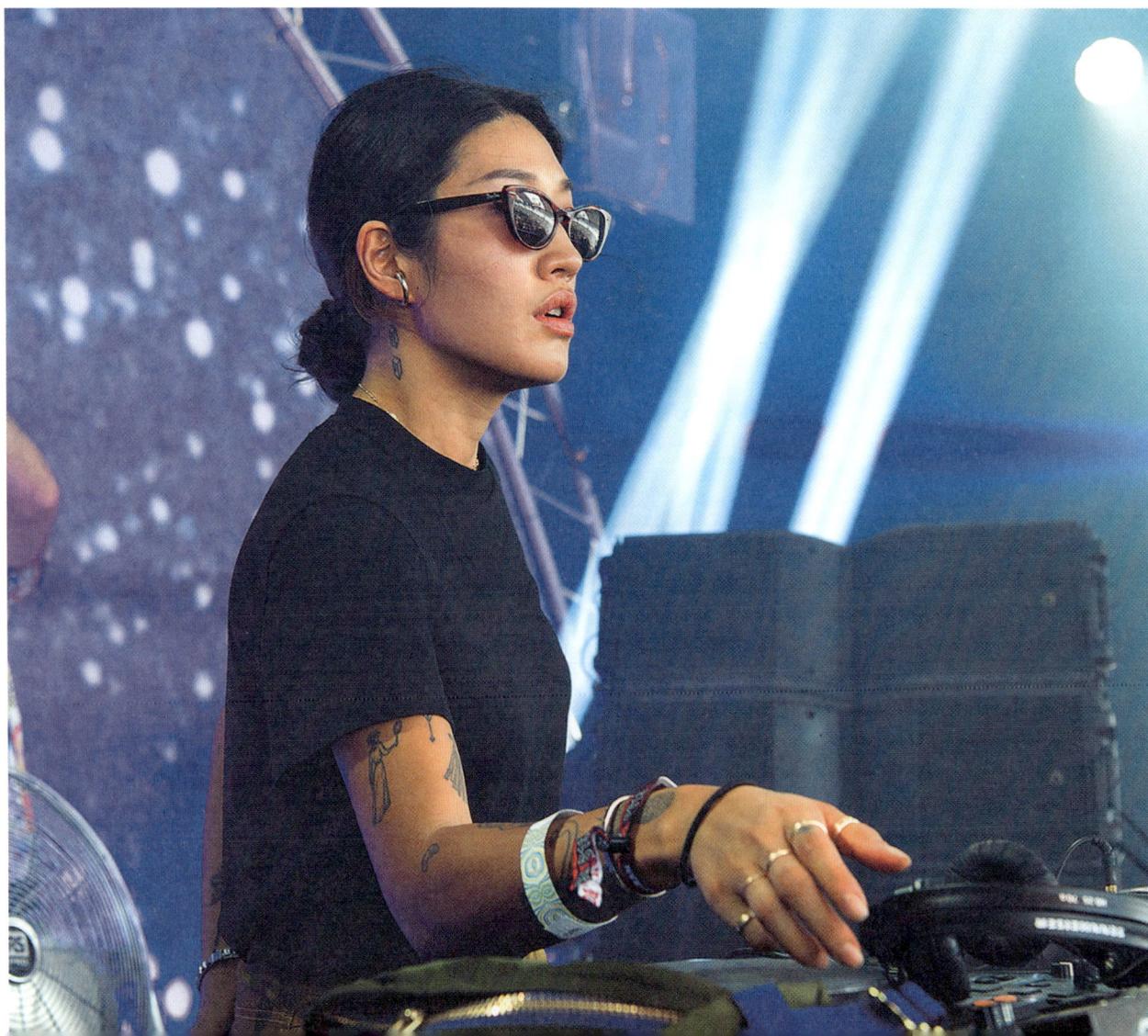

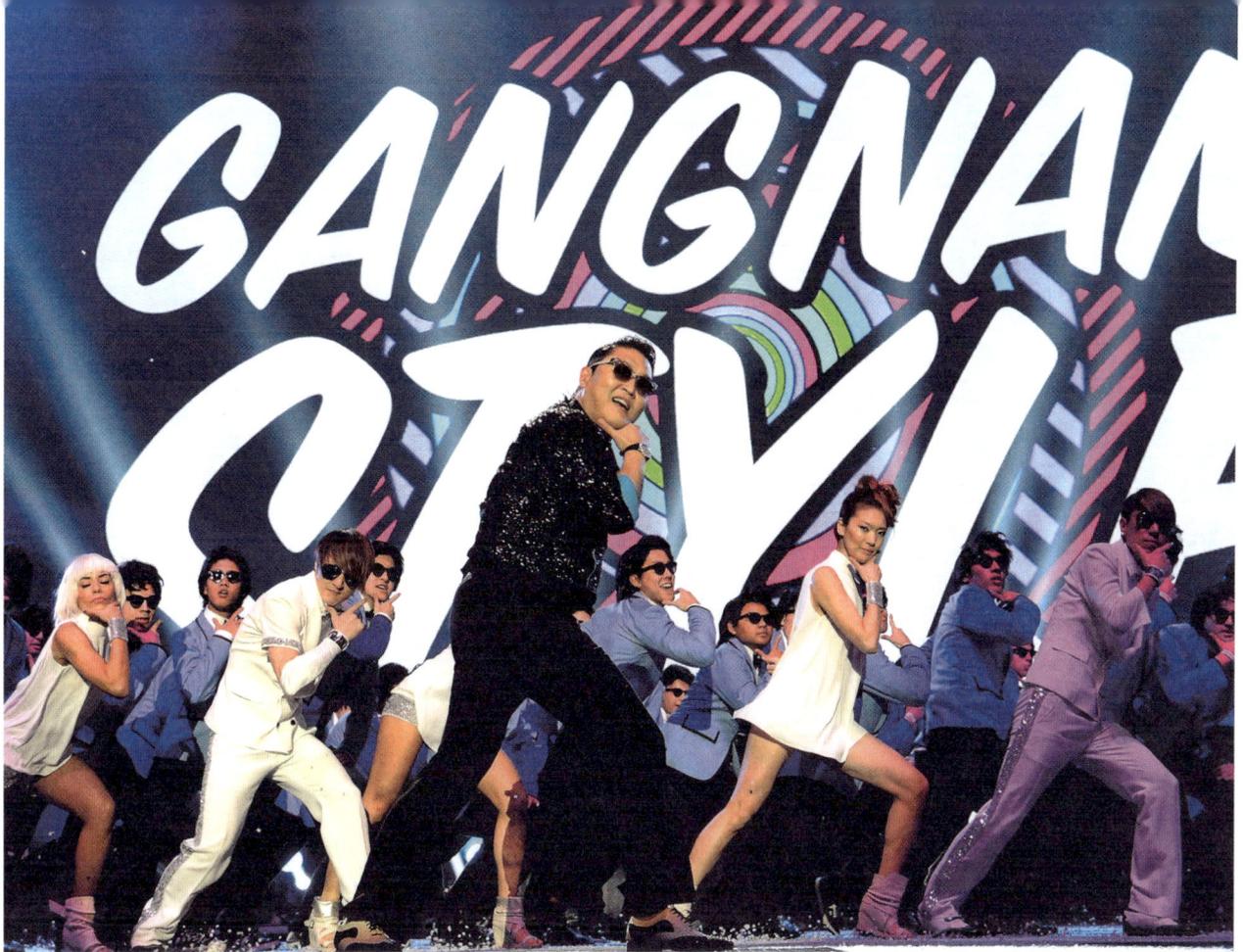

The good news is that a big city like Seoul offers a staggering variety of venues, allowing everyone to get the kind of night out they want. Not far from Hongik University, the Hongdae district will appeal to those who prefer the atmosphere of bars and music venues, together with the relaxed vibe of studenty nights out. Dance obsessives and electronic music fans will head to Itaewon, a district built around the American garrison, where the GIs stationed there would go to party. Itaewon has become a trendy area where small techno clubs with international reputations, such as Cakeshop, Soap, Trippy or Pistil, are multiplying. This has created such an effervescence in the district that the narrow streets are not always enough to contain the large flow of revellers, as was the case during the terrible accident of 29 October 2022 when more than 150 people died following a crowd movement on Halloween night.

But around the world, the nightlife of Seoul is mainly associated with the high-rise buildings and glitzy glamour of the streets of Gangnam. In 2012, the singer Psy immortalised the district on his global hit "Gangnam Style". Behind the comical dance moves, the track was intended to be a caricature of this upscale neighbourhood peopled by wealthy Koreans. Fifty years earlier, however, the place was just fields. Driven by the unbridled capitalism of the South Korean economic miracle that began in 1953 at the end of the war with North Korea, farmers saw the value of their land hit astronomic levels. Attracted by the lure of instant wealth, they sold it to property developers who built skyscrapers like totem poles to the glory of a stronger, richer and more modern country. Since that time, the tempo in Gangnam has changed radically. The buzzy nights here border on hysteria, bolstered by the wealth of former

farmers who are now millionaires. At night, vast clubs attract young Koreans, and while some are overly flashy and don't always admit foreigners, others like Club Octagon are places to spend a memorable evening.

The party may be in full swing in South Korea, but the K-night concept is also being exported beyond the borders of the peninsula. Traditions such as the Korean barbecue have already been integrated into the culture of some overseas countries, but fondness for soju is also growing, with international sales rocketing to such an extent that a distillery dedicated to the prized drink has just opened in New York. Similarly, alongside the colossal success of K-pop, South Korean electronic music is starting to be played in clubs all over the world, promoted by DJs and producers such as Peggy Gou and Park Hye-jin who made their debuts behind the turntables of clubs in Itaewon. Further proof that Korean nights out offer something special and that people party here in a unique way, without some of the prejudices and stereotypes seen in Western countries. Could South Korea hold the keys to the future of nightlife?

Gangnam nightlife borders on hysteria, bolstered by the wealth of former farmers who are now millionaires.

←
Seoul club Soap organises big events to get the Korean capital bouncing.

↓
The dance venues of South Korea are frequented by higher numbers of women than men.

케이크숍

케이크의 조각

CAKESHOP

A PIECE OF CAKE

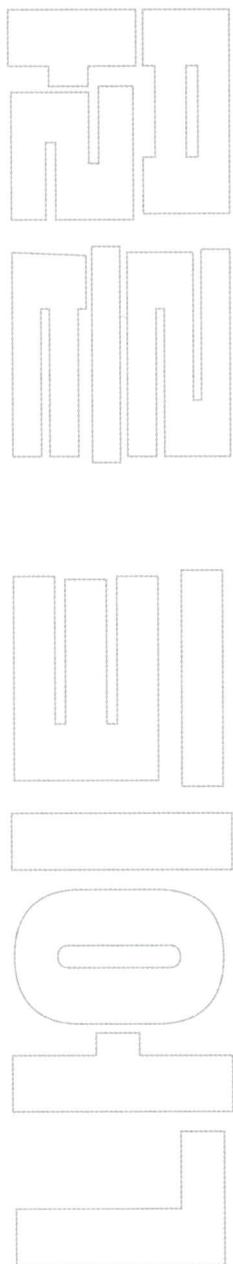

Behind its neon Cakeshop sign, this small club has been one of the best venues in Seoul for the past ten years.

Opened in a basement in 2012, to the west of the central subway in Itaewon, Cakeshop is one of the country's institutions and arguably Seoul's best-known underground club. Located on the site of a former strip club frequented by GIs from the nearby American base, the place doesn't look anything special with its small bar and standing room for 200 people. But what counts at Cakeshop is the atmosphere. And from this point of view, the club knows better than anyone how to add spice to festive nights in Itaewon, carefully avoiding the flashiness of clubs in Gangnam and focusing instead on getting the very best musical line-ups. With diverse and passionate audiences, the venue manages to attract musical heavyweights despite its tiny size, for example, English singer and producer James Blake and the late DJ Rashad. Building on its success, the team behind the venue have even opened a second establishment known as Pistil, a bar where fans can start the evening before heading over to Cakeshop.

↓
This club welcomes the best-known musicians to its space in the basement.

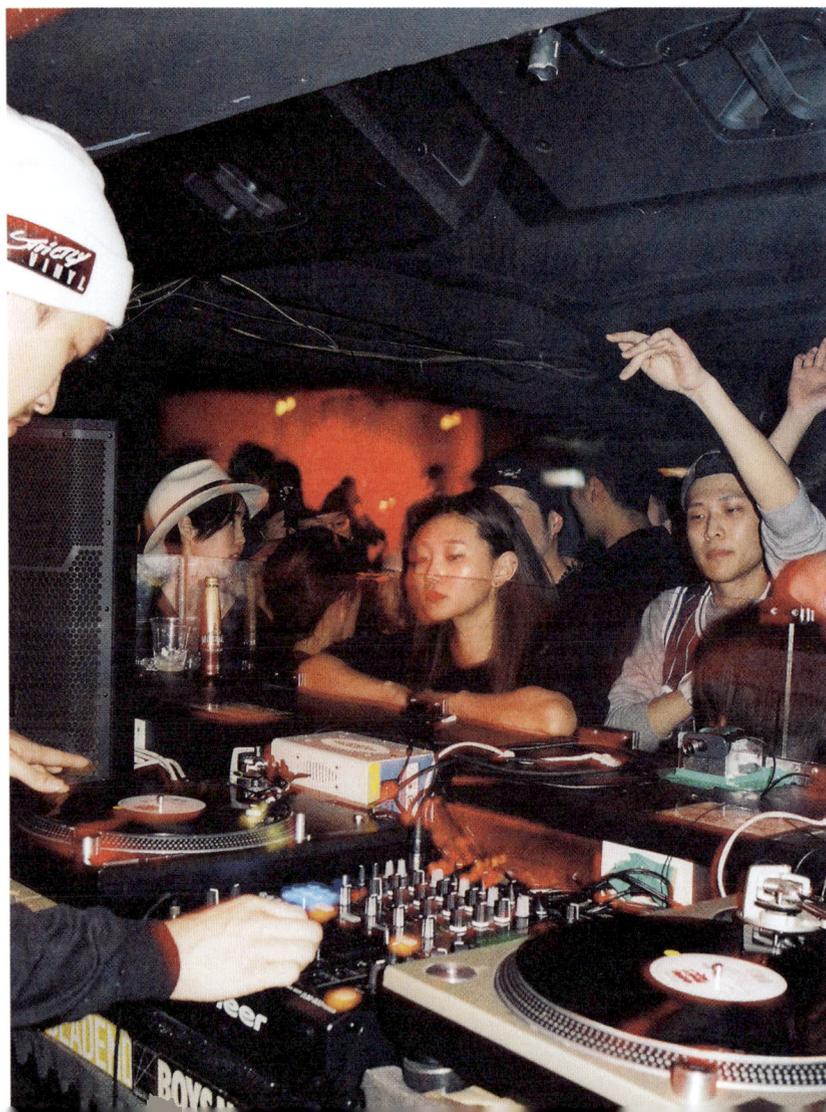

CONVENIENCE STORES

A place for both partying and supermarket shopping.

In South Korea, it's a mandatory stop on any self-respecting night out. Open-all-hours convenience stores are the best allies of late-night revellers. They can be found absolutely everywhere in the country and it's often here that the long nights of madness begin and end. Party animals make a flying visit to buy cans of beer, bottles of soju, anti-hangover cures and even to snack on a quick dish of instant noodles which can usually be heated up and wolfed down in-store. Batteries and phone chargers are also available for customers who've run out of juice. In other words, convenience stores have a solution for every problem, and this is especially true at night when other shops are closed. The best-known chains are GS25, CU and 7-Eleven.

↑
The 7-Eleven chain welcomes night owl customers on all continents.

105

THE WRISTBAND

KEY TO THE KINGDOM ON YOUR WRIST

Or how to get into a club for free without spending a fortune at the bar.

At first glance, it's a practice that might surprise foreigners. Unlike nightclubs in the West, in Seoul you can leave a venue and go back in later without any problem. The "no re-admission" refrain pronounced by adamant bouncers therefore becomes a thing of the past. This rule may not seem like that big a deal, but it completely changes the way Koreans party. It allows young hard-up punters to play the system by entering clubs before midnight to benefit from free admission, get the club's wristband or stamp, then go back out for drinks in less expensive establishments, before returning to dance the night away. This also partly explains why nights out in South Korea often take place in several stages, moving from one venue to another to get a second wind before the next round. Roll on a similar wristband policy in Europe!

↓
Wristbands open doors for fanatical dancers who go from one nightclub to another in the buzzing streets of the Korean capital.

→
Peggy Gou performs on day one of the Lovebox Festival at Gunnersbury Park in London on 13 July 2018.

106

PEGGY GOU

JUST GOU IT

하우스음악

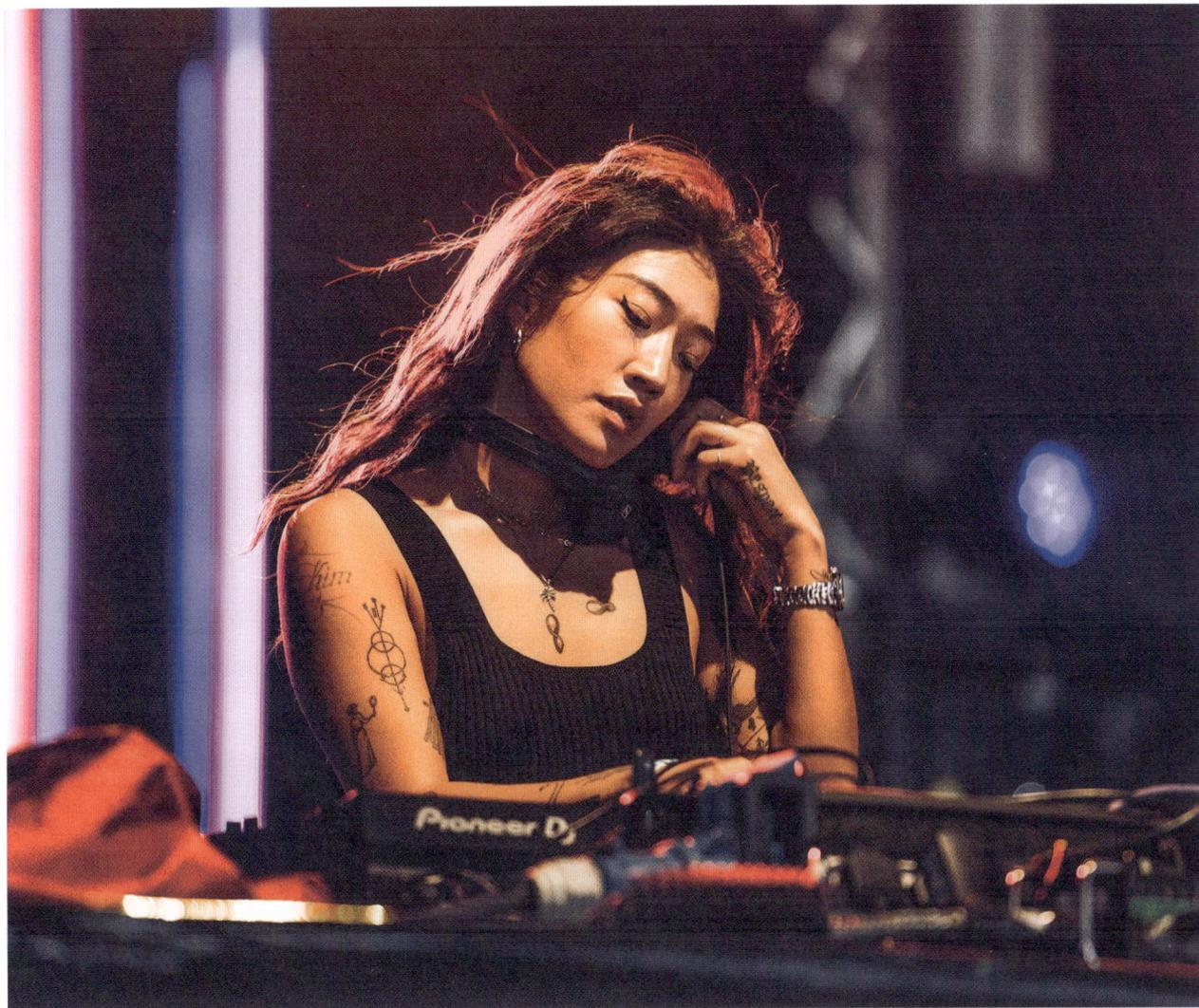

The DJ has assumed the mantle of Korean house diva in record time.

With millions of streams, contracts with the biggest brands and sold-out shows, the South Korean DJ and producer Peggy Gou has become an international, front-page star in just a few short years. The BBC even described her house hit "It Makes You Forget (Itgehane)" as "a major shift in the history of dance music". In other words, Peggy Gou is no longer simply a prime mover in electronic music, but a global pop icon. After cutting her teeth on the turntables of clubs in Seoul, she now lives in Berlin, tours all over the world - even as far as the famous Coachella festival - and has created her own clothing brand. A Gou-mania that the DJ knows how to fuel better than anyone. She takes good care of her community, pampering her fans with messages on social media, and offering improbable promotional goodies featuring dubious puns, for example "Just Gou It" T-shirts, or handheld fans with the luminous wording "HAVE A GOU TIME!" "I know it's very Asian and I love it," the South Korean declared on Facebook.

NAP TIME
THE COMEDOWN OF THE DAY AFTER

After all that effort, partygoers deserve a well-earned rest. Anywhere and anytime.

Walk through town the day after a night out and you'll see that while Koreans like to party, they're not superhuman either and have to sleep at some point. And they're not shy about where they do it. It's not unusual to see them napping pretty much anywhere. This is because most Koreans live with their parents until they get married. They therefore spend most of their time outside the home so they can get away from mum and dad. This is why you'll never be thrown out of a café, even if you stay there for six hours on the trot and only order one orange juice. It also explains why on days after a heavy night out, people happily get some shuteye in these cafés without anyone finding it odd. A top tip that may prove useful. On the other hand, it also means that if you hook up with someone, it's highly likely you'll need to get a room. Something to plan for in the budget.

↑
They suffer from insomnia and also like to party, meaning Koreans sleep wherever they can!

→
The streets of Hongdae are full of fantastic bars perfect for a great night out.

THE BARS OF HONGDAE

ROCK AROUND THE UNIVERSITY

홍대의 술집들

The student district of Seoul loves nothing better than wailing guitars.

In Seoul, the Gangnam district is known around the world for its huge, flashy nightclubs, while at the other end of the scale, Itaewon has made a name for itself with intimate venues playing cutting-edge techno. But for those who prefer to spend their nights in front of a good rock band, Hongdae is the place to go. Located near Hongik University, from which it takes its name, this district is the epicentre of studenty nights out. In the 1990s, rents were relatively low compared to the rest of Seoul, attracting musicians and street artists who settled here permanently. As a result, you're now spoiled for choice when it comes to gigs. Lovers of indie rock head to Club FF where live bands play until midnight, while those who prefer the blues make for Strange Fruit, and punk and ska fans frequent Club Ta. To be truly complete, however, an evening in Hongdae should definitely include several of these destinations.

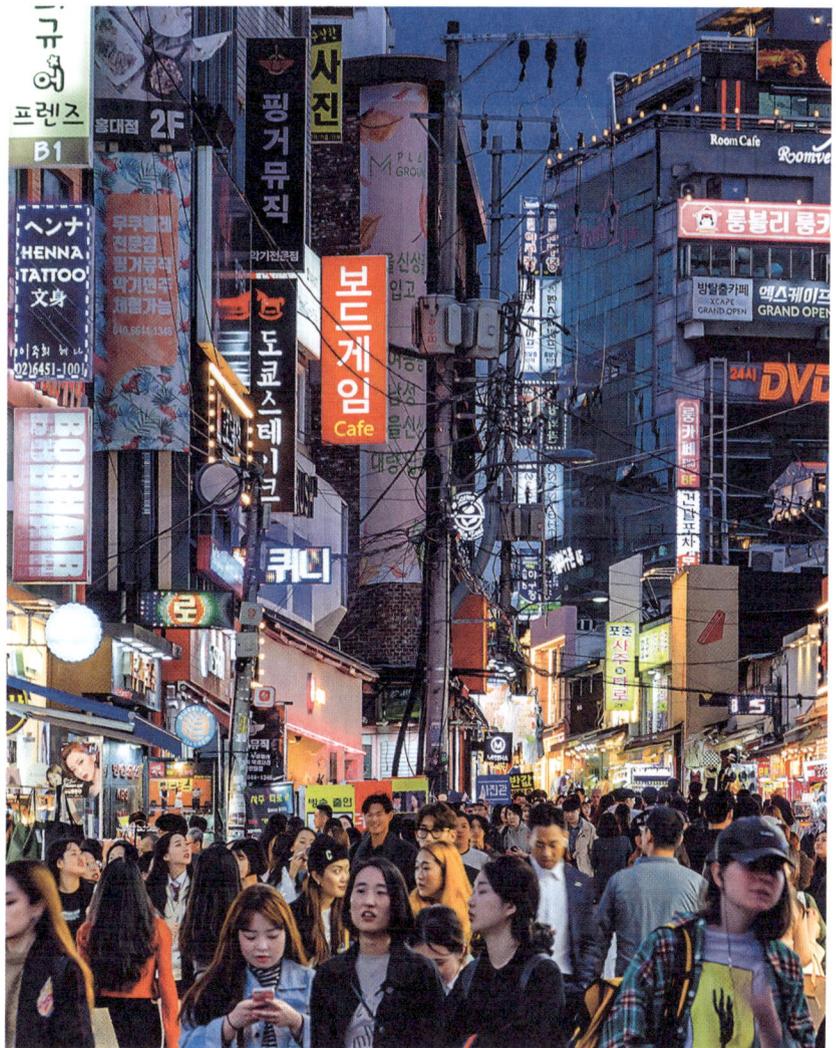

NORAEBANG

MAKING YOUR VOICE HEARD

노래방

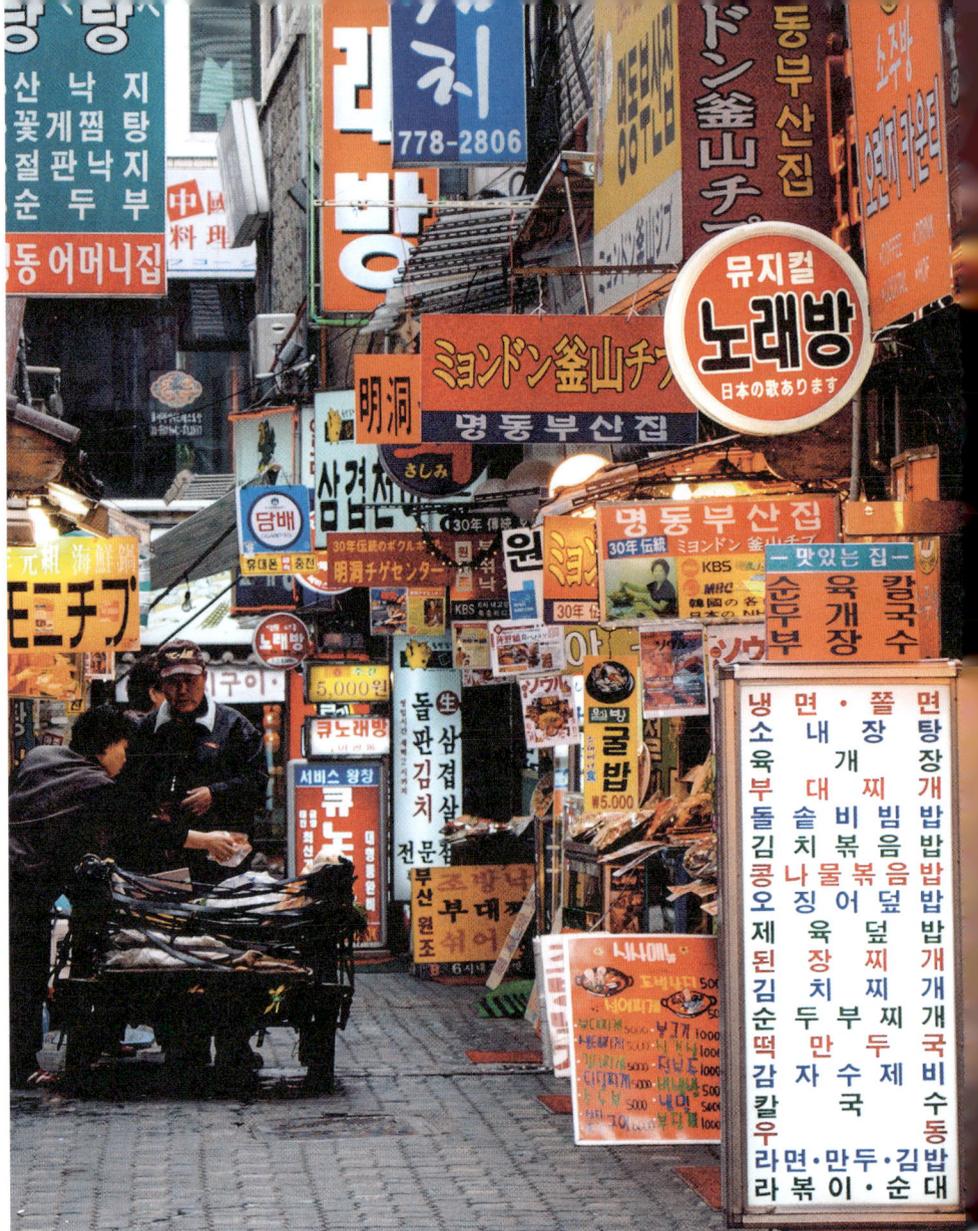

You haven't really been out in South Korea if you've never done karaoke.

The *noraebang* or "singing room" is the local version of the famous karaoke. It's a favourite activity of Koreans who like to go out and sing at any time of day or night. This is why these venues are generally open non-stop and also offer drinks, ice cream and snacks to get you through the long hours of making your voice heard. *Noraebang* are frequented by friends, lovers and colleagues, showing just how integral these places are to the country's culture and how they can be a suitable venue for any occasion. Since Koreans are always at the cutting edge of technology, karaoke rooms come with highly practical options: a specially designed remote control allows you to speed up or slow down the song, change its key, skip instrumental sections or even add a disco rhythm to the whole track. A mandatory stop for getting to grips with the festive spirit of South Korea.

↑
You won't be singing in a karaoke bar but a *noraebang*. Here you can croon tender love songs or blast out trendy K-pop tunes!

→
The terrace at Kloud offers one of the best views of the South Korean capital.

KLOUD

UP IN THE CLOUDS

Fancy going out for a drink perched high above Seoul?

The Gangnam district in Seoul is a living metaphor for the Korean economic miracle. In just 30 years, this area south of the Han River has been completely transformed. Huge skyscrapers were built on its rural fields in record time. These high-rise buildings have become the symbol of Gangnam. And since the district is now one of the most popular in the city when it comes to partying, it made sense for the roofs of these immense skyscrapers to be requisitioned for the installation of restaurants and bars sitting high above the metropolis. Among the many rooftop venues that Gangnam now offers, Kloud is undoubtedly one of the most pleasant. Located on the 21st floor of the Mercure Ambassador Hotel, it has an attractive bar serving cocktails created by a mixologist. But it's really the terrace that all eyes turn to. The view is spectacular, especially at sunset. The perfect place for an early evening drink, up among the clouds.

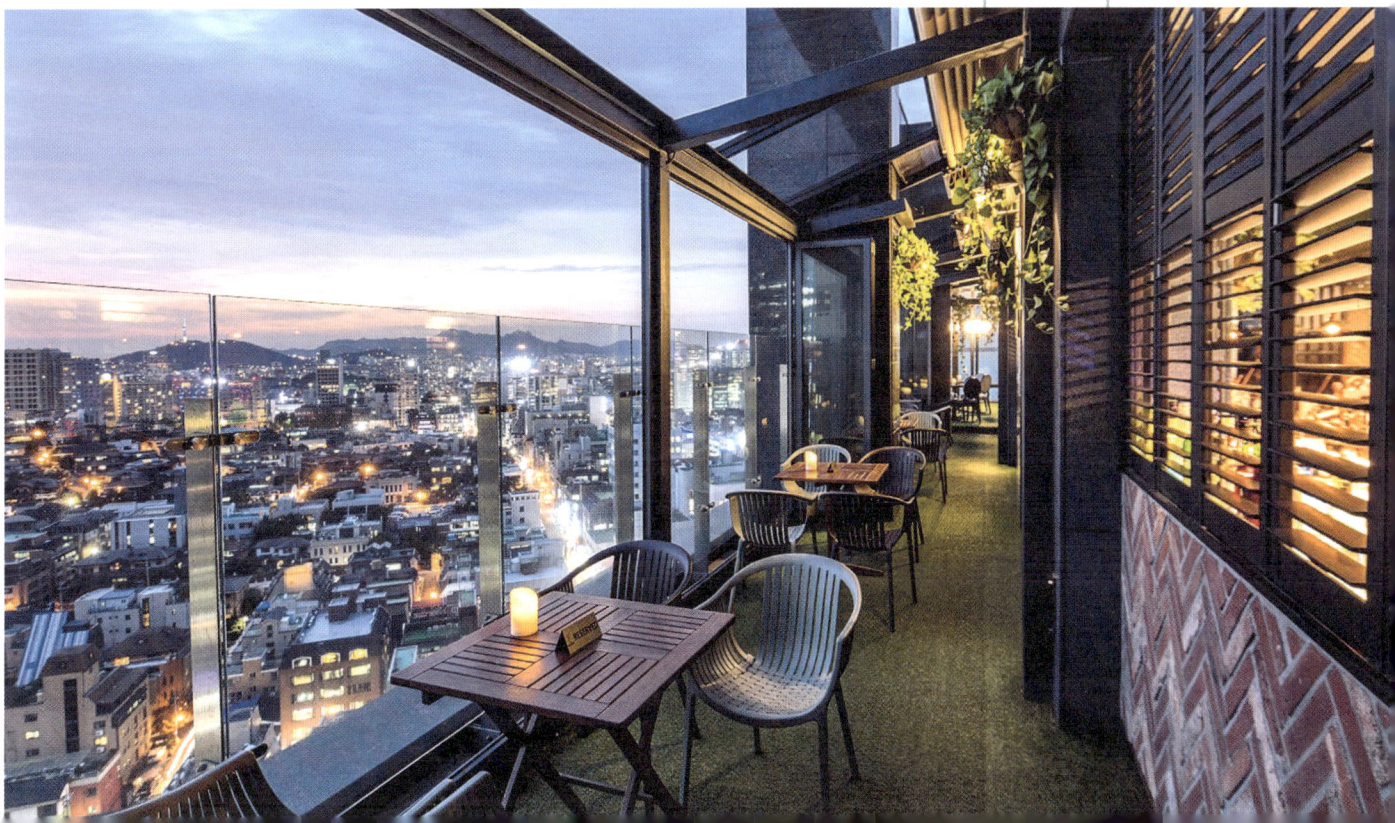

COLATHEQUES

SOCIALISING FOR SENIORS

There's no age limit when it comes to partying over a Coca-Cola.

Although the nightlife in South Korea is mainly geared towards young people, there are plenty of options for older generations too. And this is where the colatheque comes in. A contraction of the words "Coca-Cola" and "discotheque", these establishments were set up in the late 1990s and initially aimed at teenagers wanting to party without consuming alcohol. But in practice, it was mostly seniors who began to invade the dancefloors of colatheques, and the venues are now entirely dedicated to them. They act as an important hub where South Korea's elders can go out in their best clothes to meet and make friends, chat over a soft drink, play janggi - a Korean version of chess - or even go for a wild boogie-woogie under the disco lights. There's no age limit when it comes to partying.

↓
Photograph from a series taken by Françoise Huguier in these party venues for seniors.

→
The special atmosphere of the club Soap captivates party people who come here to dance the night away.

나이트클럽

SOAP

THE BLUE BUBBLE

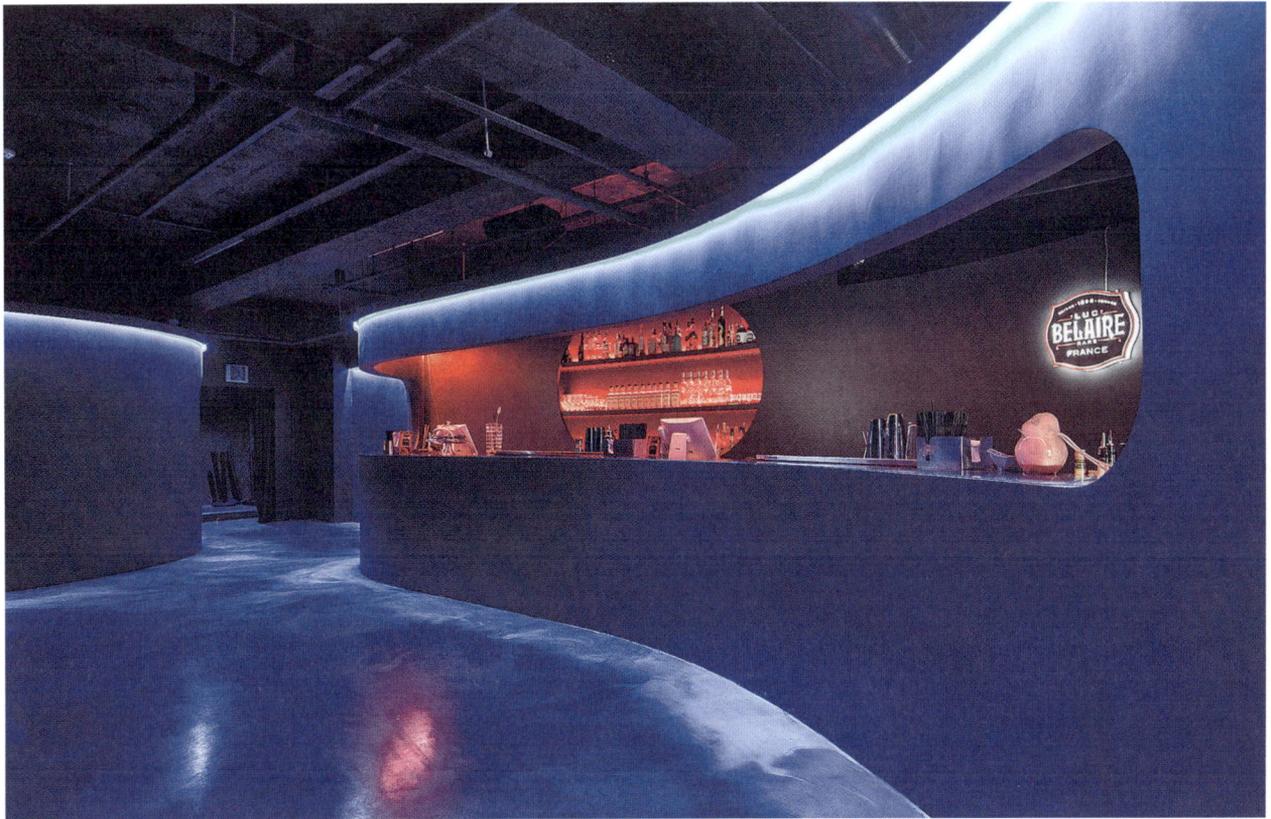

소프 서울

Founders of one of the best clubs in Seoul, the Soap collective gets the Korean capital buzzing.

It's now one of the trendiest collectives in the city. In 2017, the team from Soap opened their club of the same name in the Itaewon district and immediately met with major success. With its cool, all-blue design, this great club with dancing room for 350 offered a hang-up-free blend of electronic music, hip-hop, R'n'B and Korean pop. Forced to close because of the Covid-19 pandemic, the space allowed the collective to cement its position as a key player in Seoul nightlife and the South Korean music scene by inviting leading local and international DJs and artists to perform here. Until they open a new venue, the Soap team has multiple projects on the go: organising outdoor events, collaborating with brands such as Apple and Nike, and even developing their own clothing line which includes some original ideas such as shoe covers to stop your brand-new trainers getting dirty on the dance floor.

Say goodbye to hangovers

South Koreans know how to handle hangovers better than anyone. The country has developed innovative strategies to cope with the challenging day-after following long nights on the soju.

Fifty-eight. That's the number of times the singer Psy says the word "hangover" in his single of the same name, featuring rapper Snoop Dogg. And the Koreans have developed a number of remedies to combat the challenging day-after. The most classic is a dish called *haejangguk*, the name of which literally means "soup to chase a hangover". The recipe varies by region, but it usually includes Napa cabbage, vegetables and meat cooked in a beef broth. On the day after nights out, restaurants serving *haejangguk* are inundated with weary-looking revellers. It's the healthiest and most natural method for recovering from excesses of the alcoholic kind.

↑
Haejangguk or "soup to chase a hangover" is the secret weapon of Korean partygoers.

→
Freeze-dried versions of this life-saving soup can be found in convenience stores that stay open all night.

A bit of larva powder and off we go again!

There are also other options: numerous companies in South Korea have specialised in marketing strange mixtures in the form of anti-hangover shots. Sold right next to cans of beer in small 24/7 supermarkets, these drinks can be identified by their glass bottles and colourful labels. As for the taste, it's somewhat disconcerting. The best-known go by the names of *Condition* and *Morning Care*, both made mainly from the fruit of the oriental raisin tree, a traditional remedy to protect the liver and hydrate the body. They can be somewhat effective, especially if drunk the same evening, but shouldn't be thought of as a miracle cure either.

Lastly, the least appetising method, but also the most successful, is larva powder. Made in Jeju in the south of the country, this bug-based remedy contains proteins that reduce the adverse effects of alcohol four times faster than plants. Dried and then powdered, the unfortunate insects are mixed with honey and vitamin C to form small pellets. This miracle product is sold in orange sachets under the self-explanatory name of *Gone, Hangover Bengjooya*. Take before and after excess consumption and prepare to be amazed. The perfect excuse for a last drink.

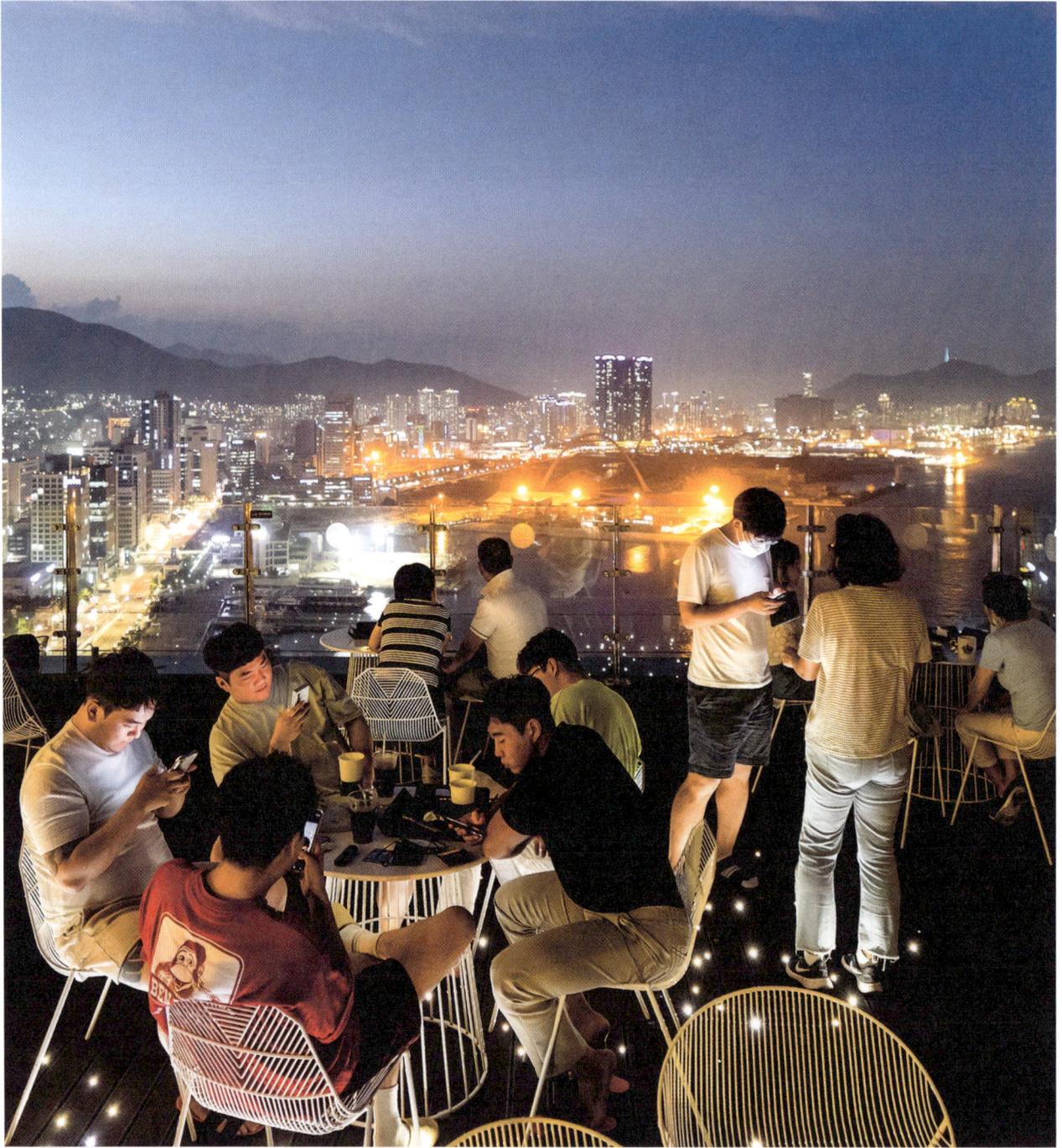

Dancing the cha-cha-cha

Partying in South Korea often resembles a boxing match. The most important thing is to be still standing at the end of the rounds, known as *cha*.

In South Korea, people party very differently from how things are done in the West. Firstly, you don't have to wait for the weekend because in big cities like Seoul, nights spent getting merry also take place during the week. But most importantly, as restaurants and bars have the distinctive characteristic of staying open almost all night, Koreans have got into the habit of eating several times over the course of the evening and alternating between time spent in clubs and time around a table drinking soju or enjoying a barbecue. This explains why Westerners often feel like they're having multiple nights out in one when they go on the town with Koreans. People here prefer to party by going through several different *cha*, in other words, stages or rounds. For example, a typical evening consists of three or four *cha* and will start in a restaurant before moving on to a bar, then to a club and finally back to another restaurant. But exceptional occasions such as birthday parties or holidays can entail up to five or six *cha* and will include spending time in late-night bars and karaoke rooms. Be warned: during these marathons, which often last into the early hours, Koreans will always offer you a drink, especially if they see you with an empty glass. If you don't want a refill, don't finish your drink. Otherwise, make the most of it and don't forget to buy a few rounds yourself. And most important of all, it's advisable not to "go mad" at the first *cha* or you may never get through a whole Korean-style evening.

←
Party atmosphere in a rooftop bar in the city of Busan.

↓
Partygoers raise a glass of beer in the bar of the Oktoberfest microbrewery in Seoul in December 2013.

A music festival in the demilitarised zone

The DMZ contains military personnel, missiles, mines and sometimes even rock bands. An extraordinary event.

It's undoubtedly one of the most heavily guarded border crossings in the world. Despite its name, the demilitarised zone (DMZ) that separates the two Koreas has up to 800,000 landmines, almost 250 kilometres of checkpoints and is guarded by an estimated 700,000 soldiers to the north and just over 400,000 to the south. In other words, on the 38th parallel where it lies, the famous DMZ doesn't offer much in the way of a welcome. And yet, as crazy as it sounds, a music festival like no other on earth is held here every year. Just a few kilometres from the border in Cheorwon Province, the DMZ Peace Train Festival brings together national and international artists who perform to an audience of almost 10,000 people.

The opportunity to drop some musical bombs.

↙ ← ↓

The demilitarised zone that separates the two Koreas has around 800,000 mines, nearly 250 kilometres of checkpoints and hosts one of the most incredible music festivals in South Korea.

The idea for this extraordinary event was born in the mind of Martin Elbourne, an English band booker working for Glastonbury Festival. In 2017, during a visit to the DMZ with his friends Dalse Kong Yoon-young and Lee Dong-yeon - both organisers of the Zandari Festa in Seoul - he thought it would make a great site for a festival. The symbolism is striking: in a place where people speak only of war and military attacks, the three friends wanted to champion music and peace. "It sort of naturally happened," explained Martin Elbourne to the magazine *Mixmag Asia* in 2019. "Over the years I've been involved with lots of things - you come up with ideas and often they don't happen. The governments of Seoul, Cheorwon Province and South Korea thought that the timing was really good. The weird thing was when we first thought this up, the situation with North Korea was much worse." This mind-boggling event finally came together in 2018, with a line-up combining South Korean punk and reggae groups, French artists such as Kid Francescoli and Joyce Jonathan, and even the former bassist of the Sex Pistols, Glen Matlock. North Korean musicians were invited to the festival but in the end were unable to obtain permission to join the party. The festival takes place on three different stages. The main one is located outside the DMZ and hosts the majority of gigs with the biggest audiences. There are also smaller concerts inside the demilitarised zone, near the old Woljeong-ri train station and in the ruins of the headquarters of the Workers' Party of Korea. An exceptional event which deserves credit for reminding us that music goes way beyond borders.

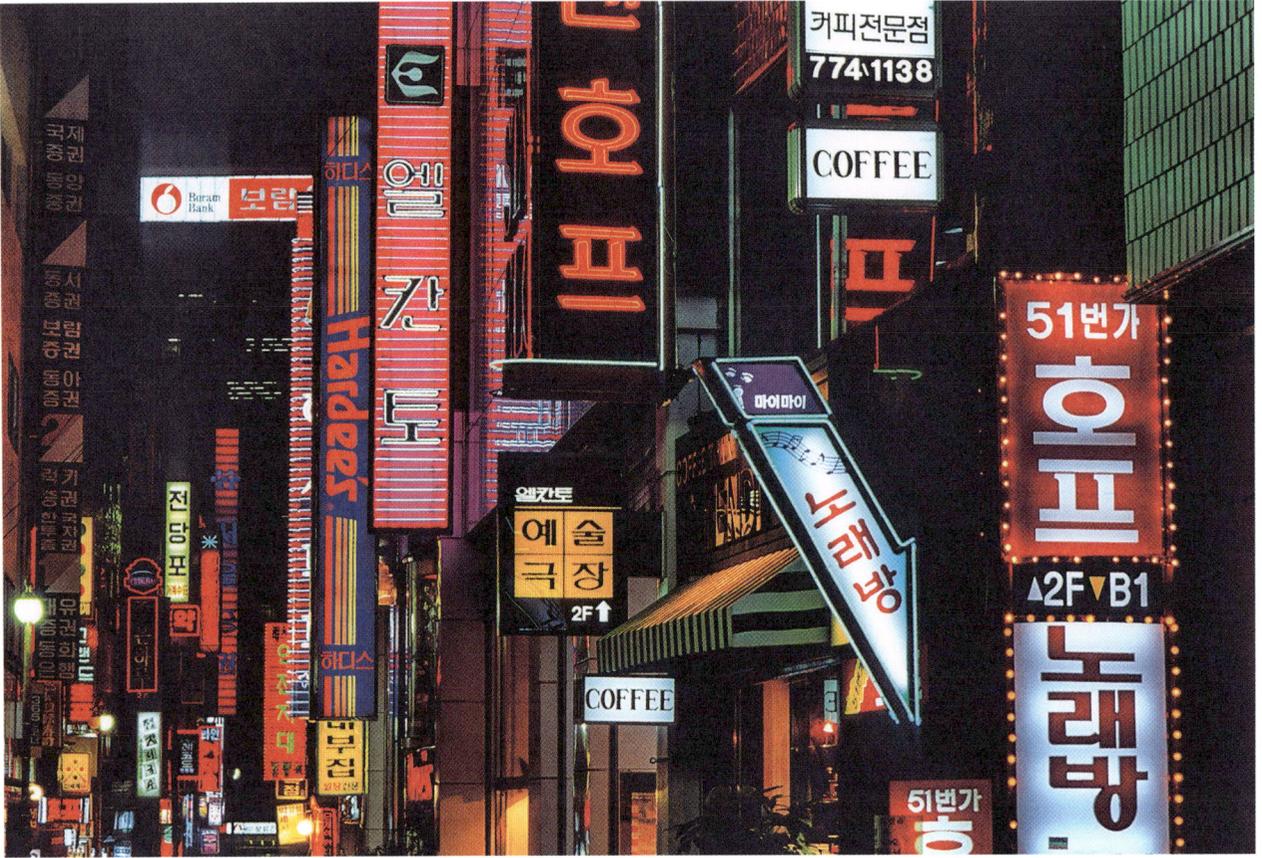

방문화

Women outnumber men in Korean clubs

In South Korea, military service is no joke. And while men learn how to handle guns, women take the opportunity to party. Quite right too.

This detail may come as a surprise, as Westerners are used to the opposite in some of their own nightclubs: spend a few evenings in the clubs of Seoul or Busan and you'll fairly quickly realise that there are often more women than men enjoying an evening here. The difference in numbers can be explained by one important fact: Korean men have to do their military service between the ages of 18 and 36, in other words, at a time in their lives when they're most likely to be going to clubs. In practice, they often join the army around the age of 28 for a period of two years, meaning there are fewer men in this age group on nights out. However, it might be a tad hasty to interpret this feature of South Korean nights as a feminist victory. In fact, the country unfortunately still has a lot of catching up to do when it comes to gender equality. In 2021, a report on the issue published by the World Economic Forum ranked South Korea in 102nd place out of 156 countries.

← At night, the district of Myeong-dong sparkles with the neon signs of shops, restaurants, cafés and clubs.

↓ Korean women take advantage of their partners being away on military service to party with their friends.

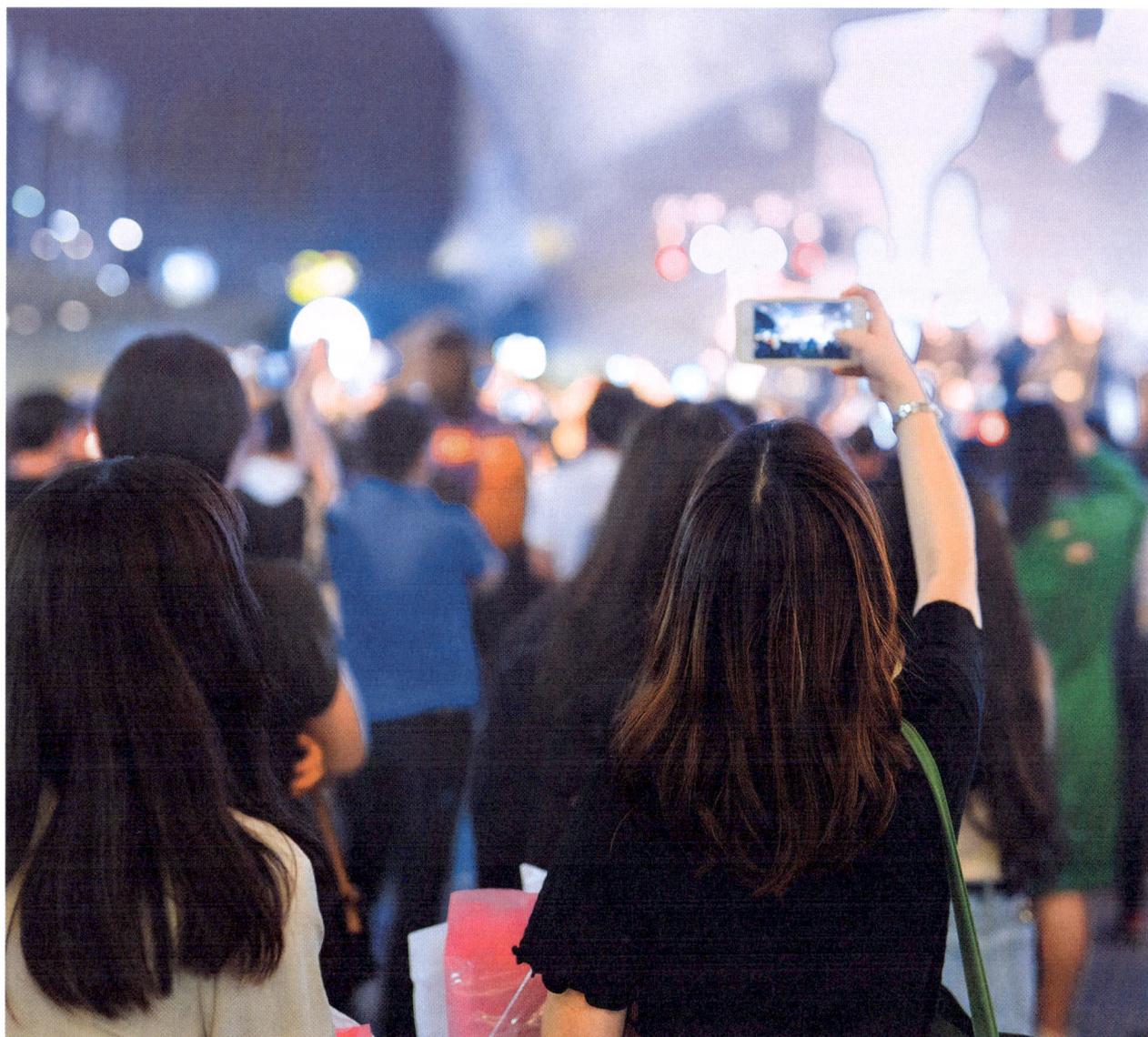

Sport

South Korea may be a relatively young country, but it's still had time to notch up some great sporting victories.

The Land of the Morning Calm is clearly a country that loves sport. First, there are traditional disciplines which are fundamentally linked to the identity of the country. For example, *ssireum* is a kind of Korean wrestling similar to Japanese sumo, where two contestants try to grab each other by the belt and throw their opponent to the ground. Historically, *ssireum* is thought to date back to primitive times and was developed as a means of defence against animals and enemy tribes. Today, the sport is highly popular everywhere in the country and is often practised at large folk festivals. Another traditional sport is *jokgu*, a blend of football and volleyball. Two teams compete over a net similar to the type used on tennis courts. Players score points by getting the ball to touch the ground on the opposing court, using only their feet or head. Finally, taekwondo is without doubt the most famous of the traditional Korean sports. This globally popular martial art was devised from different practices (such as karate and *taekkyon*) in the 1950s, with the aim of intensifying the patriotism of the young South Korean nation after the Japanese occupation of their country. This explains why, even today, taekwondo is included in the training of the South Korean army. The martial art now has more than 70 million practitioners worldwide.

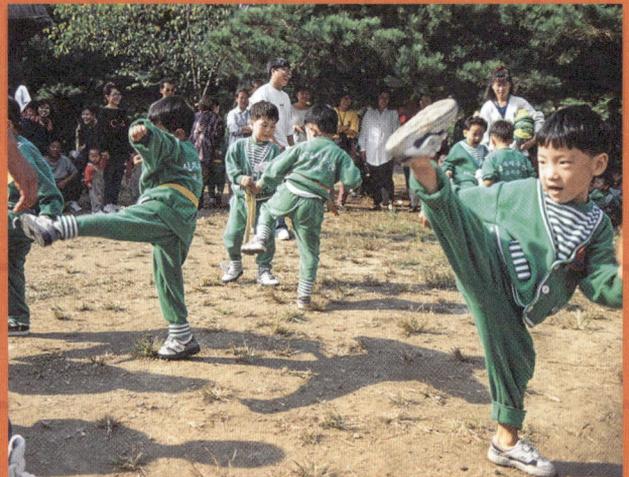

↑→
Taekwondo, the first Korean sport to conquer the world, is practised from childhood in its country of origin, as is the case all over the planet!

In addition to these traditional disciplines, when it comes to sport, Koreans also have their preferences. Many of them list football as their favourite sport. The matches of major European championships are often closely followed, as are those of the national league - known as the K-league - which runs from March to November each year and sees twelve regional teams compete against each other. The South Korean national team has been continually improving since the early 1990s. In total, they've competed in ten final stages of the World Cup, reaching the semi-finals in 2002 after eliminating Spain and Italy. The country now has international-level players, including the iconic Son Heung-min, the striker for Tottenham Hotspur and currently one of the best footballers in the world, as evidenced by his title of leading goal scorer in the Premier League's 2021-22 season. A star in his native country, he's omnipresent in adverts broadcast on national television channels and in poster campaigns on the Seoul subway.

Not far behind football, Koreans are also incredibly passionate about baseball, one of the most watched sports in the country. Consisting of ten teams, the KBO League (standing for Korean Baseball Organisation) is a breeding ground for young talent and it's not unusual for promising

←
Striker Yoichiro
Kakitani of
Japanese club
Cerezo Osaka
and striker Go
Moo-yol of South
Korean club
Pohang Steelers
competing in the
AFC Champions
League in Pohang
in February 2014.

↗
Son Heung-min
at a match in
August 2022
in London.

players to head to the United States to pursue a career in the Major League. This was the path followed by Ryu Hyun-jin, the current pitcher for the Toronto Blue Jays, who made his debut in Korea with the Hanwha Eagles in Daejeon. Another example is Oh Seung-hwan who played for the St. Louis Cardinals and Colorado Rockies before returning to compete in his native country for the Samsung Lions. In 2008, the South Korean national team took the gold medal at the Beijing Olympics. Other sports at which Koreans excel include golf, with women's champion Park In-bee winning a gold medal at Rio in 2016, and figure skating, led by record-breaking athlete Kim Yuna.

Last but not least, South Korea has a special relationship with the marathon. Running clubs have proliferated in recent years and competitions are now held every weekend across the country. Some races have more than 20,000 professional and amateur entrants. The origins of this love story can be traced back to runner Son Ki-jeong, who became a symbol of resistance for all Koreans during the Japanese occupation. At the age of 23, he set a new world record in the Tokyo Marathon in 1935. The following year, Japan forced him to run for the country's team at the Berlin Olympics, making him change his name to the Japanese-sounding Son Kitei. After a tense race, he won the event in 2 hours, 29 minutes and 19 seconds. He set a new Olympic record, ahead of the Briton Ernest Harper and his compatriot Nam Sung-yong who was also forced to run for Japan. As the Japanese anthem played, the two Koreans on the

↖
Oh Seung-hwan
of the St. Louis
Cardinals pitching
against the
Pittsburgh Pirates
at Bush Stadium
in St. Louis,
Missouri, in 2016.

→
Toronto Blue
Jays pitcher Ryu
Hyun-jin in a
game against the
Baltimore Orioles
on 7 July 2021 at
the Oriole Park at
Camden Yards,
Baltimore.

podium bowed their heads as a way of peacefully protesting against the occupation of their country. The image travelled around the world and was placed on the cover of the *Dong-a Ilbo*, one of Seoul's biggest daily newspapers, with the pointed headline: "Korean Victory in Berlin". Publication of the newspaper was immediately banned by the Japanese authorities for almost a year. After this marathon, Son Ki-jeong brought his career to a close, refusing to run under Japanese colours. He then devoted himself to fighting for his country's independence. Once the occupation was over, he returned to the sport to train the national team and champions such as Suh Yun-bok and Ham Kee-yong. Thanks to his influence and his extraordinary career, the marathon has always had a special place in South Korean hearts. One of the many sports at which the country excels.

↓→
1936 Olympics, Korean athlete Son Ki-jeong (centre, competing under the Japanese name Son Kitei in the Japanese Olympic delegation), winner of the marathon.

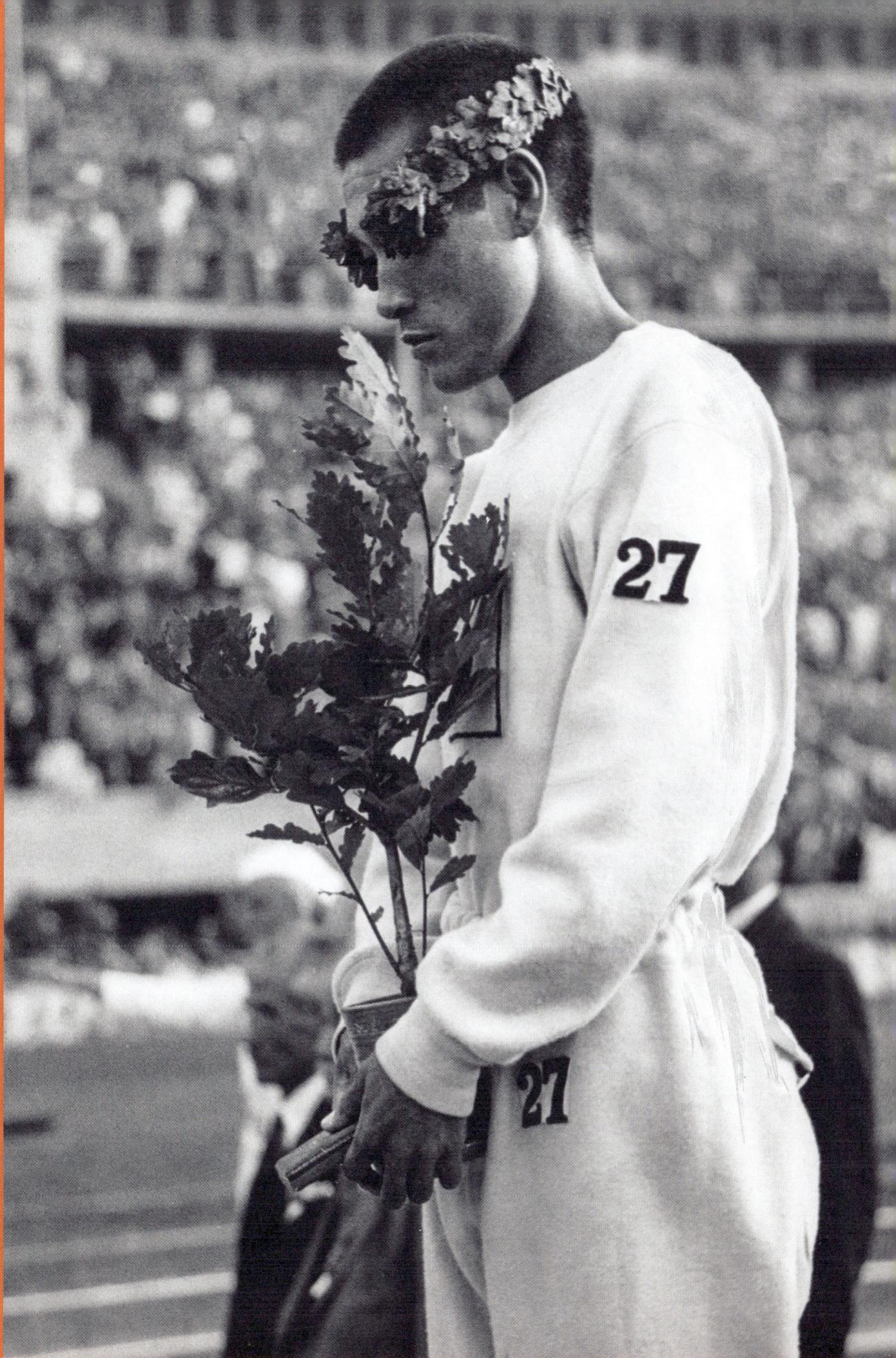

5

K·FOOD

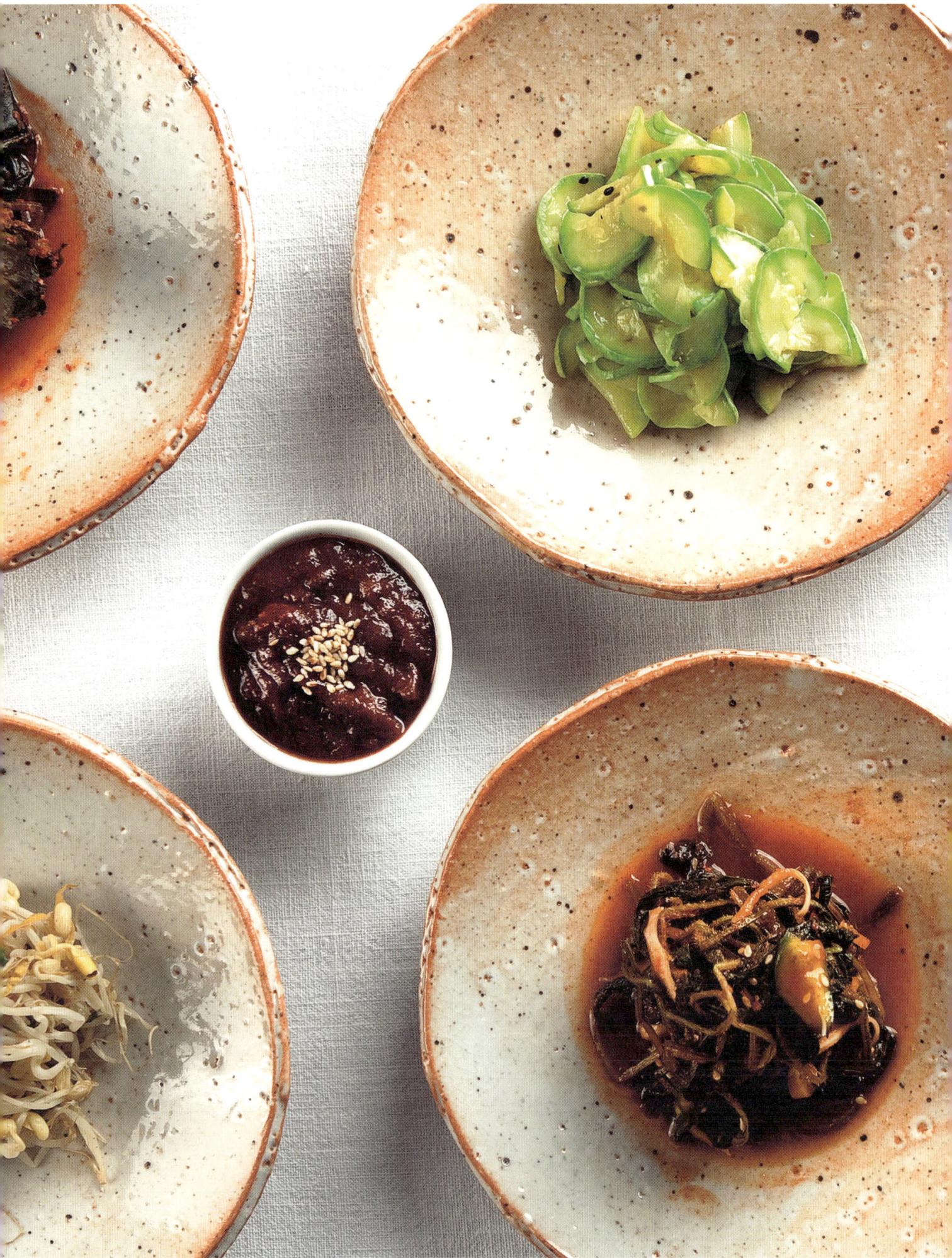

INTRODUCTION

한식

P. 130-131
–
Night out at a restaurant in Gyeongui Line Forest Park in Seoul.

←
Assortment of Korean specialities.

Spicy, tasty and complex: the signs are good for Korean cuisine becoming the next global star of Asian food.

It has to be said that in the West, when we think of Asian cuisine, it's not necessarily Korean dishes that spring to mind. Less well-known than Chinese, Vietnamese, Thai or Japanese cooking, K-food has been relegated to the back burner, or simply thought of as a variant of what its neighbours do. And yet its history and unique characteristics make it like absolutely nothing else. On the plate, it combines several philosophies specific to Korean culture. First, Taoism which emphasises the concept of balance, and harmony between flavours. Colours are seen as symbolic, representing the elements or parts of the body, as in the dish *bibimbap*, where special attention is paid to visual composition and the organisation of tastes and textures in the bowl. This spiritual heritage explains why Korean food is traditionally seen as a form of medicine. And with good reason, since studies have shown it to be one of the healthiest diets in the world.

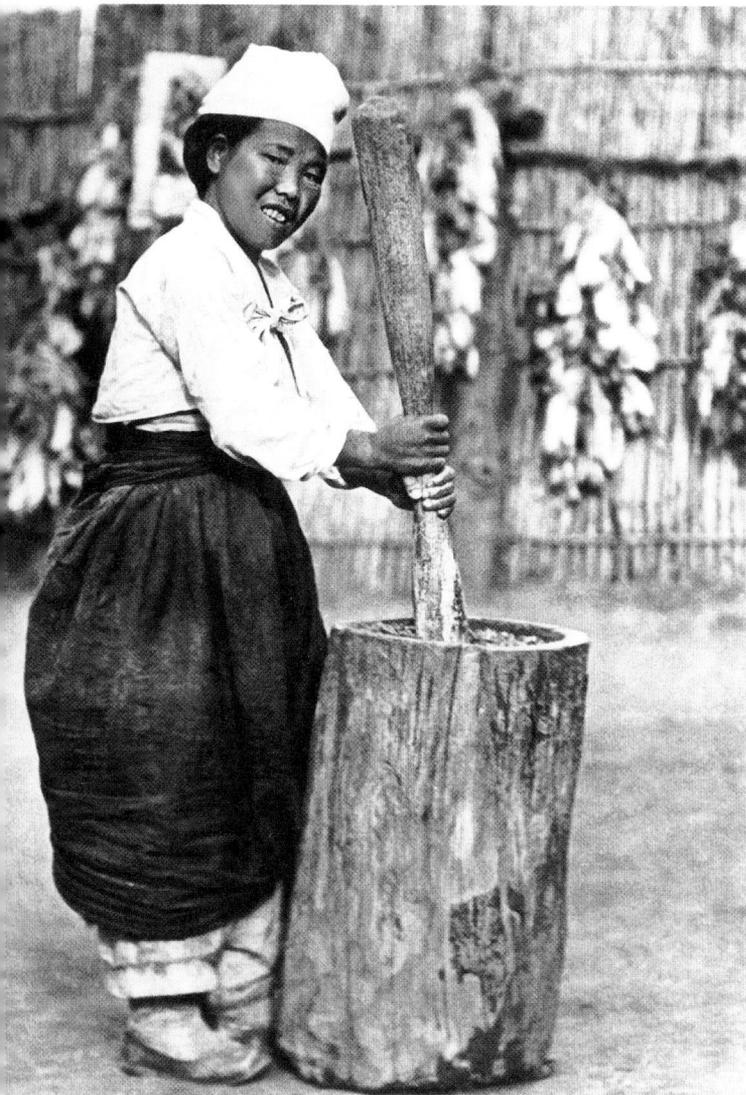

On the plate, it combines several philosophies specific to Korean culture.

↑
Korean woman
crushing cooked
soya beans
to make miso,
around 1940.

→
*The Banquet
of Seowangmo
(Xiwangmu),
Queen Mother of
the West*, Joseon
Dynasty (1392–
1910), 18th–19th
century, Los
Angeles County
Museum of Art.

Buddhism has also had a considerable influence on Korean food, anchoring it in a thousand-year-old vegetarian tradition which can be found in the cuisine typical of the country's temples, as demonstrated by the nun and cook Jeong Kwan. In contrast, the Mongol invasions introduced a culture of grilled meats which the country loves and can be seen in the famous Korean barbecue. Europe also made its own contribution around the 17th century when Portuguese traders introduced East Asia to the chilli that they'd brought back from the Americas. In South Korea, it took the form of a red powder known as *gochugaru*, and quickly became such a key part of the country's diet that Korean food is sometimes stereotyped as always being too spicy. A cliché which merits qualification as Korean chilli isn't as strong as its Caribbean or Thai equivalents. Through the region of Manchuria, China also played a crucial role in bringing a culture of fermenting vegetables and soybeans in large clay jars. By reappropriating this practice and adapting it to their national context, the Koreans invented a unique product that is the envy of the world: kimchi. A staple of Korean cuisine and the international standard-bearer of K-food, this cabbage fermented with chilli is so popular that it often serves as a gateway to local cuisine for foreigners. In 2013, UNESCO even inscribed it on its List of the Intangible Cultural Heritage of Humanity.

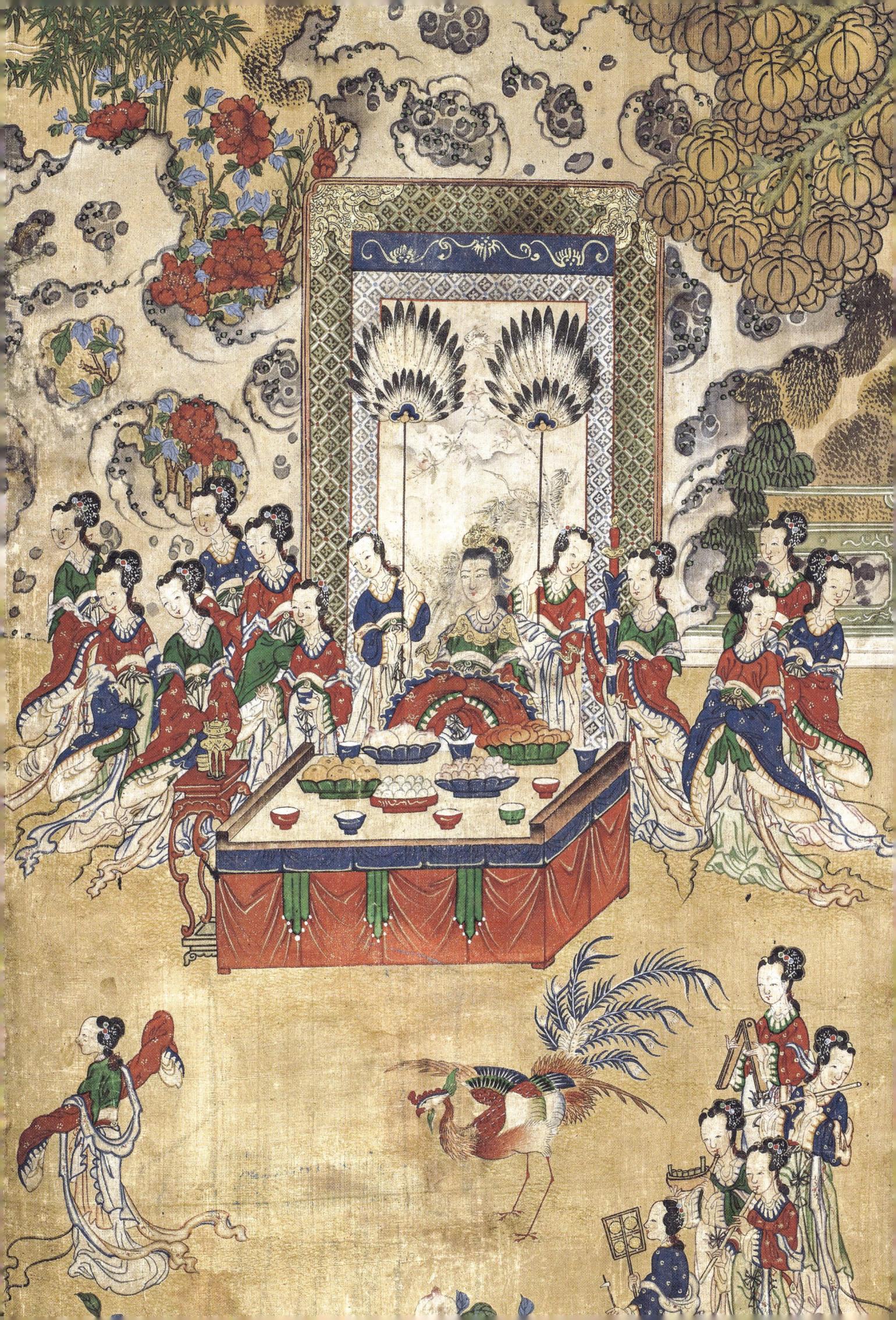

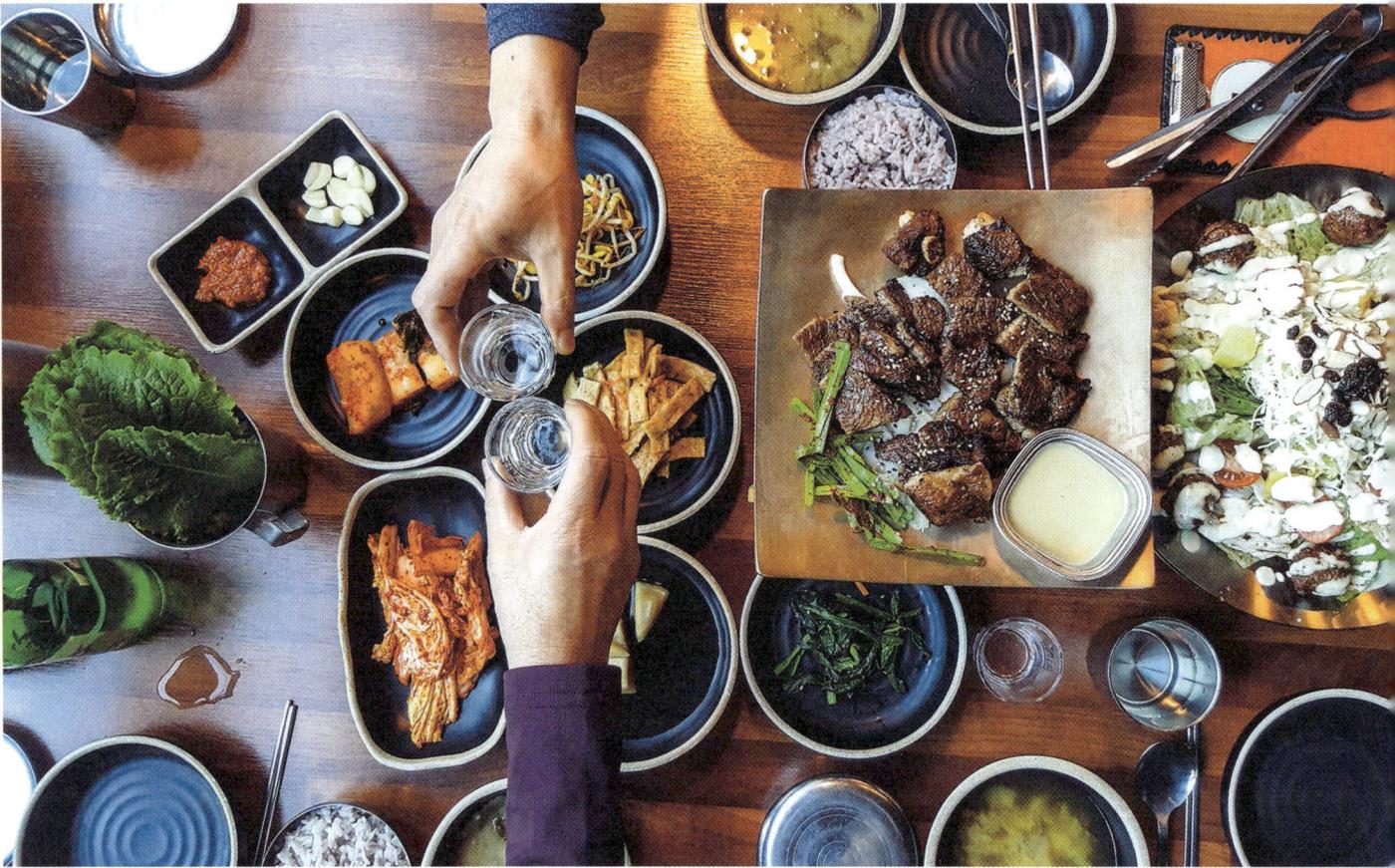

Like K-pop, the country's gastronomy has become an essential lever of soft power for South Korea.

Today, like the spectacular rise of K-pop around the world, the country's gastronomy has become an important lever of soft power for South Korea. As early as 2008, Kim Yoon-ok, First Lady of the country at the time, made the dissemination of Korean cuisine around the world one of her priorities, with the aim of attracting tourists and boosting exports of Korean foods. She came up with a variety of strategies to achieve this: publication of recipe books, creation of food festivals, grants for Koreans opening restaurants abroad, and even training of Western chefs. In the country's laboratories, scientists even worked to develop a flavour perfectly adapted to the taste buds of foreigners. Practising what she preached, Kim Yoon-ok donned her apron and prepared kimchi with her Japanese counterpart; she also cooked *pajeon* - a vegetable pancake - for Korean War veterans on an official visit to Washington. In other words, for Seoul the message is clear: to become a cultural power, the aim is to get your cuisine adopted by the rest of the world without losing its identity. You could call it kimchi diplomacy.

Thanks to the implementation of this policy by the government, as well as the growing popularity of Korean culture in general, K-food is gradually carving out a prime position in the West. Each year, the general public discovers more about the variety of its dishes, looking beyond the ever-present kimchi to explore *tteokbokki* rice cakes, *dakgangjeong* chicken, *bingsu* ice cream and

↑
Two friends clink soju glasses while eating Korean specialities.

→
Woman drying chilli peppers in a village near Seoul.

맛있게 드세요

many other specialities. The ritual of the Korean meal - with its dozens of small, simultaneously served dishes (called "ban chan"), its metal chopsticks and spicy flavours - is gradually making a lasting impact on the culinary habits of major European cities. After the successive fashions of sushi, pad thai, Vietnamese soups and the more recent Japanese ramen, it seems that the next phenomenon in Asian cuisine is likely to be Korean cooking, as evidenced by the number of restaurants springing up over the last few years in Europe and the US.

Finally, it would be remiss not to mention the fact that Korean cuisine also comes with a drinking culture - the nights are noisy and take the form of long meals copiously washed down with soju, a low-cost local alcohol which often makes things even more friendly. A veritable institution in South Korea, soju is consumed in such astronomical quantities that it holds the surprising title of best-selling spirit in the world. To go with it, Koreans may eat several times over the course of the same evening, while certain dishes were invented specifically to combat the next day's hangover. As mentioned above, Korean cuisine is a form of medicine, whatever your ailment happens to be.

BIBIMBAP
A LESSON IN METAPHYSICS

This deceptively simple dish is a reflection on the meaning of the universe.

Its name literally means "mixed rice". But behind this simplistic etymology, bibimbap is a more complex dish than it might at first appear. In fact, this classic of Korean cuisine delivers a metaphysical lesson. Traditionally served in a preheated stone bowl, bibimbap is composed with care, each ingredient being prepared separately and placed in the bowl to form an incredible colour wheel of different hues. Ancient Korean beliefs see this as a powerful allegory: water is represented by the rice, wood by green vegetables, fire is symbolised by red vegetables (carrot and fermented chilli paste), and metal by the meat and mushrooms, while at the centre of it all, the egg represents the Earth. In terms of eating etiquette, the diner should contemplate the order and universal beauty of their bibimbap, before plunging this world into chaos, mixing it all up with a long spoon. Tastes and colours are dramatically jumbled together, like a tornado at the centre of the universe.

↑
This speciality is one of Korean cuisine's most popular dishes beyond its borders.

→
A great favourite with Koreans, this generous dish has had two lives!

TTEOKBOKKI

DROPPED IN THE SPICE

떡볶이

Super-spicy and delicious, these rice cake noodles were invented by accident and are stars of Korean street food.

Also spelled *topokki*, this Korean favourite has had two lives, so to speak. Historically, this snack of cylinder-shaped rice cakes was served at court, accompanied by a brown soy sauce. But legend has it that in 1953, during the Korean War, the cook Ma Bok-lim accidentally dropped her *tteokbokki* into a highly spiced sauce. Finding that the heat of the chilli worked wonderfully well with the thick and slightly elastic texture of the rice cake, she began to sell her red-hot creation in the Sindang district of Seoul where it became such an immediate success that it eclipsed the original recipe. Since that time, it has become a great classic of the *pojangmacha* or street stalls, where patrons eat at any time of day or night. Proof that this dish has become a staple of Korean comfort food, it's now sold in a low-cost, instant version, which can also be eaten topped with melted cheese.

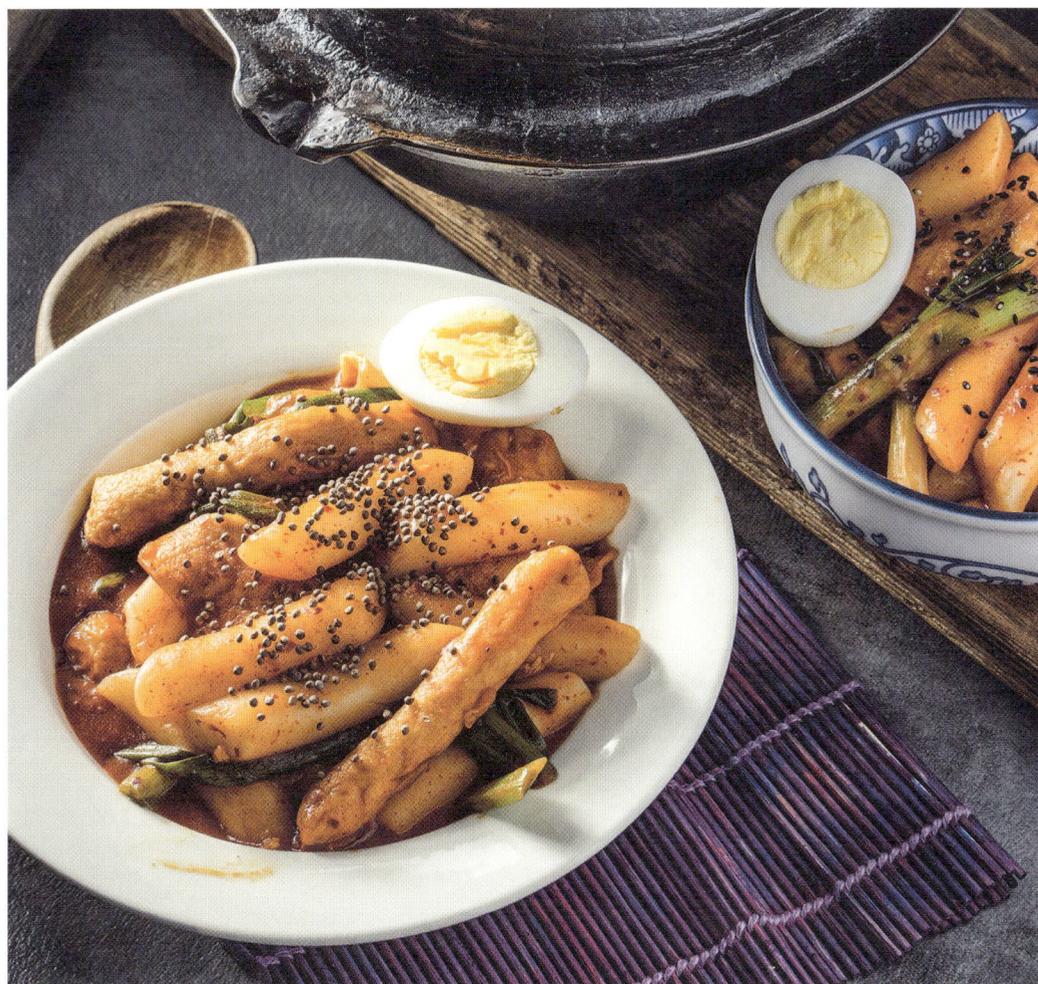

THE GLOBAL
OUTSIDER
OF GRILLING

KOREAN BARBECUE

한식 바베큐

Forget everything you know about the subject: the only real barbecue is Korean.

Even though it shares few similarities with its American counterpart, the now famous Korean barbecue is highly popular with Western foreigners because it's not super-spicy, unlike some of the rest of the local cuisine which tourists might feel is just too hot. But the term "barbecue" may seem a curious one: in this version, there's usually no direct flame or charcoal but a circular, gas-powered hotplate embedded in the dining table. Over long hours of conversation, meat is grilled in thin slices - often in the form of marinated beef known as *bulgogi* - which is eaten at the same time as an assortment of *banchan* or small accompaniments used to change up the flavours. From a practical point of view, this meal is eaten without a knife and fork. Only Korean metal chopsticks are used to retrieve the pieces of meat and place them in a lettuce or wild sesame leaf. This is then garnished to taste before being folded up and eaten in one bite. All washed down with beer, of course.

↑
The Korean barbecue, far from being overshadowed by its charcoal competitor, has become the flagship dish of Korean cuisine.

→
Fried chicken, the grand master of street food and inexpensive dishes, is as popular in Korea as it is in the United States.

FRIED CHICKEN
A STREET FOOD FAVOURITE

A classic stolen from the Americans during the Korean War.

In South Korea, party nights can be long, and between glasses of beer or soju, it's not uncommon to make multiple stops at little street food stalls to graze on snacks fatty enough to soak it all up. Korean fried chicken is the undisputed champion at this game. Introduced by American soldiers stationed on military bases during the Korean War, and known in its anglicised form as *chikin* by many Koreans, this dish became a classic of local cuisine in the 1970s when large restaurant chains in Seoul began to appropriate it. And it has to be said that the Korean version far surpasses that of the Americans. This is especially true in the recipe known as *dakgangjeong*, which owes its popularity to three characteristics: the chicken is super-crispy, caramelised with sugar, and sometimes dangerously spicy.

BAEK JONG WON

FROM KITCHENS TO TV SETS

We may have Jamie Oliver, but South Korea has Baek Jong Won.

Everyone knows his name in South Korea. For many, he's seen as a true expert whose opinion on all things food-related has more merit than any other point of view. Growing up in the rural area of Yesan, Baek Jong Won (sometimes also spelled Paik Jong-won) was already interested in cooking as a young boy, when he started experimenting to improve the hamburger recipe so loved by his father. During his military service, he spent a huge amount of time in the kitchen and perfected his approach to cooking. On the strength of this experience, he then launched his first restaurant known as Original Ssambap, which takes its name from a typically Korean way of eating dishes wrapped in steamed cabbage or lettuce leaves. He then launched the pub franchise Hanshin Pocha, which now has branches as far away as Los Angeles. But it's primarily through television that Baek Jong Won became known to the general public, appearing as a culinary expert on programmes such as *Baek Jong-won's Top 3 Chef King* and *Baek Jong-won's Food Truck*. In 2021, he even produced his own series, *Paik's Spirit*, for Netflix. A chef who's definitely cooking with gas.

↓
Chef Baek Jong Won at a press conference in November 2017.

↗
A familiar image from the streets of Asia where small plastic tables invite passers-by to stop for simple and delicious meals.

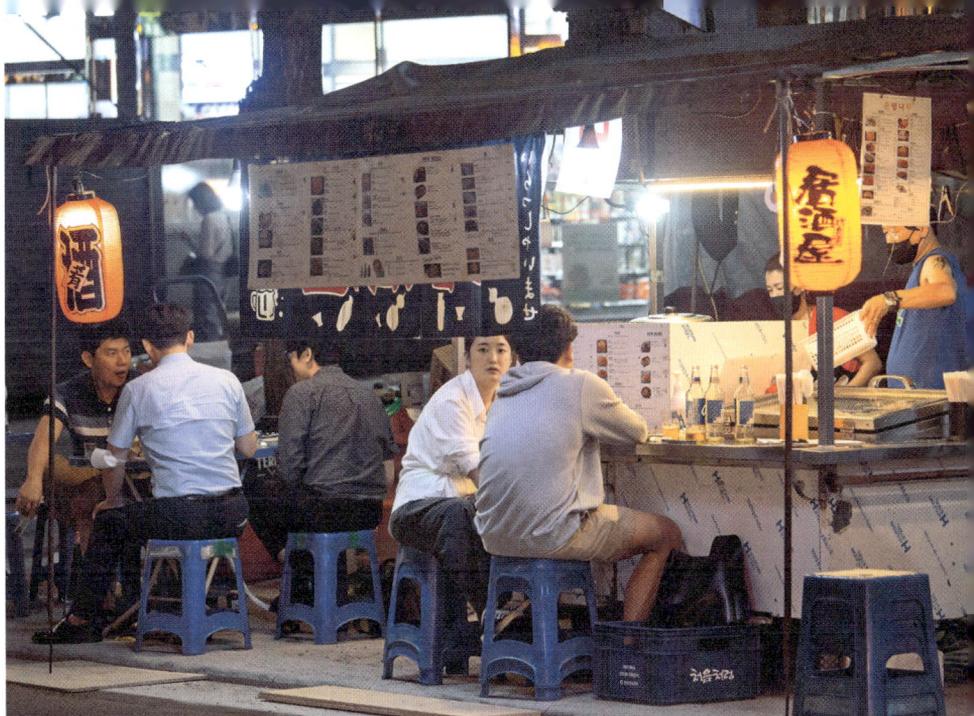

POJANGMACHA

The heart of Korean cuisine beats in these small, unpretentious food stalls.

South Korea has a strong culture of street food and it's served from small stands known as *pojangmacha*. Usually housed in a tent-like structure, these stalls proliferated widely in the 1950s after the Japanese occupation, and quickly became iconic venues in the culinary landscape of large cities like Seoul. Koreans stop off here at any time of day or night to grab a quick bite with dishes such as *tteokbokki*, a bowl of noodles or a chicken kebab. Because they're conducive to late-night chats or confessions washed down with soju, *pojangmacha* also often feature in Korean TV series with their stories of budding love or sentimental heartbreak. In Seoul, the Jongno district is the perfect place to try the dishes served in *pojangmacha*, especially near Gwangjang Market. With their delicious smells, tastes, colours and atmosphere, these places are a mandatory stop to improve your understanding of Korea.

BINGSU

A NEW INSTA STAR

The favourite dessert of Koreans is as light as a snowflake.

For those with a sweet tooth, bingsu is arguably the most famous Korean dessert. Traditionally made from shaved ice topped with red bean paste, the dish appeared during the Joseon period (1392–1910) and at that time was reserved for the aristocracy and the wealthy. They particularly appreciated the lightness of the dessert which gave the impression of eating a snowflake. Bingsu was gradually democratised and is now eaten by all social classes, especially in summer. The recipe has also moved with the times: milk is sometimes added to produce shaved ice cream and a vast array of toppings are now on offer (fruits of all kinds, green tea, caramel, sweet rice cakes, etc.). Because it's always beautifully decorated and popping with colour, bingsu has even become a cool star on Instagram over the past few years. Proof that this traditional dessert has definitely switched lanes to the future.

←
A classic of Korean desserts, bingsu is perfect for lovers of sweet treats.

KIMCHI

HERITAGE OF HUMANITY

The kingpin of Korean cuisine is a matter of national pride.

In Korean gastronomy, kimchi is the star of the show. Omnipresent in the cuisine and the local culture, this dish of fermented cabbage flavoured with chilli is the pride of the whole country and has even been listed as an example of UNESCO's Intangible Cultural Heritage of Humanity. Its preparation involves a thousand-year-old ritual known as the *kimjang*. Each autumn, Koreans gather with family and neighbours to concoct reserves of kimchi to help them get through the harsh winter months. The social dimension of this dish is part of the reason for its popularity throughout the peninsula. Following in the footsteps of Popeye and his spinach, a few years ago the government even created the character of Kimchi Warrior, a superhero who defends humanity against disease and gets his supernatural strength from the famous fermented cabbage. In Korea, where it's eaten on a daily basis, many believe that kimchi and its health benefits explain the very low levels of obesity in the country. The perfect superfood.

↑
Fermented cabbage is a key element in Korean cuisine and enjoys the status of a national symbol.

ALONE WITH THE
WHOLE WORLD

MUKBANG

곡고 진한
우육탕면

When food porn meets live streaming, the result can only be over the top.

It gets millions and millions of views on platforms like YouTube and Twitch. Mukbang, which literally means "eating show", is a viral phenomenon that appeared in the early 2010s and is based on an unusual concept: in videos often broadcast in real time, solo diners eat meals in front of the camera. At the same time, they chat to their viewers, answer questions, comment on their dishes and amplify the mouth and chewing noises beloved by Korean culture. While the initial premise may seem surprising, the most disturbing feature is the quantity of food ingested during these online feasts. Enormous dishes are consumed one after the other at bewildering speed, as if the eater were trying to urgently and vicariously satisfy the hunger of the viewers. A food frenzy which worries the public health authorities in South Korea and has resulted in the government closely monitoring the practice. In the meantime, proof that the phenomenon is now global, the Collins English Dictionary shortlisted "mukbang" as a word of the year in 2020.

↑
Lunch or dinner alone is no longer an option when you can share your meals remotely with the whole world.

→
Mingoo Kang is a rising star of South Korean cuisine.

CHEF MINGOO KANG

REINVENTOR OF CLASSICS

호리사

A chef who transforms traditional dishes by giving them a contemporary twist.

He's a key figure in the revival of Korean cuisine. Since opening his restaurant Mingles in Seoul in 2014, Mingoo Kang has become one of the most sought-after chefs in the country. He began his career abroad, working in the United States and Spain, training in techniques specific to Western cuisine. But his desire to reconnect with the tastes of his childhood brought him back to South Korea where he developed a keen interest in traditional dishes and drew inspiration from the work of the famous Cho Hee-sook and the nun Jeong Kwan. Today, his style is a contemporary reinterpretation of Korean classics. Keen to promote the flavours of his country overseas, in 2020 Mingoo Kang also opened the Hansik Goo restaurant in Hong Kong, which quickly received a first Michelin star. A top-class ambassador for South Korea.

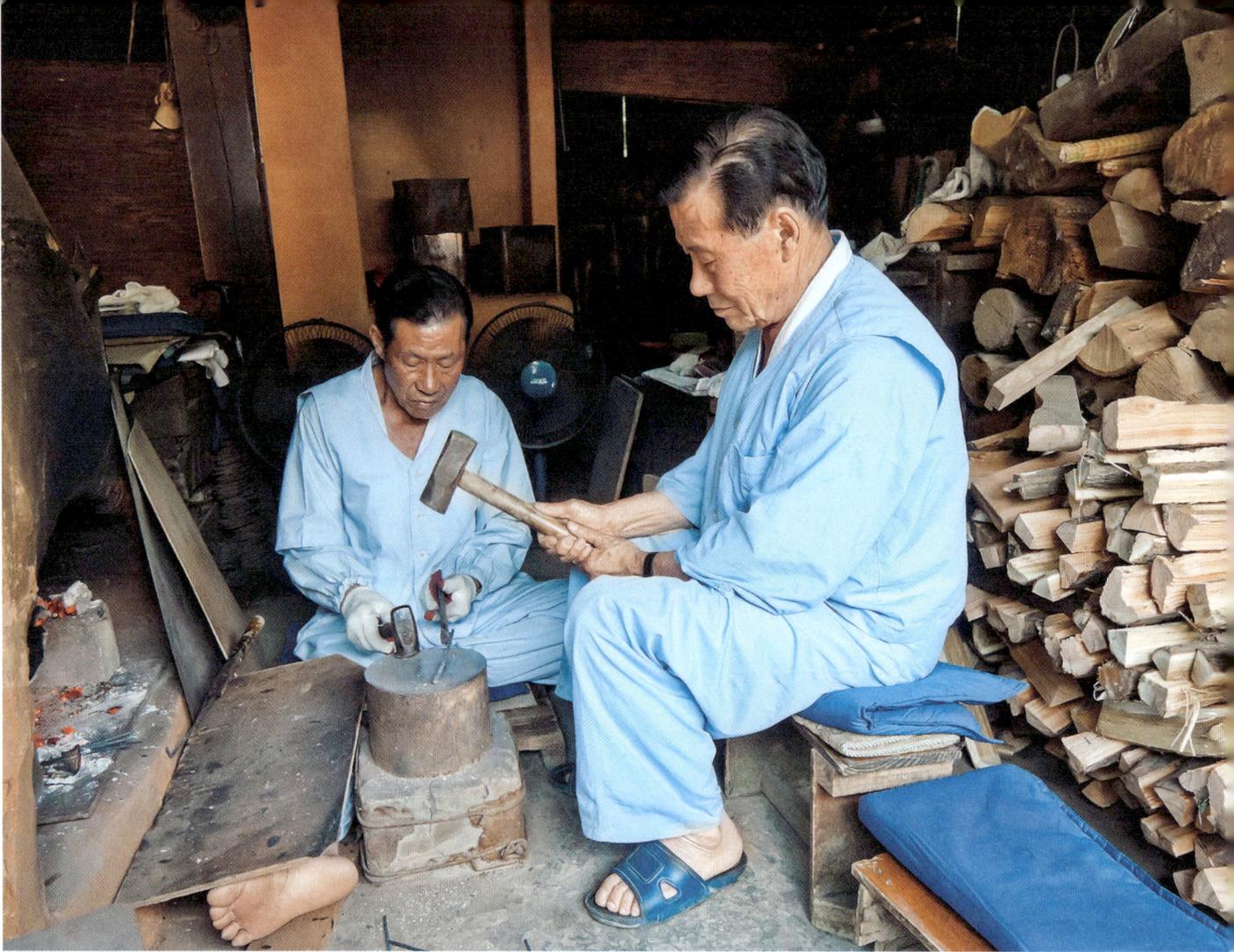

Why are Korean chopsticks made of metal?

South Korea is the only country in the world to use metal chopsticks.

This question is often raised at the first meal in the Land of the Morning Calm. It can come as a surprise to find yourself faced with two metal chopsticks that are heavy and tricky to handle, when all other Asian countries use wooden versions. The reasons for this unusual choice have always been widely debated and many different theories exist to explain it. The first hypothesis has the status of a legend: in the past, chopsticks were made of silver because this particular metal changes colour when it comes into contact with certain substances. At a time when conspiracies, betrayals and assassinations were widespread in Korea, silver chopsticks were therefore used to detect whether food had been poisoned. The second theory is related to issues of hygiene. Traditionally, Koreans never lift their bowl of rice to their mouth as the Japanese and Chinese do.

Instead, they have long metal spoons on the table for this purpose. Since they're not used to pick up rice, chopsticks are only employed to take bits of food from communal dishes. Because it attracts less bacteria than wood, metal allows Koreans to limit the transmission of germs from one dish to another. Finally, a third theory suggests that in ancient times when Koreans ate a lot of fish, they used wooden chopsticks like everyone else. But with the introduction of the Korean barbecue and grilled meat, the wooden variety quickly blackened from the flames and heat. It was therefore better to make them out of metal. It's hard to say which of these theories is the most valid, particularly as the truth is probably a mixture of all three. The fact remains that if an Asian restaurant offers you metal chopsticks, you can be sure the meal will be 100% K-food.

↖ Artisan production of the steel chopsticks. Certain antique versions can have the quality of museum pieces.

↑ Pairs of steel chopsticks, a typical Korean utensil. They can be plain or embellished with decorative patterns.

A mysterious history of conspiracies, murders, germs and grilled meats.

Spam, a luxury product in Korea

This low-cost tinned pork product has found a country of refuge in South Korea.

It makes no sense. In the United States, when Thanksgiving comes around, it's customary to give sumptuous gifts to celebrate the occasion. A tradition that the Koreans scrupulously observe during their lunar thanksgiving holidays, but with a difference: one of the gifts most regularly offered are tins of canned pork produced by the famous American brand Spam. Lavish gift sets decorated with pretty ribbons can sell for up to $75, while a single can costs just $3 in the United States. "Spam has a premium image in Korea. It's probably the most desirable gift one could receive," Shin Hyo Eun, the company's brand manager told the BBC in 2013. Which raises a question: how did this cheap tin of pre-cooked pork become a luxury product in South Korea?

First created in the United States in the late 1930s, the popularity of Spam rocketed all over the planet after the Second World War when rationing was the norm and fresh produce was scarce, with canned meat often being the only affordable option. Included in the kit of GIs stationed in South Korea, Spam was traded around American military bases at a time when the country was plagued by famine as a result of the Korean War. Over the years, the Koreans gradually incorporated it into their diet, mixing it with traditional meals to create unusual fusion dishes. The perfect example of this blend of K-food and American junk food is undoubtedly *budae jjigae*, also known as "army stew", a one-pot dish combining instant noodles, kimchi, canned beans, chilli paste, sausages, cheddar and slices of Spam. The result is an ultra-high-calorie meal that Koreans love to eat on boozy nights out. Today, supported by huge advertising campaigns featuring the biggest celebrities in the country, Spam has become a sought-after product that top chefs are quite happy to include on their menus, as if it were a premium ingredient. Not bad for a common tin of low-end ham.

A product advertised by the biggest stars in the country.

↖
The Spam brand has developed packaging specially designed for its customers in South Korea.

→
This popular product in the United States is highly valued by the Koreans who've adapted it to their specialities.

Soju, the best-selling spirit in the world

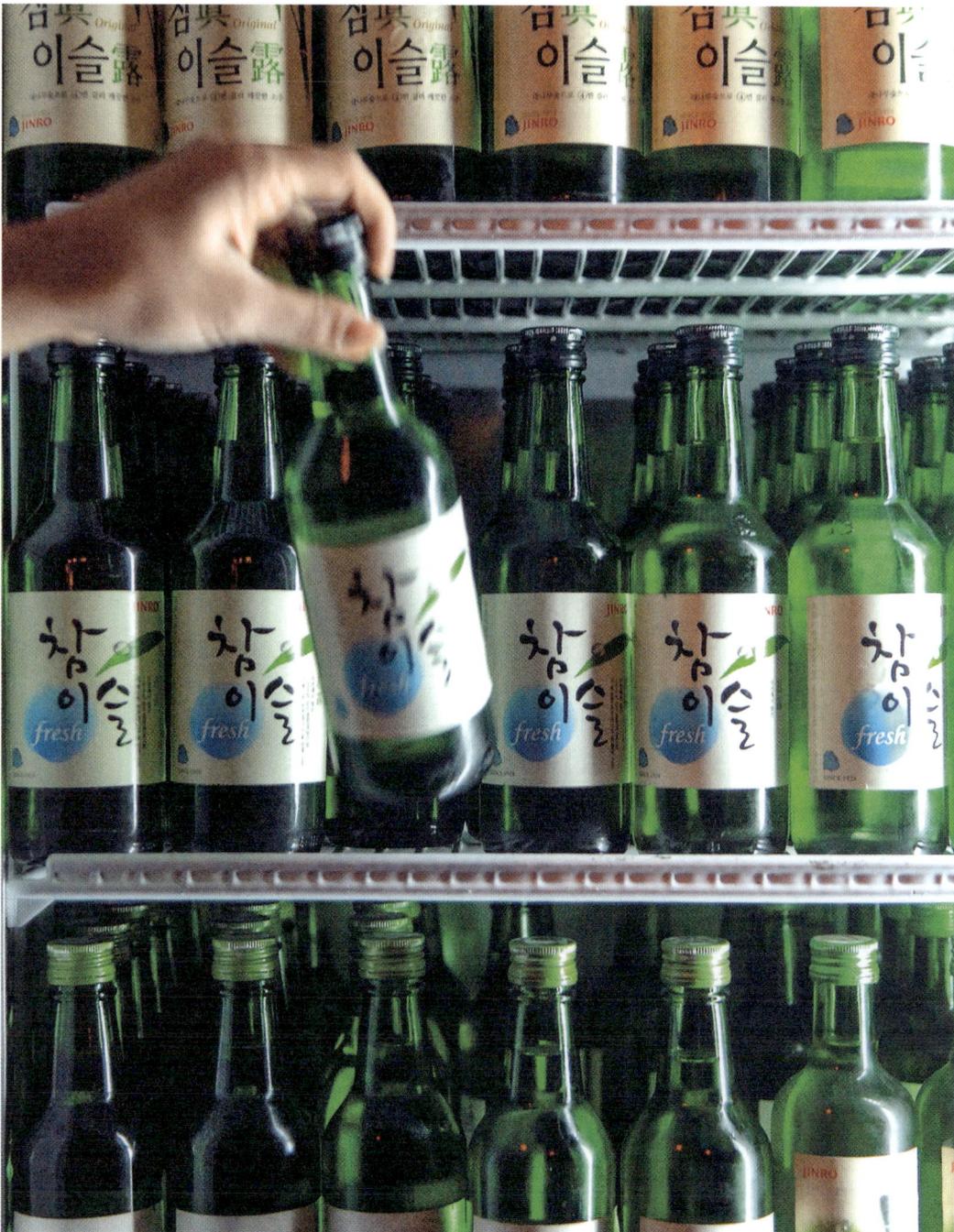

← Soju, the most commonly consumed spirit in the world, is a fundamental part of Korean life.

↗ South Korean singers Gray, Simon Dominic, Park Jae-beom (Park Jay, Jay Park) and Loco attend an event for Won Soju in Seoul on 25 February 2022.

The favourite alcohol of Koreans is still relatively unknown in Europe and the United States.

It comes in a small green bottle that you'd hardly notice as it could easily pass for a beer. And yet it's found on absolutely every table in the country. First appearing in Mongolia in the late 13th century, the alcohol quickly migrated to the southeast and became a Korean speciality. It was traditionally made from rice, but the rationing imposed by the years of dictatorship following the Korean War forced distilleries to revert to using grain for industrial production. Today, this drink is sold for a modest sum (around 2 dollars a bottle) which Koreans of all social classes drink in astronomical quantities. So much so that it's the best-selling spirit in the world. Each year, an average 650 million bottles are sold under the market-leading Jinro brand alone. A massive figure which is explained by the fact that the beverage in question is quite unlike other types of alcohol. "I always think soju is a bit like a unicorn," explains Julia Mellor, Korean alcohol specialist for The Sool Company. "It's a drink that's confusing to Westerners because it falls between several different categories. Like whisky or rum, it's a distilled beverage but is unusual in that it often contains a fairly low percentage of alcohol. Also, soju is drunk like a fermented alcohol, while eating, as you'd drink a beer or a bottle of wine. It's a weird crossbreed which makes it harder for foreigners to get to grips with." One thing's for sure: you only need to spend a few evenings in South Korea to understand how ubiquitous soju is. The biggest brands now even sponsor K-pop stars. At the same time, soju-based cocktail recipes are becoming more widespread, for example *somek* is a mixture of beer and soju which is very popular with young people.

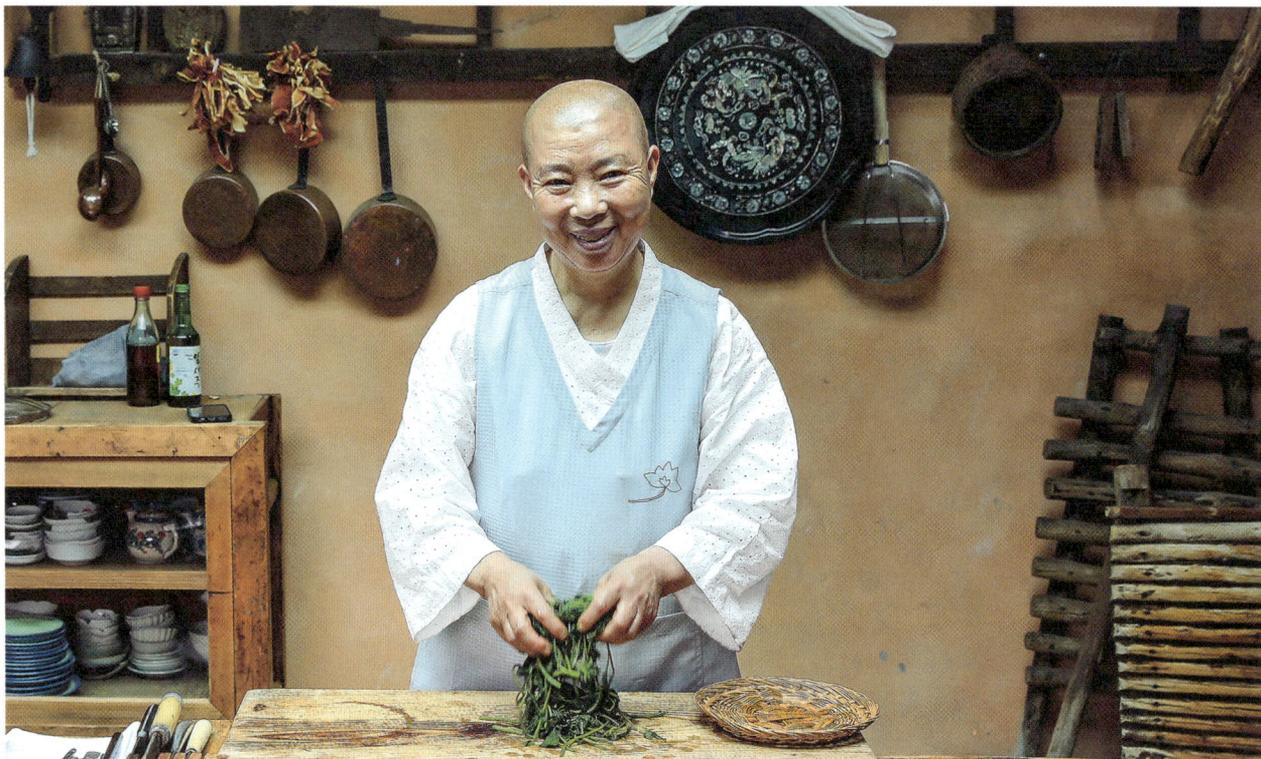

South Korea's best chef is a nun

A vegan and environmentalist, Jeong Kwan takes the slow road in order to respect her ingredients.

The new star of Korean cuisine is a Buddhist nun. At the age of 66, Jeong Kwan has become famous around the world thanks to the American show *Chef's Table* broadcast on Netflix. In the programme, we learn about her delicate culinary art built on environmental principles and a philosophy inherited from Buddhist teaching. A spiritual path that she follows in a remote monastery in South Korea, where she prepares meals for the monks. Strictly vegan and based on cabbage, mushrooms and vegetables from her garden, her cuisine respects the seasons and offers an almost meditative approach to gastronomy. At a time when the Western world is talking about "slow food", "short food supply chains" and "locavores", Jeong Kwan's culinary approach is more relevant than ever. For this reason, the nun was named Asia's foremost culinary star, winning the Icon Award in the 2022 edition of Asia's 50 Best Restaurants. A woman of total peace and serenity.

"Let nature take care of it."

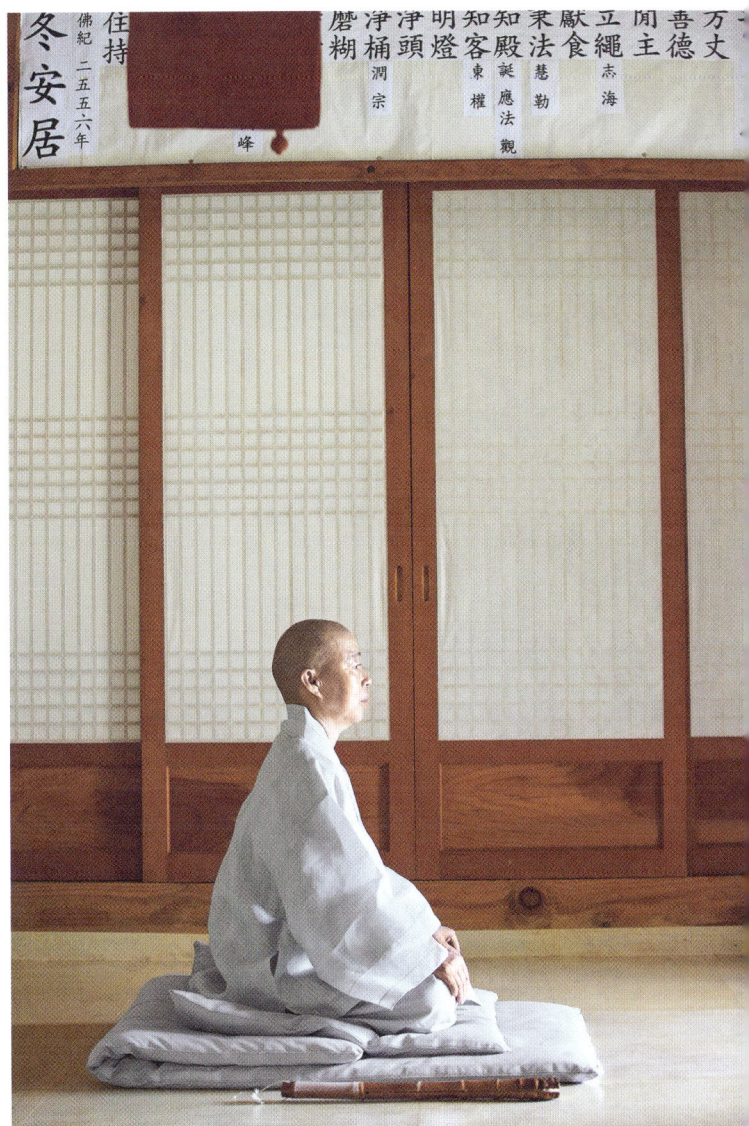

spirituality

다 하 통 장
5
FOCUS

When it comes to faith and spirituality, different traditions happily mix and match in South Korea.

The country has been impacted by many different spiritual and religious influences, making it sometimes difficult to disentangle one from the other. Officially, South Korea has a majority of Christians, around 30% of the population, split between Protestantism and Catholicism. Christianity was introduced to Korea in the 18th century, during the last Yi dynasty, via the works of the Jesuits that were published in China. The church in Korea was regarded with suspicion and some Christians suffered persecution and imprisonment. In 1883, bowing to international pressure, the kingdom of Korea agreed to allow religious freedom in the country. Initiated by the British and Americans, Protestant missions were immediately established in Korea with the aim of spreading Christianity. From 1910, the peninsula was occupied by Japan which tried to impose its state religion of Shintoism, a polytheistic faith venerating the forces that animate nature. As a result, Christians sided with the Korean nationalist movement and largely supported the independence of South Korea. After the end of the Japanese occupation, and then the Korean War, Christianity was seen as an ideological defence against the communism of North Korea. It therefore developed very quickly and eventually surpassed Buddhism in terms of number of followers.

↓
The Haeinsa temple houses the 81,258 wooden blocks of the *Tripitaka Koreana* left to the guardianship of monks.

→
Koreans came out in large numbers to meet Pope John Paul II during his visit to Seoul on 6 June 1984.

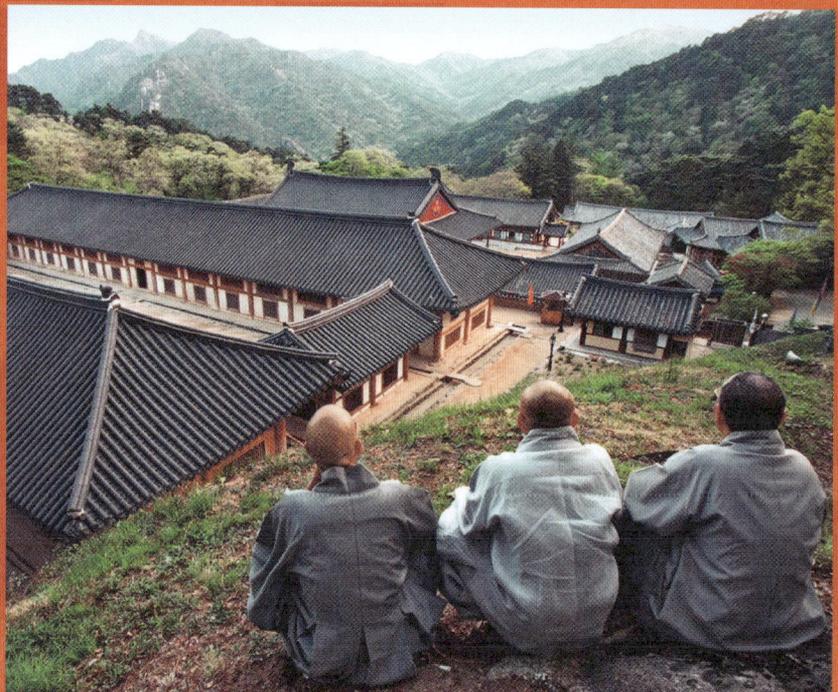

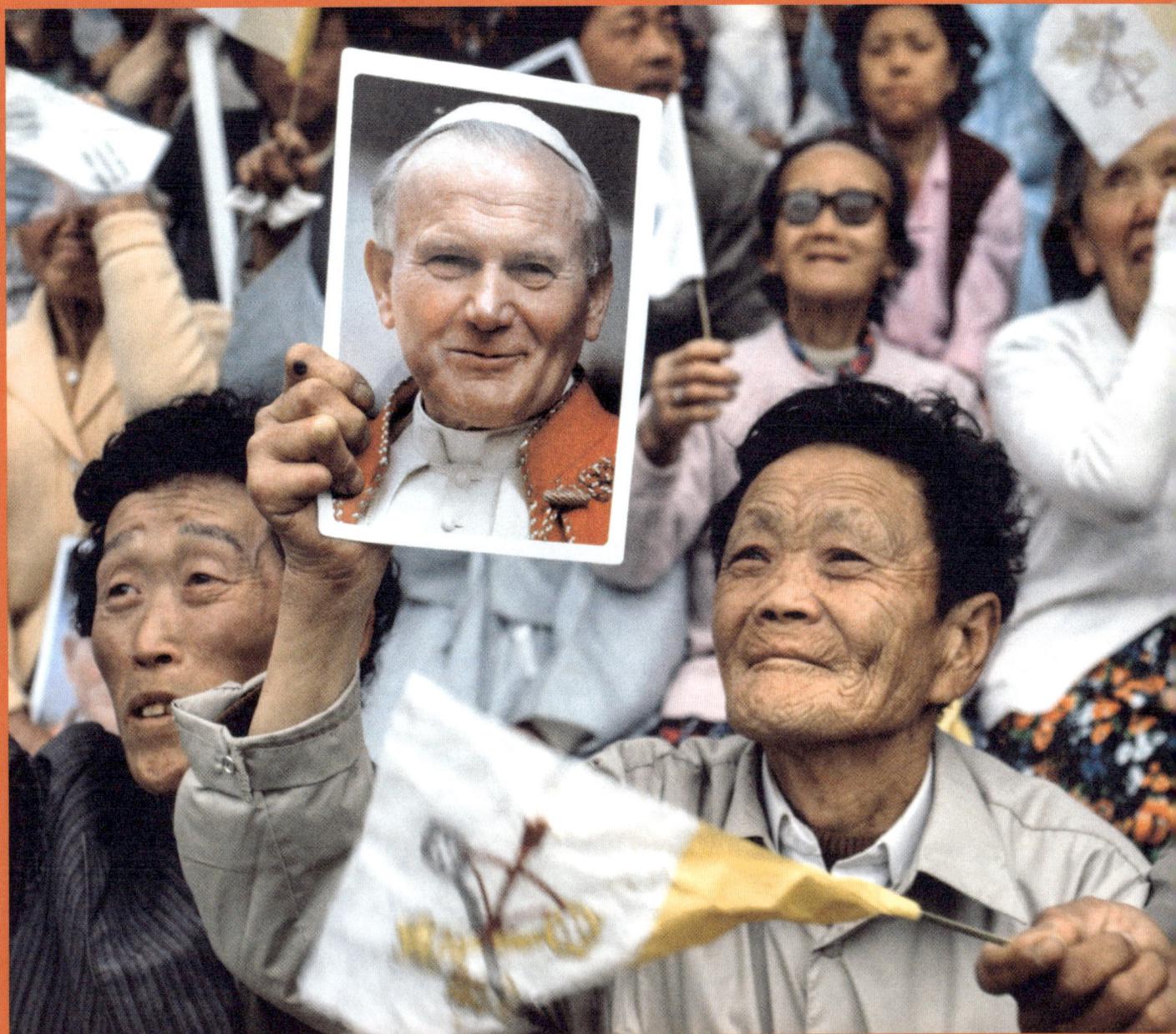

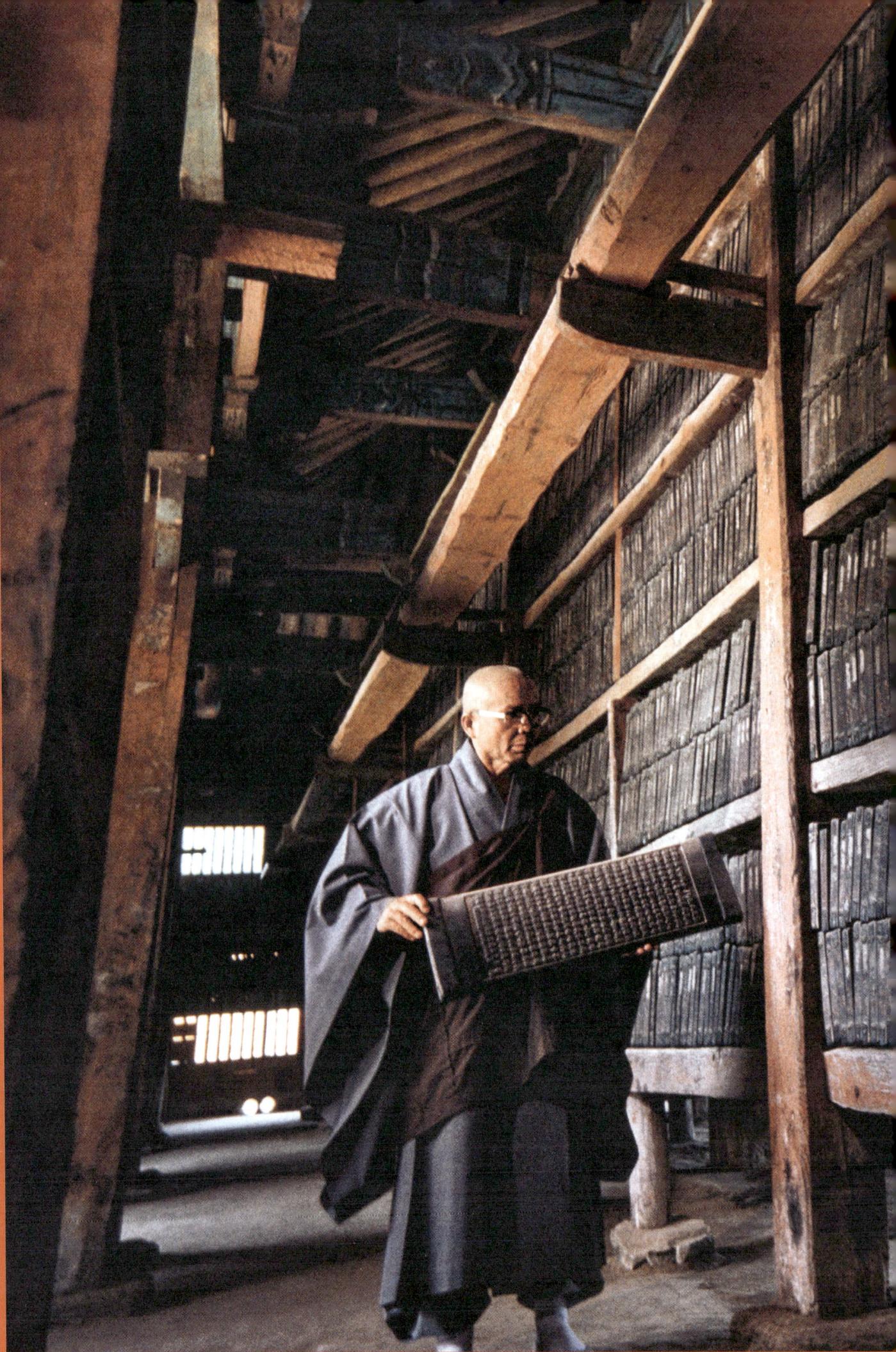

P. 158-159
—
The 13th-century woodblocks of the *Tripitaka Koreana* are engraved with one of the founding texts of Buddhism. The blocks and the temple that houses them have been on the UNESCO World Heritage List since 1995.

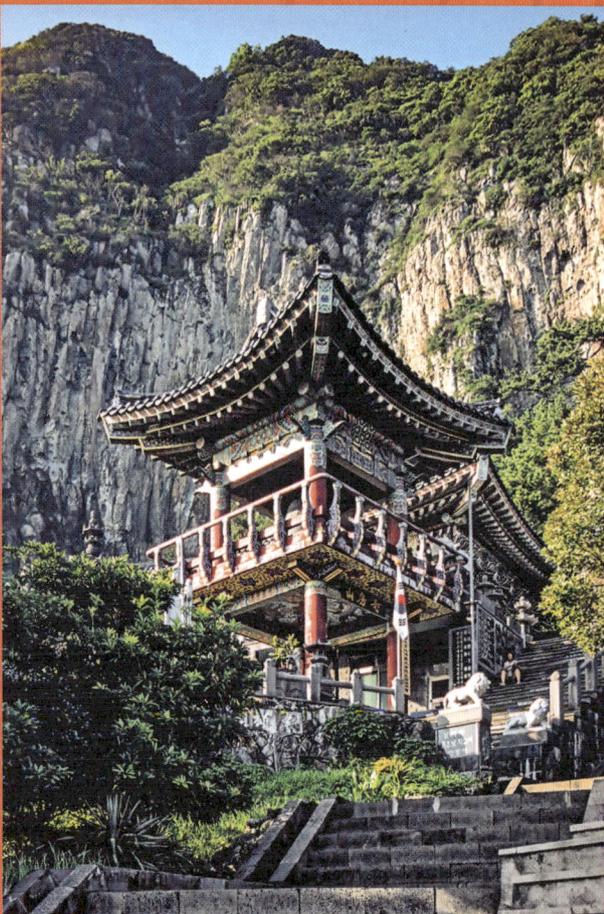

Buddhism was introduced to Korea in 374, 800 years after the historical death of the Buddha. The Korean version of this religion incorporates elements of shamanism, the only form of worship that existed prior to its arrival on the peninsula. During the Goryeo dynasty (918-1392), Buddhism became the state religion while coexisting with other currents of thought such as Taoism and Confucianism. This was a productive period for Buddhist doctrine, resulting in the creation of the *Tripitaka Koreana*, a collection of sacred texts engraved on both sides of 81,258 woodblocks and divided into 6,568 volumes, all of which are preserved at the Haeinsa temple near Daegu. Despite its widespread presence - and probably because of the corruption among its elites - Korean Buddhism lost influence during the Joseon dynasty (1392-1910) when it was heavily repressed. During the occupation that followed this period, the Japanese also imposed a large number of regulations on Buddhist practices. With the rise of Christianity after the Korean War, Buddhism lost its status as the majority religion. Today, around 20% of Koreans are Buddhist and the country has a number of beautiful temples, such as Gilsangsa in Seoul, Golgulsa near Gyeongju, and Haeinsa (which houses the *Tripitaka Koreana*) in the wilds of the Gayasan National Park.

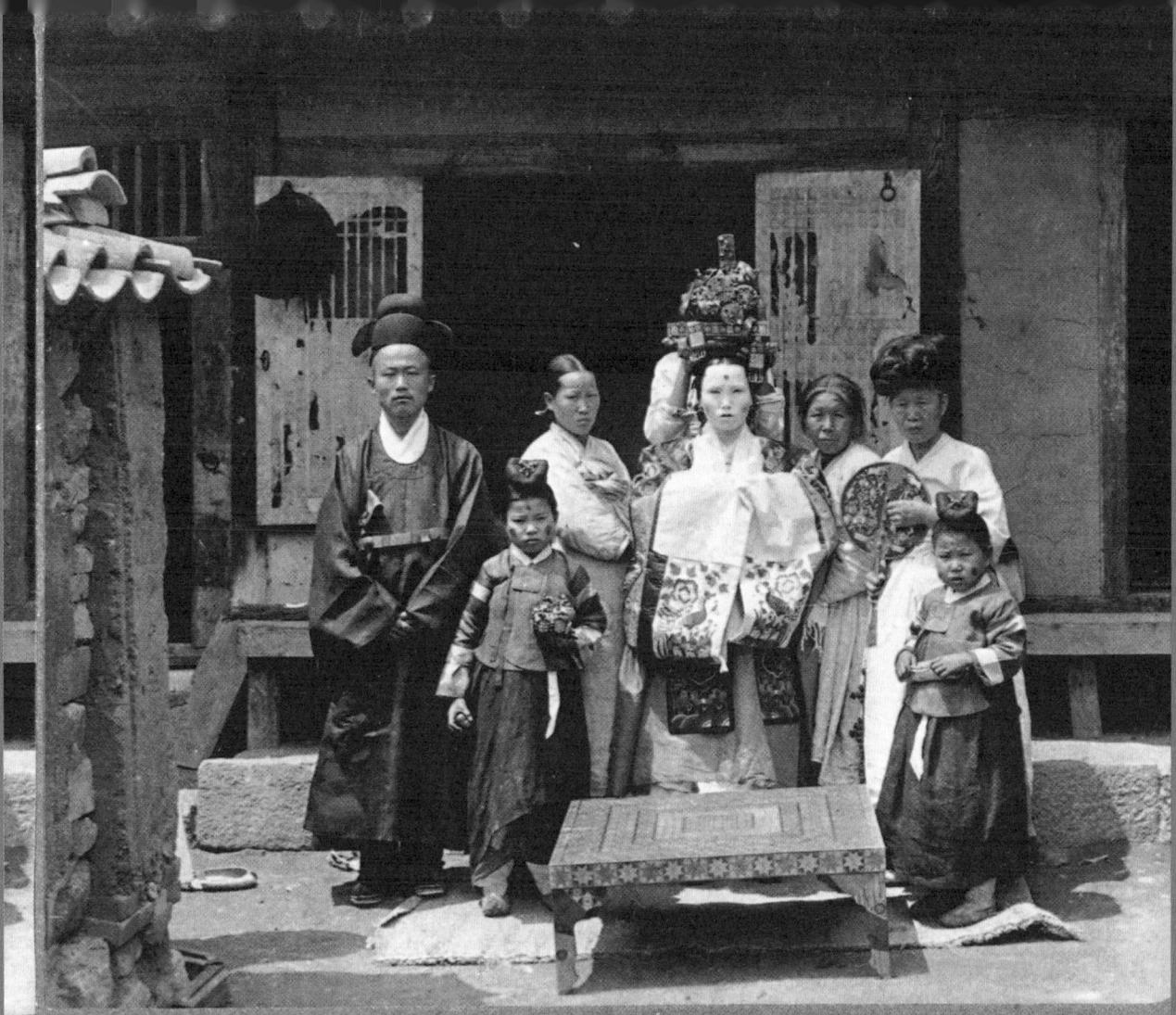

Despite the development of Korean society and the establishment of religions such as Buddhism and Christianity over the course of the country's history, certain beliefs specific to shamanism have never completely disappeared. Ungoverned by any church or political authority, they blend easily with other religions (particularly Buddhism), making it difficult to accurately measure the number of people who practise this faith. Considered the oldest belief system on the peninsula, shamanism has existed in Korea since the country was founded in 2333 BC. It revolves around the animistic worship of nature and ancestral spirits. Many people in South Korea believe that when a person dies, their spirit doesn't disappear immediately, but remains with their descendants for several generations. To honour these spirits and those that inhabit nature, a number of ancient rites are performed such as the *kosa*, in which offerings are made to spirits before starting a business, and the *kut*, a shamanic dance used to contact spirits and predict the future. The second ritual is practised by the *mudang*, a shaman who acts as an intermediary between human and divine reality. Officially, there are more than 40,000 of them in South Korea. In 2016, a major political scandal erupted in the country when the media reported on the relationship between the President of the

Republic, Park Geun-hye, and Choi Soon-sil, a businesswoman and daughter of a shaman leader. In her role as confidante, Choi allegedly used her power to influence the president, directing national policy and extorting the equivalent of 60 million dollars from large business conglomerates known as chaebol. Outraged that a *mudang* was discreetly pulling the strings of power, Koreans took to the streets and President Park Geun-hye was eventually deposed and sentenced to 30 years in prison. The scandal represented all of the paradoxes that drive modern Korean society, torn as it is between the desire to change and make progress, and the ties it has to its roots and ancestral traditions related to shamanism. This contrast is perfectly exemplified in the phenomenon of online shamanism which has developed over recent years. The internet has encouraged the revival of these beliefs and today many South Korean shamans have their own YouTube channels where they post videos of their various rituals. Some of them have even become influential personalities on the web, such as the queer and feminist shaman Hong Kali. "I think it's a positive thing that shamans are communicating with others through different channels. It allows the voices of diverse speakers

to be heard in various forms," she told *The Korea Times* in an interview. Walking a line between ancient traditions and new technologies, Korean religions have proved that they're capable of embracing both.

→
Korean shamanic ritual at a ceremony in 2005.

6

K-LIFE

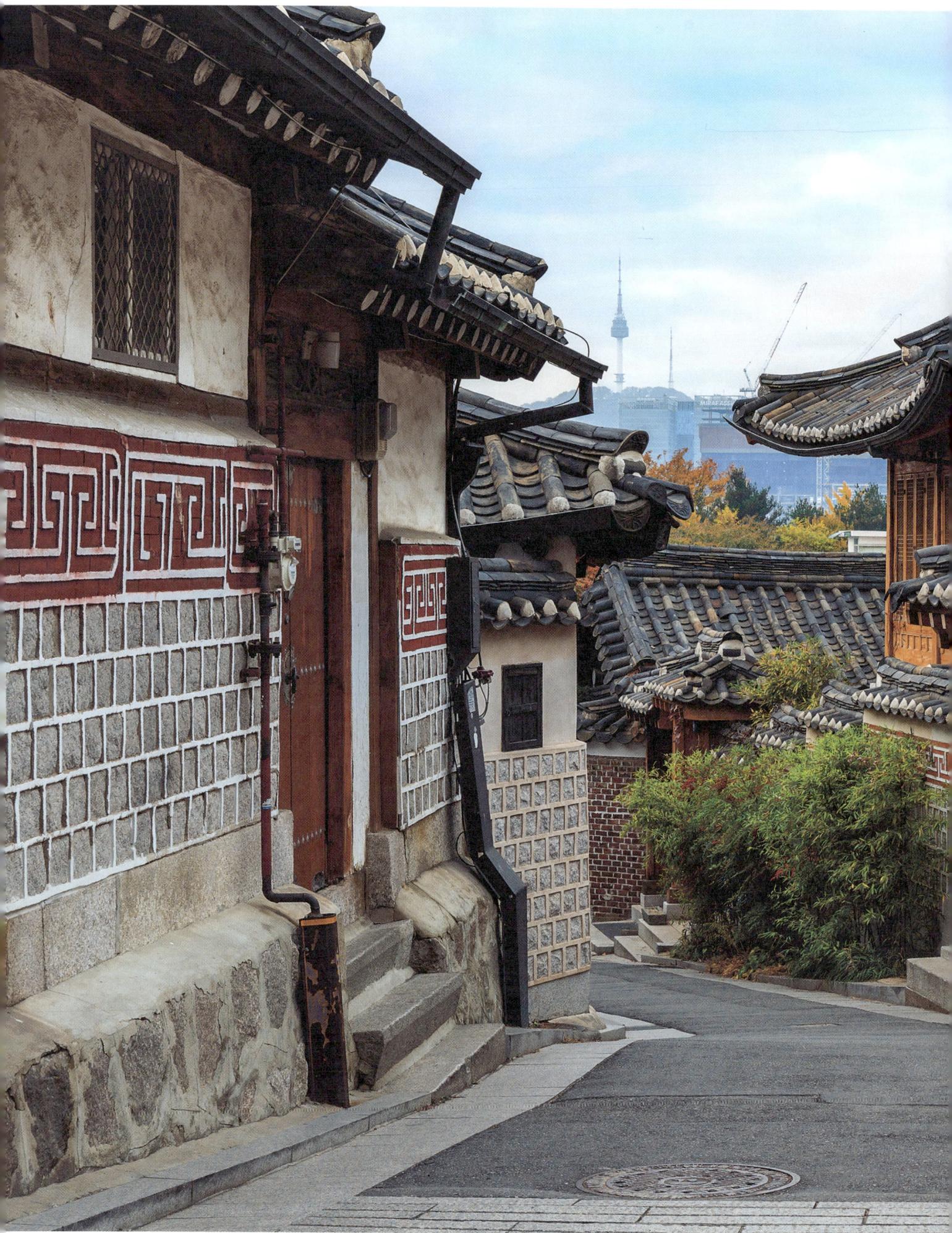

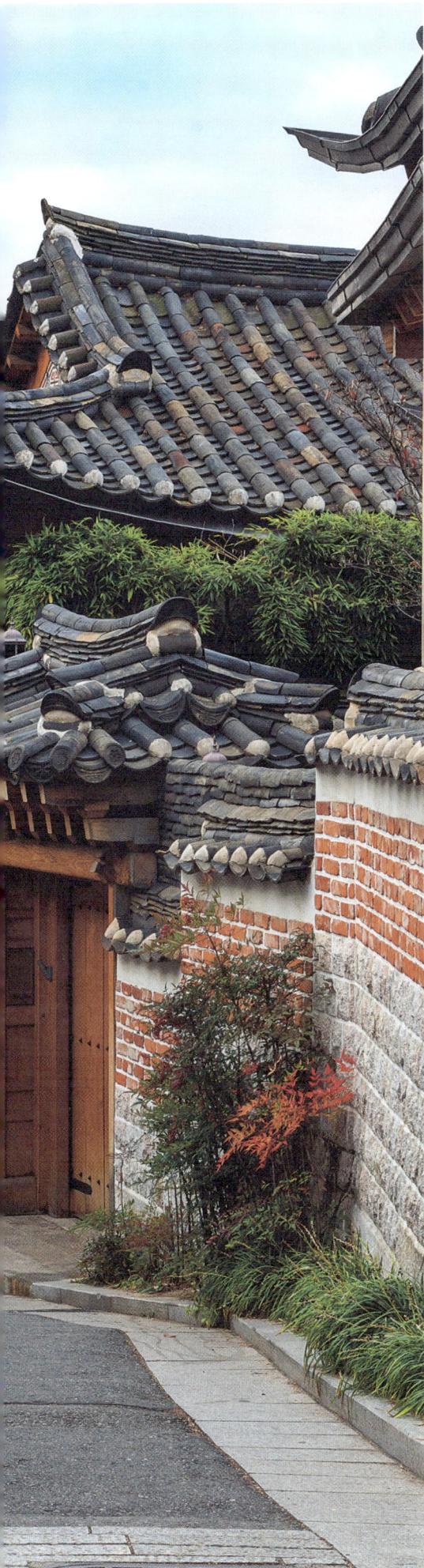

INTRODUCTION

P. 164–165
–
Maisan mountain towers over the town of Jinan on a winter morning.

←
The hilly neighbourhood of Bukchon Hanok Maeul in Seoul and its traditional houses.

Constantly oscillating between calm and chaos, South Korea lives at a unique pace which requires special mastery.

South Korea is a country that never sleeps. You only have to spend a short time here to see this in action. In big cities like Seoul and Busan, the streets never completely empty, regardless of the hour. Everyone seems to be constantly on the move, charging at full tilt, without ever having time to stop. The Koreans have a term to describe this frenetic pace of life: *ppalli-ppalli*. Translated literally, this expression means "fast" or "frenzied". In practice, this translates into vertiginous internet speeds, intensive lessons to excel at school, marathon days at work, and fast-paced evenings running from one bar to another. In his book *Way Back into Korea*, anthropologist Kim Choong-soon analyses this philosophy: "The practice of *ppalli-ppalli* is not merely part of daily life for Koreans; expeditiousness is embedded deeply in their minds as a basic value. Thanks to this culture of hurry, South Korea was able to achieve tremendous economic progress and industrialisation in a very short period of time." To outsiders, it looks as if Koreans are trying to make up for lost time. To see why this might be the case and understand their mindset, philosophy and way of life, we have to look to the past.

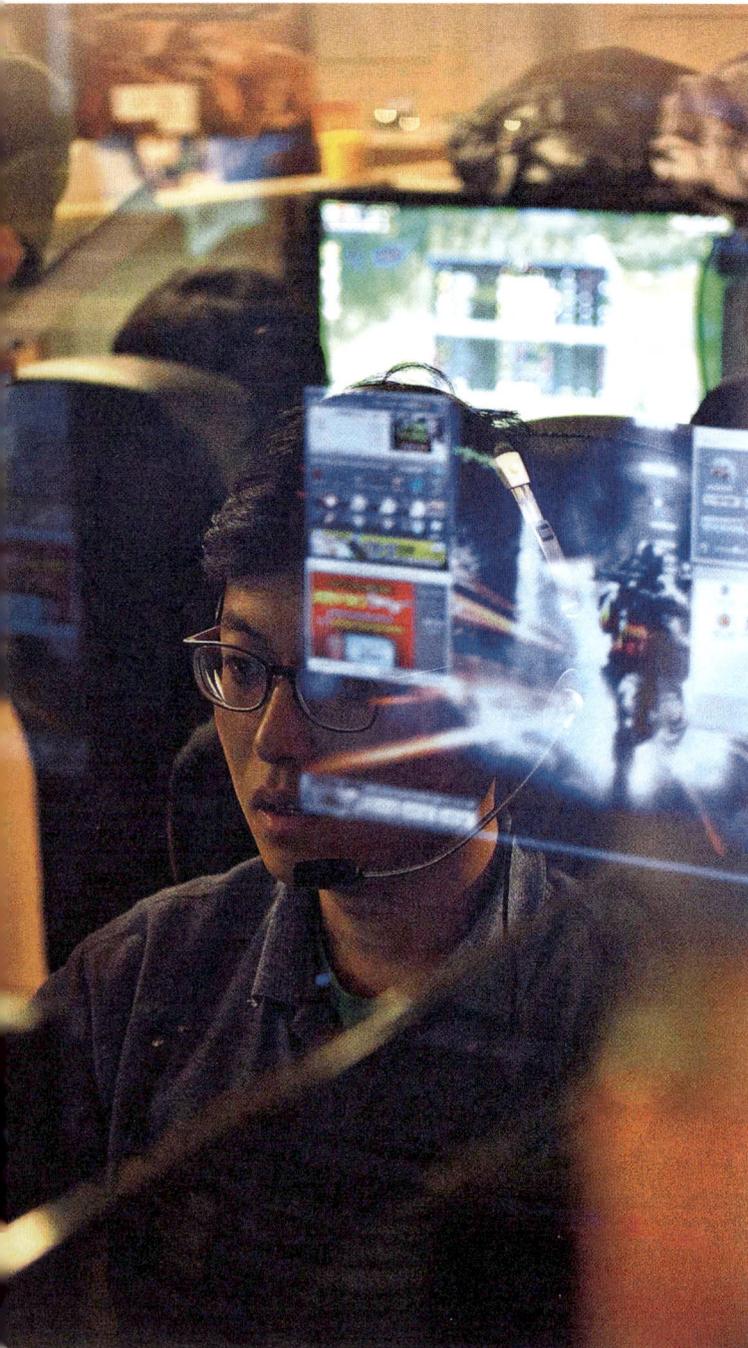

To outsiders, it looks as if Koreans are trying to make up for lost time.

For many years, Korea was dubbed the "hermit kingdom" by the West. At the end of the 19th century, the peninsula was shut off from the rest of the planet and plagued by numerous internal crises. It communicated only rarely with the outside world. Isolated to the north, Korea also fell under the influence of Japan when it became a protectorate in 1896 and was then annexed as a colony in 1910. It wasn't until the end of the Second World War that the peninsula freed itself from Japanese rule. But it was then almost immediatcly divided into two states. From that time onwards, the expression "hermit kingdom" was primarily applied to North Korea or used to describe the premodern period of South Korea. Unlike its neighbour, the south was now desperate to open up to the world. Following a series of dictatorial regimes, the country started its democratic transition in the 1980s and established the current Sixth Republic in 1987. It was at this point that everything started to take off. Determined not to waste any more time, South Korea went through a spectacular economic boom which saw its status change from developing country to developed country in record time. This period of soaring growth is known as the "Miracle on the Han River" and was founded on two key pillars: the rise of large family-run conglomerates (such as Samsung, LG and Hyundai) and a policy of exporting Korean culture. In addition to economic considerations, this period of rapid acceleration has had an obvious impact on the population's way of life. In 1960, 72% of South Koreans lived in the countryside and at their own pace. Today, this figure is only just over 15%. Town is the place to be.

Koreans have worked incredibly hard to bring about this economic boom. Maybe even a little too hard. Their society is now so fully focused on performance at work that time spent at the office often borders on the insane. Far removed from the luxury of the 35-hour week that operates in some European countries such as France, Korean employees often spend 50 to 60 hours a week at the workplace. The competitive spirit that became the norm during the economic boom is partly responsible for these disturbing figures. It also explains why South Koreans have some of the shortest sleeping hours in the world, averaging 7 hours and 41 minutes a night. It's not uncommon to see people dozing off in cafés or on public transport. Another reason for this lack of sleep is the vast range of distractions offered by large cities like Seoul. Thanks to this accelerated growth,

←
Gaming internet cafés known as PC bang are a popular source of entertainment in South Korea.

↓
N Seoul Tower dominates the Korean capital and is seen as a symbol of the city.

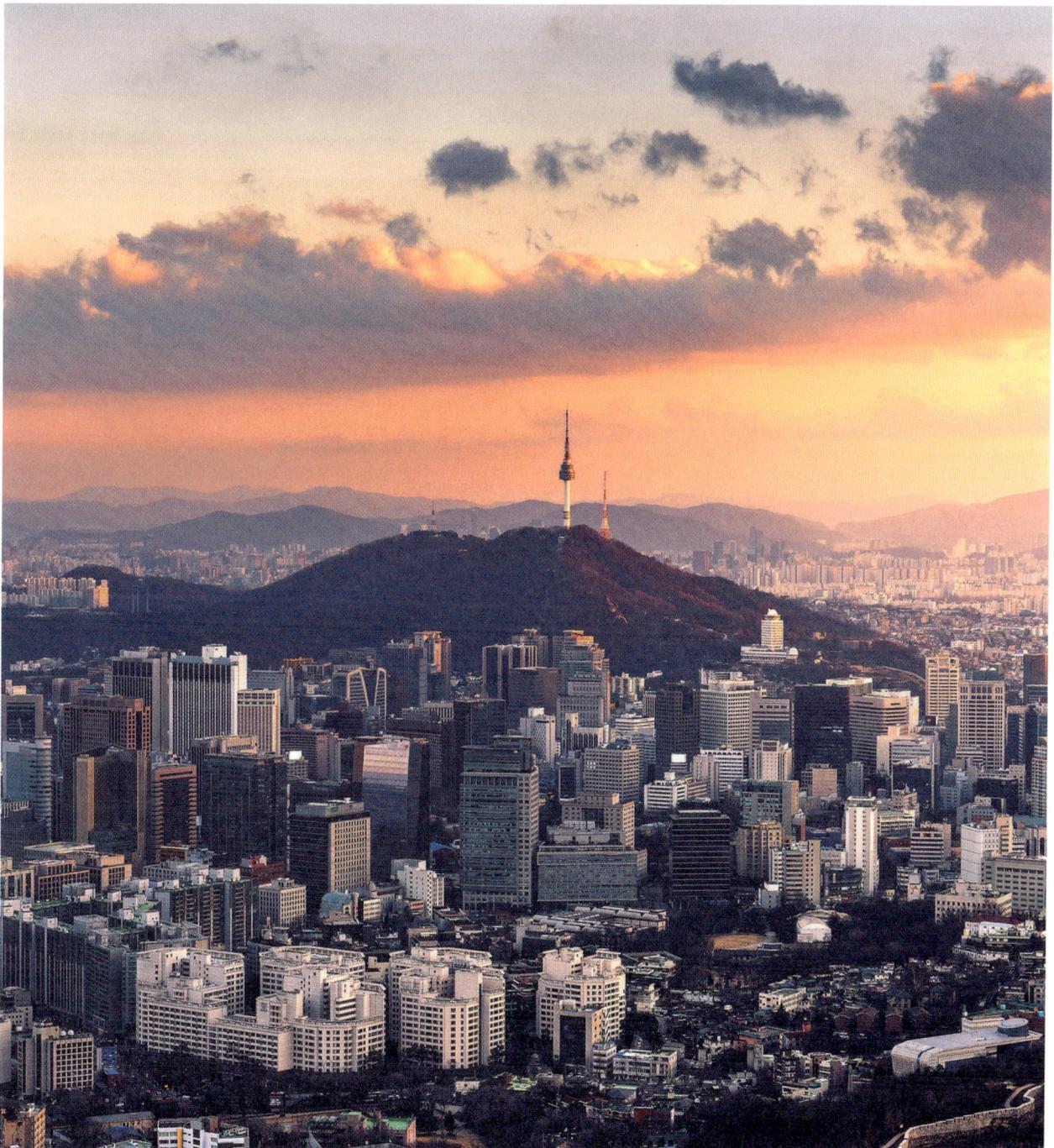

the country is now one of the most connected in the world. Technology is omnipresent here and it often monopolises the attention of Koreans once the working day is over. For example, PC bang are cafés dedicated to online gaming and they play an important role in the lifestyle of Koreans who spend long hours here with their eyes glued to the screen. These venues were responsible for the development of esports, one of the country's specialities. Perhaps because they provide a good way of decompressing, these online gaming competitions have become particularly popular. While Koreans may spend a lot of time online, they also like their cultural outings. The country offers a multitude of novel activities such as Korean-style public baths (known as *jjimjilbang*), spectacular libraries and unusual museums. There's no time to be bored in Korea.

South Korea is torn between the weight of tradition and the rampant modernity it now embraces. On issues such as tattooing and sex, its conservative side can sometimes push it towards carrying out rearguard actions. In other areas of life, its widespread hyperactivity leaves some people on the sidelines; for example, the elderly still don't benefit from an effective pension system. It's not so easy to grow at such a fast pace, and if South Korea is to continue to be a country that offers an attractive lifestyle, it will have to face a challenge that might be trickier than it looks: learning to take its foot off the pedal.

Technology is omnipresent and monopolises the attention of Koreans once the working day is over.

→
Dusk falls on a statue of the Buddha in the Bongeunsa temple in the Gangnam district of Seoul.

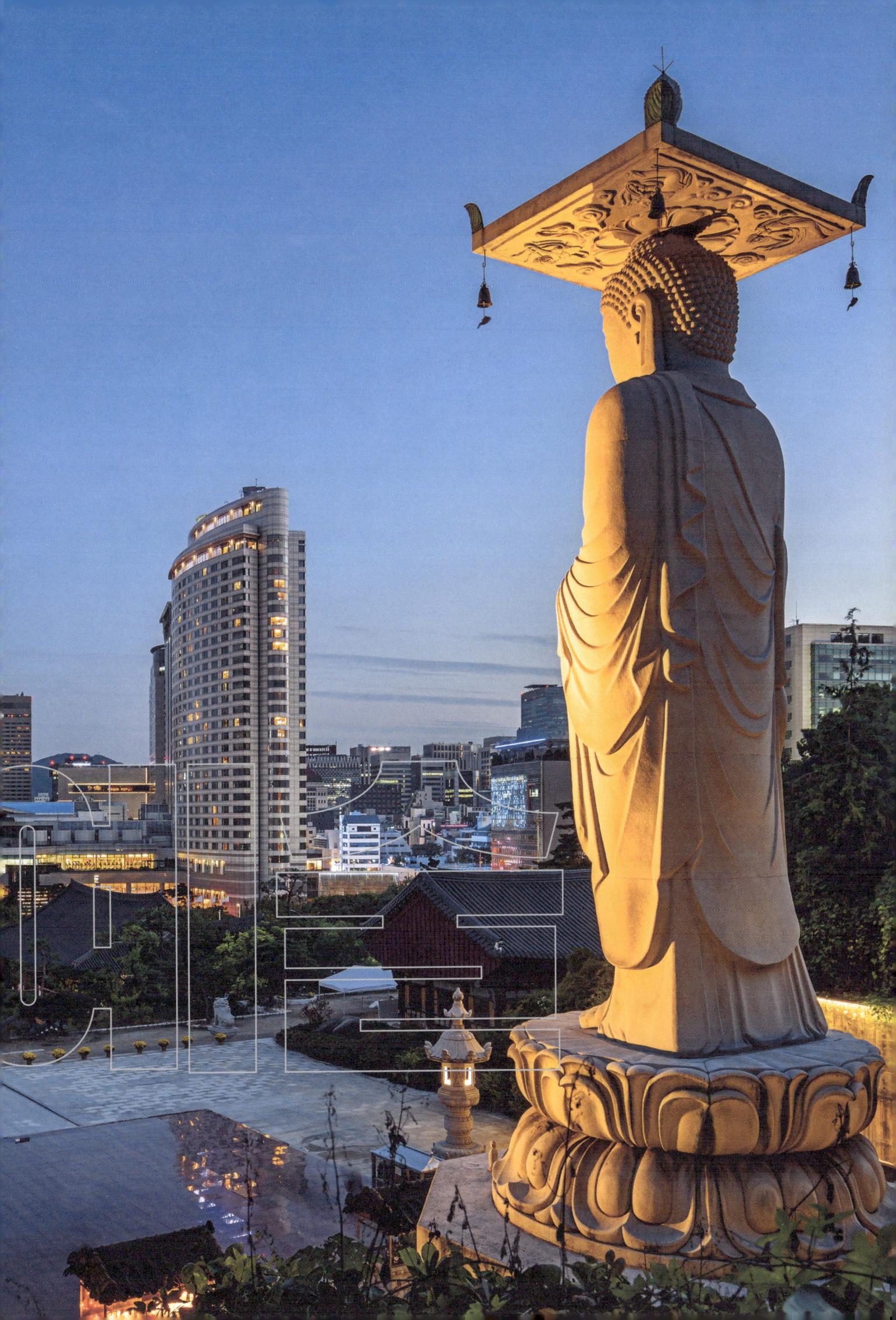

JJIMJILBANG

THE BARE NECESSITIES

찜질방

There's more to Korean public baths than naked people. Cinemas, karaoke rooms and table tennis are also on offer.

While Koreans might be thought of as a relatively reserved people, their *jjimjilbang* or public baths blow the stereotype out of the water. They've been in existence in Korea since the 15th century and are important social venues where bathers spend hours alternating between hot baths, cold baths, saunas and steam rooms. But be warned: don't expect to come here in your swimming gear. At the jjimjilbang, everyone is fully naked. And obviously men and women don't mix. As well as the services typical of a classic spa, the baths also offer a large number of on-site activities which can be enjoyed under the modesty of a robe: restaurants, arcade games, karaoke rooms, table tennis and cinemas. In other words, think of *jjimjilbang* as a condensed version of Korean popular culture with added nudity. In Seoul, one of the best known is the Dragon Hill Spa next to Yongsan station. Open 24 hours a day at an unbeatable price, it can even save you a night in a hotel.

↓
Jjimjilbang play an important social role in Korea. In addition to the rest and relaxation offered by the baths, other facilities are available such as large rooms for watching TV.

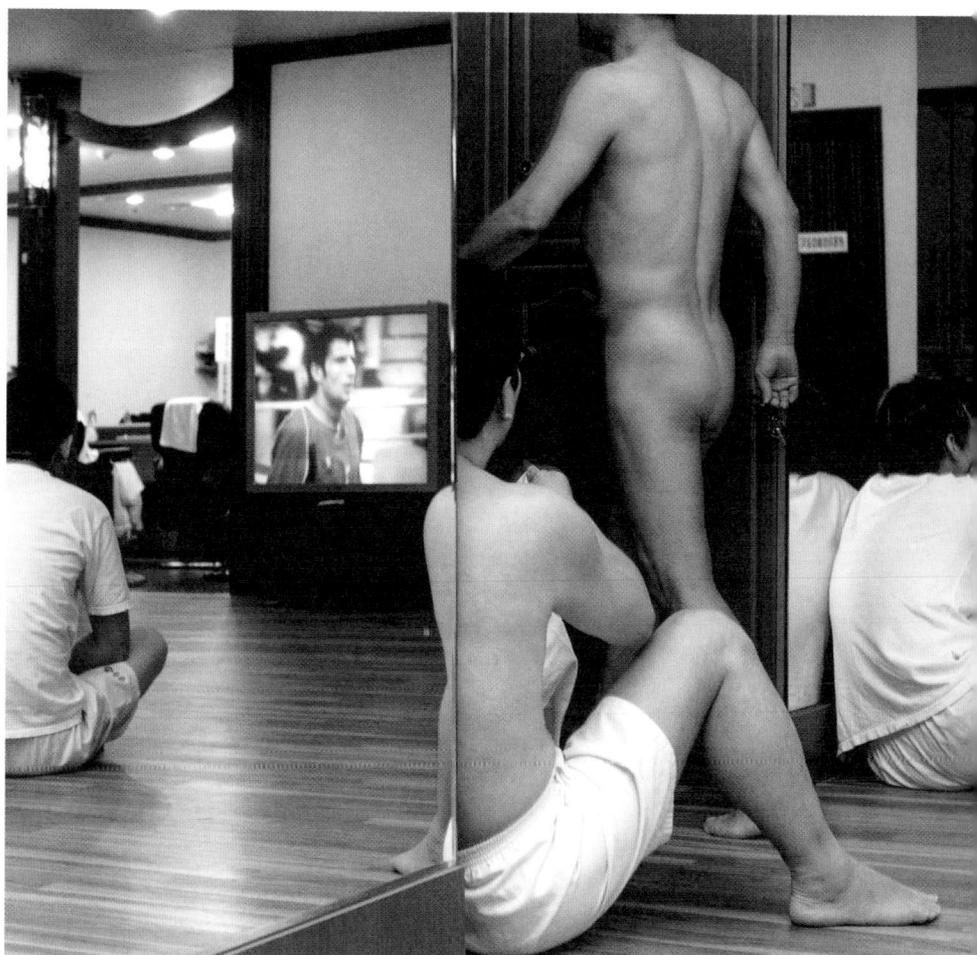

STARFIELD COEX LIBRARY

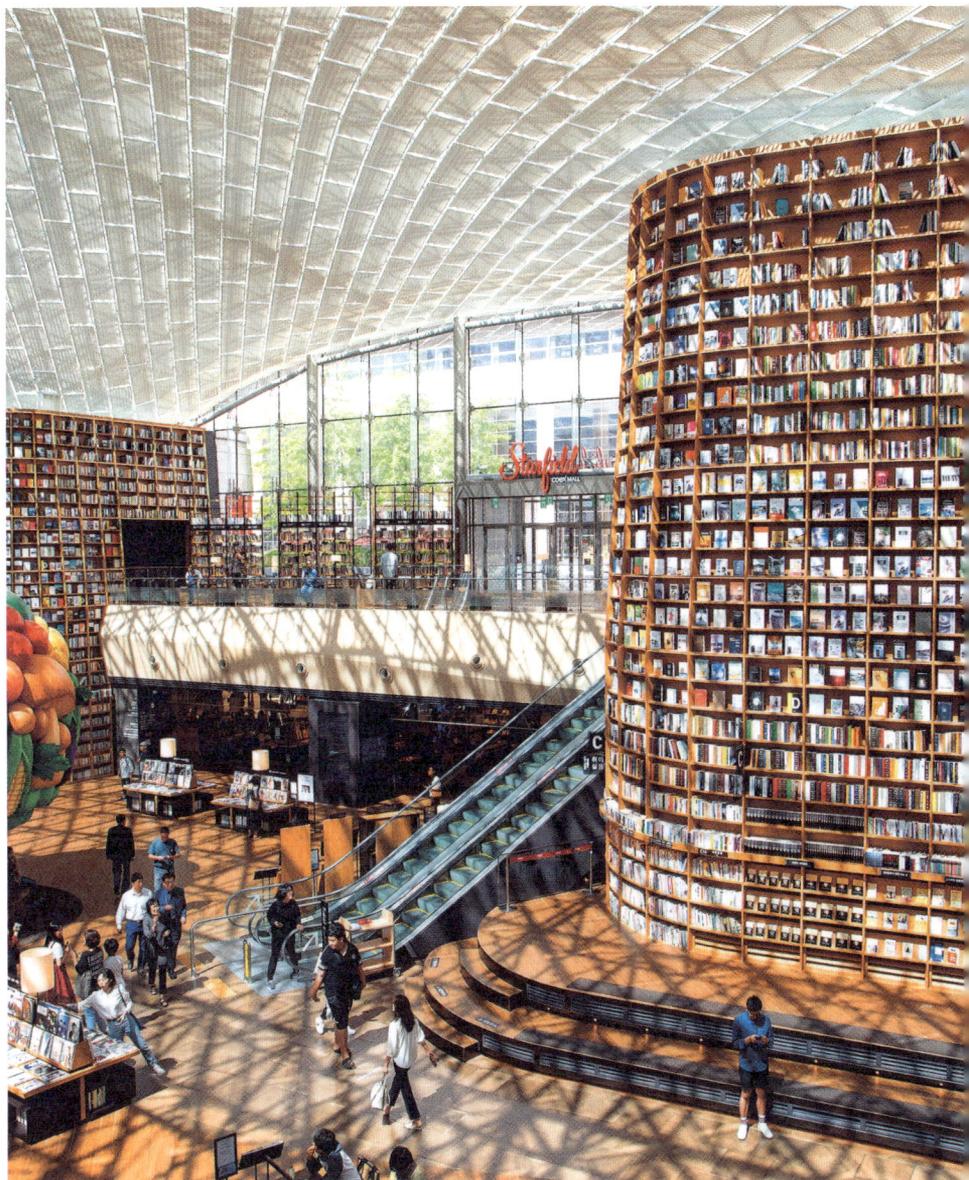

The most beautiful library in Seoul sits right in the middle of a shopping centre.

Located in the Coex Mall in Gangnam, the Starfield Library never fails to impress. The entrance is via the upper floor, immediately giving visitors an amazing bird's eye view. Most striking are the gigantic book–filled columns supporting the glass ceiling. With a footprint of 2,500 square metres, the library has more than 50,000 books and also organises exhibitions and concerts. Open to the general public and usually busy, its spaces blend harmoniously into the rest of the shopping centre, making it a place both to read and to hang out. Given the spectacular appearance of the Starfield Library, it's not uncommon to find YouTubers filming vlogs here or to see influencers getting the right angle for the perfect shot. The vibe is certainly very different from your typical Western library.

↑
The architecture of the library is stunning, with books seemingly playing a more decorative than intellectual role!

173

NAVER

THE KOREAN GOOGLE

Google has failed to conquer Korea. Unlike Naver, which took its place.

South Korea is one of the rare countries in the world where Google has never secured a dominant market share. The Naver platform is the number one browser, way ahead of the American giant. "When the internet was first created, the content available in Korean was relatively sparse and poorly referenced. We were able to maximise its potential," explained Nam Ji-woong, head of communication at Naver, to the newspaper *Libération*. Launched in 1999, the platform known as "the Korean Google" combines a search engine, news feed, email function, discussion forums and many other features. In 2004, Naver also launched Webtoon, an online comic book service which has significantly contributed to the Korean craze for manga in recent years. Today, Webtoon has 82 million users worldwide and Naver have offices in Tokyo, Paris and Los Angeles too. Korean tech sets out to conquer the world.

THE JINDO GAE

A LOYAL FRIEND

진돗개

This iconic South Korean dog has become a much-loved symbol in popular culture.

Of the four hundred dog breeds listed in the world, seven are specific to Korea. The best known is the Jindo-gae which originated from the island of the same name on the south-west coast of the peninsula where it was used to guard houses in the countryside. Strong and lively, the dog's appearance is little changed from its wolf ancestors, and over time it's acquired iconic status, featuring regularly in Korea's pop culture. For example, the anime *White Heart Baekgu* tells the true story of Baekgu, a Jindo-gae who travelled 260km (160 miles) for six months in 1995 to find his former owners. The unparalleled loyalty of the breed is one of the main reasons why Koreans love these dogs so much. It also explains why photos of them regularly go viral in parodies and memes on the internet, just like their Japanese counterpart, the shiba.

→
The Jindo-gae is an excellent hunter with a strong sense of direction and known for being courageous, vigilant and extremely loyal.

↖
Naver is the go-to search engine in Korea.

175

LOVE LAND

ISLAND OF TEMPTATION

유혹의 섬

For the perfect pre-honeymoon recon, there's nothing better than an exhibition all about sex.

When it comes to sex, South Korea is still a highly conservative country. Pornography is prohibited and sex education classes are non-existent. In 2004, this situation prompted twenty graduate artists from the art school at Hongik University to combine their talents and open a theme park dedicated to sexuality, which they called Love Land. Located on the island of Jeju, a popular honeymoon destination for Koreans, it covers almost 4,000 square metres and contains 140 erotic sculptures which certainly aren't backward in coming forward. Some also demonstrate a great sense of humour and the overall atmosphere at Love Land is good-natured and friendly. Newlywed young couples giggle shyly among the statues, taking pictures of each other next to giant phalluses and collecting ideas to spice up their night before returning to the hotel. This venue is definitely not suitable for families and is only open to visitors aged 18 and over.

↑
On Jeju Island, 140 erotic sculptures welcome visitors to this outdoor museum.

→
Gamers play *League of Legends* at the PC Bang Tournament held at the Lion Internet Café in Seoul in June 2012.

PC BANG

R & R AT THE CYBERCAFÉ

A meeting place for geeks to play online throughout the night.

An iconic part of South Korean life, it's not uncommon for scenes in TV dramas and films to be shot here. A PC bang is an internet café that's open 24/7 and specialises in video games. When they first appeared in the mid-1990s, Koreans mainly came here to carry out small everyday tasks such as answering emails, printing documents and browsing websites. When the video game StarCraft was released in 1999, the venues began to proliferate on a huge scale to cope with the craze for the game and the growing demands of online multiplayer formats. Since then, even though South Korea has one of the world's best rates of access to high-speed broadband, habits die hard and the PC bang has become a social space where players can meet and chat between rounds of a game. It's also possible to eat and drink on-site, or even spend the whole night in front of a screen. At around $1 an hour, it's still cheaper than a hotel.

MINORITY REPORT

VIDEO SURVEILLANCE

South Korea is watching you. All the time and in all locations.

In principle, a trip to South Korea is entirely risk-free. It's one of the safest countries in the world. There are no dangers to worry about when walking home alone in the evening, or leaving your bike unlocked in the street while you run an errand. This is partly due to the video surveillance system that's present absolutely everywhere in towns and cities. And when it comes to this issue, the Korean government doesn't seem to be particularly concerned about questions of privacy. In 2021, the National Assembly even passed a law allowing cameras to be installed in operating theatres to ensure that all medical procedures are done by the book. But it gets even more surprising. For the last two years, the district of Seoul has been equipped with a video surveillance system using artificial intelligence which allows crimes to be detected before they're even committed. The 3,000 cameras in question identify suspicious behaviour, abnormal movements or people carrying dangerous objects, and then notify neighbouring police stations. A *Minority Report* scenario that might send shivers down your spine.

↓
Surveillance cameras are everywhere in Korea. Even under the roofs of temples in Seoul where they don't exactly blend into the architecture…

→
Dedicated to toilets and the art of using them correctly, the Mr Toilet House museum is shaped like a toilet bowl.

MR TOILET HOUSE

A WEIRD AND WONDERFUL WC

How to get everyone to visit your toilet...

It's one of the strangest museums in South Korea. Not least because of its shape: a huge and spotlessly white toilet bowl. This eccentric building in Suwon was once the home of the city's mayor, Sim Jae-duck. Legend has it that he was born in his grandmother's toilet and as a result dedicated much of his life to promoting clean, hygienic and user-friendly public WCs. This earned him the playful nickname of Mr Toilet. "Sim Jae-duck wanted to let people know just how important toilets are. Keeping toilets clean helps prevent transmission of disease," explained Jo Bo-bae, the site guide. "He also wanted to make toilets a place of charm and culture. Sitting on the toilet, you can listen to music, read a book, or even drink a cup of tea. This is why Mr Toilet positioned the bathroom at the centre of his house." When he died in 2009, his home was converted into an interactive museum. Here you can admire medieval latrines, see statues in action and teach children the basic rules of hygiene. Playful and scatological in equal measure.

CAMP BONIFAS GOLF COURSE

GOLF WAR

Warning: it only takes one hooked ball for things to go up in smoke.

"The most dangerous golf course in the world." This is how the famous American magazine *Sports Illustrated* described this one-hole, 170-yard course lying next to the demilitarised zone separating the two Koreas. Created in Camp Bonifas, a former United Nations military post, this synthetic turf green is surrounded by minefields on three sides. Legend has it that a stray golf ball once caused a powerful explosion after it landed on a mine, as reported in *Sports Illustrated*. For those who aren't too afraid, it's still possible to try your hand at this course, but you have to know how to keep your cool. Just opposite, a watchtower full of armed soldiers acts as a referee. It's best not to try anything too clever. No one wants to start a war over a poorly executed swing.

↑
The single hole of the Bonifas golf course is played on artificial turf.

→
Insomnia is a problem in Korean society where the population sleep for an average 7 hours and 41 minutes.

INSOMNIA

ASLEEP ON THEIR FEET

KIO

한 데 잠

Koreans don't have time to sleep, and pay the price.

South Korea is one of the most sleep-deprived nations in the world. In just a few decades, it has transitioned from developing to developed country status, thanks to the relentless hard work of the entire population. People spend almost 2,000 hours a year in the office, a record figure which results in considerable stress and overwork. Koreans sleep an average of 7 hours 41 minutes a night. It's therefore not uncommon to see young working people in Seoul dozing on public transport, in parks or even at their place of work. To address this problem, a whole sleep industry has emerged in recent years, including the phenomenon of "healing cafés": these soothing establishments offer massage chairs separated by partitions, soft music and calming herbal teas, allowing Koreans to rest for a few hours. Between two work meetings.

Tattoo artists are criminals in South Korea

The country has always had an uneasy relationship with tattoos, thanks to their close association with gangs and the mafia. And yet young people want them so much they're willing to take the illegal route.

The story of South Korea and tattoos has always been complicated. In March 2022, the country's constitutional court confirmed a law that effectively bans the practice in all but name. This means that only health professionals are authorised to perform the procedure, turning tattoo artists - who aren't part of the medical world - into criminals. South Korea is therefore the only developed country in the world where the practice of tattooing can land you in jail. Since April 2021, at least six tattoo artists have been sentenced to prison terms of up to two years. Kim Do-yoon, a member of the sector's union, was forced to pay a fine of over $3,500 after a video of him inking a Korean actor was posted online. "It's almost a joke, farcical enough to make people laugh," he told current affairs channel Vice World News. "They've convinced no one that tattooing is a medical activity. Nobody thinks that way."

It was in 1992 that tattooing in South Korea was first deemed to be a medical procedure that only a qualified doctor could perform. This regulation underlines the poor historical reputation of the practice on the peninsula, where it's long been associated with the world of organised crime. Like the yakuza of Japan, Korean mafiosi wear tattoos to denote gang membership and recognise each other. This explains the taboos that still surround the art of tattooing. But in practice, times have changed. In South Korea, as in many Western

countries, young people are increasingly drawn to tattoos and this demand will only continue to rise. According to the Korean Tattoo Association, at least one million people have been tattooed in the country and this illicit sector generates around $150 million of revenue a year. Even Jungkook, one of the singers in the famous band BTS, has to wear a bandage and long sleeves to hide his tattoos when he appears on TV so as not to offend anyone. Despite these visible changes among young people, it remains to be seen whether South Korea will continue to criminalise tattooing at all costs, effectively turning it into an open secret.

Among 20-year-olds, 4 out of 5 Koreans are in favour of lifting the restrictions on tattoos.

↓
The tattooed left hand of singer and actor Park Jae-beom.

A Korean can be three different ages

한국 나이

↑
This artwork is a multiple exposure image of people walking on the streets of Seoul.

→
Three generations of Korean women enjoying time together in a park. Three women for a multitude of different ages!

South Korea has several different systems for calculating the age of its inhabitants. With the ultimate effect of baffling everyone.

"How old are you?" It's a simple question but can cause a real headache for Koreans. Strange as it may seem, they can be several different ages at the same time. Since 1962, South Korea has officially calculated the age of its inhabitants using the international system based on a person's date of birth, like everywhere else in the world. But things get more complicated because in the ancient traditions of the country, age is worked out using a very different method, namely the Hanguk-nai system. Inspired by a perception of life inherited from Buddhism, it also counts the nine months a child spends in the mother's womb before coming into the world. Using this rule, the duration of existence is calculated from conception instead of birth. This means that only three months after birth, a Korean can celebrate their first birthday since the pregnancy is also taken into account. And as if things weren't complex enough already, a third calculation method exists which originated in China and was made official by South Korea. Under this system, a child gains a year on the 1st of January following their birth. Based on the Gregorian calendar, it means a child born in December can be two years old at the switch to the new year.

Needless to say, the coexistence of these different calculation methods generates endless confusion in South Korea. To ensure their children aren't disadvantaged at school, some parents craftily use one age rather than another. The age at which Koreans retire may also involve some creative counting, and generally speaking, administrative documents are a nightmare to complete. Like an honorary title, it defines how other people should be addressed and involves a number of specific issues. For several years now, politicians have been trying to pass a law to standardise how age is calculated by definitively adopting the international system. And in December 2022, the country decided to align itself with the international system so since 1 January 2023, Koreans have been administratively one year younger.

South Korea is the birthplace of esports

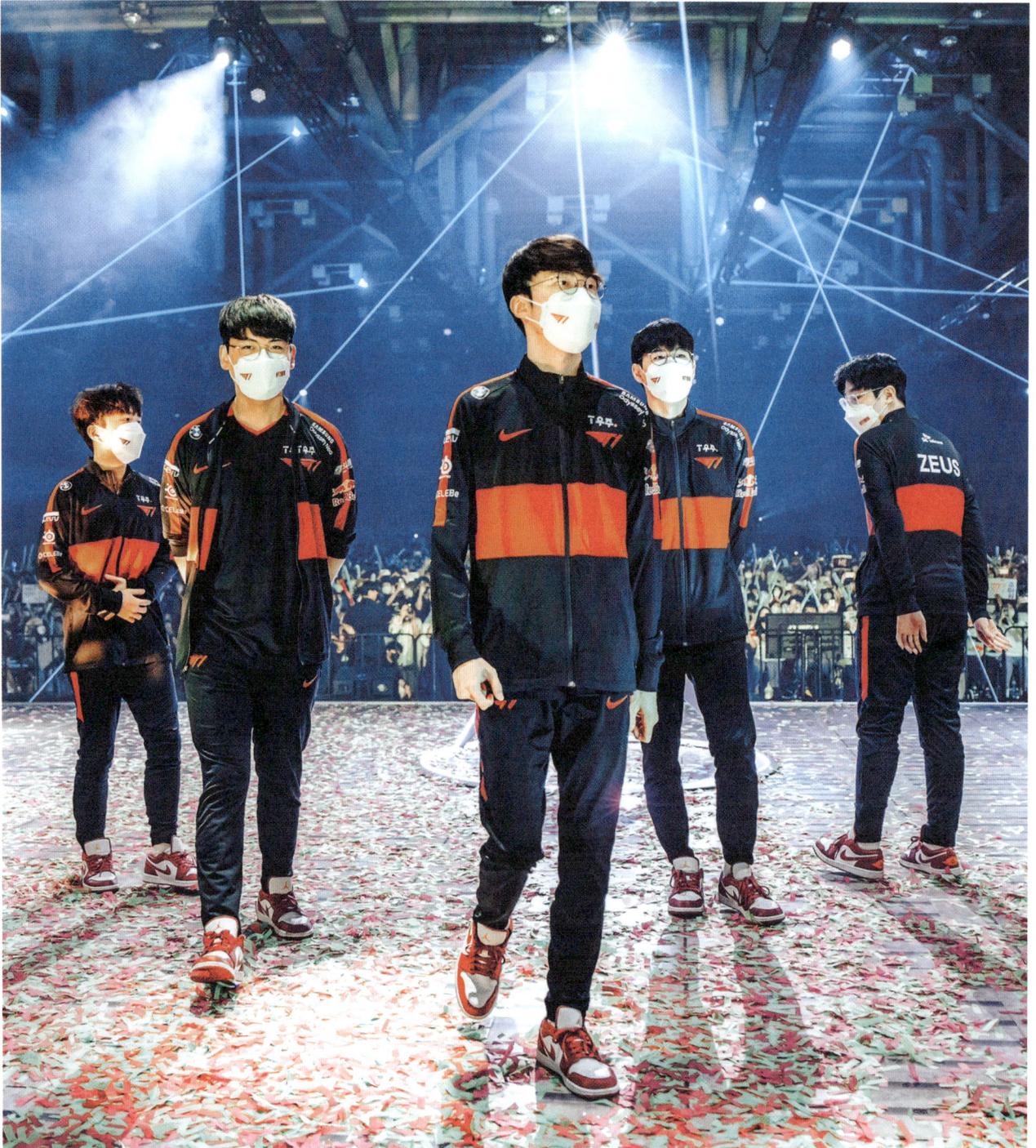

An activity that's now hugely popular thanks to government support.

← The trophy for the *League of Legends* 2022 Mid-Season Invitational is displayed on finals day on 29 May 2022 in Busan.

← T1 pose on stage at the end of the *League of Legends* 2022 Mid-Season competition in Busan.

Brought up on video games from an early age, Koreans are champions in all categories of esports and are largely responsible for making them known to the rest of the world.

South Korea was one of the very first countries to recognise esports as a legitimate sport and an official employment category. It all started in 1999 with the release of the StarCraft video game developed by the publishing studio Blizzard. The title was an immediate hit throughout the country and players flocked to gaming internet cafés or PC bang to take part in the new craze of online competitions. This in turn attracted the attention of cable TV channels which started to broadcast StarCraft matches, resulting in an esports culture ahead of its time. The first leagues were created, and in 2000 the Korean Ministry of Culture decided to sponsor the World Cyber Game Challenge, which would later become the first international esports competition in the world. This marked the start of a policy implemented by the Korean government to develop esports on a massive scale. It included the construction of several venues specifically dedicated to competitions of this type, such as the Busan Esports Arena. At the same time, the Korean e-Sports Association (KeSPA) was founded, an organisation affiliated with the South Korean Olympic Committee, which set out a framework for the new discipline and is responsible for managing professional electronic sport in the country. But this craze for online games has also been a source of concern. In 2011, the Korean parliament passed the so-called "shutdown law" prohibiting minors from playing at night. South Korean players also have to use a social security number to identify themselves when playing in online games distributed in their country. These measures were initially implemented by the government to allay fears related to young players becoming addicted to video games. However, recognising the ineffectiveness of the shutdown law and following intense lobbying from the esports sector, it was abolished in 2021. This leaves the way open for the spectacular rise of esports to continue unhindered in South Korea. Today, the country often dominates the international rankings and the most important competitions. Game over will have to wait.

187

Traditional arts

Painting, paper folding,
calligraphy and ceramics –
traditional Korean arts
come in many different
and wonderful forms.

Although South Korea appears to be a country
that is looking to the future in many ways, it's
also deeply attached to its history and past. A
past which can be seen in the complexity of its
traditional arts, with different branches resulting
in extremely varied forms of artistic expression,
some of which are still very much alive. One
of the best known is undoubtedly the craft of
ceramics which attracts the highest praise from
major international collectors. Korean pottery is
divided into three categories: *baekja* in white
porcelain, *buncheong* made from stoneware,
and *cheongja* which is a blue-green celadon. The
latter is a type of Korean stoneware developed
during the time of the Goryeo kingdom between
the beginning of the 10th and end of the 14th
centuries. It can be recognised by its jade-like
colour. "It's at eleven o'clock in the morning
that the blue of the celadons, lit by the rays of
the sun, emerges in all its beauty," explained
the famous Japanese ceramicist Miura Koheiji
when describing the elegance and sophistication
of the shades of celadon. Its beauty is clearly
undisputed, but the delicacy of Korean white
porcelain also deserves to be celebrated. Less
well-known than its counterparts in blue-green
hues, these ceramics date from the Joseon
period (1392-1910) and are characterised by a
quest for simplicity that overlaps with certain
values of Confucianism, such as frugality and
pragmatism. Occupying an intermediate position
between these two types of pottery, *buncheong*

→
Teapot in the
shape of a
bamboo shoot,
Goryeo dynasty,
12th century.

ware is slightly grey in colour and decorated with often abstract patterns, representing yet another rich vein in South Korea's ancient and time-honoured ceramic traditions.

The country has also inherited a long tradition of popular painting known as *minhwa*, which literally means "painting of the people". Emerging in the Joseon period, this style combines a wide variety of different techniques and depicts themes linked to nature, religion, popular beliefs and the lives of everyday people. The artists of this movement usually remained anonymous and emulated the trends of the artistic establishment. They very rarely signed their pieces and worked mainly on paper, often using the colours associated with the five elements of traditional Korean culture: red, yellow, blue, white and black. In terms of lines and composition, minhwa paintings are usually very simple and drawn without perspective, incorporating Chinese elements and local traditions. Their function was to bring prosperity and protection, which is why they were offered as gifts at important life events such as wedding ceremonies, the birth of a child or a first birthday. Minhwa paintings are divided into a wide variety of subgenres which sometimes overlap. Among the best known, the *janghodo* style always portrays the figures of the tiger and the magpie as respective metaphors for the aristocracy and the people. *Eohaedo* paintings depict fish, crabs and other sea creatures to demonstrate the harmony

↓
White jar decorated with dragon and clouds, 17th–18th century.

↑
This small pot was formed by hand and finished on a potter's wheel. The thick, vertical ridges covering the surface were impressed into the wet clay using a carved wooden paddle. This decorative detail is typical of early Korean ceramics.

191

of nature and freedom. The *hwajohwa* style is illustrated with flowers and birds to symbolise marital harmony. Although most minhwa artists were anonymous, some of them have been recorded in history, such as Jeong Seon (for his landscapes of mountains and rivers), Nam Gye-u (who specialised in painting butterflies) and Kim Hong-do (known for his scenes of everyday life). The tradition of minhwa painting partly explains why South Korea is now one of the world's most prolific producers of illustrated children's books. Many of the images such as the tiger are ubiquitous in local folk tales and are also found in Korean children's literature, perpetuating this popular pictorial tradition.

The different types of minhwa painting include a genre that can be considered a style in its own right. This is known as *munjado*. This term refers to a type of screen that traditionally decorated the bedroom of the master of the house. It was embellished with patterns in large calligraphic Chinese characters as a way of ostentatiously demonstrating that its owner was a literate intellectual. By extension, the term munjado now refers to all forms of Korean calligraphy. The characters represented reflect a number of virtues specific to Confucian philosophy and are

↖
In this traditional scene, a Korean magpie sits in a pine tree and calls out to a tiger. In Korean folklore, the magpie and tiger are bearers of good news. The gods send messages to the magpie, which passes them on to the tiger. The tiger is a messenger of the mountain spirits and a friend of humanity.

↑
The Character Yeom from the munjado, ink and light colour on paper, Korea, second half of the 19th century, Joseon dynasty.

192

→
The Character
Chung from the
munjado, ink
and light colour
on paper, Korea,
second half of
the 19th century,
Joseon dynasty.

P. 194-195
–
Munjado with
Flowers and
Birds, second
half of the 19th
century, ink and
watercolour on
paper, block.

adorned with secondary patterns to reinforce the decorative work or add humorous elements related to the main calligraphy figure. South Korea has produced a number of celebrated calligraphers, including Kim Jeong-hui (1786-1856) who successfully developed his own style - known as the *chusa* style - which captivated even the Chinese masters of the genre.

Last but not least, the many different forms of traditional Korean art also include an elegant discipline known as *jihwa* which consists of folding paper into the shapes of flowers. Made with a Korean type of paper called *hanji*, they can be used as decoration at important events or as objects to burn in shamanic or Buddhist rituals. Inscribed on the UNESCO List of the Intangible Cultural Heritage of Humanity, jihwa has several great masters, including the artist Joo Hwan Lee, better known by his monk's name of Seok Yong. His folded paper flowers provide proof, if it were still needed, that the traditional arts in South Korea come in infinitely varied and exquisite forms. And although the country may be evolving at high speed and has fully embraced modernity, it's clearly not about to cut ties with its rich, time-honoured heritage.

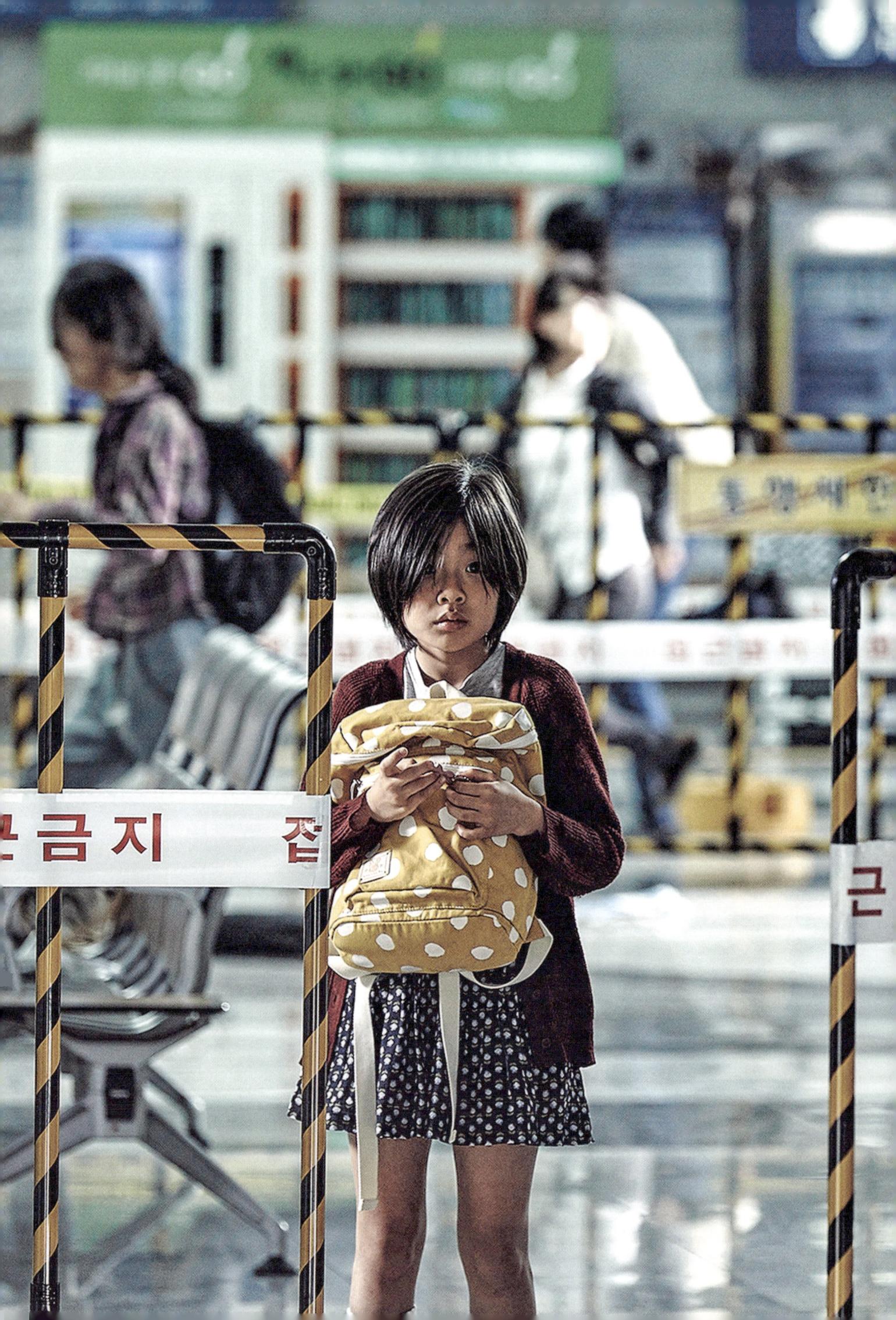

7 K-CINEMA

통행제

접근금지 접근금지 접근금지 지

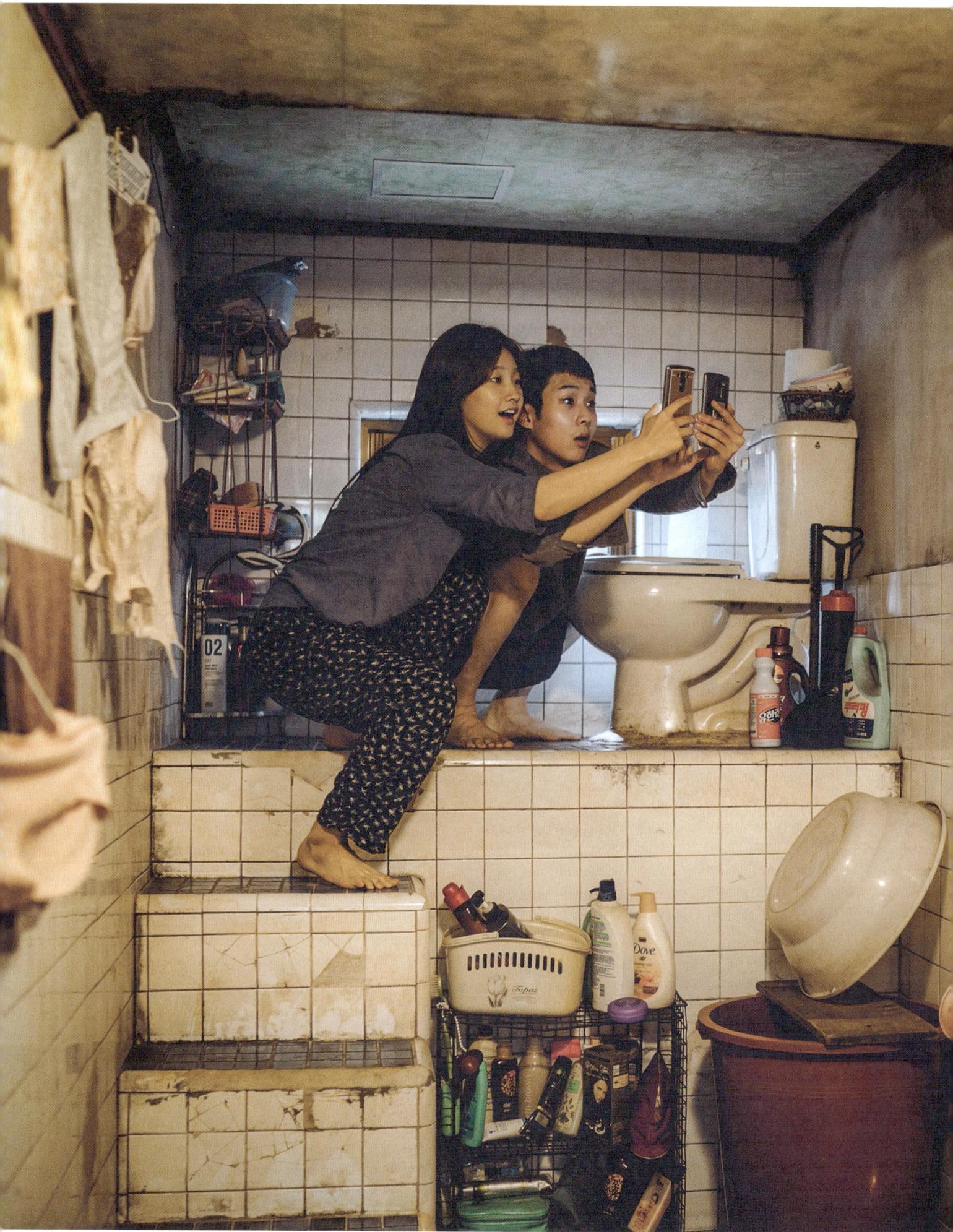

INTRODUCTION

P. 196-197
–
One of the panic scenes in Sang-ho Yeon's film *Train to Busan*.

←
Cult scene from the no less cult movie *Parasite* by Bong Joon-ho, shot in the apartment the family is trying to escape from.

In just over half a century, South Korea has cemented its position as Asia's leading filmmaker.

In the global history of cinema, the case of South Korea can only be described as spectacular. The country has developed a powerful film industry in record time despite the complex political uncertainties of its recent past. It was in 1953, with the end of the civil war, that the early signs first appeared. South Korea discovered the world of American movies which had an instant aesthetic impact on the whole country, awakening the film-loving aspirations of Koreans. Universities opened their own film departments and the largest studios in Asia were set up in Anyang near Seoul. To limit the influence of American film, the Korean government introduced a quota system to support local production. This was the first golden age of Korean cinema. Although many of the films shot at the time have been lost, some masterpieces survive, such as *The Housemaid* by Kim Ki-young and *Obaltan* by Yu Hyeon-mok, both of which are emblematic of a period when the nation's cinema still served as an outlet for the traumas inflicted by war.

The nation's cinema still served as an outlet for the traumas inflicted by the Korean War.

→
Street scene of a cinema in Seoul in the 1950s where posters are still in Japanese.

In 1961, the military coup that followed the student revolution plunged the country into dictatorship. A law was quickly brought in to radically restrict the conditions of cinematic expression. To produce a film, it was now necessary to obtain authorisation from the government which only approved around fifteen releases a year. This was accompanied by the omnipresent threat of censorship which drastically restricted the subject matter permitted and muzzled the development of film in the country. It wasn't until the political liberalisation of the late 1980s that Korean cinema was given a new lease of life, allowing the industry to more boldly assert its unique qualities in relation to its Asian counterparts.

At the end of the 20th century, as South Korea lived through a spectacular economic boom with dizzying growth rates, major industrial groups such as Samsung, Hyundai and Daewoo began to invest in cinema. At the same time, the government created the Korean Film Council (KOFIC) to promote and support local production and improve the visibility of the nation's cinema throughout the world. All of these factors played a significant role in fostering a new love of cinema, culminating in the 1996 creation of the famous Busan International Film Festival which acts as an important platform for Asian cinema in general. It was against this backdrop that the Korean New Wave of cinema emerged. Typified by directors like Park Chan-wook, Bong Joon-ho and Kim

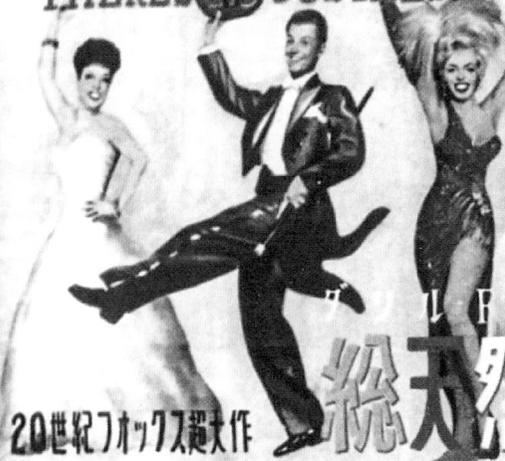

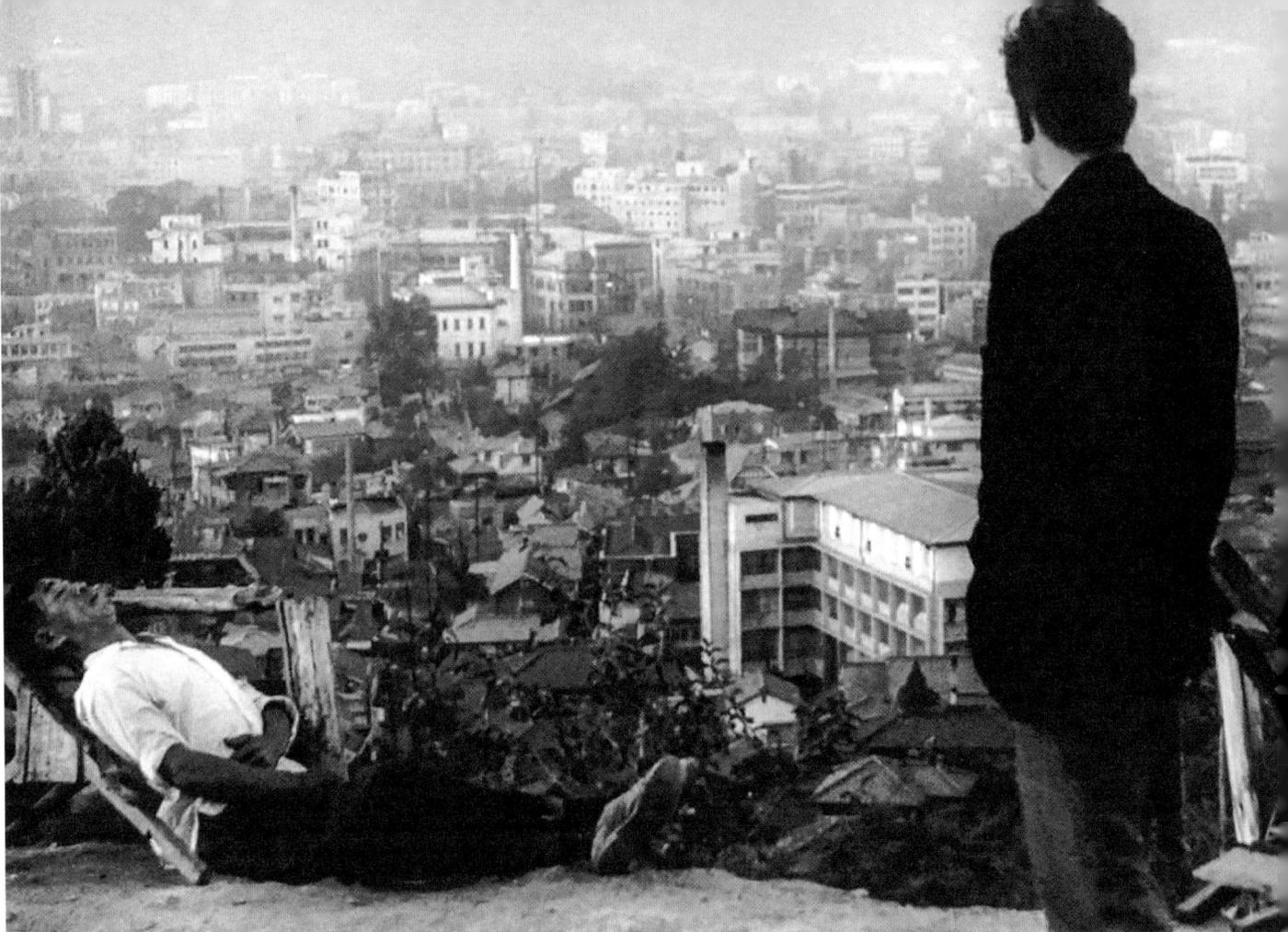

Jee-woon, the movement radically changed Korean cinema in the early 2000s by introducing new conventions and unorthodox ways of doing things.

Although the films made by this generation of passionate directors are very different from each other and vary in the subject matter treated, they share a number of common elements which have contributed to the creation of a style typical of the Korean New Wave. They often contain references drawn from genre films, a spectacular level of violence bordering on the gory, an interest in exploring the psychological complexities of the main characters, and an ability to unexpectedly jump from one tonal register to another.

When it comes to all of the above, director Park Chan-wook is a pioneering figure. Firstly, thanks to the phenomenal success of his film *Joint Security Area* in 2000 which gave him a certain amount of bargaining power in the industry, and secondly, through what's known as his revenge trilogy, an impressive series of feature films typical of his work: *Sympathy for Mister Vengeance* (2002), *Oldboy* (2003) and *Lady Vengeance* (2005). It was through these movies that Korean cinema began to gain international recognition. In 2004, *Oldboy* won the Grand Prix award at the Cannes Film Festival. From this point onwards, the Korean New Wave of cinema began to fascinate moviegoers around the world, opening the way for directors such as Bong Joon-ho with *Memories of Murder* and Na Hong-jin with *The Chaser*. These films

↑
Obaltan or *Stray Bullet*, directed by Yu Hyeon-mok and released in 1961, is an adaptation of the eponymous short story by author Yi Beom-seon.

are hugely impressive thanks to their wonderful sense of staging, their relentless rhythm and their suffocating darkness. They also often feature an underlying element of social commentary which may criticise the economic inequalities in the country, the corruption of elites and the police, or the disconnection between rural and urban populations. The cinema of the peninsula is shining a spotlight on all of these themes after many years shackled by censorship and self-censorship.

In recent times, South Korea has established its undeniable status as a big hitter on the international stage, as evidenced by the prestigious Palme d'Or won by Bong Joon-ho's film *Parasite*. This was a first for Korean cinema and the ultimate recognition for the director who also picked up four Oscars for the same movie. In 2022, the famous actor Song Kang-ho won the Best Actor Award for his role in the film *Broker* by Hirokazu Kore-eda. As a result of these successes, South Korea now holds such a privileged position in the pantheon of international cinema that it even influences the Hollywood studios. The latter keep an increasingly watchful eye on South Korea and are happy to fund remakes of great Korean films, even if the results are somewhat insipid when compared to the originals.

Many films focus on exploring the psychological complexities of the main characters.

↓
The Handmaiden by Park Chan-wook features wonderfully lavish sets and costumes.

THE
A FOUNDATIONAL FILM
HOUSEMAID

A Korean-style *Psycho*, *The Housemaid* is a pioneering and venomous work.

It was one of Korean cinema's first films. Directed by Kim Ki-young and released in 1960, *The Housemaid* depicts the happy home of a music teacher gradually imploding after the arrival of a strangely behaved maid. To understand this tragic, claustrophobic drama and its blend of passion and manipulation, the political context of South Korea at the time should be considered. The film was released during the country's very short period of democracy between August 1960 and May 1961. This was followed by the coup d'état of General Park Chung-hee, resulting in the introduction of a highly restrictive law related to the film industry. Through its freedom of tone and sense of muted violence, *The Housemaid* is an eloquent commentary on the sentiments supressed during the war years. This masterpiece has had a lasting impact on directors like Bong Joon-ho who described it as "the *Citizen Kane* of Korean cinema". His film *Parasite* was inspired by it, replicating the theme of domestic workers supporting a rich family whom they gradually asphyxiate.

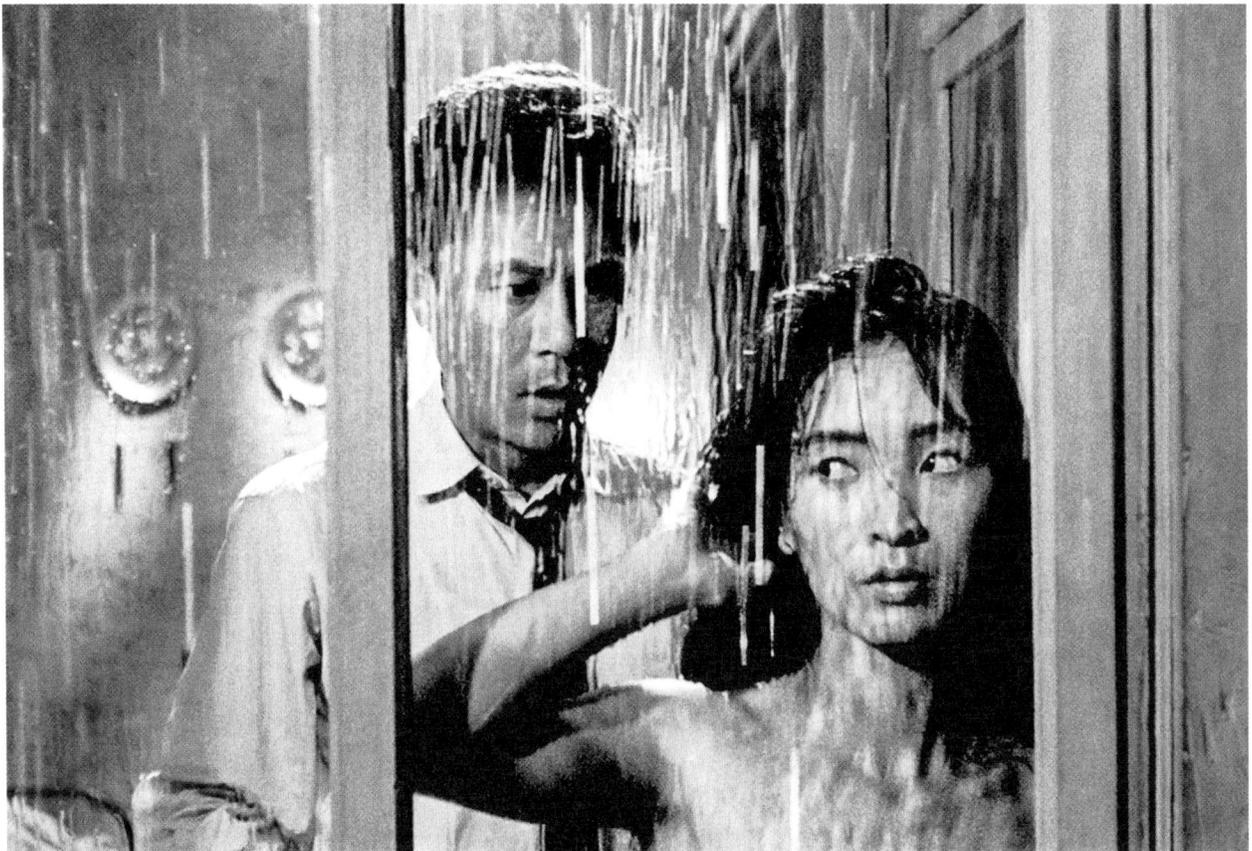

HONG SANG-SOO

THE OTHER KOREAN CINEMA

홍상수

In a class of his own, Hong Sang-soo is undoubtedly the most French of Korean filmmakers.

He sits at the other end of the spectrum. While Korean cinema is best known overseas for its explosive violence, mind-blowing plot twists and ultra-fast action scenes, the films of Hong Sang-soo move at a very different pace. After studying cinema at Chung-Ang University and then in the United States, he started his career as a television director. In 1996, he released his first film, *The Day a Pig Fell into the Well*, which met with critical acclaim and earned him the title of Best Director at the Vancouver International Film Festival. Sophisticated and delicate, his films never descend into quaint national stereotypes, focusing instead on the complexity of romantic relationships and the feelings they arouse. In the style of filmmakers such as Éric Rohmer, whom he's often compared to, Hong Sang-soo uses his feature films to explore the indecisiveness of desire and the doubts that plague his characters. The result is always a wonderful, meandering exploration of the meaning of life.

SONG KANG-HO

THE FACE OF
SOUTH KOREA

He's everywhere and
wanted in every cast.

With more than 40 films to his name, Song Kang-ho has become the face of Korean cinema. He started out in theatre, before switching to the big screen in 1996, appearing in *The Day a Pig Fell into the Well*, the first film of director Hong Sang-soo. The tragicomic power of his acting then earned him the right to work with the greatest filmmakers of the Korean New Wave, including Park Chan-wook (in the films *Joint Security Area* and *Sympathy for Mister Vengeance*) and Kim Jee-woon (*Foul King* and *The Good, the Bad, the Weird*). But it was especially alongside Bong Joon-ho that the career of Song Kang-ho would reach new heights. The famous director adopted him as one of his favourite actors, offering him leading roles in iconic films such as *Memories of Murder* in 2003, *The Host* in 2006, *Snowpiercer* in 2013 and most importantly *Parasite* in 2019. This allowed the actor to gain international recognition, earning him jury membership at the Cannes Film Festival in 2021 and the prestigious Best Actor award the following year. The ultimate sign of approval for the greatest of Korean actors.

↖
Song Kang-ho poses with the Best Actor award for the film *Broker* at the 75th Cannes Film Festival.

↗
A breathless manhunt in the film directed by Na Hong-jin.

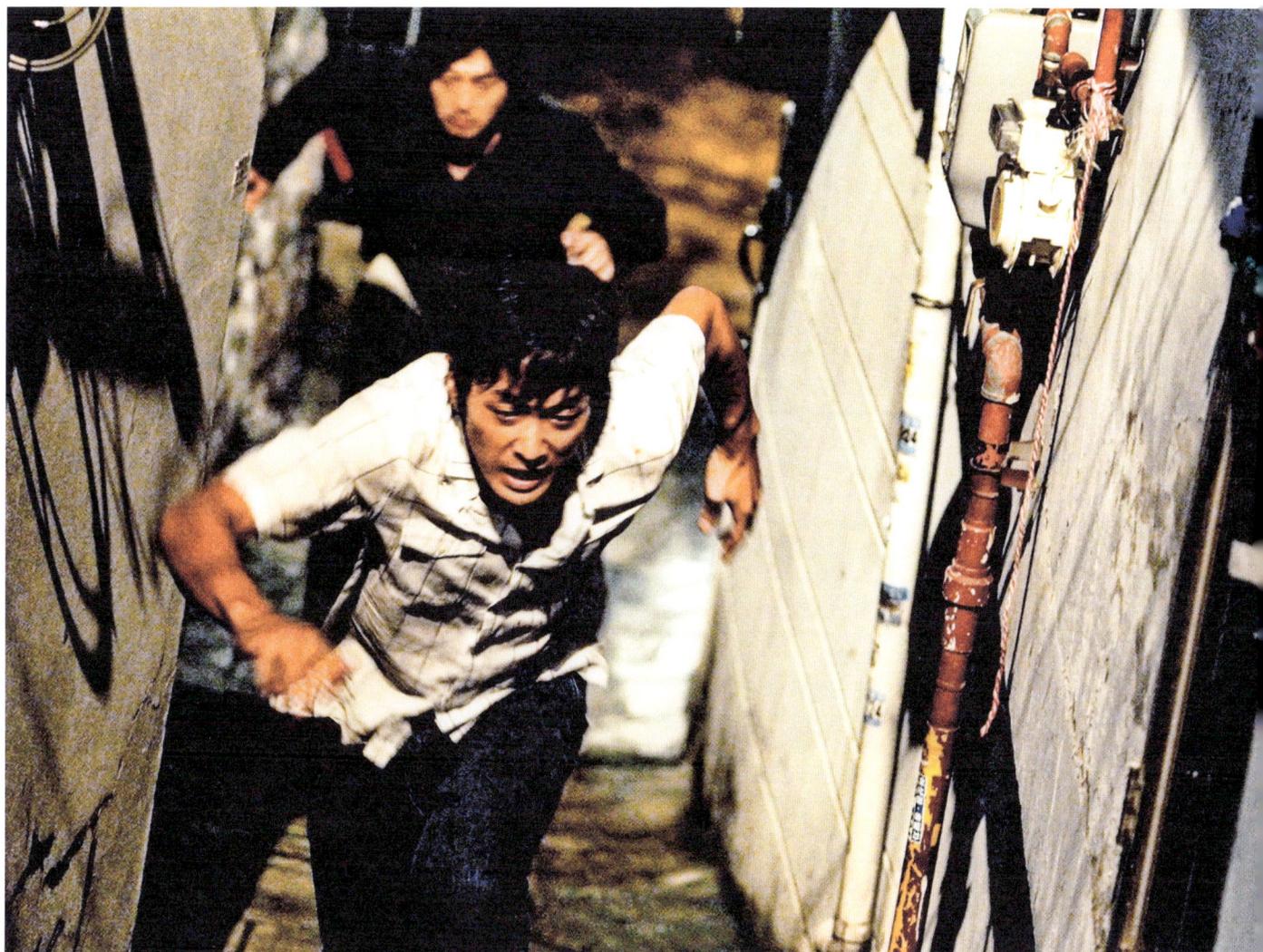

THE CHASER

NIGHT OF THE HUNTER

A murderous whodunit and manhunt in Na Hong-jin's first film.

The directorial debut of Na Hong-jin is nothing short of a masterpiece. Acclaimed by critics and awarded numerous prizes around the world, *The Chaser* made huge waves when it was released in 2008. This feature film tells the story of a former cop turned pimp who decides to return to the force when he realises his prostitutes are disappearing one after the other. The result is a frantic thriller based on the true story of serial killer Yoo Young-chul, convicted in 2005 of the murder of at least twenty people, mainly prostitutes, masseuses and bar hostesses. Driven by remarkable directing and impressive chases in the labyrinthine alleyways of Seoul, *The Chaser* features multiple references to Hollywood noir films and extrapolates the conventions of the genre to deliver a typically Korean version. With *The Wailing* in 2016, Na Hong-jin has made a permanent name for himself in the pantheon of Korean cinema.

BUSAN INTERNATIONAL FILM FESTIVAL

FILM CENTRAL

Asian cinema's biggest festival is held each year in Busan.

The second-largest city in South Korea after Seoul, Busan has become a meeting place for movie buffs after one of the most important film events in the world was created here in 1996: the Busan International Film Festival (BIFF). Held in October in the Busan Cinema Center, this annual event introduces the latest talent in Asian art-house cinema. Filmmakers such as Jia Zhangke from China, Fruit Chan from Hong Kong and the Koreans Hong Sang-soo, Kim Ki-duk and Im Sang-soo have all premiered their movies here. Each year, the festival welcomes 7,000 industry professionals and 1,700 members of the press, making it the epicentre of Asian cinema. In 2006, the BIFF even created the Asian Film Market where the international promotion of feature films is negotiated. In other words, when in Asia, Busan is the city to be in for avid cinephiles.

PARK CHAN-WOOK

박찬욱

REVENGE IS SWEET

←

The film crew of the movie *Unframed* at the 26th Busan International Film Festival on 8 October 2021.

↓

The director attending a press conference on the film *Decision to Leave* in Seoul in June 2022.

A pioneer of the Korean New Wave, the director of *Oldboy* and *The Handmaiden* means business.

It all started at a screening of *Vertigo* by Alfred Hitchcock. Still a philosophy student at the time, Park Chan-wook had a eureka moment and decided his life would be devoted to film. He set up the Sogang Film Community at his university where a group of film buffs endlessly debated the value of different camera shots and the standout films in cinematic history. After working in various roles in the film industry, Park Chan-wook released his first feature film in 1992, *The Moon is... The Sun's Dream*, which flopped at the box office. He persevered, however, and his 2000 film *Joint Security Area*, exploring tensions on the North Korean border, proved to be a massive hit in his country, watched by five million people. This was followed by a series of films on the theme of revenge, including the powerful *Oldboy* which won the Grand Prix at Cannes in 2003. With these movies and his latest offerings, *The Handmaiden* and *Decision to Leave*, Park Chan-wook has earned a place at the table of the greatest Korean directors.

209

PARASITE

GOLDEN HOUSEMATES

기생충

Or how Bong Joon-ho infiltrated the pantheon of world cinema.

When thinking about key players, it's impossible not to mention *Parasite* directed by Bong Joon-ho, given that this film has played a decisive role in the development of Asian cinema in general. With its unanimous win of the prestigious Palme d'Or at the 2019 Cannes Film Festival, the feature film quite simply made history, becoming the first Korean movie to take the coveted award. With its breathless script exploring the issue of social advancement, its intelligently constructed political discourse and its brilliant staging, *Parasite* is a masterpiece. The film also struck a chord in the United States. The *New York Times* described it as "wildly entertaining, the kind of smart, generous, aesthetically energized movie that obliterates the tired distinctions between art films and popcorn movies". At the Oscars, it won Best Picture, Best Director, Best Original Screenplay and Best International Feature Film. In other words, there's a before and after *Parasite*.

MY SASSY GIRL

TENDER MADNESS

←
Who are the parasites? That's the question posed by Bong Joon-ho in his film which became a classic as soon as it was released.

↓
Kwak Jae-yong's film from the turn of the century shows that Korean cinema is also capable of producing romantic comedies.

South Korea also offers romcoms and love stories.

Korean cinema may be primarily known around the world for its violent and uncompromising art-house films, but some movies take their inspiration from the sentimental traditions of the K-drama. *My Sassy Girl* is a case in point. This romantic comedy released in 2001 and directed by Kwak Jae-yong depicts the budding love between a naive student and a young woman whose eccentric behaviour borders on the insane. The screenplay was inspired by a true story which the author Kim Ho-sik first told on his blog before it was successfully transferred to the big screen. *My Sassy Girl* became the most profitable comedy in the history of Korean cinema, before conquering the whole of Asia where it enjoys blockbuster status. Since then, it's undergone remakes in the United States, India, China, Indonesia and Nepal, as well as being adapted for countless TV series. Which just goes to show that the simplest love stories are often universal.

엽기적인 그녀

↑
Bladed weapons are everywhere in *I Saw the Devil* by Kim Jee-woon.

KNIVES OUT

CLOAK AND DAGGER

칼부림의 미학

White steel, red blood and cut to black.

In South Korea, problems are settled with knives. This fact is immediately obvious to foreigners watching Korean action movies. The obsession directors have with knife fights is based on a concrete reality: in South Korea, carrying firearms is prohibited, and obtaining them illegally is even harder than in other countries. Even the biggest criminals have to make do with knives to carry out their nefarious activities. So it makes sense that blades are drawn in a flash in Korean action and horror films. On top of this, the theme of vengeance has always haunted the cinema of the peninsula, undoubtedly linked to the trauma inflicted by the Korean War. And as revenge is a dish best served cold, and in this case bloody, it's not uncommon to witness frighteningly graphic scenes of this type on the big screen, as in the terrifying *I Saw the Devil* by Kim Jee-woon, a blood-stained jewel of Korean cinema.

BURNING

PLAYING WITH FIRE

When writer Haruki Murakami meets director Lee Chang-dong, things get hot.

In 2018, a year before *Parasite* won the Palme d'Or at the Cannes Film Festival, another South Korean film came very close to taking the prestigious award: *Burning* by Lee Chang-dong. Inspired by the short story *Barn Burning* by Japanese writer Haruki Murakami and directed by a former Korean minister of culture, this film stood out for its ability to brilliantly switch from the tonal register of romance to psychological thriller. It portrays the budding love story between Jongsu, a shy delivery man who dreams of being a writer, and Haemi, a naive and free-spirited young woman. But her sudden disappearance transforms the film into a harrowing quest in an atmosphere of understated violence that only Korean directors know how to do. Critically acclaimed on its release, *Burning* was the first Korean film to be shortlisted for the Best Foreign Language Film Oscar in 2018. A red-hot, must-watch classic.

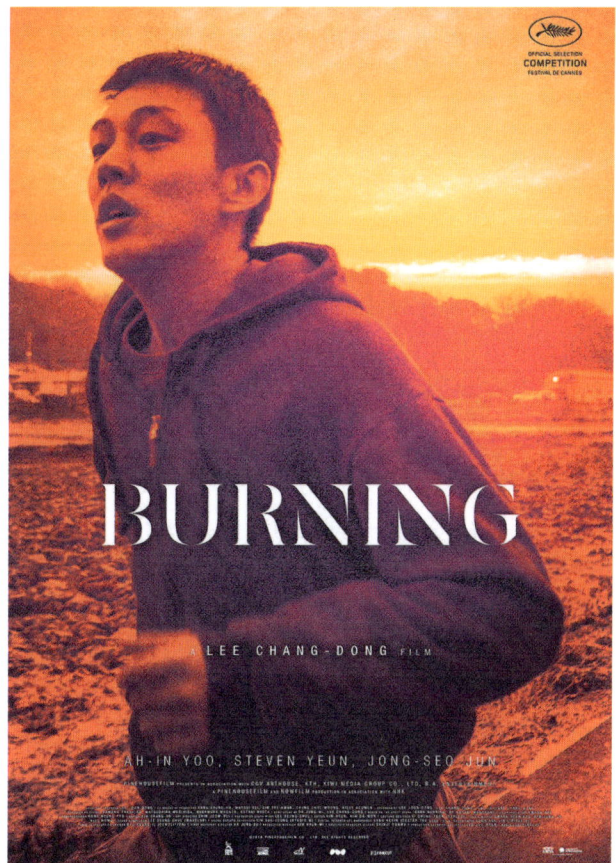

→
One of the American posters for the film *Burning* by Lee Chang-dong.

The killer of Memories of Murder finally found

When writing his screenplay, Bong Joon-ho could never have imagined that his main plot twist would actually take place, almost fifteen years after the release of his cult film.

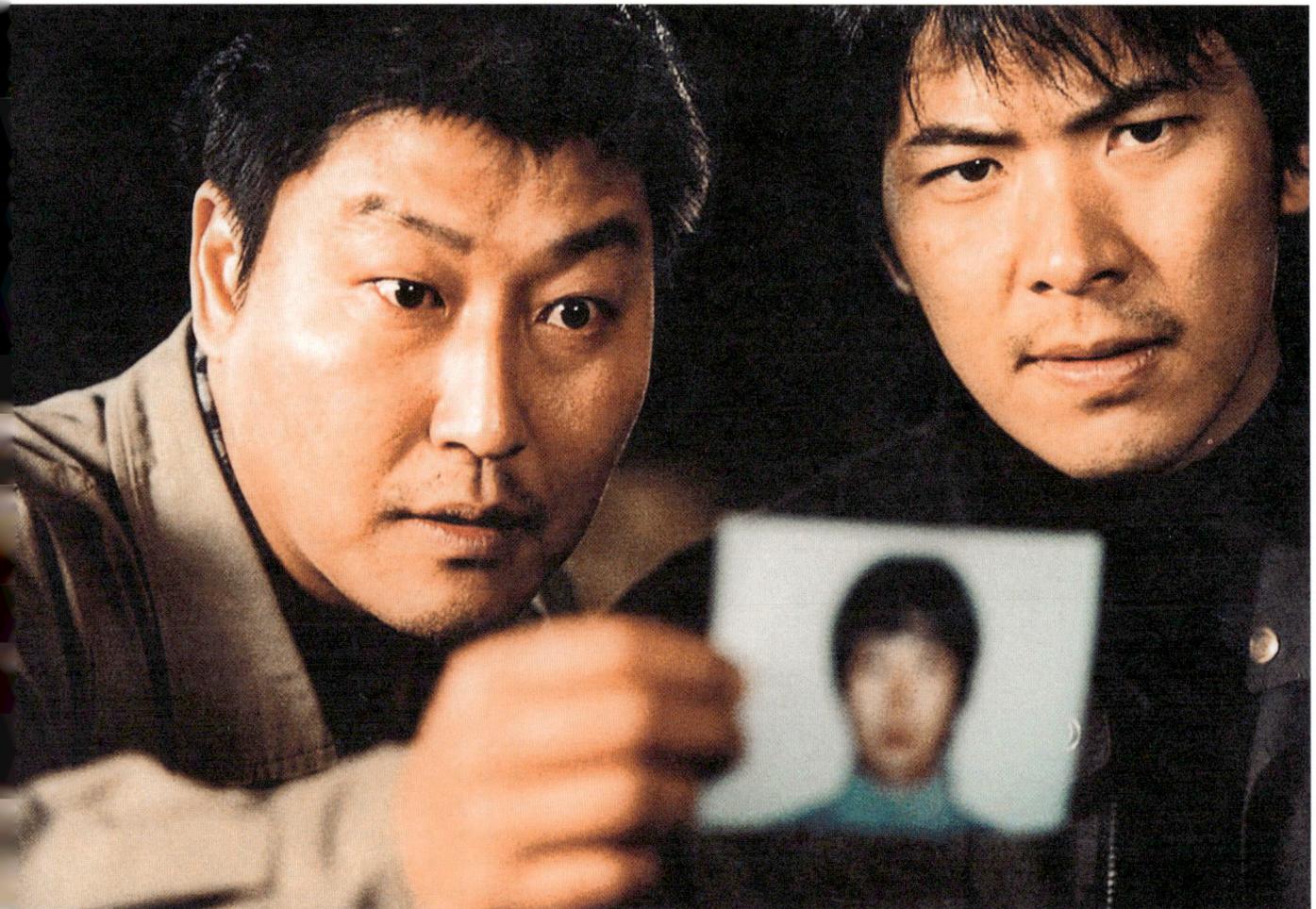

↙
Based on a true
story, this film
recounts the tale
of a manhunt.

→
Lee Choon-jae
was one of the
most prolific serial
killers in Korean
history and the
man behind Bong
Joon-ho's film.

Some crimes feel as though they'll never be solved. And this is what makes them so powerfully fascinating, and the reason why novelists, screenwriters and journalists like to retell them so often. In the rural region of Hwaseong south of Seoul, South Korea had its own equivalent of the unsolved cases of the Yorkshire Ripper and the Zodiac Killer in the United States. Between 1986 and 1991, a serial killer raped and murdered 10 women here within a radius of just two kilometres. His oldest victim was 71 years old while the youngest was a schoolgirl of only thirteen. In an attempt to find the perpetrator of these horrific murders, the Korean police mobilised 300,000 officers and questioned more than 3,000 suspects. All in vain. It proved impossible to find the serial killer of Hwaseong.

In 2003, director Bong Joon-ho re-examined this terrible series of unsolved crimes in one of his first masterpieces: *Memories of Murder*. With a suffocating atmosphere and evocative staging, the film was a huge critical success, marking a brilliant start to the director's career. It also revived a question that had never been answered: what had happened to the serial killer behind the film? The mystery remained unsolved until 18 September 2019. On that day, the whole of South Korea was in shock. The authorities announced that they'd identified a new suspect in the case, almost 30 years after the crimes were committed. The person in question was a 56-year-old former soldier called Lee Choon-jae who was sentenced to life imprisonment in 1994 for the rape and murder of his sister-in-law. Thanks to technological advances in forensics, the man's DNA was linked to three of the Hwaseong victims. Questioned by the police, Lee Choon-jae confessed to all the murders he was suspected of and even added several new names to his long list of victims. The killer of *Memories of Murder* had finally been found. This was a major event for the world of Korean cinema. The testimony of the most famous serial killer in the country revealed an outdated and poorly conducted investigation. "I still don't understand why I wasn't a suspect," the murderer told the court. "Crimes happened around me and I didn't try hard to hide things so I thought I would get caught easily. There were hundreds of police involved. I bumped into detectives all the time, but they always asked me about other people I knew." This amateurish approach had already been criticised by Bong Joon-ho in his film, providing proof, if it were needed, that cinema is often right.

300,000 police officers and over 3,000 suspects interviewed.

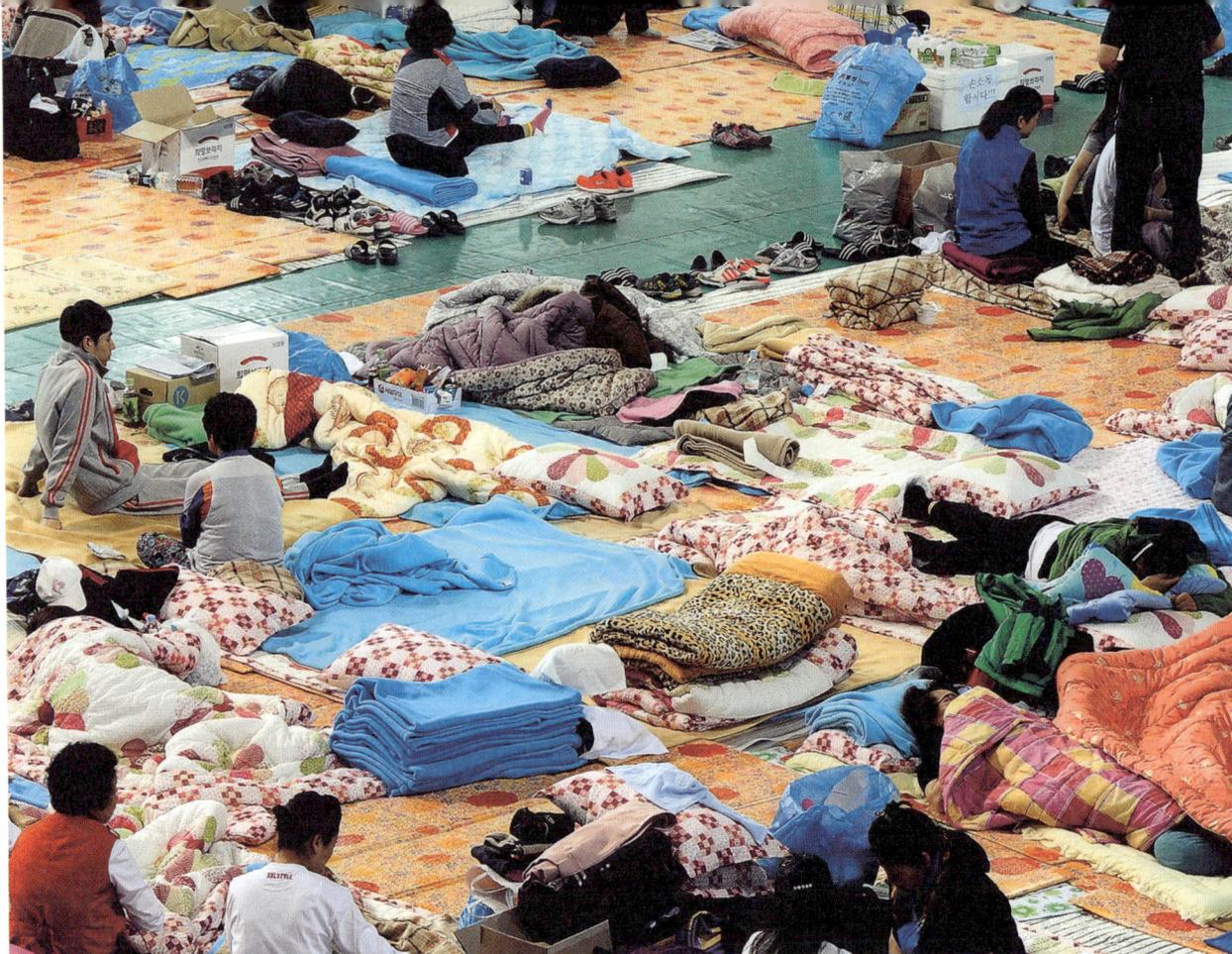

The ferry disaster that inspired Train to Busan

What if this story of a zombie train was actually a ship story? A look back at a national tragedy where the reality was unfortunately worse than the fiction created by Yeon Sang-ho.

This cult film was much talked about during the Covid-19 pandemic. Released in 2016, *Train to Busan* by director Yeon Sang-ho recounts the story of an epidemic, a virus and rampant contamination. It depicts an irresponsible biochemical industry where the race for profit results in blunders and such uncontrolled mutations that people start turning into zombies. The perfect pretext for a claustrophobic horror film on a high-speed train, driven by oppressive suspense and a race against time. The feature film met with international success on its release, but for Koreans it refers primarily to another tragic historical event: the sinking of the *Sewol* ferry.

On 16 April 2014, on the route between Incheon and Jeju in South Korea, a ferry capsized while carrying 476 passengers, most of whom were secondary school students on a field trip. A total of 304 people drowned in the disaster, most of them dying because they obeyed the instructions of the crew who told them to stay in their cabins when water began to enter the ship. More than half the survivors were rescued by fishing boats and commercial vessels because the emergency resources mobilised by the Korean authorities were so inadequate. A national catastrophe which resulted in the Korean prime minister resigning ten days after the disaster, as the tragedy revealed numerous failings. The incorrect instructions from the crew and the government's attempt to hush up the sinking and minimise its responsibilities caused a national scandal which some of the scenes in *Train to Busan* make direct reference to. In using the city of Busan, which is presented in the film as a sanctuary of freedom, Yeon Sang-ho makes the link with the famous film festival held here each year. In 2014, after the sinking of the *Sewol*, the festival organisers were involved in a showdown with the city council which wanted to cancel the screening of a documentary highlighting the government's failings in the disaster. Supported by public opinion, the festival was eventually able to screen the film as planned. One thing is certain: *Train to Busan* has ensured that the sinking of the *Sewol* won't be forgotten.

The captain of the Sewol ferry was sentenced to life imprisonment in 2015.

↖
On 24 April 2014, a gym was used to accommodate the relatives of people who had disappeared aboard the *Sewol* after it sank a few days earlier near the island of Jindo.

→
Korean poster for the film *Train to Busan* by Yeon Sang-ho.

The temptation of Hollywood

← Korean poster for the film *The Last Stand* by Kim Jee-woon, featuring Schwarzenegger in a role made for him.

↖ Dinner scene in the film *Stoker* by Park Chan-wook.

Californian gold diggers are rushing to South Korea to unearth precious nuggets and forge new collaborative ventures... with varying degrees of success.

Hallyuwood. This play on words is the nickname sometimes given to the film industry in South Korea. *Hallyu* refers to the Korean cultural wave which has recently swept the world in a host of different areas such as cinema, pop music, TV dramas and fashion. While Hallyuwood is indeed assuming an increasingly important place on the world stage, this hasn't stopped Korean directors and American producers from trying their hand at international collaborative projects. For the former, it's a way of reaching new and wider audiences, while the latter see it as an opportunity to renew the visual language of their productions. But the bringing together of Hollywood and Hallyuwood doesn't necessarily produce the best outcomes. For example, films such *The Last Stand* by Kim Jee-woon (with Arnold Schwarzenegger) and *Stoker* by Park Chan-wook (with Nicole Kidman) may not have been total disasters but both are relatively underwhelming in the filmography of the two directors. With several American experiences under his belt, including the film *Snowpiercer* which ended in a showdown with the production team who wanted to shorten it by 20 minutes, director Bong Joon-ho explained his views to *Sofilm* magazine: "I think the best way of escaping this pressure is to avoid working 100% inside the Hollywood system, and instead be able to detach from it and take a step back. For my film *Okja*, one of my essential conditions was to have total freedom right from the outset. I can't work any other way. I've turned down a lot of superhero movies, for example, such as *Iron Man 2*. It's really not my thing, I wouldn't be good at it, and would feel uncomfortable. In my hands, Iron Man would definitely become a really weird character." Hollywood has also attempted remakes of Korean classics, such as the adaptations of *My Sassy Girl* by Yann Samuell and *Oldboy* by Spike Lee, neither of which were hugely successful. Proof that, for the time being, Hallyuwood has little to fear from the American giant.

"I've turned down a lot of superhero movies, such as *Iron Man 2*."

Filming suicide

When it comes to recounting extreme forms of malaise which end in tragedy, the world of film has *The Virgin Suicides* by Sofia Coppola and *Last Days* by Gus Van Sant, but most of all it has Korean cinema.

This theme haunts South Korean cinema, reflecting the sad fact that the country has the highest rate of suicide per capita among developed countries, making it the leading cause of death among 10 to 39-year-olds. Academic pressure, perfectionism at work, deep-rooted misogyny, and the impossibility of discussing these problems with family are often mentioned as potential reasons for these tragic figures. Given this situation, it makes sense that film directors have taken to exploring the topic in an attempt to better understand the issues involved through stories and characters questioning the meaning

↑
Scene from the film *Castaway on the Moon* by Lee Hae-jun, featuring a man who fails to take his own life and wakes up on a desert island.

→
A French version of the poster for the film *After My Death* by Kim Ui-seok.

Like an obsession, the topic haunts Korean films.

of their existence. Korean cinema has produced some notable movies on the topic, for example *Castaway on the Moon* by Lee Hae-jun recounts how a debt-ridden thirty-something attempts to kill himself by jumping from a bridge but lands on a desert island in the middle of the city, where he gradually regains a taste for life. Directed by Kim Ui-seok, *After My Death* is a Korean-style version of *The Virgin Suicides*, examining the angst of teenage girls in a hyper-competitive society. The very beautiful *Poetry* by Lee Chang-dong follows a grandmother with Alzheimer's who tries to understand why a student in her grandson's class has taken her own life by jumping from a bridge. In Seoul, the Mapo Bridge is sadly known as "suicide bridge" and it's not uncommon to see it feature in films examining this serious issue which affects all of South Korea.

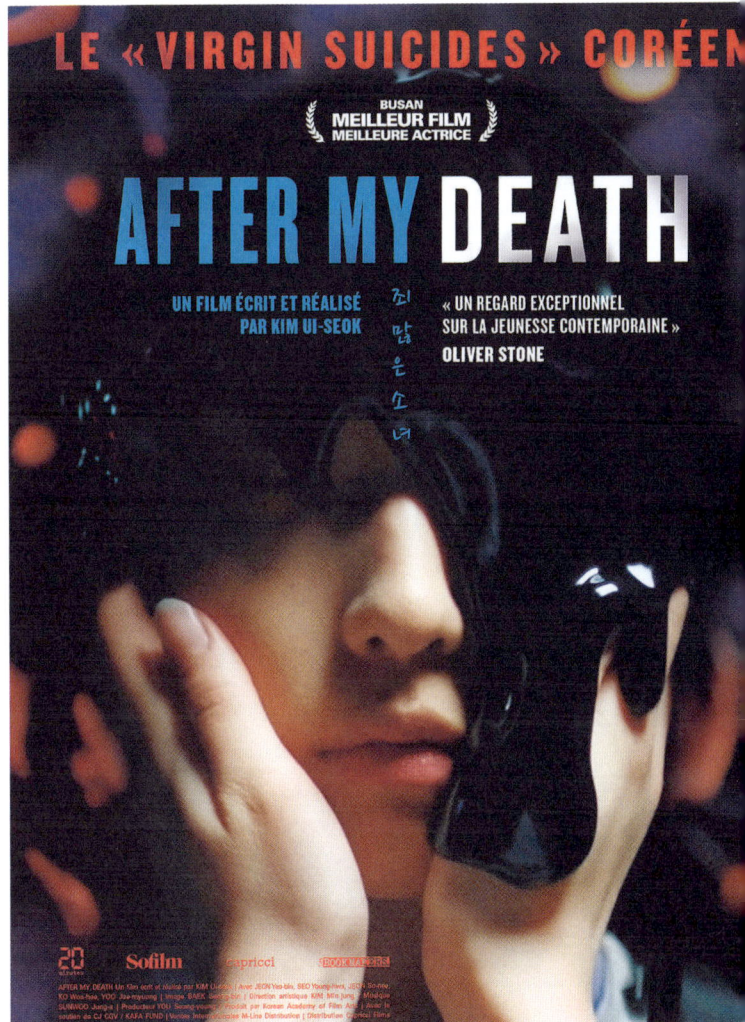

LE « VIRGIN SUICIDES » CORÉEN

BUSAN
MEILLEUR FILM
MEILLEURE ACTRICE

AFTER MY DEATH

UN FILM ÉCRIT ET RÉALISÉ
PAR KIM UI-SEOK

« UN REGARD EXCEPTIONNEL
SUR LA JEUNESSE CONTEMPORAINE »
OLIVER STONE

Contemporary art

FOCUS 다 양 동 7

Since South Korea opened up to the rest of the world and to Western artistic concepts, it has become a leading country in Asian contemporary art.

The way of thinking about artistic development in the West in the 20th century is based on notions that only partially apply to the history of Korean art. This is because before 1905 and the Japanese occupation, the peninsula had adopted a predominantly isolationist policy, and protected itself from foreign incursions in cultural matters. For example, Korean paintings were still created with ink or water on rice paper, and the artist was expected to remain hidden in the background behind the subject. But the arrival of the Japanese would change everything. Already heavily influenced by Western forms, techniques and values, they anchored the peninsula in a conception of art that tended towards the modernity seen in Europe and the United States. A first school of fine arts was founded in Korea in 1911. It introduced new perceptions and a European perspective that marked a break with the past. This split is expressed in the Korean vocabulary introduced at that time, distinguishing between "Western painting" (known as *seo yang-hwa*) and "Oriental painting" (known as *dong yang-hwa*). From that moment onwards, as in its cooking and fashion, art in South Korea has constantly swung back and forth between the expression of a traditional and ancient identity, and a modern approach based on the appropriation of artistic ideas and techniques imported from the West. After the Korean War, the south of the peninsula was politically isolated, and in the 1960s these two artistic currents tended to merge into each other. For example, certain aspects of

↗
Minimalist artist Lee Ufan at his exhibition in the Lisson Gallery, London in March 2015.

→
Nam June Paik, *Lady Secretary, Bilingual, Will Travel...*, 1991. Denver Art Museum.

Korean tradition overlapped with the concerns of Western avant-garde movements such as Fluxus and conceptual art. The Korean Culture and Arts Foundation (now known as Arts Council Korea) was founded in 1973, and in the 1980s and 1990s increasing numbers of Korean artists were invited to major contemporary art events such as the Venice Biennale. At the same time, the vast Korean industrial groups known as chaebols played a decisive role in the local development of the sector by creating exhibition spaces such as the Gallery Hyundai and the Leeum Samsung Museum of Arts. After devoting two major exhibitions to Korean art in New York and Paris in 2015 and 2016, the Emmanuel Perrotin gallery has just opened its second branch in Seoul, making the city a hub for contemporary art in Asia. Today, many leading artists have propelled South Korea onto the international stage. Examples include Lee Bae (known for his monochrome paintings in black), Nam June Paik (the precursor of video art and known as the "Michelangelo of electronic art") and Lee Ufan (a minimalist sculptor, philosopher and member of the Japanese avant-garde movement Mono-ha). Three key figures that give an insight into the incredible diversity of the South Korean contemporary art scene.

←
Do-Ho Suh,
Karma, 2011.

K

WORLD

SÃO PAULO
상파울루

TOKYO
도쿄

TORONTO
토론토

BERLIN
베를린

K

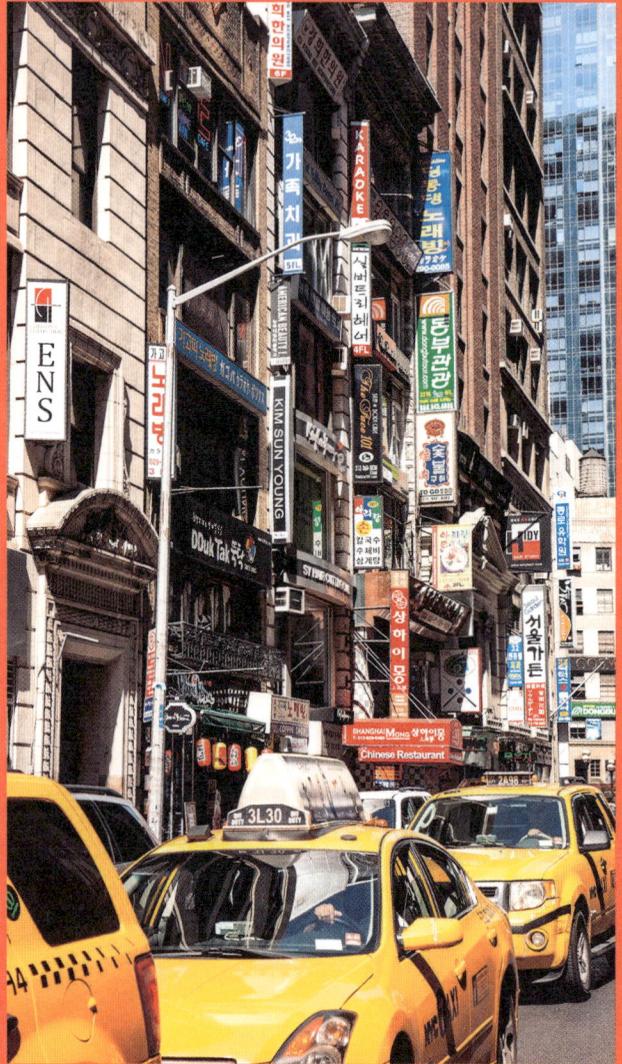

→ Koreatown

Located in Midtown Manhattan, not far from the Empire State Building, K-Town is mainly concentrated on 32nd Street, officially nicknamed Korean Way. The section between Broadway and 5th Avenue features numerous Korean shops and restaurants, giving the district its name. New York has the second largest Korean emigrant population in the world after Los Angeles, with most people living in Queens and Flushing.

Her Name is Han

www.hernameishan.com
17 E 31st St,
New York, NY 10016

A far cry from the sophisticated cuisine of gourmet restaurants, this brilliant "home away from home" offers New Yorkers nostalgic and delicious home-cooked food. All the delights of Korean soul food in one place!

Korean Culture Center

www.koreanculture.org
460 Park Avenue 6th Floor,
New York, NY 10022

Opened in 1979, the Korean Cultural Center New York is an institution in the city. In addition to the many different events organised here in a wide variety of cultural fields such as cinema, art, theatre, dance, music and cuisine, the Center also hosts educational courses and off-site gatherings. The organisation is supported by the Korean Consulate General. It also has a library offering an exceptionally wide range of resources for those interested in learning more about the country and its culture.

⊕ 40° 42' N 74° 00' W

NEW YORK

→ **Koryo Books**

35 W 32nd St,
New York, NY 10001

A long-established institution, this small but
well-stocked bookshop is one of the oldest
stores in K-Town. In existence for more than
30 years, it offers readers a comprehensive
selection of books in Korean, including fiction,
cooking, fashion and crafts, as well as a range
of English-language best-sellers translated into
Korean. Don't forget to visit the second floor
where a traditional Korean tearoom awaits!

Osamil

www.osamil.com
5 W 31st St,
New York, NY 10001

In the heart of K-Town, this stylish and modern
gastropub is the ideal place to spend time with
friends and enjoy unusual cocktails, Korean
beers and soju while tucking into grilled skewers
and the house specialty of honey butter chips!

BEST IN TOWN
필수적인

→ Jungsik

www.jungsik.kr
2 Harrison Street,
New York, NY 10013

The contemporary and creative cuisine of this Korean restaurant has earned it two Michelin stars. With subtle references to French gastronomy, chef Jungsik Yim has invented his own form of "Korean nouvelle cuisine", offering his customers the concept of new Korean fine dining in a comfortable setting.

Grace Street

www.bygracestreet.com
17 W 32nd St,
New York, NY 10001

If you're keen to try Korean doughnuts, this is the place for you! It also offers various types of teas and coffees as well as other Asian treats.

← Line Friends

www.timessquarenyc.org/
locations/line-friends
1515 Broadway,
New York, NY 10036

These sticker characters are established symbols of K-pop and can now be bought in many different forms such as cuddly toys, mugs and key rings. You're sure to find something here to add a touch of cute roundness to your decor and your look!

⊕ 40° 42' N 74° 00' W

Mandu Apparel and Accessories KPOP Store

www.manduapparel.com
1000 8th Ave STE 10,
New York, NY 10019

To the delight of all K-pop fans, this American company manufactures clothing and accessories produced in the US and printed with eco-friendly inks. A must-visit store for Korean clothes made in America!

BEST IN TOWN

← HanGawi

www.hangawirestaurant.com
12 East 32nd Street,
New York, NY 10016

You'll have to take off your shoes to enter this shrine of Korean vegetarian cuisine in New York. Advocating healthy food that balances the forces of um (yin) and yang, the space invites you to unwind and enjoy the tranquillity created by delightfully soothing traditional decor.

K

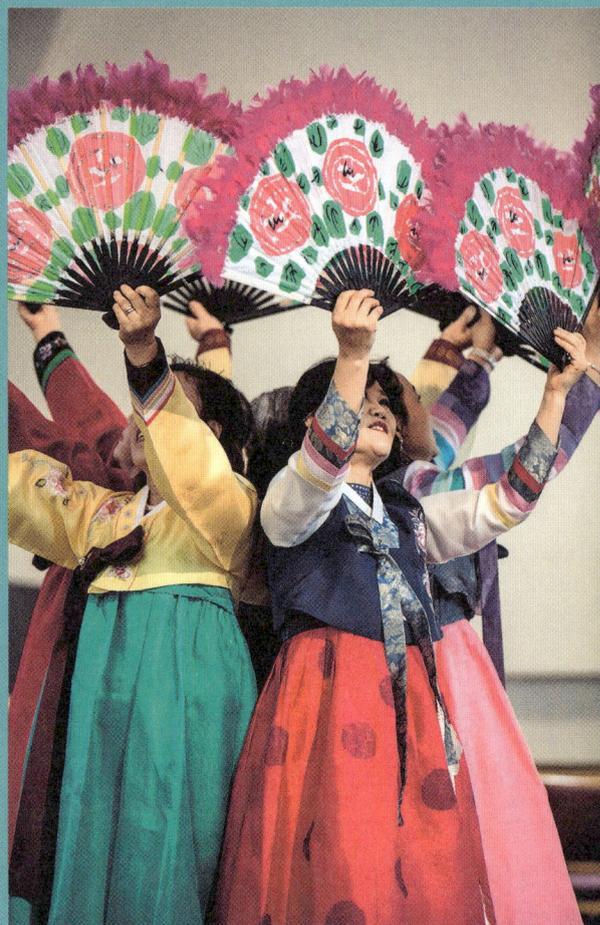

→ | Koreatown

New Malden is a suburb located 9 miles from the centre of London, straddling the districts of Kingston upon Thames and Merton. It's known for its Korean population who arrived here in the 1980s. There are so many restaurants, shops and businesses run by Koreans in the neighbourhood that the BBC nicknamed the area "London's Little Korea".

Cake & Bingsoo Cafe

www.cakeandbingsoo.co.uk
39 High St., New Malden KT3 4BY

Don't be fooled - although it has all the trappings of a classic English tearoom, this café offers amazing and delicious Korean frozen desserts!

Sokollab

www.sokollab.co.uk
14 Rathbone Place, London W1T 1HT

This shop brings Londoners authentic and exclusive products from South Korea, catering for all fans of Korean pop culture!

Victoria and Albert Museum

www.vam.ac.uk
Cromwell Road, London, SW7 2RL

Undoubtedly one of the finest museums in the world, the treasures of the V&A include a room devoted to Korean decorative arts such as ceramics, lacquerware, fashion and much more. The perfect place to discover new masterpieces.

⊕ 51° 30' 26" N, 0° 07' 39" W

LONDON

The Korean Language Centre

www.koreanlc.com
Kimchi Cottage, 41 Avondale Drive, Loughton IG10 3BZ

Offering a number of different Korean language courses, the Centre gives all fans of K-culture the opportunity to understand it better, while for those who want to do business with South Korea or even live there, they can perfect their grasp of the language here.

Influencer Korean Englishman

www.youtube.com/user/koreanenglishman/featured

Josh Carrott and Ollie Kendal are the hosts of this YouTube channel. Released every Wednesday in English and Korean, their videos are dedicated to Korean culture and cuisine. The channel originally showed the reactions of English friends to Korean food, but their videos now get millions of views and many of their subscribers are located in South Korea!

BEST IN TOWN
최고의 맛집

↓ Han Kang Restaurant

www.hankang.co.uk
16 Hanway Street, London, W1T 1UE

Established at this address since 1991, the restaurant is named after one of the largest rivers in South Korea. Here you can enjoy Korean specialities and in particular the famous barbecue featuring delicious and tender meats.

Book Village

www.londonkoreanlinks.net/2008/08/16/book-village
115B Burlington Road, New Malden, KT3 4LR

This is the go-to store in London for books in Korean. Located in Koreatown, not far from the centre of the capital, it offers a comprehensive selection of titles to those who understand the language of the Land of the Morning Calm and love its literature.

K

Korean American National Museum

www.kanmuseum.org
3727 W 6th St. #519, Los Angeles, CA 90020

Architect Eui-Sung Yi is currently redesigning this national museum, effectively grafting the form of a Korean landscape onto the City of Angels. The mission of the museum is to showcase the riches of Korean culture and civilisation, allowing visitors to learn more about all they have to offer.

Genwa

www.genwakoreanbbq.com
450 West Olympic Blvd. Ste B & C, Los Angeles, CA 90015

Specialising in Korean barbecues, this restaurant may be a little way to the west of K-Town, but it offers an elegant atmosphere and barbecues featuring an unusual blend of delicious meats.

↑ Koreatown

Los Angeles has the largest Korean emigrant population in the world. Located south of Hollywood and west of Downtown, these eight square kilometres are known for their lively nightlife with numerous bars, clubs, restaurants and karaoke rooms which stay open day and night. The neighbourhood also offers cafés, specialty shops and traditional spas.

BEST IN TOWN

Korean Cultural Center

www.kccla.org
5505 Wilshire Blvd. Los Angeles, CA 90036

Run by the Korean government, this venue is dedicated to the promotion of Korean culture and offers numerous activities to help the general public get to know it better: exhibitions, film screenings, videos for apprentice cooks interested in Korean cuisine, and K-pop and taekwondo events.

🌐 34° 03′ N, 118° 15′ W

→ Dawooljung

978 Normandie Ave., Los Angeles, CA 90006

Known as the "harmonious gathering place", this open-air pavilion marks the historic spot where the district of K-Town was founded in the late 1960s. Sitting in the middle of a 5,000 square metre garden, it's made of pine and dyed in traditional shades of green, rust and red and topped by an upswept tiled roof, making it a haven of typically Korean peace.

↘ Parks BBQ

www.parksbbq.com
955 S. Vermont Ave., Ste. G, Los Angeles, 90006

In the heart of K-Town, chef Jenee Kim invites regular customers and visiting gourmets to enjoy her must-try barbecues. The restaurant is something of an institution and has received many awards.

Quarters BBQ

www.quarterskbbq.com
3465 W. 6th St., Los Angeles, 90020

Housed in a historic building and decorated with industrial styling, this is another restaurant offering Korean barbecues, from classic grilled beef specialities to unusual fondues.

LOS ANGELES

Bumsan Organic Milk Bar

534 S Western Ave., Los Angeles, CA 90020

This organic ice cream parlour is one of K-Town's most popular hangouts. Made with milk from Korea's leading organic dairy producer, Bumsan Farm Co., these ice creams are a big hit in the city with their unique flavours, toppings and textures.

↓ Somisomi

www.somisomi.com
621 S Western Ave. #208-A, Los Angeles, CA 90005

If you fancy trying ice cream in a goldfish-shaped waffle cone, Somisomi is a must-visit! Founded in 2006 by two dessert lovers, the chain now offers its specialities throughout the country.

↑ Meehee Hanbok

meeheehanbok.com
3461 W 8th St., Los Angeles, CA 90005

Founded in 1987, this traditional Korean clothing store makes sublime bespoke hanbok costumes.

SeJong Bookstore

www.yelp.com/biz/sejong-bookstore-los-angeles
Koreatown Galleria, 3250 W Olympic Blvd, Ste 326, Los Angeles

Located on the third floor of a large shopping centre, this bookstore offers a wide choice of titles on all topics, as well as a selection of Korean and Japanese magazines. It also features a particularly well-stocked children's section with books to delight all ages.

🌐 34° 03′ N, 118° 15′ W

→ Koreatown Galleria

www.koreatowngalleria.com/about_ktg.html
Koreatown Galleria, 3250 W Olympic Blvd, Ste 326, Los Angeles

In the heart of K-Town, this large mall contains more than 70 stores, making it a shopping hotspot in the neighbourhood!

BEST IN TOWN
필수적인

Pharaoh Karaoke Lounge

www.yelp.com/biz/young-dong-nohrehbang-los-angeles
3680 Wilshire Blvd Ste B-02 Los Angeles, CA 90010

After a hard day's work, there's nowhere better to have fun and unwind than a karaoke bar. In the grand Korean tradition, this venue offers 17 private rooms where friends can sing their hearts out in complete privacy!

→ Joeun Korean Bamboo Salt

http://www.thebamboosalt.com
2785 W Olympic Blvd, Los Angeles, CA 90006

Founded in the United States 12 years ago, this company transmits the wisdom of master Insan Ilhun Kim who introduced bamboo salt to the country. With special antioxidant properties, this substance helps to detoxify the body.

K

↑ ## Centre culturel Coréen

www.coree-culture.org
20, rue La Boétie, 75008 Paris

With links to the Korean Embassy, the Centre was founded in 1980 and works to promote Korean culture in France, as well as fostering and developing artistic exchanges between the two countries. It organises many events both on-site and in other venues such as exhibitions, concerts, film screenings and talks. It also hosts workshops on Korean crafts, cuisine and dance. The centre publishes an interesting twice-yearly magazine, Culture Corée.

Musée Guimet

www.guimet.fr
6, place d'Iéna 75116 Paris

The Guimet museum is France's National Museum of Asian Arts and has a magnificent collection of objects and art from all over Asia. Although the Korean section is relatively small, there are some beautiful treasures to discover here.

→ Le Jardin de Séoul

www.jardindacclimatation.fr/
attractions/le-jardin-coreen
Jardin d'Acclimatation, Bois de Boulogne, route de la Porte Dauphine à la Porte des Sablons, 75116 Paris

An ideal place in Paris for a dreamy walk where you'll be introduced to the Pisemum, Sesimji, Bullomun and Jukujeong. Look out for swans and ducks who speak Korean, lulled by the ringing of bells hung in the surrounding bamboo groves.

Musée Cernuschi

www.cernuschi.paris.fr
7, avenue Velasquez, 75008 Paris

With links to the city council of Paris, this superb little museum has a department of Korean graphic arts mainly featuring works from the 20th and 21st centuries. Created through a collaborative venture between the artist Lee Ungno and the Cernuschi museum, the collection has continued to grow through the contributions of artists interested in the cultural relationship between France and Korea.

🌐 48° 51' 24" N, 2° 21' 07" E

PARIS

→ Kohyang

www.kohyangparis.com
6, rue du Général Estienne, 75015 Paris

The couple who own this restaurant promise their customers "a trip to traditional Korea in the centre of Paris" where they serve up hearty specialities prepared with care. With bulgogi, bibimbap and the famous Korean barbecue, passing gourmets will quickly turn into regulars!

INCONTOURNABLE 필수적인

Signature Montmartre

signature-montmartre.fr/
12, rue des Trois Frères, 75018 Paris

Serving delicate and gourmet French-Korean cuisine, this restaurant with its subtle decor is one of the best addresses in Paris, run by a brilliant team who excel at showcasing the fusion of two gastronomic cultures!

Mandoobar

www.mandoobar.fr/mandoobar-en.html
7, rue d'Édimbourg, 75008 Paris

Chef Kim Kwang-loc was born in Seoul where he owns another restaurant. With a lifelong interest in traditional Korean herbs, he creates delicious, delicate and tasty Korean specialities in the French capital.

+82 Paris

www.instagram.com/plus82paris
11 bis, rue Vauquelin, 75005 Paris

Taking its name from the dialling code for Korea, this tearoom run by two Koreans is a popular hangout in the capital. The typical, simple and tasteful decor is a perfect match for the delicious specialities on offer. The ideal spot for a little break.

Binici

www.binici.business.site/
18, rue Chapon, 75003 Paris

For those in need of a plum tea, a hot chocolate with matcha, or a latte made with a roasted grain known as Job's tears, this Korean-style café is the ideal venue in the Marais district of Paris. It also serves delicious roll cakes to go with any beverage.

Korean influencer Laurent Caccia

www.youtube.com/c/
LaurentCacciaVlog/featured

A traveller with a passion for Asia, Laurent Caccia eventually settled in Korea where he married and now has a family. His French-language YouTube channel explores the differences between Korean and French society, as well as explaining his daily life, his favourite recipes and his relationship to Korean culture. His videos are a great way of discovering everyday Korea.

⊕ 48° 51' 24" N, 2° 21' 07" E

Korean influencer Pape San

https://www.youtube.com/c/PapeSan/videos

Since he posted his first video on YouTube in 2017, French influencer Pape San (real name Pape Sy) has been introducing Korean life to all of his followers. Living in the Land of the Morning Calm on a university exchange, he explains the nightlife, the cuisine and different cultural aspects of life in Seoul.

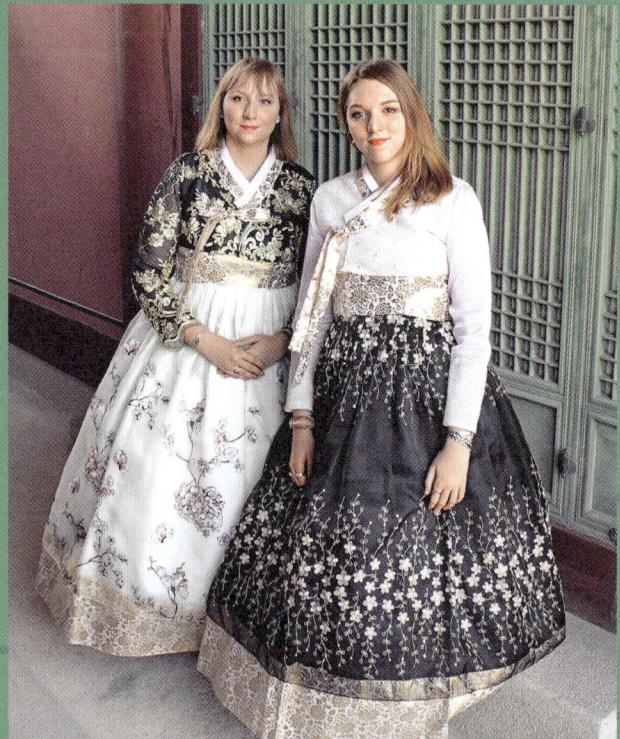

↑ Influencer Korean Coffee Break

https://www.koreancoffeebreak.com/

Clothilde and Julia are two sisters passionate about the Land of the Morning Calm. Informed by their interests and travels, their richly evocative cultural blog allows readers to discover Korean culture without any of the usual stereotypes.

→ Bonjour Corée

www.bonjour-coree.org

Founded in 2012, Bonjour Corée is one of the most active organisations in France promoting Korean culture. It hosts events on major themes, including music, film, cuisine, technology, K-dramas, etc. Its most famous activities are the K-pop Dance Battle, the Franco-Korean Quest and the Drama Party!

INCONTOURNABLE 한국사필

Besides Kimchi

www.besideskimchi.com
7, rue Saint-Martin, 75004 Paris

Shopping aficionados and fans of Korea are sure to find what they're looking for in this concept store in a wide variety of forms, from clothing and accessories to decorative objects and stationery.

↘ Acemart

www.acemartmall.com
63, rue Sainte-Anne, 75002 Paris

A Parisian institution, Acemart offers a vast array of Japanese and Korean food products.

Seoul Station

www.seoulstation.fr
147, rue Saint-Charles, 75015 Paris

This shop showcases the Korean art of living: kitchen accessories, decorative objects, cosmetic products and much more. There's something here for everyone.

K-Pop Dance Academy

www.k-popdanceacademy.com
91, rue Alexandre Dumas, 75020 Paris

The K-Pop Dance Academy was founded in 2012 by Antsi Hossié, a hip-hop teacher also trained in classical Indian and African dance. She discovered K-pop in London and came up with the idea of a creating a venue where she could teach K-pop moves and bring this culture to life with other fans.

K

↑ | Koreatown

The Bom Retiro district in the centre of the city is known by the semi-official name of "Bairro Coreano em São Paulo" or the Korean District of São Paulo. It's home to Brazil's largest Korean community and the country's biggest Korean clothing market. The area is particularly famous for its fashion stores and garment wholesalers and retailers. But there are also many restaurants, bars and cafés here, and major cultural events are organised in the neighbourhood by the Korean community.

Centro Cultural Coreano

www.brazil.korean-culture.org/PT
Av. Paulista, 460 – Bela Vista,
São Paulo – SP, 01311-000

Brazil's Korean Cultural Centre was opened on 23 October 2013. Its mission is to promote and defend the different aspects of Korean culture such as K-pop, taekwondo, food, etc. Or to put it another way, everything that Korea stands for in the eyes of Brazilians. Opened in 2017, the Brasil Hallyu Expo is a key event hosted by the centre: in 2019, 20,000 Brazilian visitors came to the show - proof of the growing enthusiasm for K-culture!

Bicol

www.bicol.com.br
R. José Getúlio, 422 – Liberdade, São Paulo – SP, 01509-000

Catering to all fans of Korean cuisine, this restaurant serves up favourite dishes accompanied by a glass or two of soju, making it one of the best places in the city to enjoy a memorable evening. Bicol has many regular customers who are attracted by the friendly staff and pleasant surroundings.

SÃO PAULO

UM DEVER TER
맛집 슛 적인

↗ | Komah

www.komahrestaurante.com.br
R. Cônego Vicente Miguel Marino, 378 –
Barra Funda, São Paulo – SP, 01135–020

Born in Brazil to Korean parents, chef Paulo
Shin serves up generous and delicious
cuisine in the relaxed, urban ambiance of his
restaurant, bridging the gap between tradition
and modernity with his reworked versions
of Korean classics. The queue in front of the
restaurant's ivy-covered façade is a sure sign
of its deserved success!

Next Bar Karaokê

www.next-bar-karaoke.negocio.site
R. Salvador Leme, 278 – Bom Retiro,
São Paulo – SP, 01124–020

It may be called a karaoke bar but don't
be fooled, we're definitely in the land of the
Koreans. The machine controls and signs in
the Korean language are living proof!

⊕ 23° 32' 52" S, 46° 38' 11" W

243

K

↓ Koreatown

Arriving here in the 1980s, Koreans made this district in the heart of the Japanese capital their own. A stone's throw from Shinjuku, Shin-Ôkubo is Japan's Koreatown. Its many small shops sell every Korean product under the sun, like pop culture merchandise featuring the latest stars but also cosmetics, clothing and groceries. Visitors with an untrained eye will find it hard to tell the difference between the Japanese and Korean ideograms covering the shopfronts of the district, but these streets offer a very special and unique atmosphere in Tokyo.

Tokyo Korean Culture Center

www.koreanculture.jp/intro_greeting.php
4 Chome-10 Yotsuya, Shinjuku City, Tokyo 160-0004

This is the introduction on the website of the Tokyo Korean Culture Centre: "A place that plays a role in connecting Korea and Japan through culture. A place where Korean and Japanese people can exchange true friendship. A place to exchange information about Korea. We are the Korean Culture Center." Supported by the Korean Ministry of Culture, the centre is clearly the beating heart of Korea's cultural institutions in Japan.

Hanno Daidokoro Bettei

www.hannodaidokorobettei.gorp.jp/
2-29-8 Dogenzaka, Dogenzaka Center Bldg 7F, Shibuya, Tokyo 150-0043

This restaurant serves up a superbly Japanese take on the traditional Korean barbecue. As well as iconic Kobe beef, the menu offers other remarkable and wonderfully tasty Japanese meats such as Yamagata beef.

🌐 35° 41' 22" N, 139° 41' 30" E

TOKYO

Shijan Dak Galbi

www.bulmakyeolsam.jp/2go.html
1 Chome-16-16 Okubo, Shinjuku City,
Tokyo 169-0072

On its à la carte menu, this Japanese restaurant offers a Korean must-try tripe dish known as *makchang* which is rich in vitamins, minerals and collagen. The dish has purported beauty and health benefits, and its surprising texture makes it an interesting culinary attraction!

Delica Ondoru

www.delicaondoru.com
1 Chome-16-13, B1F Okubo, Shinjuku
City, Tokyo 169-0072

With two branches in the Shin-Ôkubo district, this restaurant serving Korean specialities is one of the busiest in the city. With a comprehensive menu, varied and inexpensive set meals and high-quality products, authentic and generous cuisine is guaranteed.

↗ BT21 Cafe

www.box-cafe.jp/information/shibuya_information
109, 2 Chome-29-1 Dogenzaka,
Shibuya City, Tokyo 150-0043

BT21 are eight animated characters created by boy band BTS. Part of a chain in Japan, this café offers dishes where styling is more important than taste. In fact, each dish features the characters so adored by fans, allowing them to snack on their favourites! The tableware and atmosphere are of course perfectly matched!

It's Skin

www.skinholic.jp/c/brand_list/itsskin
17, Shinjuku City, Tokyo 169-0072

This store in Koreatown offers a wide range of Korean cosmetics from the brand IT'S SKIN, one of the most popular in South Korea.

K

↓ Koreatown

Located between Christie Pits Park to the west and the University of Toronto to the east, Koreatown is the ideal place in Toronto for Korean enthusiasts to do their shopping. Here you can find cosmetics, fashion, Korean stationery and of course a host of restaurants, bars, tearooms and cake shops offering the very best specialities from Korea. In the heart of Seaton Village, the district gradually turned South Korean during the 1970s. Toronto now has the largest Korean community in Canada, with nearly 60,000 people expressing their culture in the city.

Korean Canadian Cultural Association of Metropolitan Toronto

www.kccatoronto.ca
1133 Leslie St, North York, ON M3C 2J6

The KCCA is a non-profit, community-based charity organisation. Active for more than 50 years, it plays a key role in promoting Korean culture and heritage among Canadians.

Kevin's Taiyaki

www.instagram.com/ kevinstaiyaki/?hl=fr
675 Bloor St. W, Toronto, ON M6G 4B9

When it comes to sweet treats, this might be the best *bungeobbang* in town, with its fluffy yet crispy fish-shaped waffle cone. Lovers of red bean paste won't be disappointed!

→ Hodo Kwaja

www.hodokwaja.ca
656 Bloor St. W, Toronto, ON M6G 1K9

This Korean bakery has been offering its delicious specialities since 2012. The menu includes walnut cakes (*hodo kwaja*), pancakes (*hotteok*) and waffle-like biscuits (*chun byung*). With a wide variety of flavours and textures, there's something here for everyone!

🌐 43° 40′ 13″ N, 79° 23′ 12″ W

TORONTO

PAT Central

www.patmart.ca
675 Bloor St. W, Toronto, ON M6G 1L3

This vast Korean grocery store also sells products from other Asian countries. Certain specialities are prepared on site while imported products are all of excellent quality. Undoubtedly the best food store of its type in town.

Mr. Pen

www.shopmrpen.com
683 Bloor St. W, Toronto, ON M6G 1L3

This charming stationery store offers a wide choice of Korean pens and pencils, notebooks, papers and gift items, many of them imported.

Echo Karaoke on Bloor

www.echokaraoke.ca
693 Bloor St. W, Toronto, ON M6G 1L5

Although this karaoke bar offers a song selection from around the world, we recommend singing your heart out to the great tunes of K-pop in one of the private rooms available for all the amateur singers out there.

BEST IN TOWN
시내 최적인

Seoul Zimzilbang Korean Sauna

www.ilovesauna.com
382 Magnetic Dr, North York, ON M3J 2C4

This traditional Korean sauna offers a lounge with televisions, exercise equipment and comfortable loungewear so you can wander around the establishment as if you were at home. Note that everyone here is clothed, whereas in Korea it's the norm to get naked!

호도과자
Hodo Kwaja
호도과자

Korean Snacks: · Walnut Cakes · Korean Pancakes · Red Bean Pastries

호도과자 538-1208

OPEN

Cool Down
our Sherbet

Warm
your
Taste

K

Koreanisches Kulturzentrum

www.kulturkorea.org
Leipziger Platz 3, 10117 Berlin

Linked to the Press and Culture Department of the Embassy of the Republic of Korea and founded in 1994, this cultural centre aims to make traditional and modern Korean culture and arts accessible to a wide audience in Germany. It organises exhibitions, talks and concerts, and delivers courses on all types of cultural activity.

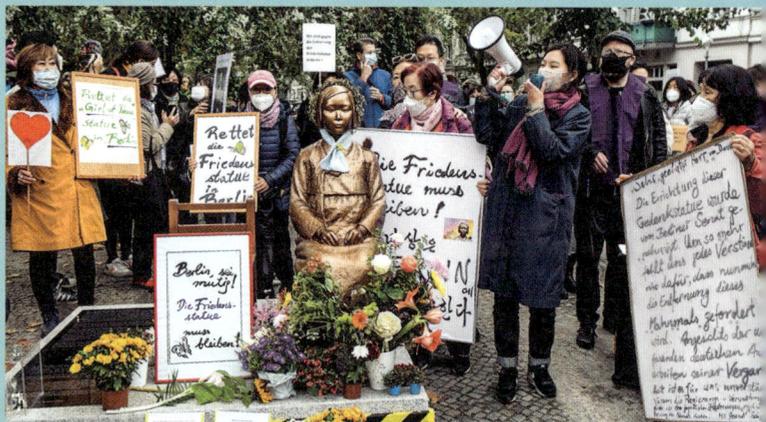

↘ Koreanischer Garten

www.gaertenderwelt.de
Eisenacher Str. 99, 12685 Berlin

Opened in 2006, the idea for this Korean garden was initiated by the Mayor of Seoul on a visit to Berlin in order to "deepen friendly relations between the two capitals". Created using only traditional materials, the landscape reflects Korean nature, featuring typical tree species typical such as pine, bamboo, oak and Japanese maple. The garden is composed of four courtyards and a magnificent central structure, the Kye Zeong (Pavilion on the Water) built on rocks and overlooking water.

↑ Statue of Peace

Bremer Str. 41, 10551 Berlin

Created by two Korean artists Kim Seo-kyung and Kim Eun-sung, this statue commemorates the women forced into sexual slavery who were kidnapped, tortured and raped by Japanese soldiers between 1932 and 1948. They were euphemistically known as comfort women. A similar statue exists in Seoul.

Coréen

www.coreen-restaurant.de
Torstraße 179, 10115 Berlin

This Korean restaurant offers delicious specialities in a minimalist, stylish setting. The staff are pleasant and the service exemplary. Drop in for the best kimchi pancakes in the German capital!

🌐 52° 31′ N, 13° 23′ E

BERLIN

→ YamYam

www.yamyam-berlin.de
Alte Schönhauser Str. 6, 10119 Berlin

Undoubtedly one of the best places in Berlin for lovers of Korean cuisine. Behind its unassuming storefront, this small restaurant with elegant decor serves up excellent soups as well as all the usual specialities from Korea: kimchi, bulgogi, bibimbap and much more.

UNUMGÄNGLICH 필수 코스

Abonim

www.abonim.de
Wisbyer Str. 69, 10439 Berlin

Although this restaurant serves mainly Japanese cuisine, it also offers the traditional Korean barbecue and six different bibimbaps! A comprehensive selection to satisfy the curiosity of all K-food fans.

Damso

www.damso-teehaus.de/speisekarte
Teltower Damm 54, 14167 Berlin

The Korean couple running this adorable and charming tearoom welcome you to their indoor wooden tables and outdoor terrace. The products here are fresh and delicious. With an incredible selection of teas from Korea, this is the ideal place for a peaceful break in the city.

Seoulstation Berlin

www.seoulstation.berlin
Kantstraße 103, 10627 Berlin

Seoulstation Berlin is the perfect spot for all K-pop fans. Whether it's BTS, Stray Kids, BT21, Ateez or Blackpink, visit this store to find the latest new releases and products, along with the most incredible merchandise.

Koreanische Schule Berlin

www.hanhag.de
Schillerstraße 125–127, 10625 Berlin

Not far from Berlin's Zoological Garden, this Korean school was opened in 1980. Its mission is to keep Korean culture alive in the city by delivering courses and workshops for both Koreans living in Germany and the general public. The school also offers the services of an impressive library.

BIBLIOGRAPHY

▶ Cadieux, Axel, Clairefond, Raphaël, "Bong Joon-ho: Netflix, écologie et syndrome de Peter Pan", Sofilm no 51, June 2017.

▶ Cambon, Pierre, *L'Art coréen au musée Guimet*, Paris, Réunion des musées nationaux, 2001.

▶ Carbonero, Cédric, "Hyein Seo, la jeune créatrice coréenne qui a inspiré le style de Rihanna", 11 May 2017, *konbini.com*.

▶ Clair, Simon, "Qu'est-ce que le soju, spiritueux le plus vendu au monde?", 11 January 2018, *lesinrocks.com*.

▶ Dudek, Maria Anna, "Minhwa, peinture folklorique coréenne", 20 June 2021, *planete-coree.com*.

▶ Dudek, Maria Anna, "Jihwa, l'art des fleurs en papier", 21 November 2021, *planete-coree.com*.

▶ Durieux, Jeanne, "Les Sud-Coréens tentent de rajeunir depuis 2019, voici pourquoi", 27 April 2022, *ouest-france.fr*.

▶ Gordinier, Jeff, "Jeong Kwan, the Philosopher Chef", 16 October 2015, *nytimes.com*.

▶ Gratien, Antonin, "Dernier train pour Busan : faux zombies, vraies plaies de Corée", 28 June 2021, *konbini.com*.

▶ Han-Sol, Park, "Feminist, queer shaman reads fortunes to challenge prejudices", 7 October 2021, *koreatimes.co.kr*.

▶ Jeannin, Marine, "Pourquoi les séries sud-coréennes font aussi un carton en Afrique", 30 June 2022, *lemonde.fr*.

▶ John, Eva, "Naver le coréen qui navre Google", 17 March 2013, *liberation.fr*.

▶ J. Park, Anna, "Yang Joon-il, a musician living ahead of his time, finally recognized 30 year later", 10 December 2019, *koreatimes.co.kr*.

▶ Khameneh, Arian, "'Muscles look cool': South Korean women reshape idea of beauty", 10 June 2022, *theguardian.com*.

▶ Kim, Ye Eun, "'Next in Fashion' winner Minju Kim on her inspirations and why she joined the Netflix show", 24 February 2020, *hypebae.com*.

▶ Barbery-Coulon, Lili, "La beauté fait son marché en Corée", 8 November 2013, *lemonde.fr*.

▶ Kwon, Junhyup, "La Corée du Sud interdit les tatoueurs de tatouer", 12 April 2022, *vice.com*.

▶ Légaré-Tremblay, Jean-Frédéric, "Place à la diplomatie du kimchi", 17 October 2015, *ledevoir.com*.

▶ Mesmer, Philippe, "En Corée du Sud, le bistouri est à la fête", 6 October 2017, *lemonde.fr*.

▶ Moss, Hilary, "Soo Joo Park Doesn't Want to Be Typecast As an Asian Model", *thecut.com*.

▶ Odell, Kat, "Meet Mingoo Kang, the chef expanding the possibilities of Korean cuisine", 11 March 2021, *theworlds50best.com*.

▶ Ojardias, Frédéric, "En Corée du Sud, les femmes en révolte contre l'obsession de la beauté physique", 28 June 2018, *rfi.fr*.

▶ Ojardias, Frédéric, "Les plus grandes toilettes du monde sont à Séoul", *rfi.fr*.

▶ Ojardias, Frédéric, "Santé : pourquoi les Sud-Coréens dorment-ils moins que les autres?", 11 April 2017, *rfi.fr*.

▶ Polverini, Léa, "Geongangmi : comment les femmes coréennes redéfinissent les normes de beauté", 11 June 2022, *slate.fr*.

▶ Rodrigues-Ely, Nina, Kozsilovics, Vincent, "Les clés pour comprendre l'art contemporain en Corée du Sud et ses enjeux", 28 March 2016, *observatoire-art-contemporain.com*.

▶ Son, Sua, "Sung Hee Kim : mannequin à suivre", *matchesfashion.com*.

▶ Sông-Mi, Yi, *Raffinement, élégance et vertu. Les femmes coréennes dans les arts et les lettres*, Éditions Autres Temps, 2007.

▶ Tan, Gerald, "Irene Kim On The Importance Of Keeping Good Vibes In The Fashion Industry", 19 May 2017, *harpersbazaar.com*.

▶ Turcan, Marie, "Netflix perd des abonnés fidèles depuis des années, et c'est un nouveau problème", 20 May 2022, *numerama.com*.

▶ Williamson, Lucy, "Why is Spam a luxury food in South Korea?", 19 September 2013, *bbc.com*.

▶ Yj Lee, Elaine, "Sora Choi", October 2021, *The WOW Magazine*.

▶ Yousif, Nur, "Korea's DMZ Peace Train Festival: Bringing happiness to the world's most heavily guarded frontier", 20 September 2019, *mixmag.net*.

ACKNOWLEDGEMENTS

The author would like to thank the E/P/A publishing team, and in particular Boris Guilbert and Charles Ameline.

He would also like to acknowledge the work of South Korean enthusiasts - such as the website planete-coree.com - whose detailed articles were of invaluable help in his research on the subject.

Finally, he sends heartfelt thanks to his father, Serge Clair, for all his support over so many years.

The publisher, Éditions E/P/A, Hachette Livre, would like to thank Ji-young Woo and Georges Arsenijevic, from the Centre Culturel Coréen in Paris, for their feedback on the idea for this project. We would like to send friendly thanks to Claudia De Bonis for her consistent and long-standing kindness. And also to thank Liyu N'Guyen-Bousseau for her precious assistance and Janice Yip for her proofreading.

We would also like to thank the organisation Bonjour Corée, Yann Cavaille (Soap Seoul club), Terri Choi (HanGawi), Clothilde & Julia (Korean Coffee Break), Gianna Görtz (Komah restaurant), Françoise Huguier, Alice Kim (Meehee Hanbok), Sunna Kim (Kohyang restaurant), Young and Jason Kim (Osamil), Kyeonghi Min (Centre Culturel Coréen), Lee (Echo Karaoke), Lee Suki (Hodo Kwaja), Nakanishi Nobi (Somisomi), No Suki (Grace Street), Parks BBQ, Michael Powers (Jungsik), Mingles restaurant, Mira Irene Sánchez (Coréen restaurant), Kim Woojin (Cultural Corps of Korean Buddhism), Cecilia Soojeong Yi (DMZ Festival), Seoul Zimzilbang Korean Sauna.

INDEX

INDEX

The English language edition published in 2023 by Quadrille.

First published in 2023 by Quadrille,
an imprint of Hardie Grant Publishing
Quadrille
52-54 Southwark Street
London SE1 1UN
quadrille.com

For the English language edition:
Publishing Director: Sarah Lavelle
Senior Commissioning Editor: Sophie Allen
Translator: Alison Murray
Senior Designer: Katherine Keeble
Head of Production: Stephen Lang
Production Controller: Sabeena Atchia

Text © Simon Clair 2022
Photographs - see page 251
Cover illustrations © Jisu Choi

Cataloguing in Publication Data: a catalogue record for this book is available from the British Library.

ISBN 978 1 83783 087 9

MIX
Paper from
responsible sources
FSC
www.fsc.org
FSC™ C020056

Printed in China

The French edition, first published in 2022, as
Corée - La K culture © Hachette-Livre (Editions EPA), 2022

Publishing Director: Ariane Lainé-Forrest
Managing Editor: Boris Guilbert
Art Director: Charles Ameline
Graphic design and production: Studio Zerozoro
Proofreading: Marie Odile Mauchamp
Production: Amélie Moncarré
Photoengraving: Hyphen-Media for c/o Hyphen-France

Published by E/P/A
58, rue Jean-Bleuzen
92179 Vanves Cedex
Printed in Spain in September 2022 by Macrolibros
Copyrighted: November 2022
ISBN: 9782376713364
6131680